MUNCH

MUNCH
HIS LIFE AND WORK

REINHOLD HELLER

JOHN MURRAY

© 1984 John Calmann and Cooper Ltd, London

This book was designed and produced
by John Calmann and Cooper Ltd, London

First published 1984
by John Murray (Publishers) Ltd
50 Albemarle Street, London W1X 4BD

Filmset by Composing Operations Ltd,
Tunbridge Wells, Kent
Printed and bound in Hong Kong by
Mandarin Offset Ltd

British Library Cataloguing in Publication Data
Heller, Reinhold
 Munch.
 1. Munch, Edvard 2. Painters—Norway—
 Biography
 I. Title
 759.81 ND773.M8
 ISBN 0-7195-4116-6

CONTENTS

ACKNOWLEDGEMENTS

This book was first proposed by John Calmann, and without his encouragement it is unlikely that it would ever have been written. The shock of his death slowed the manuscript down, but it remains my hope that he would have been satisfied with the final result.

Edvard Munch became a subject of study for me in the mid-1960s; to now recall everyone who helped me during the twenty years that have elapsed since then is clearly not possible, but I wish to let all those not mentioned here know of my gratitude. It is particularly necessary, however, to express my appreciation to the Munch Museum and the National Gallery in Oslo, whose unequalled collections of Munch's art and manuscripts were made available to me. Among the many singled out should be Mrs Ragna Stang, who as director of the Munch Museum constantly proved most helpful, and Reidar Revold, the former curator of the Museum; that neither of them lived to see the current study is one of the sadder aspects of my work. Also to Pal Hougen, Arne Eggum, Jan Thurmann-Moe, Bente Torjusen, and particularly Trygve Nergaard, I am indebted for numerous discussions and the willingness to share observations, ideas and information; without them, my studies of Munch would have been far less enjoyable and also far less meaningful. Much the same must be said of my teachers, colleagues and students at Indiana University, the University of Pittsburgh and the University of Chicago; Albert Elsen more than anyone else gave me guidance and significant example.

Various editors have slaved over the manuscript, and to them it owes its cohesion: Elisabeth Ingles, Sue Wagstaff and Diana Davies. Typing was largely done by Joanne Keegan, a task for which I thank her almost as much as for her friendship.

As always, my wife Vivian was an observant critic, constant help and willing contributor to the book, and was patient during the times of discouragement when progress seemed most elusive. To her I dedicate this book, but ask her to share the dedication with the memories of her father, Andrew Hall, and my father, Friedrich Heller, as well as with the hope for the future represented by our two sons, Frederik and Erik.

LIST OF ILLUSTRATIONS

List of Illustrations

List of Illustrations

CHILDHOOD AND YOUTH
1863–1880

'I was born dying'

During the afternoon of 23 January 1944, in his house at Ekely overlooking the frozen waters of the Oslofjord just outside Oslo, Edvard Munch died peacefully, alone. Resting in bed after a visit from his doctor in the morning, Munch laid aside the book he was reading—Dostoevsky's *The Possessed* —and silently fell asleep a month and eleven days after his eightieth birthday.

Munch's death echoed the pattern of his life. In an heroic effort he had attempted to inure himself against the social and historical forces surrounding him. As his bulwark he used the products of sixty years' activity as an artist—the paintings and drawings and prints that he arranged and re-arranged about him. Outside life constantly pierced his shelter, forcing him psychologically and artistically to rebuild it. On 23 January 1944, his strength was finally gone. During the massive explosion of Nazi armaments at Filipstad on 9 December 1943, the first major violent action of the Second World War in Oslo, several windows were broken in the house at Ekely. Munch caught a cold. It was an insignificant event in the violence of world-wide war. To one of his infrequent visitors he remarked: 'For me, this war is dragging on too long',[1] and he himself became one of its incidental victims.

The suggestion of resignation and submission just before his death was uncharacteristic; the silence and isolation were not. His daily existence was marked by this silence, broken only infrequently, and by a determined

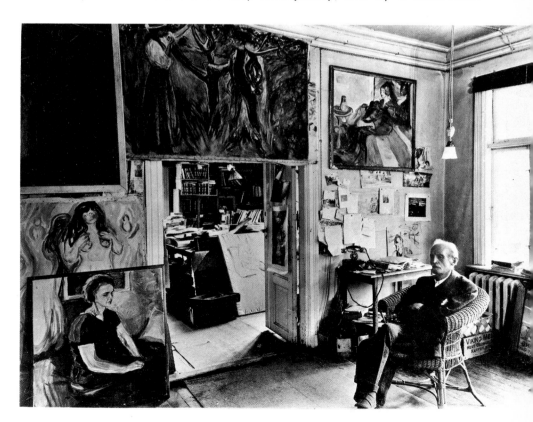

1 Edvard Munch in Ekely, *c.* 1943. Photograph. Oslo, Munch–Museet

resistance to all human contact. Curt Glaser, the German art historian who was his first biographer, observed that Munch

belongs only to his art. And he fears what others seek. Fears the peace of a comfortable existence. He condemns himself to life in an impossible house whose rooms are stripped of nearly all furnishings because possessions seem to him to be a threatening burden, and because he recognizes only the barest demands of his life, nothing that others deem necessary for comfort. A bed, a table, a chair. Other than that, only the tools of his art.[2]

After visiting Munch in 1927, Glaser wrote:

the isolation that he needs is the greatest luxury Munch permits himself, but at the same time it signifies a monk-like existence. . . . Where he works, he wants to be alone, undisturbed by people as well as by objects. . . . If pictures are hung up or are standing about, if drawings and prints are attached rudely to walls and doors with thumbtacks, it is because Munch is constantly preoccupied with his own pictorial creations. Once Munch said to me: 'You see, there are painters who collect paintings by others. I know of one who owns an entire gallery of French Impressionists. He needs them for his work. I can understand that very well. In the same way, I need my own paintings. I must have them near me if I am to continue working.'[3]

Periodically, Munch appeared to break through his silent, self-protective shield and became extremely talkative, chattering feverishly about art, about literature, about his analysis of nature and life, or about his own youth embroidered by his inventive imagination:

Then he speaks ceaselessly in his aphoristic manner with kaleidoscopically changing content and sudden shifts in the direction of his thought. 'Why, in Heaven's name, do you speak so much while painting?' he was asked, for when he is not silent, he speaks so that it is impossible to get a word in edgewise. 'Self-defence', answered Munch with his open, almost childlike smile. 'I build myself a sort of wall, so that behind this wall I can paint in peace.'[4]

The response—direct, honest and perceptive—is typical. If his spurts of rapid-fire conversation, like his art, were designed to ward off the quizzical disturbance of human relationships, they were also, like his art, intensely self-analytical, revealing a personality seemingly capable of stepping back from itself while protecting itself with the results of persistent self-dissection.

Edvard Munch was born on 12 December 1863, the eldest son and second child of Laura Cathrine Bjølstad and Dr Christian Munch, at the Engelhaug Estate in Løten in Hedmark.[5] During the next five years Laura Munch gave birth to three more children, and then died of tuberculosis. In all respects she appears to have been typical of those Norwegian women admired by a visiting English clergyman during the 1860s as 'thoroughly domesticated, kind, attentive and affectionate mothers'.[6] When she married Dr Munch in 1861 she was twenty-three; he was forty-four and had spent most of his life as a military physician either at sea or stationed with cavalry squadrons. A restless youth spent in virtually constant travel followed, shortly after the age of forty, by a deliberate break with a roving life, is a pattern found in previous generations of the Munch family; it is also the pattern of Edvard Munch's life.

According to a family legend, the Munch family originated in England or Scotland, although the first known Munch was an eighteenth-century naval lieutenant of Danish descent. Lieutenant Munch's descendants often chose military careers, but also became clergymen, poets and artists—Edvard Munch being only the most noted: there was Jacob Munch, who studied with

Jacques-Louis David in Paris and befriended Thorvaldsen in Rome; Frits Thaulow, who introduced Impressionism to Norway; and Edvard Diriks, who followed Norwegian artists' frequent habit of living and working outside their native country—as indeed Edvard Munch was to do for nearly twenty years.

In a nation where family pride is a primary characteristic, Edvard had ample reason to glory in his ancestors. In his house their portraits hung among his own paintings, incongruous companions created by the accidents of heredity; and he delighted in telling family anecdotes about heretical bishops and ghost-defying, bottle-smashing parsons. The pride of the Munch family, however, was a scholar, Dr Christian Munch's own brother, Peter Andreas Munch. Historian, mythologist, archaeologist, linguist, geographer, poet, cultural critic and art historian, P. A. Munch was born on 15 December 1810; he died while in Rome researching the Vatican archives on 25 May 1863, only months before his nephew was born. In Edvard's childhood home,

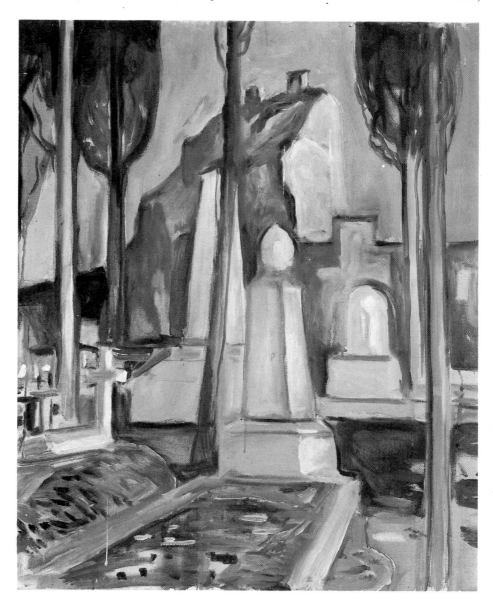

2 *The Grave of P.A. Munch,*
1927. Oil on canvas.
Oslo, Munch—Museet

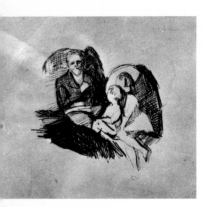

3 *Dr Christian Munch with his Daughters*, 1889/90. Pen and ink. Oslo, Munch–Museet

his uncle's books were read aloud, a constant reminder of the family's cultural achievements. In 1927, after Edvard had attended the opening of his massive retrospective exhibition in Berlin where he was celebrated as one of the old masters of modern art, he made a pilgrimage to Rome, sought out the Protestant cemetery and painted the image of his uncle's grave at the foot of the Pyramid of Cestius.

Shortly after his birth, Edvard's family moved to Kristiania, a city founded by the Danish king Christian IV in 1624 near the medieval town Oslo, which by the 1860s was no more than an impoverished suburb swallowed by the expanding city of some 55,000 inhabitants.[7] Although Norway's largest city and capital, Kristiania was highly provincial, with all its major buildings—a royal palace, the university and the Storting or parliament building, completed in 1866—arranged within sight of each other on the main street, Karl Johan's Street. As the centre of a developing railway network, Kristiania was also Norway's major industrial city, both benefiting and suffering from the effects of the Industrial Revolution. Housing for the exploding population was inadequate. 'Towns' of shabby wooden huts were constructed and liberally sprinkled with *brennevinnsjapper*—brandy shops—but not with running water or adequate toilet facilities. Slowly, the older wooden tenements were replaced by stone and concrete, highly profitable apartment buildings scattered randomly like grey sores on the still green countryside surrounding the city.

Into a newly built, somewhat draughty workers' barracks, Dr Munch's family moved early in 1864. The doctor's sense of Christian compassion for the impoverished workers was undoubtedly one motive for the choice of unfashionable habitat as he took his new post with the cavalry brigade in Kristiania, but his household, despite his culturally rich ancestral heritage, was and remained relatively poor.

In the Munch home, Dr Munch fully played the role of loving father but also of a strict, pious patriarch ruling his offspring with kindness and force, fusing a sense of military duty and obedience with an overpowering religious faith. Constant economic need reinforced military severity and religious puritanism. Softening their effect, however, was his love of storytelling; he would gather his five children around him, the smallest balanced on his knees, and they would listen absorbed to his tales. 'The way he could tell about his life and his travels,' recalled Edvard, 'or narrate the Sagas, so that we actually *saw* the events taking place before our very eyes, that was absolutely remarkable. By nature, he was a poet, and he never should have become a doctor.'[8] According to Edvard, however, scenes of paternal affection became less common after Dr Munch's young wife died of tuberculosis in 1868. The adventures of the Sagas were replaced by the terrors of eternal damnation, and the comforting religious focus of the home increasingly became an obsession for the doctor. His children's frequent severe illnesses—particularly tuberculosis, which killed both his wife and his eldest daughter and was so common in Norway that it was known as the national illness—also contributed to Dr Munch's religious fanaticism and gloom. During a particularly difficult time psychologically, Edvard recalled this morbid aspect of his childhood with a gloomy exaggeration that mirrors his father's religious fervour as well as his ability to tell ghost stories:

Two of mankind's most horrible enemies were granted to me as an inheritance. An inheritance of tuberculosis and mental illness. Sickness and insanity were the black angels that guarded my cradle.

A mother who died young gave me a weakness for tuberculosis; an overly nervous

father, so pietistically religious as to be almost insane, the descendant of an ancient family, gave me the seeds of insanity.

From the moment of my birth, the angels of anxiety, worry, and death stood at my side, followed me out when I played, followed me in the sun of springtime and in the glories of summer. They stood at my side in the evening when I closed my eyes, and intimidated me with death, hell and eternal damnation. And I would often wake up at night and stare wildly into the room: Am I in Hell?[9]

A source of illness and religious anxieties, the dogmatic father thus stood accused by the dogmatically unforgiving son. Viewing himself as constantly dying and genetically burdened, Munch suppressed thoughts of everyday happiness and replaced them with what were to become life-long fixations on the isolated but memorable moments in which he witnessed or experienced the fragility of life. 'Sickness', he wrote when he was nearly fifty, 'followed me through my entire childhood and youth. . . . And those I loved most died, one after the other.'[10]

His mother became a shadowy, slender, black-clad figure of embracing love in contrast to the unpredictable severity of his father. She appears weak but tender in his memory of an afternoon walk she took with her 'pale, sweet little Edvard', an event about which Munch repeatedly wrote and also repeatedly visualized with paint or pencil.[11] To those who objected that he could hardly have remembered her, having been barely five when she died, Munch vehemently protested: 'I remember many scenes with her but most readily her deathbed. I was deeply affected and was fully aware of the loss of my mother.'[12]

Laura Munch died on 29 December 1868. Months earlier, as she waited to give birth to her last child, she wrote a letter to her children admonishing them that

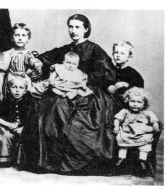

4 *Edvard and his Mother,* 1891/2. Charcoal. Oslo, Munch–Museet

5 Laura Munch with her Children. 1868. Photograph. Oslo, Munch–Museet

Jesus Christ will make you happy here and in the hereafter; love Him above all things, and do not grieve Him by turning your backs to Him; often I am filled with fear that in Heaven I might not see some of you who are my heart's delight here on earth again, but with faith in the Lord who has promised to hear our prayers, so long as the Lord still grants me life, I shall beseech Him to save your souls. And now, my beloved children, my dear, sweet small ones, I say farewell to you. Your beloved Papa will better teach you the way to Heaven. I shall be waiting for all of you there.[13]

The letter, preserved and treasured, was read to the children frequently. The possibility that they would never again see their mother, that in their weakness they would disappoint both her and Jesus, loomed as ultimate punishment for their childhood transgressions, and infused them with a sense of guilt and anxiety about the Christian faith. The threat of hell was a fact of life.

Some twenty years after Laura Munch's death, Munch recorded his own memories of it. As an aid to his memory, he used the last photograph of his mother, showing her surrounded by the family she then knew would soon be without her. Narrated in the third person and with fictitious names given to the children, these recollections are at least in part embroideries on Munch's experiences. Concerning these and his other *optegnelser* or 'jottings', Munch warned: 'It is not my intention precisely to reconstruct my life. Rather, it is my intention to search for the hidden forces of life, to draw them out, to reorganize them, to intensify them in order to demonstrate most clearly the effects of these forces on the machinery that is known as a human life, and in its conflicts with other human lives.'[14]

In the most self-contained version of these ruminations on his mother's

death Munch is called 'Karleman' or 'Karl'; Sophie, his eldest and favourite sister, is 'Bertha'; Inger, the youngest child and the only one who would survive Munch, is 'Tulla'; his father is 'The Doctor' or 'The Captain'; and the mother is anonymously referred to as 'she'.[15]

I

There were many white lights shining all the way to the top of the Christmas tree—some were dripping. It was shining in all the colours of light, but mostly in red and yellow and green. It was a sea of light so intense that one almost could not see. The air was hot and smelled intensely of burned spruce and smoke. Supported by a pillow in her back, she sat silent and pale on the sofa in a deep black silk dress. On her lap sat Tulla while the rest of us sat or stood around her with our large, enraptured eyes gazing at the tree. Father paced back and forth. Then he sat down next to Mother on the sofa. They whispered together and bent down towards each other. Karleman looked at them and wondered why tears were rolling down their cheeks.

II

It was so bright and quiet in the room. And then Bertha sang, 'Silent Night, Holy Night, Angels float to earth unseen'. Karleman thought something opened up. He saw fluffy clouds way, way up there. It was Heaven, and angels floated down to earth; smiling kindly, they wore long white robes and carried palm branches, and far, far up there sat God. He was glisteningly golden. He was immovably majestic, and the angels bowed before Him. At his side stood the Virgin Mary with the Christ Child. He had a glistening ring above His head. Today He was born so that she and Bertha and all of us could be saved and have wings.

III

The children had to leave.
A large, dark room—oppressive, stuffy atmosphere. At the foot of the large bed stood a stranger clothed in black. .
He was praying with folded hands.
The children stood by the bed with their coats on.
The Maid was waiting at the door. She in the bed stretched out her hands towards them.
One by one they went over to her and she kissed them.

IV

They were in the house of some strangers.
There was a woman who was so friendly. They were given cookies; Bertha, a doll. On the wall above the sofa hung a picture that depicted a flock of sheep attacked by a wolf. A wolf bit one in the neck so that the blood ran.
One day, the Doctor came: Mama is in Heaven now.
She is dead.
Everyone spoke so very strangely. They said 'poor child' to them.
Bertha began to sob, then Karleman, and then everyone. They were so nice to them all, and patted them on their cheeks, but they cried even more. Then Bertha was given a doll and Karl a Noah's Ark, and then the crying stopped. But when they got outside, they began again. It was cold. The snow crunched underfoot. The cathedral bells could be heard in the distance. The sky was filled with stars.
 When they arrived home, they looked at their toys and then Karl went into the bedroom. It looked so different. The two big beds were covered up, and everything seemed so huge and barren. He crawled under the bed, looked in the corner—Mama was nowhere.
'Mama is in Heaven and she has been saved', said Bertha, who had her doll on her arm, 'she is not here.'
Then they played with the animals and the ark.
Then they started to argue. Bertha was tired of the doll and wanted all of the ark. Then Karl scratched Bertha's face. 'Mama sees you', said the doctor.
Karl looked up at the door. He expected it to open and for her to stand there, tall and clad in black and alive.

Despite Munch's protestations, it is unlikely that he retained significant

memories of his mother, but the memorable events surrounding her death, including her last walk with him, left a permanent impression. His recollections, written and depicted with an obsessive frequency, became a form of auto-therapy through which the imprecise memories of a five-year-old boy were given a precision that provided the mother with a reality that she otherwise lacked.[16] Constantly expected by him and seemingly constantly on the verge of appearing as she watched over him, Laura Munch only returned to her son when given form by his artistic and poetic talent. Perversely, his mother ceased to be a maternal life-giver and forced that role on to her artist son. It was he who granted the dead woman physical form, perpetual youth and life. Artistically resurrected, she was deprived of her invisible, ghostly watchfulness over 'Karleman', who instead gained control over her.

According to Munch, his mother's death also altered his image of his father. No longer was he the affectionate and compassionate parent who played games and told delightful stories; he became a moody, melancholic religious fanatic given to near-violent outbursts of temper, someone who remained forever a reserved stranger towards his son in a world suddenly deprived of all parental love. However, there is little evidence to suggest that this transformation actually took place. Munch's sister remembered her father far more kindly, as did others. Nor was the religious fervour a new manifestation. The letters exchanged between Laura Bjølstad and Christian Munch prior to their marriage are full of words of love and endearment, mutual charges that each should be 'trusting and thankful and humble, may God grant it. Amen', and prayers that 'Oh, Lord Jesus! may our marriage be virtuously contracted in Thee and be blessed by Thee! Amen.'[17] Although these religious obsessions existed well before Laura Munch died, her death revealed to Edvard a father who was secretive and withdrawn, who rejected his children and sent them to strangers, who permitted Mama to leave them and go to Jesus. The understandable efforts of Christian Munch to protect his children from the unsettling sight of their dying or dead mother and to reassure them that Mama lived even after death were interpreted by Edvard as signs of rejection. When his mother died, 'poor, pale Edvard' felt as if he had lost both his parents.

Shortly before Laura Munch's death, the Munch family had moved to a larger apartment because of the increasing size of the family. The move was registered by four-year-old Edvard as a rupture with an idyllic, largely imagined past. He took a similar view when Karen Bjølstad, Laura's younger sister, who had previously helped in the household, came to care for the motherless family, and he later proudly but ruefully observed: 'My marvellous aunt, who came to us after my mother's death, was remote to me during the first few years. That is to say, my mother's memory was alive in me, and Aunt long remained the stranger although she became more and more a permanent member of the family and the female head of the house'.[18] What the father viewed as best for his family and as a necessary means of overcoming the effects of his wife's death, Edvard resented as a process harshly estranging him from his mother's comforting presence. His sense of isolation continued to take form.

In the motherless home where the three youngest children demanded the greatest amount of attention, Edvard turned to his six-year-old sister Sophie as he searched desperately for continued love, compassion and understanding. In his poeticized memoirs and drawings, she is always singled out: 'Bertha' and 'Karleman' explore the world together, lending each other support and companionship, and are linked by the shared memory of their

6 *Bertha and Karleman. c. 1890. Pen and ink. Oslo, Munch–Museet*

mother, a memory the younger children lacked. 'It was different for my sisters and brother', Munch wrote, 'they did not remember their mother. For them, my aunt was a mother, and was emotionally recognized by them as their mother.'[19]

The family within which Munch felt so isolated in turn fostered social aloofness. Surrounded by families in which both parents and children worked in order to pay for small crowded apartments, Dr Munch's household appeared comparatively well-to-do. His civil servant status guaranteed freedom from major financial worries,[20] and although Karen Bjølstad from time to time sold some of the landscape collages she made of dried leaves, twigs and moss, neither she nor the children were forced to work as long as Dr Munch lived, nor was the household ever without the help of one or more serving girls.

In contrast, even during the prosperity and rising employment of the early 1870s, Norwegian workers and their families were faced with periodic, seasonal unemployment and hunger in the increasingly crowded city, whose population in 1875 reached 100,000, nearly double that of 1864. After 1876, in Norway, as in the rest of Europe, the time of prosperity suddenly ended, wages declined and strikes, only infrequently successful, broke out. In 1878 and 1880, Kristiania's labourers and unemployed briefly took to the streets; mounted cavalry (possibly the brigade in which Dr Munch served) with drawn sabres hunted them down. Fearing starvation, the demonstrators were forced to submit to the capitalist laws of economic necessity and accept lower wages rather than none at all.[21] Into the strict, bourgeois home of Dr Munch, such concerns did not enter.

In 1877, ten years after the death of her mother, Sophie Munch died of tuberculosis. Munch's reaction to this loss, just as he was entering adolescence, was extreme. It affected him even more than had the death of his mother, and gave rise to vehement feelings of isolation and rejection, of

personal guilt, of alienation from his family, and of resentment towards his father.

Dr Munch had spared his children the sight of their mother's death, but they were not total strangers to death, having had classmates their own age die. In the small, cramped dingy apartment at Fossvein 7, the sight of Sophie, spitting blood and pleading for life as she lay in her bed in the children's bedroom, was unavoidable. Yet this experience seems to have left scars on none of the Munch children, except the impressionable adolescent Edvard. His attachment to Sophie as well as his empathy with her suffering resulted in his viewing his other siblings as strangers. Although living in close physical proximity with them, experiencing the identical external events, inhabiting the same space, Edvard felt alienated from them; they took on the character of a crowd, neither knowing nor recognizing the qualities of his individual existence.

In his recollections of Sophie's death some ten years later, Munch emphasized not so much the physical progress of disease or the specific event of death, but rather his own helplessness and his father's inability to aid his daughter despite his medical training. Sophie is presented as burning with fever, having hallucinations in which she sees the grimacing head of death, and begging her 'dear, sweet Karleman' to 'take this away from me, it hurts so, won't you do that?' She looked imploringly at him. 'Yes, I know you will.' But 'Karleman' could not help, and instead went to the window, stood behind the curtains, and cried. Likewise Dr Munch, having expended the limited medical means then available to cure tuberculosis, could only assure Sophie: 'If I could, I would go in your place—I am sixty years old. I know that there is nothing that I would miss. It means so little, so little—to live. . . . And then, you will meet Mama, and I will soon come along too. After all, I am old. We will all be together.' Edvard watched the irreversible process of death approaching and heard his father belittle its significance; a priest came, prayed alone with Sophie, and assured the father that she 'is a child of God . . . so innocent and loving, she will go straight to Heaven'. Reassured, the father seemed to become more resigned, although his dying daughter still wished to live. Perhaps as a means of comforting her, he asked her to sing some hymns.[22] On 15 November she was buried next to her mother.

Ironically it was Edvard and not Sophie who was sickly and weak during childhood. As often happens to those who survive the death of someone near to them, Munch developed a sense of guilt, guilt that Sophie, and not he, had died, which perhaps accounts for his attempts in paintings and writings to vicariously experience death through her. Even as Sophie showed the first signs of her fatal illness, Edvard was recovering from his most recent flirtation with tubercular death, and he later recalled the dank atmosphere of the darkened sickroom in which his father prayed and watched over him:

'Papa, it is so dark, this stuff that I am spitting.' . . .
It seemed as if the entire inside of his chest was dissolving, and as if all of his blood would come spurting out of his mouth.—Jesus Christ, Jesus Christ.—He folded his hands.
'Papa, I'm dying; I can't die; Jesus Christ, I must not die.'
'Don't speak too loudly, my boy. I shall pray with you.'
And he raised his folded hands high above the bed and prayed: 'Lord, help him. If it be Thy will, do not let him die. I beseech Thee, Lord God, we come now to Thee in our hour of need . . . I beg Thee, Lord; I pray Thee in the Name of the Blood of Jesus Christ, make him well.'[23]

Edvard was terrified rather than comforted by the sight of his desperate father

begging God for his life; that time Dr Munch's fervent entreaties were answered, but within a few months the same prayers on behalf of his daughter were useless.

What later most impressed Edvard was not his father's compassion and concern, but rather the extreme fervour of his prayers and the powerlessness of humanity as God imparted fatal sickness in punishment for sin. The arbitrariness of Sophie's death seemed to reveal a vengeful, selfish and incomprehensible God. In the Munch home as in innumerable other Norwegian homes at the time, God proclaimed love but revealed Himself in life largely through anger, punishment and threats of eternal damnation. This is also how Edvard saw his patriarchal father. Like God, Dr Munch failed to cure Sophie. Like God, he promised heavenly family reunions while his demands for hymns from the weakened girl seemed to declare an unwillingness to cure her so that she might gain eternal life the sooner. The judgment—which in its harshness ironically brings Munch himself close to his views of an unforgiving Nordic Lutheran deity—is unjust and unfair. Most Norwegian doctors, including Dr Munch, had studied at the major medical centres of Vienna, Paris and London, but they possessed no true cures for the illnesses then common: tuberculosis, scarlet fever and whooping cough. Over one-third of those infected died.[24] Prayer was the only refuge. From Edvard's personally implacable point of view, however, his father and his God were judged equally guilty.

During a rare moment of understanding, Munch wrote in 1890: 'How he suffered for my sake, during the nights, because I could not share his faith.'[25] Lutheranism continued to be practised by the Munch family despite Dr Munch's unsuccessful bargaining with God. Edvard, too, followed the external manifestations of faith by going to church regularly, listening attentively to sermons and being confirmed when he was sixteen. By the mid-1880s, however, the religious doubts engendered by Sophie's death were converted to a professed denial of God. The silence of God in response to Dr Munch's prayers became an eternal cosmic silence for Edvard and testified to a void where human life and existence appeared incongruous anomalies. With death and nothingness as his only companions, with nothing before or after life, the adolescent Munch began to develop the radical individualism that postulated an anarchic isolation and physical fragility in which only he himself could provide eternal life and salvation. He manufactured his own immortality and companionship through his art.[26] Rejecting his father's intention that he become an engineer and make use of his talent for mathematics, a talent inherited from his father—on Monday, 8 November 1880, Edvard noted in his diary: 'I have now decided to become a painter.'[27]

ARTISTIC BEGINNINGS
1880–1886
'My ideas ripened in the Bohème'

To Jens Thiis, his chosen biographer, Munch wrote defensively in 1932 about *The Sick Child*, a painting created nearly fifty years earlier:

Now I have painted a new version of it for a fifth time. . . . A painting and a motif that I struggle with for an entire year are not expended in a single picture. If it is of such significance to me, why should I then not paint and vary a motif five times? Just look at what other painters depict over and over again ad infinitum: apples, palm trees, church towers, haystacks.[1]

Beginning in 1885, at intervals of roughly ten years, Munch varied the motif of 'perhaps my most important painting'[2] six times, leaving the paintings as milestones punctuating the passage of the decades of his life. In prints and drawings, worked and reworked, the image of the sick girl with her grieving attendant recurs constantly. To no other motif did Munch turn with such obsessive regularity.

On 18 October 1886, when the Kristiania Autumn Exhibition opened, the first version of *The Sick Child* was centrally located in a room visitors had to traverse while both entering and leaving. A bold and rash declaration of artistic independence by the twenty-two-year-old painter, it could not be ignored. Through its innovative style and ostentatious size, Munch proclaimed his intention to overcome the prolonged limitations of Norway's artistic tradition, to establish alone a new tradition of the future, and to take upon himself an artistic mantle matching in renown his uncle P. A. Munch's recognition as Norway's greatest historian. Historically, Munch succeeded; no other painting in the entire previous history of Norwegian art matches *The Sick Child* in quality or significance, and only Munch's own works equal it later. In 1886, however, the painting represented his failure.

Until 1800, Norway had imported her artists. Medieval and Viking artistic traditions subsisted in isolated pockets of folk art, but otherwise Norway was dependent artistically on Denmark, Germany and England. Politically, Denmark dominated the country, treating Norway as a province despite the constitutional equality that had been established between the two kingdoms in the fourteenth century. Napoleon had dissolved the union when he forced Denmark to defend him, and Britain, in retaliation, blockaded Norway's ports. After Napoleon's defeat, the divorce of the two kingdoms was legally proclaimed; simultaneously a new marriage with Sweden was arranged. In 1818, Maréchal Bernadotte, formerly of Napoleon's France, was named King Karl Johan of both Sweden and Norway. His coronation took place in the incomplete cathedral of Trondheim, Norway's medieval capital, and the coronation scene was portrayed by one of David's pupils: Jacob Munch.

Just as Jacob Munch had studied in Paris, Copenhagen and Rome, so other Norwegian painters sought their training and frequently their careers abroad during the nineteenth century. Impoverished by the Napoleonic Wars, the agrarian economy supported no market for art. Only one institution to train artists existed: Kristiania's Royal School of Art and Design, founded by Jacob Munch in 1819 and later attended—in 1881—by Edvard. Living in Germany, 'The Father of Norwegian Painting' Johan Christian Clausen Dahl painted

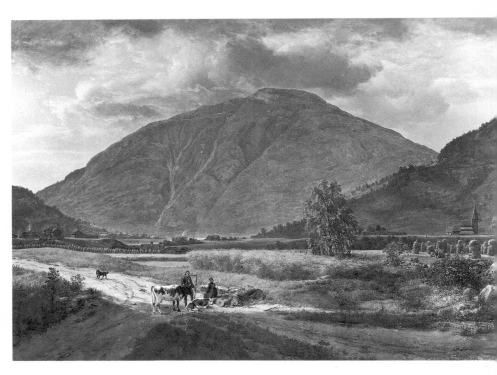

7 Johan Christian Clausen Dahl: *View of Sogn, c.* 1836. Oil on canvas. Bergen, Rasmus Meyers Samlinger

romantic views of rough and picturesque Nordic mountains, fjords and peasants, thereby establishing a tradition of landscape painting that was dominant for over fifty years. The images, however, were seen in Norway only as rough engraved reproductions; the originals entered German collections.

Finally in the 1870s, Norway's artists returned home. Back in Kristiania in 1880, Christian Krohg, Erik Werenskiold and Frits Thaulow pledged to found a native school of Norwegian painting through Naturalism to replace the foreign influences prevalent since the Middle Ages. 'Naturalism', they pronounced, 'arose from the love of nature, and the love of nature necessarily leads an artist home, because he cannot love and comprehend a foreign landscape as intensely as he comprehends and loves his own.' With this as their basic premise, seconded by the conviction that artists should depict only what they see, they concluded that 'Naturalism necessarily will give birth to a national school of art' as the artists paint in, and depict, their Nordic environment.[3]

Kristiania, now a city of 115,000 recently urbanized inhabitants, did not respond favourably to this bold artistic renewal. 'All in all, it must be said that the Kristiania public, which at the end of the 1870s was prepared to accept neither a national art nor a truly national artistic life with artists alive in its midst, was a neglected and unrefined public.'[4] A single annual opportunity existed to view new art: the exhibitions arranged by the Kristiania Art Association, founded in 1836 to 'wake the public sense for art by pooling private means'. In the 1870s, the jury for these exhibitions consisted of a physician, a law clerk, a lawyer, the headmaster of a local school and an architect.

Paintings by the young artists were refused by the Art Association jury; and Thaulow demanded that artists be elected to the jury since professionals had a right to be judged by professionals. The Association, pointing to its private support, proclaimed that artists had no such right. In response, the artists

exhibited their works in Karl Johan's Street shop windows, organized themselves into a Creative Artists' Union, and went on strike against the Association. In 1882, they organized the first of their annual Autumn Exhibitions. Thiis recalled:

It was a stormy and angry time, this time of Norwegian Naturalism's breakthrough. A time with loud noises filling the air: slogans, cries of battle, taunting, quarrelling, and squabbling. . . . The new artistic gospel was painted, was talked about, was drunk to, yes, even actual physical blows were struck for it.[5]

Munch arrived at his decision to become an artist just as the battle for Naturalism was joined, and he documented his resolution with a self-portrait painted in a style distantly modelled on that of Krohg and Thaulow. It is awkward and hesitant in composition and manner; its muted colours encompass a range of browns extending from the near black of the background to the red-brown of the artist's lips emphatically placed near the painting's geometric centre, and are applied in testy, tiny touches of the brush. An amateurish application of the techniques of Naturalism, the self-portrait nonetheless testifies to Munch's self-assured determination to emulate, not the past, but the controversial and untested paths of a new art based on the present.[6] The discipline of learning through the art of others was, and remained, alien to him.

At the Royal School of Art and Design, which he entered in August 1881, he was judged an advanced student not needing the practice of drawing from plaster casts of sculpture, and under the guidance of the sculptor Julius Middelthun he learned to draw from living models. Thus Munch was fostered in his virulently antagonistic attitude toward all art other than his own. Existing art for him was not a master, only a model to be distorted and adapted at will.

The self-centred mode of the self-portrait appealed to Munch, and he returned to it after several months' of Middelthun's teaching. The conservative teacher succeeded in imposing a less radical style upon his student, but also taught him to create a more subtle composition, filled with an implicit sense of life which is generated by a slight turning of the head. Self-conscious severity joins a continuing naiveté in the self-portrait as well as in family portraits and views of Kristiania's environs which Munch painted late in 1881. The combination apparently proved commercially attractive, as he sold two paintings at auction in December. The impractical choice of art as a career, only hesitantly approved of by Dr Munch, seemed to promise practical results after all. Publishing a series of drawings of Kristiania scenes and peddling others to illustrated periodicals, Munch sought to profit from the discovery—but the initial success was not duplicated. At an auction in February 1882, three paintings sold for barely the cost of their frames.[7] Middelthun's guidance seemed inadequate, and Munch prepared to look for an alternative prophet promising artistic and commercial success. Naturalism radicalized as Impressionism by an influx of newly imported French influences provided an irresistible allure that Munch quickly and uncompromisingly followed. He announced his rejection of his 'paintings out of brown gravy' in favour of those created 'in open air, preferably in bright sunlight that casts deep, powerful shadows'.[8]

Visiting the Paris salons during March 1882, Krohg, Thaulow and Werenskiold had encountered the art of Impressionism and immediately became its enthusiastic advocates in Norway. With unshaken faith in the truths of Naturalism, they celebrated the works of Manet and Monet, Degas

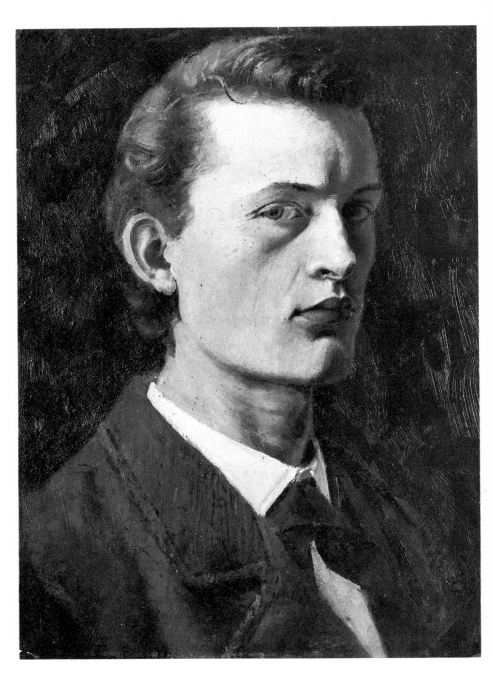

8 *Self-Portrait*, 1881. Oil on panel, 26 × 18 cm (10 × 7¼ in). Oslo, Munch–Museet

and Caillebotte as a radical new revelation of their artistic credo. The vision of an artist at a particular moment was proclaimed supreme and objects were to be depicted, 'not as we *know* them to be [tactilely], but as they *appear* to be visually at a given moment'. Immediately Norwegian painters set out to apply the new gospel to their Naturalistic views of Nordic proletarian life. Gustav Wentzel, four years Munch's senior, returned from his first Paris visit and promptly began to add to his genre scene *Breakfast I*, representing a worker's morning meal, the study of light effects filtered through curtained windows and reflecting off tables, pitchers and mauve walls. Using paints specially prepared so as not to coagulate in the freezing air, Thaulow painted a view of children sledding on a snow-covered village street; on the advice of Middel-

thun, the painting was purchased for the still homeless Norwegian National Gallery. Thus by 1882, a new impetus was apparent in Norwegian art, and to the younger artists it seemed to promise financial as well as artistic reward.

For Krohg and his teenage followers, it was Manet who was to be the distant, prophetic guide. Lecturing to a group of students in 1883, Krohg described Manet as an anarchist who rejected all academic rules, who declared the old masters invalid, and who recognized only nature seen 'with

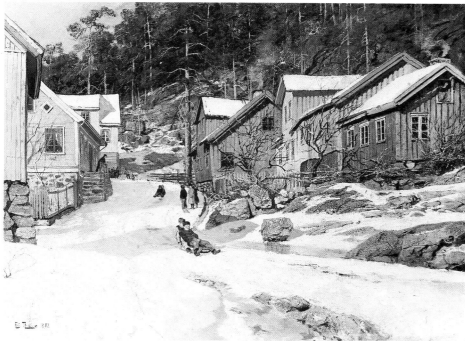

9 Gustav Wentzel: *Breakfast I*, 1882. Oil on canvas, 100.5 × 137.5 cm (39½ × 54 in). Oslo, Nasjonalgalleriet

10 Frits Thaulow: *Street in Kragerø*, 1882. Oil on canvas, 58 × 79 cm (22¾ × 31 in). Oslo, Nasjonalgalleriet

his own eyes and with the eyes of his era' as the content of art. The name of Manet was a call to action, political as well as artistic, and Krohg concluded his manifesto with a stirring demand that Norway's future be guided by her artists:

This generation of Norwegian painters to which I belong, we are not yet Impressionists—much to our own shame. We can only stand on the mountaintop and gaze longingly into the promised land. . . . But already a new shift of workers is prepared with paint and easel to create the image of our time. They will take our place and, one day, they will look back at us with scorn. We hail these new labourers. Begin! Hurry! There is no time to waste! Today our times are impatient ones![9]

11 *Study of the Head of a Worker*, 1883. Chalk and ink, 45 × 32 cm (17¾ × 12½ in). Oslo, Nasjonalgalleriet

12 *Young Servant Girl Kindling a Stove*, 1883. Oil on canvas, 97 × 66 cm (38 × 26 in). Private Collection

13 Christian Krohg: *Johan Sverdrup*, 1882. Oil on canvas, 255 × 148 cm (100¼ × 58¼ in). Oslo, Nasjonalgalleriet

In Kristiania and the mountain village Modum, Krohg and Thaulow chose as models for the aspiring Naturalists men and women brought from the streets and clad in rough, often ragged clothes. In contrast, at the Royal School of Art and Design, temporarily housed along with the National Gallery above an army barracks, Middelthun's models were adolescent recruits or children; selected for the smooth idealism of their bodies, they posed naked in the attitudes of Greek, Roman or Renaissance statues, whose plaster casts the Norwegian public first saw in 1882 in a new Sculpture Museum. Unlike these neutralized models in their *l'art pour l'art* context, the Naturalists' workers proclaimed an attachment to the verities of contemporary life and implied proletarian political ideals during a politically volatile time. Krohg's pupils concentrated on the models' faces, not on artistically nude bodies, in a constant search for individual dramatic character. Under Krohg's guidance, Munch replaced Middelthun's depersonalized style with forms rendered as large, light-equivalent masses that overpowered the minutiae of irrelevant detail. For the first time, his colours came to life; blues, greens and reds brushed broadly on to the canvas replaced pristinely daubed tones of muted browns. By the time the 1882 Autumn Exhibition opened in a Kristiania beer hall, he had completed his first ambitious composition.

In *Young Servant Girl Kindling a Stove Early in the Morning* all forms are bathed in the gentle light of a winter morning, its blond tones acting as unifier. Krohg, just returned from Paris, proclaimed the painting 'superb' and overpoweringly true to life.[10] Gunnar Heiberg, whose controversial play *Aunt Ulrike* celebrated the futile attempts of the 1870s to organize Kristiania's workers, wrote in the newspaper *Dagbladet* that among the young painters Munch has 'delivered the most significant work and bears witness to a refined, sincere sensitivity'. He decried Munch's and Krohg's 'careless handling of paint' but concluded that Munch's painting 'has virtues that cannot be learned, while its deficiencies are such as can be overcome with a little effort'.[11]

The lessons Krohg had taught him, Munch had learned well. 'We all liked Krohg', he later reminisced, 'and thought him a remarkable painter. As a teacher he was first-rate, and the unusual interest he showed for our work strengthened our own determination.'[12]

As Krohg and Thaulow drafted Munch into their version of a Norwegian Impressionist revolution, Norway's political leaders were inaugurating a similarly drastic but peaceful transformation under the leadership of the fiery orator and parliamentarian Johan Sverdrup, head of a liberal coalition in the Storting. Krohg's life-sized portrait of him—accompanied by a speaker's platform and thoughtfully provided glass of water—formed the pivotal image of the first Autumn Exhibition; it visualized a conscious alliance between the artists' Naturalism, their desire for independence from older artists' associations, and Sverdrup's liberal ideals. Sverdrup's political success encouraged Krohg's artists. Acting as 'guides in the cultural life of the future', they believed their political success also pointed to artistic success. The annual exhibitions were to be educational tools delivering their liberal and Naturalist message to a receptive public, and in 1884 Sverdrup's new government agreed to sponsor the annual art shows.

Munch's proletarian serving girl, belonging to the class popularly and derogatorily known as seamstresses, suited Norway's didactic, politicized Naturalism. While the conservative newspaper *Morgenbladet* complained that 'this political fever is seeping into even our private lives to create division and unhappiness, dissolving friendships, breaking up families',[13] Munch's

14 *Morning (A Servant Girl)*, 1884. Oil on canvas, 96.5 × 103.5 cm (38 × 40¾ in). Bergen, Rasmus Meyers Samlinger

genre scene sufficed to place him in the camp of parliamentary liberalism as radicalized by Krohg into a pro-proletarian, ideal anarchism. For Munch, the attachment to the style and content of Naturalism also had more personal consequences, since it identified him with a stance inimical to the traditional ideals—intellectual aristocracy, attachment to the past, and conservative fundamentalist Christianity—of his family. The gulf between his own values and beliefs and those of Dr Christian Munch, unconsciously opened at the time of Sophie's death, continued to widen. The antagonism was to become an obsession.

At the 1884 Autumn Exhibition, Thaulow introduced works by his French brother-in-law recently turned artist, Paul Gauguin. Munch continued to display his political and artistic Naturalism through a stylistic shift further to the left, towards the Impressionism Krohg advocated. Surveying the possibilities provided by Middelthun's attachment to the past and Krohg's attachment to the present, Munch chose to pioneer the future. A larger painting than *Young Servant Girl Kindling a Stove*, *A Servant Girl* (later retitled *Morning*) was created during September, while he nursed his fragile health in the country air at Modum in the company of Thaulow.[14] The motif is in the Naturalist tradition of his teachers: a 'seamstress' seated on the edge of her unmade bed in the morning sunlight pauses in the task of putting on her multicoloured stockings to gaze pensively towards the curtained window of her pale blue chamber. The painting is a study in light: light filters through the curtains' gauze, dissolves the shape of a water bottle, and models the contours

15 *Dr Christian Munch with Inger Munch*, 1884. Oil on canvas, 45.7 × 77.5 cm (18 × 30½ in). Oslo, Munch–Museet

16 *View of Olaf Rye's Square, Kristiania*, 1884. Oil on canvas, 48 × 25.5 cm (18¾ × 10 in). Stockholm, Nationalmuseum

of the seated figure. Intense sunlight illuminating a proletarian interior had become a hallmark of Norwegian Naturalist painting, and was persistently used as a test of artistic mastery, as in Wentzel's two *Breakfast* paintings or the more dramatic interior scenes by Hans Heyerdahl. In the painting's size, in its light and in its motif, the twenty-year-old Munch hurled a challenge, proclaiming the scorn Krohg had predicted a new generation of Impressionists would have for his Naturalism, and seeking a position of radical leadership among the younger painters.

Indeed, Munch's painting does surpass all other Norwegian painting of the time in its dominant whiteness and in its rendering of light's ability to dissolve forms, causing sharp contours to disappear, an effect Munch achieved through the unorthodox method of gouging parallel tracks into the wet paint with the handle of a brush. The intense light, the break-up of forms, the colouristic simplicity, all suggest an attempt directly to meet the criteria of Impressionism as then understood in Kristiania, an Impressionism apparently capable of being bent and adjusted to the volatile local artistic and political conditions. The effort met with critical rejection, however. Kristiania's critics felt themselves 'injured by his treatment of colour' while they proclaimed the motif 'so obviously vulgar, that even the most progressive public will refuse to accept it'.[15] In response to the critical barrage, the artists rallied to Munch's support. Thaulow purchased the painting for 100 kroner, making it Munch's first significant sale, and giving his art the *imprimatur* of the established avant-garde. Sharp critical dispute was to accompany Munch for the next forty years.

Although in 1884 Munch painted several other Impressionist scenes, such as the aerial view of Olav Rye Square seen from the window of his family's apartment, he was already searching for an art more personal than either Krohg's Naturalism or its radicalization as Impressionism. His extremely adaptable talent quickly mastered new styles and techniques, practising them in only a few images before restlessly rushing on to yet other innovations. Sensitive colour variations, as in *Morning* or in the black-on-black portrait of Inger Munch wearing her confirmation dress, attracted him, but more significantly the image of his adolescent sister, with her trembling uncertain hands, reveals a psychological insight totally unlike the surface-orientated art advocated by Krohg, Thaulow or Werenskiold. The portrait of his sister and various scenes of family life of 1884 to 1885 also indicate that he was seeking

a more congenial subject-matter than the alien proletarian 'seamstresses'. They may also signify a temporary reconciliation with Dr Munch and bourgeois life. Painted while Munch recuperated from a lengthy rheumatic illness, they represent a peaceful, comfortable, largely uneventful family existence. It is a 'family art that was created within the four walls of the home', as Thiis later observed under Munch's guidance.[16]

However, Munch's restless search for a new art could not long be satisfied, and with a shy enthusiasm he envisioned a future masterpiece, a painting more powerful than all he had created previously and colouristically even more refined. In a conversation recorded in the mid-1880s by Hermann Colditz:

He spoke sporadically, haltingly, almost in a whisper. Nonetheless, there was a sense of excitability in the tone of his voice that became quite feverish as he discussed colours and emotive moods. Frequently he then failed to finish his sentences, letting his hands fill in what his words left out: 'Perhaps some other painter can depict chamber pots under a bed better than I can. But put a sensitive, suffering young girl into the bed, a girl consumptively beautiful with a blue-white skin turning yellow in the blue shadows—and her hands! Can't you imagine them?—Yes, that would be a

17 *Karen Bjølstad in a Rocking Chair*, 1884. Oil on canvas, 47 × 41 cm (18½ × 16¼ in). Oslo, Munch–Museet

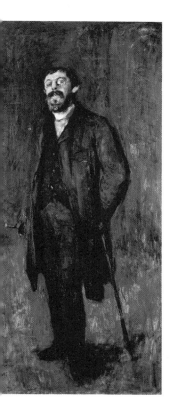

18 Top *Portrait of Inger Munch*, 1884. Oil on canvas, 97 × 67 cm (38 × 26¼ in). Oslo, Nasjonalgalleriet

19 *Portrait of Karl Jensen-Hjell*, 1885. Oil on canvas, 190 × 100 cm (74¾ × 39¼ in). Private Collection

real accomplishment, painting such hands, showing how tired they are as they rest on the blanket, fiddle with the sheet, and fold back the blanket seam. It's a white blanket: can't you see it? Some day, I shall paint just such a picture. And then imagine light breaking into the room with spots of sun on the dark walls. O, that will be so remarkably beautiful—so simple and peaceful.'[17]

Sharing the optimistic, almost euphoric mood of Norway's artists, Munch began to plan the creation of his *Sick Child*. Thiis described the painting as 'the first monumental figure painting in our Norwegian art'.[18] Munch wrote about it as an historic milestone in his career: 'In the sick girl, I broke new trails for myself. It was a breakthrough in my art. Most of what I later did was born in this painting.'[19] Both in Munch's art and in the history of Norwegian art, *The Sick Child* is a uniquely significant work.

Unlike other European countries, Norway lacked a post-medieval tradition of monumental painting. With the exception of Krohg's portrait of Sverdrup, *The Sick Child* with its full-sized figures and physical dimensions—119.5 × 118.5cm (47 × 46.6in)—had no precedent of significance in Norwegian figurative art. In a less self-conscious artists' community, this would have mattered little; in Kristiania, the painting's size alone already indicated the twenty-two-year-old painter's unparalleled ambition and self-esteem. Other Norwegian artists, moreover, seemed to be reaching the conclusion that Munch was fated to carry Norwegian art to new triumphs. Krohg repeatedly praised his 'superb' works; Werenskiold singled them out in reviews of the Autumn Exhibitions; and Thaulow—as well as buying *Morning*—awarded him a grant to visit Paris in May 1885.

Thaulow's fellowships for promising young Norwegian artists were intended to make them aware of contemporary European, notably French, artistic trends. Supporting the Paris trip, Krohg felt Munch would attain a sense of maturity and industry that the meagre competition of Kristiania could not induce.[20] Munch spent the weeks in Paris visiting the Louvre and the official Salon and sites made famous by the French Revolution. With no Salon des Indépendants that year, he had little opportunity to see any quantity of Impressionist or other innovative art, and the official Salon was dominated by mediocrity.[21] It was certainly not the atmosphere to inspire him with humility. Determined not to contribute to such bourgeois art, Munch returned from Paris with his dreams very much intact of an art surpassing that of all his contemporaries.

The stridency and prominence of Munch's anti-bourgeois, anti-traditional and implicitly anti-paternalistic attitudes in 1885 strongly counteracted the brief period of peaceful submission the previous year. It was thus not a portrait of his father Munch presented to the 1885 Autumn Exhibition, but a large, life-sized standing portrait of the crippled painter Karl Jensen-Hjell, an obvious challenge in motif, pose and size to Krohg's noted portrait of Sverdrup. Munch's Jensen-Hjell stands haughtily self-aware, propping himself on a cane, a cigar held nonchalantly in his gloved right hand, his coat unbuttoned; he throws back his head and looks down—literally as well as metaphorically—through his lorgnette on the viewers, the public, the enemy, the bourgeoisie. The composition derives its formal vocabulary from Spanish and Flemish Baroque portraiture, as well as from Manet by way of Krohg. Munch's painting breaks virtually all the demands both of traditional painting's meticulous finish and *plein-air* Naturalism's accentuation of intense light and colour. Muted tones of brown, brushed on with broad, thick, highly visible strokes, are broken only by the lighter colouration of the face and the glimmering cigar ash.

Critics noisily associated the image with Impressionism, a term that for Kristiania's conservative writers on art embodied the most virulent condemnation, artistically, politically and morally. 'It is not even proper underpainting', one complained, 'but is slapped rawly on to the canvas. As a result, it looks as if it were painted with a hodgepodge of paint remnants left over on a palette after another painting was completed. It is Impressionism in its most extreme form. The travesty of art.'[22] Created by an artist who belonged by birth to Norway's social and cultural élite, the portrait was viewed as a challenge to established values.

Rather than a true image of the quiet, reserved, timid and little-known Jensen-Hjell, the picture was really a disguised self-portrait. In arrogance of pose, in the carefully arranged *deshabillé* of dress, and in technique, the portrait depicted a rebellious dandy, one of the small group of literary and artistic bohemians attracting noisy attention in Kristiania, the Kristiania Bohème. At twenty-one, Munch had entered an extended phase of adolescent rebellion. He replaced regular Sunday attendance at church with frequent visits to cafés where he could listen to heated discussions on atheism and free love. He rejected the cultured protection of his childhood world in favour of a bohemian milieu consisting, in the view of his father's generation, of 'sexual anarchism, drink, carousing, nights filled with a surplus of women, bodies weakened by excesses, and by all sorts of diseases resulting in the decay of the backbone'.[23]

Munch's art had consistently been defended by members of the bohemian group, such as Heiberg and Krohg, and they now welcomed him as a peer into a persistently revolutionary, self-consciously avant-garde circle, a factor contributing to Munch's unbounded optimism in 1885. But the new group identification also exacerbated the rift between father and son, resulting in sharp, accusatory exchanges. The peaceful co-existence of the previous year was permanently destroyed.

For the avant-garde painter, his father was an embarrassment. Old-fashioned, revering the historical past, relentlessly religious, Dr Munch stood in constant antagonism to the values of the group with which Edvard wished to associate. Nonetheless, his attachment and dependence on his father continued so long as artistic success failed to bring with it financial independence. Admonishments, desperate prayers and disturbing memories of a dead mother overseeing the degenerate life of her godless son could not therefore be avoided. To replace, at least emotionally, his disapproving and rejected father, Munch sought substitutes in his 'artistic father' Krohg and, even more, in the thirty-one-year-old leader of the Kristiania Bohème, Hans Jæger, whose impressionistic novellas and novels expounded his doctrines of atheism, anarchism and free love. As Munch searched for a new system of values, the world of his father and the world of Jæger locked in a battle for his loyalty. During the mid-1880s, Jæger was triumphant, to the deep disappointment of Dr Munch who turned increasingly to prayer for comfort. 'And then there was Jæger,' Munch wrote with unusual compassion, 'possibly my father's greatest sorrow. Sometimes I almost hated Jæger, but I was convinced, after all, that he was right. Nonetheless—. This was the hardest of all for my father to bear, the business with Jæger.'[24]

In a sense, Munch was an even better convert for Jæger than the sons and daughters of lawyers and government officials, the conservative group opposing Sverdrup, for Munch's ancestors represented the acme of Norwegian cultural achievement. Munch's attachment to the bohemian group thus could not but be provocative, not only for his father, but also for the

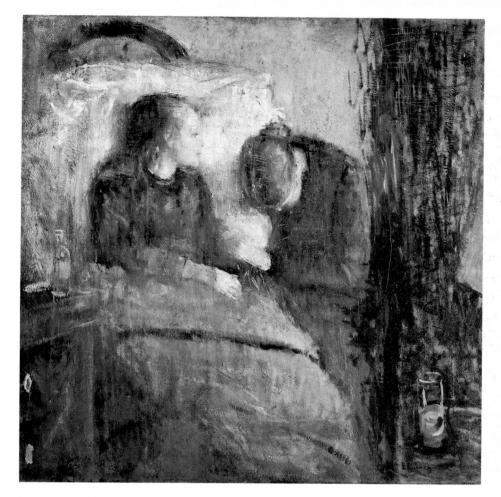

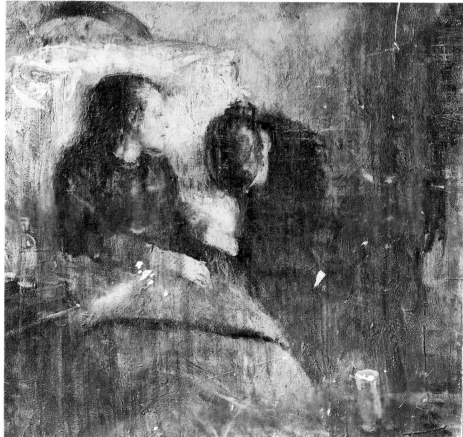

20 *The Sick Child*, 1885–6
and *c.* 1893.
Oil on canvas, 119.5 ×
118.5 cm (47 × 46½ in).
Oslo, Nasjonalgalleriet

21 *The Sick Child*.
Photograph taken in 1893.

critics who saw in his art the sad results of perverse influences on the social and moral health of Norwegian life.

An ideological witches' brew of Kantian idealism, Hegelian determinism, atheism and freely interpreted anarchism, Jæger's bohemian social reforms had as their primary principle a doctrine of free love. With all limitation on sexual relationships rejected, Jæger argued, love could become the dominant emotion of human activity, making possible a society in which all love all. As a social experiment for his beliefs, he formed a love triangle involving himself, Krohg and one of Krohg's students, Oda Lasson, the young ex-wife of a wholesale grocer. The three were to record separately their common experiences and emotions; but the experiment faltered as Oda married Krohg, and only Jæger published his third of the experiment as *Syk kjærlihet* ('Perverse Love').[25]

'So', Munch wrote of himself, 'he thought he too could find a woman. There could be some significance to that, outside the bonds of marriage.'[26] Following Jæger's tempting example, during the summer of 1885 he entered into a relationship with the woman known in his *optegnelser* as 'Mrs Heiberg', in reality Emily 'Milly' Ihlen Thaulow, the twenty-four-year-old daughter of Admiral Nils Ihlen, married to Munch's cousin, the naval physician Captain Carl Thaulow. In his illicit romance with the tall blonde woman 'who drives everyone crazy', Munch did not forget the social origins he was rebelling against. During idyllic days and evenings, the two explored the forests and seashore near the resort town of Borre on the Oslofjord, and the realization that this woman, experienced in love and desired by 'everyone', had chosen him, was a vital component in Munch's overwhelming optimism. In her company, he discovered the final inspiration for *The Sick Child*, the painting which should demonstrate definitively his artistic superiority to the other 'Karl Johan lions' now that he had triumphed over them in love.

Apparently without preliminary sketches, Munch painted the scene directly on to canvas, using as models for the sick girl and her attendant the twelve-year-old Betzy Nielsen and Karen Bjølstad. The process was born in the teachings of Naturalism, as Munch was attempting to depict a scene from the past—his sister's traumatic death—by reconstructing it through the living tableau of his models in the present, thereby enabling him to paint what he saw as he saw it. The process, however, neglected the content of psychological autobiography Munch had as his goal. For the antagonism between the intended subjectivity of his aims and the intended objectivity of his Naturalist approach there was no solution.

Munch worked on the painting for over a year, repeatedly scratching out, repainting and scratching out again. The series of overlaid conflicting images built up encrusted layers of paint, so that into the coagulated centre of the canvas the figures of child and mother are scratched and gouged rather than painted. Heavily scarred, the painting became a crippled relic of the physical battle between painter, painting and thwarted goals. Naturalist means and technique were inadequate within the visionary, exorcizing context of the painting. Retroactively, it became for him a desperate declaration of independence, an intended liberation from Krohg's influence and from Naturalism, despite the fact that demonstrably he remained dependent on both. Much later, in the 1930s, he sought to dissociate the painting from the specific milieu that generated it, so that at least in memory it could fulfil his numerous aims:

No, there can be absolutely no question of influence on my *Sick Child* other than the one that wells forth independently from my home. These are pictures of my home and childhood. Someone truly knowing the conditions of my home would know that there could be no external influence except possibly one serving as midwife. You might just as well talk about a midwife influencing the child that is born. It was the pillows time; it was the time of sickbeds and of quilts; I am willing to admit that. But I insist that not a single one of those other painters experienced his motif with his very last drop of pain the way I did *The Sick Child*. Because I was not the only one to sit there, there was everyone I loved.[27]

It was because the painting represented such an intensity of experience that it became Munch's life-long obsession. He not only painted a scene of approaching death but projected himself into it, subconsciously taking Sophie's place—as the passage quoted above reveals—in an attempt to exorcize the guilt he felt for her death. What in fact had been his own and his father's helplessness as Sophie pleaded for life was transformed subjectively into an unwillingness to help or to take her place. In each of his repetitions of the motif, he intended to resolve the same artistic and psychological problems, but found each new image imperfect. As when he was fourteen, he was incapable of saving his sister and returning to her the life for which she yearned so intensely.

Here was the crux of the problem Munch faced. *The Sick Child* was not only the record of a personal experience, as Jæger insisted all Naturalism should be. It also transferred the objects of the event into the artist himself. The technique available to him, the visual equivalent of Jæger's stenographic writing style, provided no means of fulfilling this expressionist intent, so the painting was destined to be Munch's failed masterpiece.

22 Christian Krohg: *Sick Girl*, 1880–1. Oil on wood, 102 × 58 cm (40 × 22¾ in). Oslo, Nasjonalgalleriet

Munch's dependence on Krohg went beyond a dependence on motif or Naturalistic approach. Unlike other depictions of sick and dying adolescents such as proliferated in Naturalist art, Krohg's *Sick Girl*—like Munch's at least partly inspired by memories of a dying sister—presents no details of sickroom or doctors and relatives. He focuses on the frontally facing girl who is placed within a collapsed space. Munch, too, places his figures in a claustrophobically contracted space lacking traditional perspective. However, the results differ. Krohg's manipulated space was intended to concentrate the viewer's attention, and probably was partly inspired by photographic images. Munch flattened not only the space, but also all forms within the painting, permitting only the pale, depersonalized profile of the girl, the bowed head of the mother and their clasped trembling hands to possess three-dimensional effects. *The Sick Child* sought to capture the silence and helplessness with which sickness and death are encountered. Not the scene of his sister's approaching death, it becomes an emotional compensation for her death, inviting viewers to share the experience of his own failure.

Although developed from Krohg's and Jæger's Naturalism, Munch's technique as well as his intentions act finally as the antithesis Munch himself saw. The painting continued to use the 'Impressionistic' style of the previous year, dissolving forms in a soft light of indeterminate origin, but the small broken brushstrokes of Impressionism are here just erratic flecks of red, green and white dispersed randomly over the canvas surface. Much of the paint he trowelled on heavily, then scored it with the gouges after it had dried, or he transformed the partially dried skin of paint into uneven hills and valleys by patting the surface with rags. Memories of Courbet's and Rembrandt's scumbling technique seen in Paris underlie Munch's treatment of paint but he simulated rather than imitated what he saw.[28] To unify these disparate

surface and formal elements, Munch resorted to yet another technical device: rainy, parallel streaks of diluted green paint run down the surface to form an eyelash-like veil through which the dematerialized memory image could be seen.[29]

Kristiania's critics, already seeing Munch as a dangerous propagator of the excesses of anarchist Impressionism, rejected *The Sick Child* in 1886 with unprecedented vehemence. Arrogantly optimistic, Munch had also provoked them, not only through the physical size of his painting and its central position in the exhibition room, but also by giving it no title other than *Study*, an ironic reference to the critics' frequent verdict that all his paintings were only unfinished studies testifying to incomplete but promising talent. This 'Study', however, could not be ignored or acidly dismissed, although one critic advised that it be silently and disdainfully passed by. A virtually unanimous chorus of critical chastisement ensued:

Yes, what can we say about [Munch]? Certainly public opinion is much inclined—no, no, as if with a single voice it has concluded that this artist must be condemned. Undeniably he is a remarkable character, an unhappy revolutionary visionary who does not care in the least for rendering details, for proper design, or any such stuff. Perhaps he lacks the ability to control or to learn them.[30]

Even Norway's most perceptive critic, Andreas Aubert, although he had previously praised and encouraged Munch, now concluded that despite its refined colouration and 'soulful' girl, *The Sick Child* should not be exhibited

because it demonstrates that [Munch] is careless in his training. As this 'Study' (!) now appears, it is no more than a rough sketch, half of which has been scraped away. He himself became exhausted from the work. It is a miscarriage, of the sort that Zola describes so well in his novel of artistic frustration *The [Unknown] Masterpiece*.

For the 'miscarriage' Aubert blamed the 'midwife': Krohg. Munch, he argued, was Krohg's most receptive pupil, encouraged by his teacher's enthusiastic praise to adopt a position of 'perpetual opposition finding joy in provocation'.[31] Nearly fifty years later, this was the criticism Munch still recalled most vividly, not because it rejected his painting but because it proclaimed his dependence on Krohg.

Implicit in all the criticism was the suggestion that Munch, although possessing extraordinary artistic talent, had been led astray by a 'variant of the Impressionist', by a group of 'incoherents praising the aberrations of young artists for the sake of pleasure and amusement'.[32] Not surprisingly, the social implications of Munch's rebellious painting style were also recognized by his father. He refused to attend the exhibition in order to avoid being publicly humiliated by 'this puzzling picture'.[33]

Seeking independence through a masterpiece, Munch was rejected by family, critics and even other artists—Wentzel, perhaps smarting from criticisms Munch had previously made of his work, declared Munch's art to be 'humbug'. Only within the Kristiania Bohème did Munch find support—Krohg and Jæger confided that the painting was 'brilliant' and 'magnificent'.[34] In a lengthy review published on 20 October in *Dagen*, Jæger assiduously countered the critics' arguments. He described Munch's working method, saying the painting had been scratched out and repainted twenty times, only to remain in the end a sketch that retained a sense of mood all the preceding 'finished' versions lacked:

In it, there is genius. True, it was unable to take on definitive form. It has run in great

streaks over the surface of the poor, unsuccessful painting. But what Munch has presented to us in his study is something that cannot be learned. What he did not do, can still be learned.

Like Aubert, Jæger could not resist the temptation to preach. He advised Munch to cease making such ambitious pictures until he had mastered his technique. Then he should create a 'great art', a universal art that would be deeply moving to everyone, even the least comprehending artistic snob.[35]

His fingers properly slapped by enemies and friends alike, Munch responded by joining the chorus of criticism as he himself rejected his aborted masterpiece. With an implicit accusation that his teacher was directly at fault for the failure, he presented the unwanted child to its midwife Krohg. Having isolated himself as the most radical and innovative Norwegian artist, Munch found himself isolated in return, lacking support from artists and family. He also discovered Milly Thaulow to be untrue, a final overwhelming blow which he associated with the fiasco of *The Sick Child*. The disillusioned artist retreated. During the following years his art lost its radical experimentation to return in theme and style to the fold of the acceptable avant-garde of *plein-air* Naturalism. Temporarily, his position at the edge of artistic acceptability was abandoned.

YEARS OF INDECISION
1886–1889

'I took my leave of Impressionism and Realism'

On 11 December 1885, the two-volume novel *Fra Kristiania-Bohemen* ('From the Kristiania Bohème') by Hans Jæger was published. Sverdrup's liberal government immediately confiscated all copies, placed Jæger on trial and sentenced him to sixty days' jail for his 'immoral' book that 'blasphemed against God's word'.[1] The day after his review of Munch's *The Sick Child* appeared, Jæger began serving his sentence, taking to his cell a portrait of himself and several paintings of nudes. Among these was Munch's *Hulda*, now lost, a life-sized image of a woman naked to the waist, her arms raised and her hair in disarray as she reclines on a bed.[2]

Physically, life in the prison cell with his erotic frieze was not too severe for Jæger; he used much of his time to write for his new periodical *Impressionisten* ('The Impressionist'), which confirmed the association of the term 'Impressionism' with anarchism and immorality in the Norwegian popular mind. However, the confiscation of his book and his imprisonment generated heated debate in Kristiania on topics of censorship, freedom of the press and morality in art. Above all, his treatment—and that of the Naturalist novelist Alexander Kielland, who at about the same time was refused a pension on the grounds of his rejection of Christianity—demonstrated the failure of Sverdrup's regime to fulfil its utopian promises. Having come to office through a coalition of liberal urban voters and conservative nationalistic landowners, both factions desirous of breaking the civil servants' power and their loyalty to the Court in Stockholm, Sverdrup proceeded to reject his liberal supporters. As the most radical group, politically as well as culturally, the artists and writers were among the most disillusioned. 'Thus was revealed in the most ugly manner how lacking in character and how cowardly the reigning "liberalism" was', wrote one of them. 'One day it became apparent that the

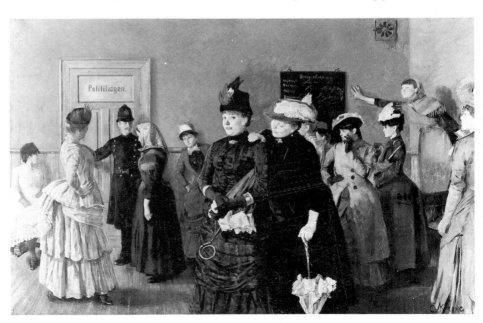

23 Christian Krohg: *Albertine in the Police Waiting Room*, 1886–7. Oil on canvas, 211 × 326 cm (83 × 128¼ in). Oslo, Nasjonalgalleriet

dream was over. ... What we now found facing us was the same drab existence as before, only now it seemed doubly repulsive because our visions had disappeared.'[3] Before the 1880s were over, Jæger was to be imprisoned a second time, having shipped to Sweden copies of his banned novel disguised as 'Christmas Stories', and then was to go into exile in France; Thaulow was to serve a brief sentence in the same cell as Jæger; and Krohg's novel *Albertine* was to be confiscated for the 'immorality' of its attack on legalized prostitution. The puritanical grip of institutionalized Christianity on the cultural policies of the government had not changed.

Lacking a political base and losing faith in the reformatory power of their art, most Norwegian painters ceased to depict urban social ills. One of the few not to retreat from these concerns was Krohg: When unable to exhibit his painting *Albertine in the Police Waiting Room* (1886–7), for which Munch allegedly painted one of the figures, Krohg rented an empty warehouse. There he displayed the massive canvas showing the heroine of his novel waiting to be examined for syphilis, a vaginal examination performed—in the presence of the doctor and several other men—to protect the health of Kristiania's prostitutes' customers. In a second large programmatic painting, *The Struggle for Survival*, he turned from the motif of public shame to that of public hunger, depicting a starving mob fighting for bread. However, such pathetic scenes of proletarian life in Kristiania, previously frequent, became rare in Norwegian art. Werenskiold and several others turned to folk tales, folk songs and Nordic epics, but it was primarily in depictions of nature's myriad moods that a Naturalistic art for art's sake evolved. Seeking the emotive poetry of late evening scenes, these painters turned from the bright colours of Impressionism to the rendition of sombrely coloured details. An emotive, subjective and resigned silence issued from the paintings.

Munch followed suit. In 1887, the year after the debacle of *The Sick Child*, he sent six paintings to the Autumn Exhibition, but too late to be included in the catalogue's first printing, suggesting he sent them with reluctance. Neither in size nor subject matter did the six landscape and portrait paintings display his previous grandiose ambitions. Most critics totally ignored him, failing even to cite his name in their reviews. A few took brief note of his *Study of a Late Afternoon*, an attempt from 1884 to apply a modified Impressionist technique and aerial viewpoint in a city scene. The painting could be seen as a renunciation of his experiments of 1885 to 1886 in favour of older, less controversial, although still non-traditional, values.

Much the same message was proclaimed by the group portrait *Studying Law*. Although members of Jæger's bohemian set, the students are depicted engaged in study, not carousal. The phosphorescent blue light emitted by the lamp translates all colours into hues of blue, but despite this Impressionistic light effect, the main concern is with the rendition of traditional portrait-likenesses. Ideologically, *Studying Law* is an aesthetic compromise.

More significant than what he included in the Exhibition is what Munch chose not to display: a self-portrait, using the technique of *The Sick Child*, showing Munch disdainfully looking down at his viewers through half-closed eyes; Karl Jensen-Hjell and Inger Munch sharing glasses of whisky and soda in a smoke-filled café, a study in hinted erotic attraction; another scene of bohemians seated around a table, drinking and icily staring past each other into bilious nothingness; the naked Hulda; and the figure study of a pubescent female model shyly posing for the first time. Munch even kept back his *Flowering Meadow in Veierland*, a painting bathed in an intense sunlight which dissolves all forms into a rich harmony of bright colours.

24 *Self-Portrait*, 1886. Oil on canvas, 33 × 24.5 cm (13 × 9½ in). Oslo, Nasjonalgalleriet

Like the critics, Milly Thaulow was also paying more attention to others. Frequently seen in the company of a young army lieutenant and actor, she aroused in Munch such intense jealousy that he began hallucinating, which contributed further to his sense of powerlessness and despair. Daily he would wander along Karl Johan's Street at two in the afternoon, the time when the military band marched down the street from the palace and Kristiania's burghers displayed their finery in the city's main thoroughfare. It was the time to see and be seen. The afternoon perambulations in welcome spring sunshine also provided a natural means for semi-public and thus private lovers' rendezvous, such as Munch hoped for in vain with 'Mrs Heiberg'.

Two years later, in a text remarkable for its pathological self-revelation, he was to record how 'the horrible face of mental illness' was revealed to him:

At the University clock, he turned around and crossed the street, intently looking ahead.—There she comes.—He felt something like an electric shock pass through him. —How much like her this one looked from the distance.—

. . . And then finally she came. He felt long before that she had to come. . . . He saw only her pale, slightly plump face, horribly pale in the yellow reflection from the horizon and against the blue [sky] behind her.

Never before had he seen her so beautiful. How lovely was the bearing of her head, a bit sorrowful.

She greeted him with a weak smile and went on. . . . He felt so empty and so alone. Why did he not stop her and tell her she was the only one—that he deserved no love, that he never appreciated her enough, that everything was his fault. She looked so sad. Perhaps she is unhappy. Maybe she is the one who believes that he does not care for her, and that it is his own fault. What a spineless wretch you are, a yellow coward, a yellow yellow yellow yellow coward.

He worked himself into a frenzy. Suddenly everything seemed strangely quiet. The noise from the street seemed far away, as if coming somewhere from above. He no longer felt his legs. They no longer wanted to carry him.

All the people passing by looked so strange and odd, and he felt as if they were all staring at him, all these faces pale in the evening light.[4]

No longer attainable, Milly Thaulow became an obsession; 'she was in my blood', he wrote.[5] In doubt about his worth as an artist, questioning the values that led to the critical debacle and his own rejection of *The Sick Child*, Munch let his thoughts turn to death. 'It is so weird to think that one day you will be totally gone. That you *have* to be. That the time *must* come when you can say to yourself, Now you have ten minutes more, and then it will happen. Then you will feel how little by little you become nothing.'[6]

To his followers, Jæger recommended that when they reached the ultimate conclusion that a society ruled by Christian morality and bourgeois values had already destroyed their life, they should draw the logical consequence of self-destruction. He drew up a suicide pact with Oda Lasson after she decided in 1888 to terminate her conflict-ridden love affair with himself and Krohg, and to marry the painter. Fusing erotic memories with his death-wish, Jæger dreamed of dying, with Oda stroking his smiling head resting on her lap, as they looked out over Kristiania from a nearby hill on a sunny afternoon. The destined day arrived but, just as the physical accident of his periodic impotence prevented Jæger from fully living his dreams of free love, so the accidental manifestations of the day prevented his self-destruction: it was drearily cloudy, Oda was unable to be with him until evening and Krohg wished to prevent the suicide. Instead of death, art resulted as Jæger transformed his experience into a novella, 'A Day of my Life'.[7] Recording the determinant acts of life, art became a form of auto-confessional therapy.

Munch's *optegnelser* about 'Mrs Heiberg', begun in 1890 after his relation-

ship with her finally ended, similarly exorcized the past, providing it with the allure of art and thus eternalizing it according to his own fixed vision. If Jæger's advice produced no great literature, it proved to be of excellent therapeutic value. It was habitually put into practice by Munch as he faced the major psychological crises of his life, each of which he carefully chronicled in these diary-like, semi-fictionalized 'jottings'.

The erotic and jealous moods generated by Milly's activities began to appear in his paintings. *Hulda*, the self-proffering nude that had accompanied Jæger to prison, may have been a homage to her sensuousness. By 1888, this erotic celebration had given way to silent despair. As Munch's hallucinatory jealousy yielded to self-pitying, suffering melancholy, he encapsulated the mood in *Evening*, a painting showing his sister Laura pensively seated in the foreground of an evening landscape. The silent condemnation that had met Munch at the 1887 Autumn Exhibition continued in 1888, broken only by one critic who complained of *Evening's* unnaturalistic colouration: the 'comical girl with a violet face under a yellow straw hat in a blue meadow in front of a white house'.[8]

If *Morning* (1884) was a variation on the white light of a new day, possibly even a Naturalistic allegory of a brighter proletarian future, *Evening* presented a variation on blue, a colour Munch used now for its associations not just with dusk but also with moods of sadness and melancholy. The illusionistic, descriptive function of colour was only secondary. Munch further reduced the painting's mimetic qualities by creating extreme contrasts in scale between Laura and the figures of a man and woman in the background. In *Evening*, Munch developed a pictorial structure—possibly dependent on Manet but also paralleling the post-Impressionist anti-Naturalism of Seurat and Gauguin—that uses manneristic alterations of scale and perspective to lend his image an intense dramatic tension. These devices are for a single purpose: to isolate the monumental, melancholy figure of Laura within an impenetrable loneliness. In 1888, this is Munch's own mood. Unlike the servant girl of *Morning*, Laura was associated with Munch's own emotional attachments making it possible for her to act as a pictorial surrogate for the artist. The painting depicts a psychological state, but brings it under control, neutralizing its demonic effect in a manner akin to Jæger's post-1885 use of literature. Art, for Munch, was not only a means to fame, but also a means of therapeutic self-presentation intended to effect a cure while transmitting to the viewer his subjective soul-state.[9]

While in prison, in April 1887, Jæger had published in *Impressionisten* a review of Krohg's novel *Albertine*. With vehement sarcasm, Jæger chastized the painter-author for writing a book about something he had not personally experienced. In contrast, he praised Krohg's painting, *The Struggle for Survival*, because it derived from an overpowering emotional experience:

You actually did stand down there at the corner of Karl Johan's and Skipper Street, and you saw that line of famished females and kids, all of them stretching their skinny, demanding arms into the air as the door is opened and bread is doled out. You stood there, overwhelmed by the sight, and said to yourself that you had to present *this* picture to the public, because just as *you* were overwhelmed by the sight, so the public should be overwhelmed by it.[10]

Jæger's exhortations that the artist's own reactions to a scene visually experienced must be recognizable in the final painting echo Zola's dictum that art must reveal the man, not only a corner of nature. This element of emotive subjectivity, which should cause viewers to feel emotions similar to those of the artist, Jæger described as Impressionism. In 1882, when Werenskiold had

introduced the concept to Norwegian art, Impressionism had been considered a stylistically radical form of Naturalism founded on the principle of *plein-air* painting, whereas by 1887 Jæger saw it as a search for truth to nature attained through the rendition of an emotional reaction spontaneously engendered by the artist's experience of a scene.

This version of Impressionism was adopted by Krohg. In a lecture entitled 'The One Thing Needed by Art', he advised his followers to 'paint in such a way as to delight, excite, move or irritate people in *precisely the same way* as you were delighted, excited, or irritated'.[11] Krohg attributed the transformation from external objectivity to emotive subjectivity to a new generation of Norwegian artists, 'The Third Generation', following upon his own generation of Naturalists and its students. 'Our new generation', he opined in 1889, 'is Munch. He raises the greatest hopes for the future. He is like no one else. . . . He is an Impressionist, our only one so far!'[12]

Munch's tentative efforts to overcome Naturalism by creating an Impressionism of egocentric subjectivity, as in *Evening*, were a response to Jæger's and Krohg's exhortations, but similar calls were being raised throughout Europe. In Copenhagen, the critic Julius Lange—in an article published in 1889 which received significant attention in Norway—observed that Impressionism (understood as a form of Naturalism) and 'painting in the field' were incapable of creating monumental painting, only quickly rendered studies from nature. Instead, he advocated an 'art of memory' whose 'images will appear to the inner eye, dim and mysterious images from the birth-giving night of the soul's unconscious life, from its dark, infinitely fertile soil'.[13] The ideals he expressed are remarkably similar to those of the German Romantic painter Caspar David Friedrich who, like Lange, advised artists to 'close your physical eye, so that you can see your image first with your spiritual eye, then bring to light what you saw in darkness, so that it may reflect on to others from their exterior to their interior vision.'[14]

Romanticism's subjectivity was resurrected, but its fascination with highly literary and fanciful content continued to be rejected in order that Naturalism's stylistic lessons and emphasis on personal experience could continue to be applied. The key to this unlikely marriage of dream and reality, as both Krohg and Lange emphasized, was memory—asserted by Munch, too, when later he proclaimed: 'I paint, not what I see, but what I saw.'[15]

Artists were advised to continue painting 'in the fields' and to create 'studies' there, but they should not remain satisfied with achieving an objective image of external nature. 'Something', Lange wrote, 'should also enter into the artist's soul, into his painterly development, to expand and mature his spirit.' Existing in the soul as 'inherited talents', such studies—'not the kind that can hang on walls'—should be used in the campaign of forging a new, post-Naturalist modern art. What Lange's and Krohg's essays of 1889—and Munch's paintings of 1888—postulated was the transference of Naturalism's concern with actual, living experience from the present into the past. Personal experience remained paramount. But the picture no longer recorded the experience at the moment it was lived, as in *plein-air* Impressionism, but rather as it was transformed by time and emotions. The painted image had to conform to the memory image of the artist, a goal similar to Munch's in *The Sick Child*. 'It is, after all', Lange succinctly stated, 'not the task of art to present an image of reality.'[16]

From 1888 to 1889, these anti-Naturalist and anti-positivist stirrings were gaining strength in Scandinavia, notably in literature. The optimistic concept of historical evolution and the belief that society would be reformed under the

impetus of paintings and novels representing its injustices, such as Krohg's *Albertine*, were rejected. A new age, heralded by the tempestuous progress of industrialization and the phenomenal expansion of cities such as Kristiania, was not the democratic golden age of freedom and enlightenment, not the *république naturaliste* of Zola that Jæger prophesied. Instead, it was soon recognized by the politically abandoned artists as a repressive system threatening all significant creativity and humanity. 'It was a sad moment', Ibsen wrote in 1886, 'when Johan Sverdrup came to power and was muzzled and handcuffed.'[17] The poisonous atmosphere of hypocritical self-righteousness characterizing the ruling mores of Scandinavia's newly powerful bourgeoisie was captured by Ibsen in his play *Rosmersholm* (1886).

The posthumous publication of Jens Peter Jacobsen's *Poems and Sketches* in Copenhagen in 1886, the growing awareness of English 'Pre-Raphaelite' poetry by Christina and Dante Gabriel Rossetti as well as Swinburne, and the translations into Danish and Swedish of Turgenev's and Dostoevsky's psychologically obsessive novels, all further contributed to the call for a Scandinavian art of numinous thought and subjective insight:

The world is deep
Deeper than day had been aware.[18]

In October 1888, the Danish periodical *Ny Jord* ('New Soil') began serializing a novel by the young Norwegian writer Knut Hamsun. *Sult* (*Hunger*) was a semi-autobiographical record of hallucinations, misery and inspiration suffered during days of virtual starvation in Kristiania, 'that remarkable city no one leaves without bearing its mark'.[19] Themes of hunger and poverty in the city were a hallmark of Norwegian Naturalist literature, as of Krohg's painting *The Struggle for Survival*, but Hamsun used the physical deprivations of hunger as the physiological occasion for the extreme nervous sensitivity of the narrative ego, the isolated genius, 'the visionary, the artist, the day-dreamer fated by the grace of God'.[20]

Like Munch, Hamsun represented a new generation devoted to an art antagonistic to Naturalism while also dependent on it. Hamsun's first-person narrative, his concern for the outcasts of society and his style all are unthinkable without the precedent of Jæger's 'From the Kristiania Bohème', just as Munch's neo-Romantic landscapes had their foundations in the Impressionist Naturalism of Krohg. However, Hamsun and Munch sought to externalize an internal world impossible to measure according to positivistic criteria. Implicitly, they announced the independence of their art from all verifiable reality.

Krohg's essay proclaiming Munch to be the entirety of Norway's 'Third Generation' was written in response to a massive retrospective of 110 works by Munch in the Students Organization in Kristiania in April and May 1889. It was the first such one-man exhibition to take place in Norway. 'A young, immature artist must possess great impudence and a total lack of modesty to appear like this', wrote one critic, 'especially when he is obviously not at all finished with his training.' He concluded that 'the new theories and ideas currently fashionable have gone to [Munch's] head', and that the exhibition gave witness to confusion.[21] The criticism was not without justification. Judging from the paintings and drawings displayed, Munch's work lacked direction and testified to indecision, a feverish and persistent changing of painterly modes, as if the artist was in a hurry to attempt all he could, particularly after the 'failure' of *The Sick Child*, but could find no single answer as to how his own art should look. Highly Naturalistic genre scenes

showing interiors of country stores and young fishermen tying nets alternated with the neo-Romantic Impressionism praised by Krohg. A large, provocative portrait of Jæger painted just after he had served his second prison term was included. And, as if to answer his earlier critics, Munch painted for the exhibition a larger but stylistically less daring version of *The Sick Child; Spring*, still entitled *Study* in the exhibition listing, was an academic demonstration piece of colouristic technique in a Naturalistic mode.[22]

The immodest exhibition served a variety of purposes for Munch. Once again it trumpeted his ambitions. Once again, following a bout of near-fatal pneumonia during the winter, it announced his regained health and powers of survival.[23] Above all, it demonstrated the uniqueness of his talent and its promise just as he was being considered for the Norwegian Fellowship for Artists. It was Munch's fourth attempt to obtain the grant set up by Sverdrup's government to provide 'economic support from his fellow citizens'

25 *Portrait of Hans Jæger,* 1889. Oil on canvas, 109.5 × 84.3 cm (43 × 33¼ in). Oslo, Nasjonalgalleriet

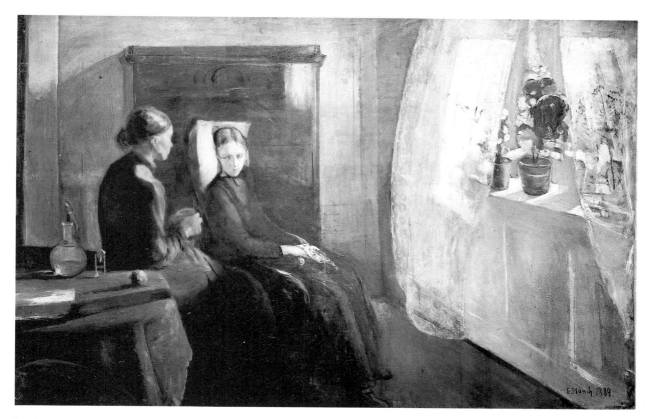

26 *Spring*, 1889. Oil on
canvas, 169 × 263.5 cm
(66½ × 103¾ in). Oslo,
Nasjonalgalleriet

for a Norwegian artist who 'displayed his unique talent' to the public, thereby
affirming his 'right' to such support.[24] The exhibition acted as a fellowship
application. Established avant-garde artists—Krohg, Werenskiold, Heyer-
dahl—supported him, as did the recalcitrant advocate of the young artists,
Aubert, who recommended that Munch be granted a two-year fellowship to
study drawing techniques, particularly drawing of the human figure.[25]

In July, Munch was awarded the fellowship. Before going to Paris in
October, however, he spent his first summer at Aasgaardstrand, a seaside
resort that for a period of twenty years was to be the site of innumerable
paintings. During a brief visit to his family in Kristiania, he was 'inexplicably
restless-nervous';[26] perhaps a rendezvous with 'Mrs Heiberg' took place or
failed to do so. But the months at Aasgaardstrand proved to be calm and
satisfying, spent in the company of his sister and various members of the
Kristiania Bohème: Christian and Oda Krohg, to whose newborn son Munch
was godfather (a baptism apparently being desirable despite atheistic bohem-
ian convictions); the playwright Gunnar Heiberg; the poet Sigurd Bødtker,
who was wooing Inger Munch; the painter Hans Heyerdahl, who began
painting scenes Munch felt were copies of his own; and various non-artistic
bohemians such as the lawyer Ludvig Meyer and the young officer Georg
Stang, whose portrait Munch painted.

Munch was later to write about two events that took place that summer.
First, the young painter Aase Carlsen, who had frequently painted in Munch's
company and who had futilely provided competition for the temptations of
Milly Thaulow, married the young lawyer Harald Nørregaard. Munch
attended the wedding, hiding in a corner behind a column, regretting that he
had never proclaimed his love for her, and wondering whether the beautiful
bride thought of her 'pale bohemian' as she took her vows.[27] The second

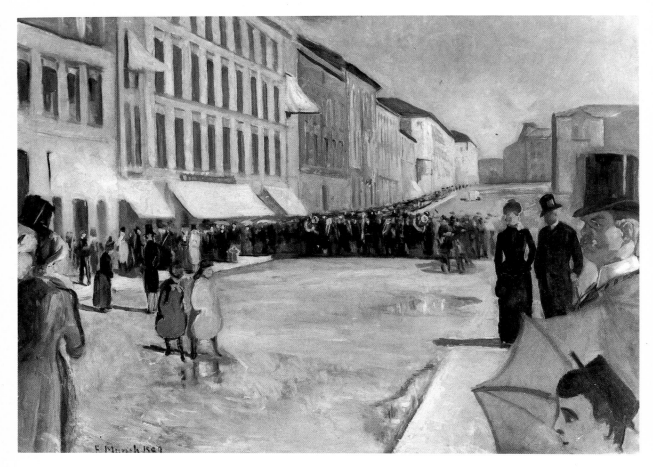

27 *Music on Karl Johan's Street, c.* 1889. Oil on canvas, 102 × 141.5 cm (40 × 55¾ in). Zurich, Kunsthaus

event was a portrait commission received early in the summer. The subject was the corpse of the attorney Hazeland, a self-proclaimed atheist and socialist:

At first I was captivated by the strange, clammy feeling one gets from a corpse. Then I was seized by the great, powerful gravity that lay in these congealed features. How handsome the old head was as it lay there greyish-yellow against the blue-white sheet. The great forehead with the hair carefully stroked back, the nose seeming a bit crooked and having become pointed, and the firmly closed mouth as if shut by some mighty mystery. . . . He had no god in life and no god in death.[28]

Despite these experiences of thwarted love and of death, Munch demonstrated a rediscovered optimism and self-confidence during the summer. He worked on three massive paintings, each nearly the size of *Spring*, but he totally finished only one of them. *Music on Karl Johan's Street,* the earliest, takes a view facing the Storting as promenaders gather on the pavements to hear the military band pass by on its way to the Palace. Often compared to works by Manet and Degas, the painting is more dependent on Krohg, their admirer and imitator, particularly in its spatial composition and its yellow, blue and rose colouration.[29] If one takes away the face and deep red parasol in the lower right-hand corner that were added later, the painting also provides a variant on Munch's frequent compositional device of isolating a single foreground figure—the man in the top hat—and setting it off against a charged movement into depth. The vast expanse of the street with its images of promenading men and women in the spring sunshine is placed in sharp and

46

poignant contrast to the lone foreground figure, as if the two were in different realms of reality. As in the image of Laura in *Evening* (1888), the device gives the picture a feeling of insurmountable separation. The man, who resembles Oda Krohg's first husband, gazes intently across the picture space at a couple appearing on the framing edge opposite him. A gouache study showing Krohg and Jæger walking in the foreground before the shadow of Oda who accompanies the military band in the background suggests that Munch, at least implicitly, intended the painting as a commentary on the obsessive jealousy marking the romances, including his own, in his circle. It was jealousy—along with the continued appearance among the bohemians of the bourgeois institution of marriage—that denied the dream of free love its fulfilment.[30]

Evening Conversation, which in 1889 probably consisted of little more than the facial portraits of Inger Munch and Sigurd Bødtker with the landscape only sketched in, not to be painted until 1893,[31] shows a similar compositional formula of figures isolated within a landscape. With his sister gazing sternly out of the painting at the viewer or the painter while Bødtker glances at her, Munch again formulated a triangular relationship in which plans for marriage found no fulfilment, and Inger remained within the Munch family.

Inger's isolation was represented once again in the one painting of this group that Munch completed in 1889. His lone entry at the 1889 Autumn Exhibition, *Evening (Summer Night: Inger at the Seashore)*, shows his sister seated on a rocky seashore near the house he rented in Aasgaardstrand. Dressed in white, seen in profile, she rests her hands on her lap and holds a yellow straw hat. In preparation for the painting, Munch sought to capture the light effects of a Nordic summer night, painting out of doors in the evenings between nine and eleven.[32] The kinship to *plein-air* painting's interests thus remains, but in the final painting these 'inherited talents'—to use Lange's terminology—became an 'art of memory'. More than a specific time of day, the painting seeks to represent a mood, as did *Evening* of the

28 *Krohg, Jæger and Oda Krohg with the Military Band on Karl Johan's Street, c. 1889. Gouache. Oslo, Munch—Museet*

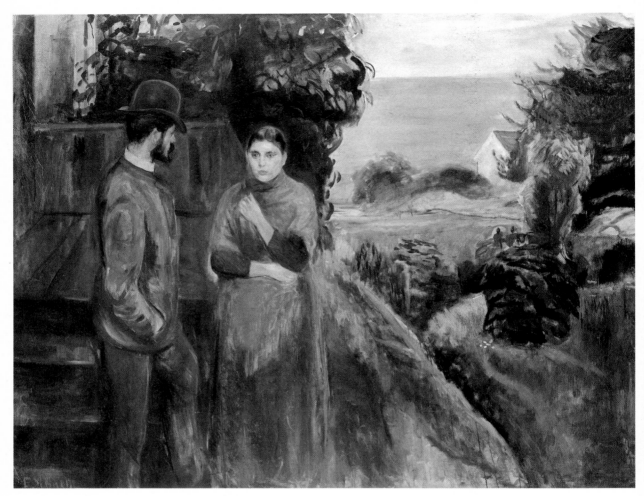

29 *Evening Conversation*, 1889 and *c.* 1893. Oil on canvas, 150 × 195 cm (59 × 76¾ in). Copenhagen, Statens Museum for Kunst

previous year. While that painting retained a high degree of illusionism, however, in 1889 Munch strove for a more decorative effect, outlining his figure, flattening the stones, minimizing the horizon line and using a virtually monotone blue throughout, in order to produce a highly flattened, artificial image. Munch may have had in mind the works of Puvis de Chavannes, an artist then becoming highly influential in Norway. Through Puvis, Munch again was seeking a path to a modern monumental Nordic art, an art he had failed to found in *The Sick Child*.[33] Although still within the vocabulary of Norwegian neo-Romantic mood paintings, *Evening* thus contained a formalistic daring akin to the more radical contemporary works of Seurat or Gauguin in France. In terms of his own development as a painter, he was well prepared to be receptive to the stylistic and psychological experimentation of contemporary French art.

Early in October, he left for Paris to study drawing with Léon Bonnat. Milly Thaulow finally ceased to be part of his life. Parting from his father, with whom he had so bitterly argued throughout the decade, proved the most difficult, and Munch recorded numerous times in his *optegnelser* the scene of their farewell handshake, their mutual embarrassment at their emotions, and his hesitancy to leave.[34] They would never see each other again.

30 *The Sick Child* (detail of
Plate 20)

FORMATION OF A NEW AESTHETIC
1889–1892

'Art must be created with your heart's blood'

'I hated living in Paris', wrote Munch early in 1890[1] in a letter he never sent to Aase Carlsen, the woman whose marriage he had ruefully witnessed the previous summer. Alone and lonely, yearning for company and compassion, he projected into his presence, into 'our room', the lost bohemian love to which he had never admitted.[2] But neither she, nor any other woman, brought him the comfort and love he so ardently desired during those months. Instead, a Danish poet, Emanuel Goldstein—an admirer of Hans Jæger, a Naturalist dissatisfied with Naturalism, a man preoccupied with the memory of a tortured love affair—became Munch's comforter and guide, a Danish Virgil to the Norwegian Dante passing through a spiritual hell and purgatory in a search for a revised paradise of art. 'We are like two clocks synchronized in Saint-Cloud', Goldstein was to write in 1892, 'and since then we have been keeping the same time.'[3]

Goldstein and Munch met in the autumn of 1889 in the Scandinavian artists' colony of Paris that had also welcomed Jæger, briefly, during his first exile from Norway in 1888. Munch arrived early in October to study at the Ecole des Beaux-Arts. His mornings he dutifully spent drawing 'boring nudes'; during the afternoons and evenings until the end of November he frequented the World's Fair whose trademark was Gustave Eiffel's controversial iron tower. In the Norwegian section of the fair was Munch's sole exhibit, *Morning* of 1883, a painting once condemned as anarchic and tasteless, but after six years a safe substitute for his more recent art. In the fair's Centenary Exhibition of French Art, for the first time Munch directly encountered works by the French Impressionists Monet and Pissarro, as well as by Manet, Krohg's archetype of the modern artist. In Munch's letters and sketchbooks, however, none of these was mentioned. It was Buffalo Bill's Wild West Show that he wrote about in the last letter home his father was to answer.[4]

At the Café des Arts on the fair grounds, Munch also could have seen the exhibition that introduced to the Paris art world and to art history the revolutionary works of the Groupe Impressionniste et Synthétiste.[5] The major force within the group was Paul Gauguin, then living in Brittany. Munch knew him as Frits Thaulow's brother-in-law who had exhibited three paintings in Kristiania in 1884: still-lifes and portraits in an Impressionist manner largely derived from Pissarro. In 1889, Gauguin's paintings and prints at the Café des Arts were radically flattened images with their heavily outlined forms rendered in exaggerated colour. The young radical critic G. Albert Aurier wrote of them: 'I seem to have noticed a marked tendency towards a synthesis of drawing, composition and colour, as well as an effort to simplify the means of expression.'[6] In a style he called Synthetist, Aurier saw a 'special language of painting depicting ideas' rather than imitations of nature.[7] The concept was one with which Lange, who in Denmark was denying that art should present an image of reality, would readily have agreed. Similarly, in the most extensive of the handful of reviews in the little-known journals that paid any attention at all to the unorthodox café exhibition, the progressive Parisian art critic Félix Fénéon considered

Gauguin's works to have a 'mysterious, hostile, and rough aspect' which distinguished them from those of his Impressionist contemporaries:

Reality for him was only the pretext for a creation quite removed from it: he puts into a new order the materials furnished for him by reality; he disdains all illusion, even the [Impressionists'] illusion of atmosphere; he accentuates lines, limits their number, makes them hierarchic; and within each of the spacious areas formed by their interlacing, an opulent and sultry colour bleakly extends its own pride without in any way threatening the independence of the neighbouring colours, lacking even the slightest degree of shading.[8]

The intentions attributed to Gauguin and Synthetism corresponded to those of the major avant-garde current of contemporary French poetry, Symbolism. The name was first applied and the movement defined in 1886, in Jean Moreas' Symbolist Manifesto ('Le Symbolisme: Manifeste de Moreas', *Figaro littéraire*, 18 September 1886), which sought to supplant the more widespread term 'Decadence'. Decadence implied sickness, weakness, an approaching end and the autumn of a civilization; Symbolism, Moreas argued, could point the way to the future, following an ineluctable artistic evolution. According to one sensitive observer, Hermann Bahr, its writers represented:

the strong urge away from the superficiality and crudeness of Naturalism and towards the profundity of refined ideals. They do not seek an art of the exterior world. They want no imitation of nature. . . . Not emotions, only moods are sought by them. . . . These new nerves are highly sensitive, acoustically acute and many-sided, so that they share among themselves every flowing movement. Tones are seen, colours sing and voices are fragrant.[9]

Naturalism and Realism were the great enemies of Symbolism, embodying a puerile method whose particular practitioner was Emile Zola. He had defined art as 'a corner of nature seen through a temperament'. He thus recognized that a certain subjectivity was inevitable because individuals create art, but saw the ultimate criteria and inspirations in nature. Symbolists, according to Moreas, saw nature only as 'a simple point of departure of infinitesimal significance'; their main goal was to give sensible form to an idea by means of subjective deformation and to Beauty, achieved through style. The true precursor of the movement, it was generally agreed, was Charles Baudelaire, whose poems were characterized—in the classic formulation of Théophile Gautier—by:

a style that is ingenious, complicated, learned; filled with nuance and refinement; constantly pushing back the limits of language; taking colours from all palettes, notes from all keyboards; endeavouring to render thought in its most vague and fleeting contours; listening, in order to translate them, to the most subtle confidences of neuroses, the confessions of aging passions entering depravity, and the bizarre hallucinations of obsession changing into madness.[10]

As enemies of objective description and advocates of the new stylistically refined subjectivity in poetry, Stéphane Mallarmé, Paul Verlaine and Arthur Rimbaud were seen as the major poets of Decadence after Baudelaire. By the late 1880s, the label Decadence was fashionable (and caricatured) throughout Europe, and its ideas had become a major international aesthetic force, even converting previous spokesmen of Naturalism. A major component in the popularization process was a novel that became known as the 'Breviary of Decadence', J. K. Huysmans' *À Rebours* ('Against Nature') of 1887.

In Huysmans' account of the private fantasies of a neurotic aesthete, the

31 Overleaf left *Self-Portrait*, 1882. Oil on panel, 25.5 × 18.4 cm (10 × 7¼ in). Oslo, Bymuseum (see p. 23)

32 Overleaf right *Flowering Meadow in Veierland*, 1887. Oil on paper, 66.5 × 44 cm (26 × 17¼ in). Oslo, Nasjonalgalleriet (see p. 39)

paintings of Gustave Moreau and the lithographs of Odilon Redon are particularly praised as visual equivalents to the literary movement. Other writers found corollaries to their poetry in the prints and paintings of Puvis de Chavannes, Félicien Rops and Fernand Khnopff. In their accentuation of an internal, subjective universe, was discovered a new religiosity and mysticism that either abjectly accepted or boldly rejected traditional religious dogmas. Together, artists and poets formed an aristocratic body, carriers of a mysterious revelation and personal sense of pure beauty that locked out the disturbingly materialistic society of the late nineteenth century.

By the late 1880s a definite Symbolist Movement in painting could be discerned among the entire generation of younger artists, including Gauguin. Numerous attempts were made to define Symbolist art; most successful remains Aurier's definition of a Symbolist painting as:

1 *Ideist,* for its unique ideal will be the expression of the Idea.
2 *Symbolist,* for it will express this Idea by means of forms.
3 *Synthetist,* for it will present these forms, these signs, according to a method which is generally understandable.
4 *Subjective,* for the object will never be considered as an object but as the sign of an idea perceived by the subject.
5 (It is consequentially) *Decorative*—for decorative painting in its proper sense . . . is nothing other than a manifestation of art at once subjective, synthetic, symbolic and ideist.[11]

Until 1890 and the discovery of Gauguin, the pictorial style most frequently linked with Symbolism's concerns was Neo-Impressionism. Seurat, Signac, Pissarro and others, it was argued by poet-critics such as Gustave Kahn, strove towards an 'essential goal . . . to objectify the subjective (the exteriorization of the Idea) instead of to subjectify the objective (nature seen through a temperament)'. The appeal of the style was its intent to systematize the subjective, to permit lines and colours to synthesize into an emotive statement so as to guarantee that each viewer would identify this 'idealist' content hidden in the overt image. In this aim, the Neo-Impressionists were very influenced by the colour theories of Charles Henry. These sought to link different colours and lines with different moods, in order to establish an objective or scientific basis for an emotive art. As Kahn wrote:

These theories are founded on the purely idealist philosophic principle that causes us to reject all reality for matter and not to admit the existence of the world except as representation.[12]

In 1890, Norwegian critics were also to associate Munch with these French artistic movements; in the autumn of 1889, however, if Munch saw Gauguin's pioneering example, he rejected it. So vehement a denial of art's traditional dependence on the external forms of nature he was not yet prepared to accept.[13] Instead, remaining submissive to Bonnat, he drew the academy's 'boring nudes'. It was the last time he would submit to the discipline of a teacher.

The World's Fair closed early in November. Lacking its entertainment, Munch felt pangs of boredom, loneliness, dissatisfaction and restlessness. He moved from one rented room to another, from one area of Paris to another, from the city which he considered too noisy and damp to the suburbs which were too cold and expensive.[14] About a week before his birthday in December, a letter arrived from his aunt; in it she announced that Dr Christian Munch had died unexpectedly of heart failure. For Munch the

shock of this death inaugurated a severe psychological crisis.

Dr Munch's death was the peaceful end of a believing Christian, Karen Bjølstad wrote to 'dear, poor, poor, Edvard'. Her words echoed her sister's farewell letter to the Munch children twenty years earlier:

It seems like a dream. It is almost impossible for us to comprehend it. And yet, it is verily so. Now Papa is together with Mama and Sophie, and he really can see our deep sorrow, and can peer into our poor burdened hearts. For us here at home, there is great consolation in this. . . . We most often find recourse in God's Word, the refreshing spring from which Papa himself—as you know so well—drew comfort and strength. Would that you were here together with us as we in this way find refuge in God's Word![15]

For Munch in Paris, God's word was not a sheltering refuge. Having rejected religion, he experienced the death as a total annihilation of his father's existence, and reacted by isolating himself in his rented room. On loose sheets of stationery, randomly picked up, he wrote down the thoughts and the events of his mental turmoil. He retreated into the past. 'I live with the dead', he proclaimed, 'and every memory, even the most insignificant one, comes back to me. . . . As my only friend, I have the fire in the fireplace.'[16] And on another occasion:

Alone and lonely, I sit surrounded by a million memories; they tear into my heart, leaving me with open gaping wounds.

. . . Now I would give anything to be able to hold his old grey head in my arms just once, and to tell him how much I care for him. A foolish sense of chagrin always separated us. The worries I caused him do not bother me as much as all the small things, like turning away from him when he offered compassion. . . . How I wish for a time for us to relax and talk to each other, for me to embrace his old grey head.

But I felt I did the right thing in what I did, that it was true. But for you there was only the devil.

I could not share your faith.[17]

Out of habit, Munch addressed his father directly, as if he shared his family's belief in his father's after-life; but there was no conviction of faith in his heart. 'Think of everlasting eternity!' the dying Christian father had inscribed in the Bible he sent his errant artist son in Paris;[18] the son did heed the admonition—but his everlasting eternity was nothingness and darkness.

Ever since Sophie's death Edvard had felt an outsider within his own family. Now, feeling yet more alienated, grief-ridden and remorseful, he created small pen sketches recording memories of his father surrounded by all the Munch children except himself. There was accusation in this exclusion, but also a sense of helplessness and doom. 'What I wanted', Munch wrote, 'he failed to understand; what he valued most, I could not understand.'

In addition to his sketched and written memories, Munch attempted to formulate an image of his father's death. From a Naturalist's viewpoint, he could depict neither the corpse nor the scene of death since he had witnessed neither. His memories were of his father alive and active. Accordingly, Munch drew the figure of Dr Munch walking—but down a barren, endless road.[19] The image has its source in the expression that death is 'the road from which there is no return', and is thus a modern allegory of death without hope or salvation. However, the pessimistic message and its awkward allegorical presentation were extended beyond the Naturalists' dependence on temporal experience. To cope with his father's death pictorially and psychologically, art and life as he had accepted them during the 1880s in Kristiania and Paris no longer seemed sufficient.

33 *Evening (Summer Night: Inger at the Seashore)*, 1889. Oil on canvas, 126.4 × 161.7 cm (49¾ × 63½ in). Bergen, Rasmus Meyers Samlinger (see p. 47)

He withdrew from Bonnat's academy. His recollections became virtually his only concern. In these, ironically joining Dr Munch's pietistic image, was the figure of the unfaithful Milly Thaulow. News had reached Munch that she now had left her husband, had become a chanteuse in a café and was living with Munch's rival, the actor Ludvig Bergh. Attempting to purge himself of guilt and to destroy the demonic force her memory retained for him, Munch attributed to her a power that imposed itself on him against his will. She, not he, had wronged his father.[20]

In the dusk-filled atmosphere of his room at Saint-Cloud, he re-read her letters and the scraps of treasured paper invitingly inscribed 'Beloved: Come tomorrow, 3 o'clock':

I leaned against the desk. I stared at each single letter, turned the bit of paper over again and again, looked at each fold in order to find marks left by her fingers.

It has been a long time since I thought about her, and yet it all comes back. How deep a mark she must have dug into my heart so that no other image can ever totally erase it.[21]

Munch's acerbic melancholy and obsession with the past soon isolated him

34 *Night (Night in Saint–Cloud)*, 1890. Oil on canvas, 64 × 54 cm (25¼ × 21¼ in). Oslo, Nasjonalgalleriet (see p. 65)

35 *Spring Day on Karl Johan's Street*, 1890–1. Oil on canvas, 80 × 100.3 cm (31½ × 39½ in). Bergen, Rasmus Meyers Samlinger (see pp. 68–9)

36 *Allegory of Death (The Barren Road)*, 1889–90. Pen and ink, 22.2 × 17.7 cm (8¾ × 7 in). Oslo, Munch–Museet

37 Sketchbook drawing: *Study for Night in Saint-Cloud*, 1890. Oslo, Munch–Museet

from virtually the entire Scandinavian artistic community in Paris. Only Goldstein remained. During those winter months he was to bring not only personal comfort but also a message of artistic salvation. He was to introduce Munch to the current ideas of Symbolism that would replace the doctrines of his artistic fathers Krohg and Jæger.

'When I think back to the time in Paris', Munch later wrote to his Danish friend, 'I feel such immense gratitude for the days you were with me in Saint-Cloud. We had so much to discuss.'[22] Goldstein wrote to Munch in similar vein: 'My tongue is burning with so many things about which I would like to talk to you. After all, you are the only person to whom I can speak.'[23] In all Munch's correspondence, there is no other admission of love and dependence of such magnitude; never would there be another 'clock' set to the same time as his own. Into Goldstein, Munch projected his own ego, and in turn absorbed that of the poet. In initial sketches made that winter for *Night*, a painting that was to be a turning point in his development, Munch posed Goldstein as his alter-ego, a lone figure sitting at a window, lost in his thoughts. Twenty years later, Munch still confessed: 'I believed then that I had lived through the same experience as you.'[24] Even if the experiences, both aesthetic and erotic, were not the same, they were sufficiently similar to allow Munch, during this personal crisis, to confuse the poet's biography with his own.

'There was that business with her', Munch ruefully noted, referring of course to his tumultuous relationship with Milly Thaulow. Goldstein's young life too had been scarred by a tormented liaison. By 1890, Munch had begun to translate his affair into quasi-fictional recollections, notes for a Jægeresque novel, and into small sketches—perhaps intended to become a series of paintings—recounting moments in the relationship, as when he stood with her under a street light while workers passed by on their way home from work, or as he, with exaggerated ceremony, doffed his hat to 'Mrs Heiberg' and her husband. Goldstein had been able to go beyond such projects. In 1886, the year Munch exhibited *The Sick Child*, Goldstein had published a small collection of poems on the subject of love, *Vekselspillet* ('Reciprocal Interaction'). The love relationship of the nineteen-year-old poet was predict-

ably tortuous, filled with intense longing, intense jealousy and intense hatred in a manner not unlike Munch's experience:

There exists no soul on earth
I hate as frantically as you.
There is no soul on earth
I love as tenderly as you.

I could cleave your skull
and drink your flowing blood—
Cast myself enslaved into the dust
and lick your naked foot.[25]

The painful memory of the love affair never left Goldstein. The woman and her effect on him became an obsession; he returned repeatedly to the poems composed in response to it, preparing at the time of his death in 1921 a fourth revision of *Vekselspillet*. Beginning with the second edition, in 1892, the poems were dedicated to Edvard Munch.

Munch and Goldstein were drawn together by their experiences. Having both recently terminated affairs in which they saw, in Goldstein's phrase, 'the vampire sucking my blood ... [while] my body burns like a desert's shifting sands',[26] their distrust of women was intense and mutually supported. In Paris, while Munch might yearn for a reunion with his other recently married 'blonde, bohemian love', their contact with women was limited almost totally to prostitutes or near-prostitutes, such as waitresses or chambermaids. Alone and lonely, the two men sought out each other. Fearing their sublimated attraction even more than the women who had jilted them, each felt a bewildering rage and jealousy when witnessing the other flirting with a woman. In an atmosphere thus charged with suppressed erotic emotion, with a recognition of similar love relationships, and with thoughts of death and after-life, Munch and Goldstein together formulated an alternative to Naturalist art.

'All I have to do is think of Naturalism and Realism and all that other

38 *Lovers under a Lamp-post*, c. 1890–1. Pen and ink. Oslo, Munch–Museet

39 Overleaf *Portrait of Anne Buhre*, 1891. Oil on canvas, 73.4 × 59.4 cm (28¾ × 23¼ in). Copenhagen, Statens Museum for Kunst

40 Opposite top *The Yellow Boat: Jealousy*, 1892. Oil on canvas, 65.5 × 96 cm (25¾ × 37¾ in). Oslo, Nasjonalgalleriet

41 Opposite bottom *The Kiss*, 1892. Oil on canvas, 72 × 91 cm (28¼ × 35¾ in). Oslo, Nasjonalgalleriet

sham-filled art, and I am nauseated', Goldstein was to write to Munch in 1891.[27] Salvation, he believed, would come from Symbolism:

That is to say, an artistic tendency in which the artist imposes his dominion on to reality, so that it is *his* servant, not vice versa. Symbolism is the art that values moods and thoughts over all else, and uses reality only as a symbol. . . . No longer should a visual presentation of conventional reality be given, but rather a visual presentation of what lives in the mind. . . . The reality thus depicted will be solely symbols of thoughts and feelings.[28]

Munch's entire experience and life at Saint-Cloud during the next few months completed his conversion from an artist of Jæger's atheistic bohemian Naturalism to an artist for whom nature was only a symbol, an imperfect reflection of a spiritual reality formed by his own fantasy and psychological history. In jotting down diary notations for his life's novel, Munch was acting like the Decadent anti-hero of a novel by Arne Garborg, *Trætte Mænd* ('Exhausted People'), published in Norway in 1891 and described as 'the novel of our times ... by far the most typical work of the Norwegian Decadence'.[29] Garborg's anti-hero was portrayed as transforming life into art, his own experiences into a novel:

Oh, these old notebooks with their almost illegible pencil scribbles, and all these ridiculous loose papers, envelopes, backs of letters, folio-sized pages, and fine small stationery ... on which during lonely hours I scratched the day's impressions, experiences, ideas, moods! Almost every scrap of paper and every entry has its own unique associated recollection. Here is one written while I sat alone in some dive and waited for the clock to strike the expected hour, or else I was upset because that afternoon, I had nothing to wait for. This other one was written as I sat on a stone out in the Frogner Woods near Kristiania or else on a tree stump up in Ekeberg where I sat and tried to forget. Then there is this one written right here in my room as I sat lonely at midnight over a final glass and a final cigarette and let the day pass by in review. Indefinite, sentimental hints of moods rise from these much-fingered jottings and surround me as if in a soft, sheltering fog.[30]

For Munch too, the diary notations became his environment, the 'soft, sheltering fog' within which his personal crisis was acted out in isolation.

Through memories of the past and the new ideas of Symbolism—both shared with Goldstein—Munch began to discover a non-material, spiritual dimension within himself, and became able to counter the nothingness of death in the face of which art and life as an artist had seemed totally insignificant only a few months before. Immortality seemed real again, and this helped him come to terms with the deaths in his family and to lose the fear of his own death. In 1892 he was to write:

It is foolish to deny the existence of the soul; after all, that a life begins cannot be denied.

It is necessary to believe in immortality, insofar as it can be demonstrated that the atoms of life or the spirit of life must continue to exist after the body's death. But of what does it consist, this characteristic of holding a body together, of causing matter to change and to develop, this spirit of life?

Nothing ceases to exist; there is no example of it in nature. The body that dies does not disappear. Its components separate one from the other and are transformed.

The fanatical faith in a single religion such as Christianity resulted in a rejection of faith, resulted in a fanatical faith in the non-existence of God.

... All of it was associated with that great wave that spread over the earth: Realism. Things did not exist unless they could be demonstrated, explained arithmetically or physiologically. Painting and literature became whatever could be seen with one's eyes or heard with one's ears. It was the shell of nature.

People were satisfied with the great discoveries they had made. They did not realize that the more discoveries are made, the greater and the more are the mysteries to be solved.

Mysticism will always be with us. The more we discover, the more unexplained things there will be.

The new movement, whose advances and fires can be detected everywhere, will express all those things that have been repressed for a generation, everything that mankind will always have in great abundance: mysticism. It will find expression for what now is so refined as to be recognized only in vague inclinations, in experiments of thought. There is an entire mass of things that cannot be explained rationally. There are newborn thoughts that have not yet found form.[31]

Continuing to reject the theories of a Christian after-life, Munch arrived at a solution to the issue of immortality that ironically depended precisely on the Naturalist faith in science and scientific knowledge that his new-found mysticism sought to reject. Popularized concepts of physics and evolutionary biology formed the foundations for his Decadent faith. From pre-atomic physics derived the primary law that nothing in nature is destroyed, that matter only changes in form. From the philosophical Monism of Ernst Haeckel, a professor of zoology at Jena whose ideas were circulating during the 1880s, Munch may have got the idea that the entire universe could be seen as a unity of spirit and matter ruled by a universal law of evolution eternally valid.[32] As a modern substitute for traditional religion God was seen as an impersonal and immanent force in which the law of the eternal transformation of matter was founded. The dual demands of scientific support – Darwin's theories and the law of the conservation of force and matter – were joined with a more mystical principle: a pantheistic God serving as the original foundation of all substance.

It was a new optimistic faith and it was enthusiastically welcomed by many as a replacement for a puritanical, pessimistic Christianity. Faith in life as life, faith in life as never-ending, became the new secular religion of the times, and Munch happily embraced it. On a late winter day, as the renewed life of nature began to appear in the grasses and trees of the ancient park at Saint-Cloud, with its crumbling castle a ruin of the past, Munch's faith was reborn:

For a long time it was cold, then suddenly the weather turned warm and spring-like. I went out on to the hill and enjoyed the gentle air and sun. The sun felt warm, and only occasionally was there a cool breeze that felt as if it came from a burial vault.

The moist soil was steaming. It smelled of rotting leaves. And around me everything was so still. And nonetheless I sensed that there was ferment and life in this steaming soil, in these naked branches. Soon they would blossom and live, and the sun would shine on green leaves and on flowers, and the wind would gently sway them.

To me it seemed as if becoming united with this life would be a rapturous delight, to be one with the earth at all times fermenting, always being warmed by the sun. And living—living!

I would be united with it and from my rotting body plants and trees would sprout. Trees and plants and flowers. And they would be warmed by the sun, and nothing would pass away. That is eternity.

I stopped suddenly. As if from a funerary chapel, freezing cold, a slight breeze rose up. And I shuddered, and went home to my room, chilled to the bone.[33]

Neither his father's Christian faith in a personal spiritual after-life, nor Jæger's desolate denial of all vital human survival after death, Munch's new faith was personally formulated and announced as new independence of thought. The death of his father, although it had initiated a period of grief, guilt and melancholic lethargy, was also the single event granting Munch freedom from his biological, intellectual, religious and artistic past.

Back in his room, Munch wrote down his feelings, in notes that became known as his 'Saint-Cloud Manifesto', because they seemed to represent the core of his new beliefs:

I felt I should make something—I thought it would be so easy—it would take form under my hands like magic.

Then people would see!

A strong naked arm—a tanned powerful neck—a young woman rests her head on the arching chest.

She closes her eyes and listens with open and quivering lips to the words he whispers into her long flowing hair.

I would like to give it form as I now saw it, but in the blue haze.

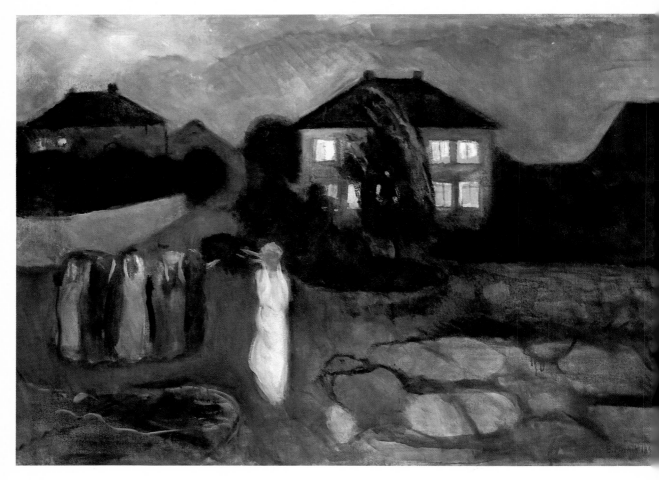

42 *The Storm*, 1893. Oil on canvas, 91.8 × 130.8 cm (36⅛ × 51½ in). New York, The Museum of Modern Art (see pp. 119–21)

These two in that moment when they are not themselves, but only one of the thousands of sexual links tying one generation to another generation.

People should understand the sanctity, the grandeur of it, and would take off their hats as if in a church.

I would make a number of such paintings.

No longer would interiors, people who read and women who knit, be painted.

There should be living people who breathe and feel, suffer and love.[34]

Conventional reality was rejected. The visual aspects of reality should be transformed. Then they would cease to be re-presentations or mirror images of the tactile world. Paintings would be signs or hieroglyphs functioning through a process of association in viewers in such a way as to arouse in them ideas and moods. These ideas and moods would be the actual content of the art works.

Munch now returned to an image of himself that had haunted him throughout the winter, as he sat alone grieving in the moon-tinged evening darkness. Of this image he wrote in 1890:

How light it was outside. One would think it was daylight. I always lie here with the curtains pulled back. It is the moon shining over the Seine; it shines into my room, through the windows, and casts a bluish rectangle of light on to the floor.

As I lay there and looked out of the window, other images flashed before my eyes dim and blurred like projections from a magic lantern.[35]

Munch had already made sketches of this scene in which he showed Goldstein

at the window. It now formed the basis for a painting. Simply entitled *Night* when exhibited in Kristiania in 1890, it was drastically different in technique, style and intent from his previous work. In a sparse and dark interior, a lone, pensive figure sits on a bench and stares out of a window at the Seine. Bluish exterior light, reflecting off snow, water and ice provides the only illumination, casting the form of the French window and its frame on to the barren floor. Except for isolated spots of red and yellow, blue (in association with blue-violets and bluish browns) is the dominant colour.

Munch had seen works by Seurat and other Neo-Impressionists at the Salon, and his use of colour in *Night* indicates that he shared their knowledge of Henry's theories that sought to supply an objective basis for the emotive power of colours and lines. [36] With its dominant blue and violet-green tones, and its diagonal spatial organization, *Night* corresponds to the directional and colour emphasis categorized as sad, depressive and melancholy in Henry's colour wheel. Accordingly, *Night* becomes a symbolic representation of a melancholic mood of reflection.

In the post-Naturalist, post-Impressionist attitudes of artists and in the works seen in Paris early in 1890, Munch had found the resources for transcending the provincialism of Kristiania's artists. He became part of the international avant-garde. *Night* thus marked a break with Munch's artistic past that paralleled the psychological crisis at Saint-Cloud induced by the break in his biological past—the death of his father. Adhering to the subjective ideals of the embryonic European Decadent and Symbolist art, the painting depicted the mood of grief and melancholy, but it was also a declaration of intended independence from the mores of an externally orientated art concerned with documenting the visible life surrounding it. 'The aesthetic doctrine of Naturalism reversed itself', wrote Bahr. 'No longer would the temperament of the artist be the tool of external reality creating its own mirror image, but rather the reverse was true: reality now became the tool of the artist in order to express his subjective nature in clear and effective symbols.' [37]

Stylistically, *Night's* blue-tinged atmosphere owes much to James McNeil Whistler, the expatriate American painter celebrated in Paris in 1890 for his poetically evocative nocturnal landscapes. The technique of *Night,* however, consisting of thin washes of paint rapidly brushed on to the canvas, and the exaggerated lines of perspective, suggests that at that year's Salon des Indépendants Munch had sought inspiration in the views of Parisian night life depicted by Henri de Toulouse-Lautrec. [38]

In the course of 1890, Munch developed the ideas of an associative Symbolist art further. After a summer in Norway, he harked back to Krohg's theories of Impressionism, as well as to Jæger's critique of Krohg, demanding that art should represent the artist's response to a scene so that the public could share the feeling. Munch's lengthy proclamation, a life-long artistic credo, reveals his Naturalist roots but is also more radical in its anti-Naturalist persuasion than was the 'Saint-Cloud Manifesto':

It would be quite amusing to preach a bit to all those people who for many years now have been looking at our paintings and either laughed or shook their heads reproachfully. They do not believe that these impressions, these instant sensations, could contain even the smallest grain of sanity. If a tree is red or blue, or a face is blue or green, they are sure that is insanity. . . . They will not get it into their heads that these paintings were created in all seriousness and in suffering, that they are the products of sleepless nights, that they have cost me blood and weakened my nerves. [39]

And on another occasion he wrote:

You see, the point is that at different moments you see with different eyes. You see differently in the morning than you do in the evening. In addition, how you see is also dependent on your emotional state.

Because of this, a motif can be seen in many different ways, and this is what makes art interesting.

If you leave a dark bedroom and enter the living room in the morning light, then for example you will see everything in a bluish veil of light. Even the deepest shadows have an atmosphere of light about them.

After a few moments, you will get used to the light, the shadows will become darker, and you will be able to see everything in detail. However, if what you want to paint is the emotive mood in all its strength—that mood of blue and light in the morning—then you must not sit and stare at everything and depict it *exactly as one sees it*. You must paint *the way it must be*, exactly the way it appeared when you responded emotionally to the motif.

... [But] it is, after all, precisely this and this alone that can give a deeper meaning to art. You must depict the human being. Life itself, not dead nature.

Certainly a chair can be just as interesting as a human being. But first the chair must be perceived by a human being. In one way or another it must have affected him emotionally, and the viewer must be made to feel the same way. You should not paint the chair, but only what someone has felt about it.[40]

Impressionism's emphasis on the perception of a particular moment in time remained a major component of Munch's concerns. But whereas the Impressionist sought to capture, albeit through the individual vision of an artist, the facts of an object's visual and atmospheric presence, Munch advocated the depiction of subjective visual distortion engendered by emotional predispositions. In one of his sketchbooks, between 1890 and 1894, Munch named his new art Symbolism, which he defined: 'Naturen formes efter ens Sindstemning' ('Nature is transformed according to one's subjective disposition').[41]

The formulation is yet another Symbolist response to Zola's view of art. By shifting the focus from the external model of natural things to the transforming activity of the artist's mind, mood or emotions, Munch destroys the external model's primary significance. It becomes a means towards a symbol, not an end in its illusionistic representation.

The attitudes of Munch and Goldstein were not totally identical with those of their French contemporaries, however. French Symbolism, with few exceptions, was fundamentally Neo-Platonic in its conception of both world and art. Following the example of Baudelaire, and through him of the eighteenth-century Swedish scientist and mystic Emanuel Swedenborg, the French Symbolists and Decadents confessed a faith in the gospel of correspondences, which taught that the phenomena of the physical world were symbols corresponding to a spiritual world of archetypal Ideas. The Ideas or symbols were accordingly considered to be hidden within things, and it was the task of the artist to discover and reveal this veiled soul by peeling away the skin of material substances. As 'correspondence', nature then existed separate from the artist, and nature's moods were not necessarily those of the artist. Through emotional intuition, artists were to seek a reality more objective in its spiritual impermeability than the Naturalists had sought through the mirror of their 'temperaments'. When Munch spoke of nature being transformed, however, he retained Naturalism's emphasis on an external nature as artistic reference, and Naturalism's practice of careful observation of reality remained an essential one for him. Symbolism, in the manner of Naturalism, then became a process of observation, but observation of the self rather than another.

The practices of Naturalism were thus adapted, not superseded, by Munch and Goldstein. In 1892 Goldstein wrote:

Symbolism has gone beyond the corpses of Naturalism and Impressionism, and incorporates into itself both these preceding movements. Without Naturalism and Impressionism, Symbolism would be sterile and pale and no more than empty forms. Naturalism, after all, taught us to keep our feet on the ground. Impressionism [taught us] that it is more significant to reproduce our impressions during a certain frame of mind. Now Symbolism shall aid us in finding a subjective form. No longer should plastic images of conventional reality be reproduced, but rather a plastic image of the reality alive in one's mind. . . . The poet shall produce his reality himself.[42]

'The reality alive in one's mind' was the archetypal world of Munch's symbols. Insofar as what was symbolized possessed universal human qualities, such as the holiness Munch saw in the act of procreation and the linking of the chain of life, it could also point towards an archetypal presence, but it could be recognized only subjectively. Munch's concept of a symbolic image thus takes on three interrelated aspects. First, every object is a symbol of itself, so that in *Night* the painting is simply a genre scene showing a figure seated in a darkened room. Secondly, it is a symbol in terms of the associations it arouses directly: for Munch *Night* was a symbol of death, specifically of his father's death, and a symbol of melancholy in terms of his own melancholy during the winter, and thoughts of a Monistic eternal life. Finally, it is the symbol of more universal concepts; *Night*, showing the contemplative painter himself in the blue atmosphere of death, is a symbol of artistic creation as Munch defined it: 'I paint not what I see, but what I saw.'

The process was one beset with problems for Munch, as demonstrated by his attempt to visualize the scene described in his 'Saint-Cloud Manifesto'. A pen drawing shows a man 'with strong naked arm' and a woman with 'long flowing hair' embracing in a bed; a dark, haze-like ambience surrounds them. Obtrusively present in the foreground are a water glass and a flask. Overtly, the drawing is a demure depiction of a couple engaged in the act of love, and a simple translation into visual terms of the scene Munch described. But the text of the 'Manifesto' indicates that more was intended. As in *Night*, the 'blue haze' represents death; yet at that moment—a moment of grandeur and sanctity—the living couple should be a link in the chain of life granting

43 *Embracing Couple*, 1890. Pen and ink. Oslo, Munch–Museet

physiological immortality through the generation of a child, thereby defeating death. The image actually created, however, was a Naturalistic one, depicting the scene as it might have been witnessed by the artist. For Munch, here and throughout much of his life, the issue was how to reconcile his Naturalist insistence that only what is actually experienced can be depicted, with his Symbolist intent. The solution in 1890 was far from satisfactory. Only the flask, similar to the one that in *Spring* holds the sprout of a plant, may point towards the non-visual visionary aspect of the image, if—as in *Spring*—it symbolizes the bearer of new life, the female womb in which egg and sperm are united. Since few, if any, viewers would have been making this type of association—one wonders if perhaps Munch consulted Goldstein as to the metaphor's communicative ability—Munch did not at the time translate the drawing into a painting; it remained a private notation of symbolic intent not publicized until 1929. The flask reappeared in several drawings and prints by Munch early in the 1890s, including the drypoint and aquatint engraving *Moonlight* (1895) in which he repeated the composition of *Night*.[43]

Apart from *Night*, the paintings from Saint-Cloud testify to different aspects of Munch's concerns in 1890. In a modified Impressionist technique, drawing motifs either from the picturesque world of cafés or from Saint-Cloud, they represent a quite conservative approach to both subject matter and style. Other Norwegian painters were simultaneously discovering a Nordic market for scenes from 'exotic' French cities, suburbs and colourful Parisian bars. After the death of Dr Munch, the Munch family was experiencing financial difficulties. 'It does not look particularly good for us, in regard to the future and getting along,' Munch wrote home, 'but it will have to do. . . . I should certainly be able to sell a few paintings if I send them to the various art associations.'[44] Despite all his idealism about art's function as a carrier of 'sacred' messages, he did not reject the commercial value of art.

In May 1890, shortly after completing *Night*, Munch returned to Norway. In addition to *Night*, he brought back with him the academic drawings from Bonnat's studio, Naturalistic views of the Seine seen through his window at Saint-Cloud, and realistic genre scenes closely modelled on those of F.-J. Raffaëlli, depicting the bourgeois frequenters of the café below his room. They testify to the narrowness of Munch's Parisian world; once he left Bonnat's academy, Munch rarely went beyond the confined spaces of his room and the nearby park. After the arrival of spring, in the company of visiting Norwegian artists, he made excursions into the Salons. Art became his sole reality, and he constructed from the fragile fabric of his paintings a protective fortress to ward off an alien world.

Back in Norway Munch continued the intense activity of his last weeks in Saint-Cloud. Reunited with his family, he regained his former self-confidence and cast off his despairing melancholy. He returned to the world of the Kristiania Bohème—now more a social group reflecting the artistic battles of the 1880s than an artistic avant-garde, although a few young poets had begun tangential association with it. In a summer of artistic experimentation unequalled in his career, he oscillated between the various innovative styles of the Parisian artists whose works he had admired at the Salon du Champs-de-Mars and the Salon des Indépendants. Using pastels, a technique newly learned in Paris, he created portraits and Lautrec-like café scenes.

More ambitiously, in a large painting depicting a bright spring afternoon with milling crowds parading on the sidewalks of Karl Johan's Street as seen from the Storting,[45] Munch made use of a divisionist technique derived from the Pointillism or Neo-Impressionism of Seurat and his followers seen at the

Salons des Indépendants in 1889 and 1890. In such works, modern life was symbolized in terms of the evocative moods of scenes: the emotive neutrality of relaxation on a Sunday afternoon excursion to the Island of the Grande Jatte or the intense yellow and prickly excitement of a circus performance. 'The very sensation of life itself' was recognized, not in the details of external appearance, but in 'a superior, sublimated reality' through which the artist's 'personality is transformed'.[46]

Much like Seurat's *Sunday Afternoon on the Island of the Grande Jatte* (1884–6), *Spring Day on Karl Johan's Street* represents a solemnly festive mood, silent in its majestic absorption of the welcome and overpowering spring sunlight. The painting's mood contrasts sharply with the despondency of Saint-Cloud, as if fulfilling Munch's own wish for a 'summer of sun-filled days' after he had rejected the possibility of suicide as the answer to his melancholy. 'And I love life', he wrote at the time, 'life, even if I must be sick. Summer days with long hours of sunlight, with noise in the streets, the noise of carriages, the dust in the streets, people promenading on the pavements. I love the sun that shines in through my window.'[47]

On seeing Munch's ten paintings at the 1890 Kristiania Autumn Exhibition—including *Night* and *Spring Day on Karl Johan's Street*, the latter with its large size again demanding critical attention while announcing an artistic programme—the critics recognized his attachments to French innovations and the experimental factors of his new art. But only Aubert understood the real importance of the pictures. He proclaimed that now Munch was 'the archetype of the "fourth generation" of an age that apparently is about to begin'. Munch thus superseded the 'third generation' of Krohg's Naturalism whose sole representative he had been declared only a year earlier. Implicitly Aubert announced the death of Norwegian Naturalism:

Among our painters, Munch is the one whose entire temperament is formed by the *neurasthenic*. He belongs to the generation of fine, sickly sensitive people that we encounter more and more frequently in the newest art. And not seldom they find a personal satisfaction in calling themselves 'Decadents', the children of a refined, overly civilized age.[48]

All the other critics reacted with strong antagonism to Norway's resident 'intransigent'. Nils Vogt wrote:

Munch's paintings in this year's Autumn Exhibition are the fruit of a period of study in Paris, which nonetheless does not seem to have straightened out his artistic production. Quite the opposite, it has led him into new experiments. Specifically, in Paris he has fallen head over heels in love with a new manner, represented in our exhibition by a genre picture by the French painter Pizarro [sic] and which is founded on the principle of paint dabs on a white ground to capture the vibrations of sunlight. ... In his painting *Karl Johan* ... Munch provides an instructive demonstration of what a painter, grasping for vague emotive moods without mastering form or colour, can present in terms of painterly hopelessness when he submits to experimentation in strange surroundings.[49]

Despite his reactionary response to Munch's new work, as well as to works by Pissarro and Monet, Vogt conceded that significant transformations had taken place, and that they corresponded to the 'strange surroundings' of international anti-Naturalist tendencies.

In Norway during the summer of 1890 which Munch spent in the seaside resort town of Aasgaardstrand, demands for a reform of art away from

naturalistic external realism towards an idealist, subjective, internalized realism became increasingly frequent. Garborg, just completing *Exhausted People*, published a series of articles advocating 'the Idealist Reaction':

A steady distaste grows for Naturalism's preference for rendering people that consist only of nerve ends and the physical phenomena of the senses. Instead we long for depictions of people with souls, of personalities that are the expression of our time's entire complicated cultural and intellectual life. The phalanx of young authors has already formulated a new slogan: *l'esprit seul importe*: only the spirit matters; exterior events do not exist in themselves, but only in our minds.[50]

Similarly, Aubert discussed 'Ideal Art and Realist Art', predicting a future subjective art of images drawn from the depths of the soul and using a technique learned from Impressionism. The ground was prepared for the arrival of a new attitude to art and literature.

Munch's paintings at the Autumn Exhibition were among the first products. The soil was cultivated further by a new periodical, *Samtiden* ('This Age'), a Nordic equivalent to the newly revived *Mercure de France*, the Paris mouthpiece of international Symbolist concerns. Edited by Gerhard Gran and Jørgen Brunchorst, two of Jæger's disciples, during its first year *Samtiden* published articles on the significance of dreams, on Friedrich Nietzsche's aesthetic 'Decadent' philosophy beyond good and evil, and by Hamsun on 'The Unconscious Life of the Soul':

In more and more people, there is active an overly exerted thought process side by side with a delicately sensitive disposition; among these, there often arise emotive effects of the most remarkable nature . . . some sort of inexplicable state of mind . . . phenomena that cannot be grasped by crude, raw shopkeeper mentalities. . . . What if literature now were to become more concerned with states of the soul, and less with marriage plans and dances and hiking and disasters. . . . We would learn a bit about the secret movements that take place in the . . . unconscious life of the soul.[51]

The thoughts echo Munch's 'Saint-Cloud Manifesto'. A few months later, Hamsun inaugurated a lecture tour, in which he continued to criticize Norwegian literature for its materialism, its concern with social issues instead of with human beings and its democratic tendentiousness instead of the psychology of 'cultivated, sensitive, refined men'.[52]

In literature these Neo-Romantic tendencies were most fully realized in three poems published in the Christmas issue of *Samtiden*. The author was Vilhelm Krag, an eighteen-year-old student at Kristiania University. Late in October—while Munch's *Night* and *Spring Day on Karl Johan's Street* were on display at the Autumn Exhibition—Krag's poems were read to the public at a Saturday evening meeting of the student organization, and Nyromantik-ken (Neo-Romanticism), a new movement in Norwegian poetry and art, was born. The young poets promising a renaissance of Norwegian verse shared Munch's artistic convictions. They wrote poems about his new paintings and he made plans to illustrate their writings.

Munch may have attended the October poetry reading before leaving for France, once again having received the Norwegian Fellowship. By the time he reached Le Havre he was seriously ill with rheumatic fever and was hospitalized. Unable to paint, he again turned to his semi-fictional memoirs, again recalled 'Mrs Heiberg' and again engaged in ruminations on the nature of life and death. For two months he remained convalescent in the damp, rainy northern French city, until in desperation he went on to Paris in a cold, third-class railway carriage, 'where I was colder than ever before in my life'.[53]

44 *Promenade des Anglais, Nice*, 1891. Oil and pastel on canvas, 55 × 74 cm (21½ × 29 in). Oslo, Munch–Museet

Paris, too, was cold and damp; Munch spent the days there in bed, suffering from rheumatic pains and palpitations of the heart. Finally, he mustered sufficient strength to take a train to Nice and the Mediterranean.

The southern sun brought new life into his cold-ridden body. Money worries remained, however. For two weeks he could not afford a proper meal. Finally a lump sum arrived made up of monies from his Fellowship, the sale of three paintings from the Autumn Exhibition, and the insurance payments from paintings burned at a Kristiania frame-maker's shop. But money consistently arrived later than wanted or needed. Desperate to overcome this lack of funds, he visited the gambling casino, played roulette, spent hours attempting to work out a mathematical system to defeat the odds, lost, and yearned for more money. As in Paris a year earlier, he moved from rented room to rented room in a search for more comfortable quarters, and repeatedly wrote home to assure his family that he had found them. Finally he purchased painting supplies with the intention of creating works that would satisfy the appetite of the Scandinavian market for scenes of the Mediterranean and the sunlit streets of Nice. In pastels, oils and mixtures of the two media, he created examples of an Impressionistic souvenir art. The need for money as well as, perhaps, a desire for greater acceptance, caused him temporarily to forget his avant-garde Symbolist ideals.

He wrote brief essays, hoping to sell them to newspapers in Norway and Copenhagen, where Goldstein tried to place them for him. It was Munch who broke the silence there had been between them since the months in Saint-

Cloud. On 22 January 1891 he sent a card plaintively complaining of his loneliness in the sunlit Mediterranean city:

Isn't it high time that we heard a bit from each other? Yes, now I am in Nice, where I dreamed of going for so many years.

Here I sit in front of an open window while you freeze up there. It is far more wonderful here than I had imagined. The Promenade des Anglais is imposing with the remarkably blue water on one side, water such an aerial blue that it seems to be painted with naphtha.—But how lonely it is! Long ago I gave up listening for footsteps outside my door, since I know they would never be for me.

I know it is not modern for people to write to each other. But when I think of the time in Paris, I feel a certain gratitude for the days we spent together in Saint-Cloud. We had so much to talk about. . . . Write to me, or better yet, join me here in my loneliness . . . P.S. What are your thoughts about art now?[54]

Goldstein, however, did not come, nor did his thoughts on art; Munch remained alone, and the months in Nice were artistically fallow.

The artistic isolation ended in April; on the 25th he wrote to his aunt, only recently recovered from pneumonia herself, that he had arrived in Paris, was living in a room with a balcony at rue Lafayette 49, near the Opera, and was hungrily 'racing from one exhibition to the other'.[55] He arrived only a few days before the closing of the Salon des Indépendants, where some 1,300 works by artists of different nationalities, active in France but unacceptable to the official Salon, were displayed.

The Neo-Impressionists, who had provided Munch with the stylistic means for his new art the previous year, were well represented. Seurat had died a month before Munch arrived in Paris, but his painting *The Circus* hung alongside four landscapes from Gravelines, multiple images attempting to convey an overall presentation of the harbour. Similarly, Paul Signac illustrated the moods of *The River* and *The Ocean*, Symbolist pictorial tone poems to the magic of water. Displayed on a wall hung with a black cloth of mourning were ten paintings by Van Gogh, who had perpetrated his slow and painful suicide the year before: depictions of cypresses, a sunrise, fields of wheat and a *Resurrection* based on an engraving by Rembrandt. In the *Echo de Paris* on 31 March 1891, the respected critic Octave Mirbeau described the Dutch painter as a magnificent visionary artist and a Symbolist.

Although Munch was probably aware of Van Gogh's paintings and of the attention being paid to them by critics, the paintings he created in Paris demonstrate that it was Impressionism, Seurat and the varieties of Neo-Impressionism that continued to absorb him. Taking a motif frequently treated by Monet, Pissarro and Caillebotte,[56] as well as by Krohg, Munch depicted the rue de Rivoli, the Boulevard Hausmann and the rue Lafayette as viewed from balconies overlooking them. What Munch achieved, however, was quite antagonistic to the dominant mood of calm and quiet in the paintings of his predecessors. Taking the Neo-Impressionist technique of divided brushstrokes, Munch lengthened the strokes so that they formed linear patterns of diagonal movement on his canvas. In the rendition of the balcony, its railing and the man standing looking down on to the street in *Rue Lafayette*, Munch rejected the Neo-Impressionist technique altogether, and instead worked with straight and curving linear patterns of thinned paint. These fused techniques—reminiscent of Van Gogh's Paris paintings of 1888 to 1889 or even more of contemporary Lautrec works, such as the nine displayed at the Salon des Indépendants with their accented linear movement and flickering splashes of colour—evoke the street traffic: the blurs of moving horse-drawn carriages and taxis, the rushing movement of the crowds, the

45 *Rue Lafayette, Paris*,
1891. Oil on canvas, 92 ×
73 cm (36¼ × 28¾ in). Oslo,
Nasjonalgalleriet

blurred shadows of individuals dashing across the street. An exaggerated
sense of perspective is generated by the balcony railing and roof line of the
houses, joining at a vanishing point high up the canvas. As a result the depth-
movement seems almost to spill off the top of the painting and deprives the
image of virtually all sense of static or restful composition. The two elements
of *Rue Lafayette*—the street and balcony areas—are not harmonized; the
composition is split into two antagonistic parts, thematically as well as
formally. This was a compositional device Munch had already used during
the 1880s. Through a transformation of the visual scene—nature seen and
remembered, advocated in his writings of 1890 and 1891—the 'mood' of the
bustling anonymity of a Parisian street is captured.

The month in Paris proved extremely significant, confirming Munch's faith
in a revolutionary interiorized art. In order to continue his experiments and
search for his own personal style, Munch applied for a third Fellowship,
pointing out that his illness in Le Havre had hindered his work and prevented
him from being in Paris for long enough:

Under these circumstances, the results of my period of study cannot be great, and
therefore it would be of extraordinary significance for me especially now to receive the
support of the Fellowship, in that with it, through study next year in Paris or Florence,
I could secure and develop what I gained from my previous stay in Paris.[57]

Despite its awkward wording, the letter indicates Munch's basic faith in
himself. The Symbolist and Decadent doctrines to which he had been
converted were the path he chose to affirm; his mention of a possible trip to
Florence to study the Renaissance masters may indicate some hesitancy in his
convictions, but it was more probably a device to reassure the more
conservative members of the Fellowship selection committee. The committee
responded positively, and Munch was assured of a further year of govern-
mental support for his experimental art for which, as yet, no significant
audience had been found.

On 29 May, a steamer from Amsterdam brought Munch back to Kristiania
for the summer and autumn. To Goldstein he reported:

Now I am once again back in that quaint city of Kristiania with its remarkable
bohemian women who tempt you, and cause even an old confirmed 'gentleman' such
as myself to dream of eternal love. Nonetheless, it is a unique and wonderful city, this
Kristiania. Everything is in ferment. Everything is seeking its form.[58]

Munch kept company with the 'remarkable bohemian women', both married
and single, and was tempted, but entered no new liaison; the memory of Milly
Thaulow remained too painful for him to risk another such attachment.
Shortly before he arrived back in Kristiania, her divorce from Dr Thaulow
was finalized, and within a few weeks she married her actor lover. Hearing
later in the summer that she needed to have her mouth operated upon, and
fearing that her beauty was threatened, Munch reacted intensely, unable to
overcome the emotions he had felt for her: 'I sat motionless. Every word,
every smallest tone, every pause in conversation fell like a heavy blow against
my pounding head—She, who for six years of my life . . .'[59] He never
completed the sentence. For him, the experiment in Jæger's bohemian free
love had left scars far deeper than those 'Mrs Heiberg' would receive from her
operation. Later in the year, back in Nice, he wrote:

I sit and stare into the fire in the fireplace and watch it flicker and burn. Suddenly I
come upon thoughts of the inquisition and all the evils one aspect of religion had

caused. And then I begin thinking about the women for whom I had cared, think about the others and remember her.

I saw her name in the newspaper. She had performed at a concert. Once again the question arises: did she love me at all? Was it all my fault or hers? I think about what I was like before I met her. And now—what a contrast! Now I feel as if I am a cast-off, broken bit of wreckage.

Munch relived the painful affair during the summer of 1891 as he empathized with a new love triangle that had formed around Oda Krohg. While her husband watched with bohemian acquiescence and intense male jealousy, Oda sought out the company of a teenage journalist, Jappe Nilssen, luring him, teasing him and playing with him until both her unhappy lovers suffered hallucinations and feared insanity as sleepless night followed sleepless night. The trio turned into a horrified quartet when Jæger arrived and coldly observed the effects of his doctrines of free love, his experiments in human psychology:

'Jæger, do you know what? I think you will end up dancing the can-can on the graves of all your friends, all those who die of drink, all those whom you drove to drink themselves to death.'
Jæger laughed.

Recording all this, Munch grieved over his loneliness and inability to form a new attachment:

I cross the street and meet Oda and Jappe as they ride by in a carriage, probably going out towards Drammensveien. For a moment I felt so envious. I, however, I have no one.

Another time, on meeting the painter Holmboe's wife with a friend, Munch jokingly said: 'Now I have finally found her, someone for whom I truly can care.' 'Yes, well, Munch', Mrs Holmboe replied, 'I do not believe you. You will never truly care for anyone, never, never, Munch. To know that, all one has to do is listen to the tone of your voice; it is so cold.'

Added to the emotional isolation into which he had been forced by his unfaithful lover, by Aase Carlsen's marriage, by Krohg's preoccupation with Oda and Jappe, and by Jæger's seeming harshness, was an artistic isolation, caused by his adherence to the styles of French Symbolism. His loneliness in the midst of talkative friends, as at Saint-Cloud but compounded now by an increasing consumption of alcohol, brought Munch into a state of virtual emotional collapse:

I have felt so weak, that I have to drag myself through the streets. The day before yesterday, I had to go to bed at eight o'clock, and I slept through until the next morning at eleven, and I woke up tired. The entire time I've had a disgusting feeling of indifference towards everything. Painting is just not important enough. Most of the time I've been sitting in the Grand Café. I've barely been able to think and I have felt as if I were going mad.

The activity of art, even the promise of artistic immortality, failed to overcome the stupor. Munch recorded a conversation:

He—You shall create great works, undying masterpieces shall come from your hand.
I—Yes, I know that. But can they get rid of the worm that lies gnawing at the roots of my heart? No. Never.

His new pessimism, rejecting even the possibility of art's therapeutic effects,

reached a depth equalled only in the weeks of crisis following Dr Munch's death. His recollections recall the scene of the lonely room at Saint-Cloud:

Memories gnaw deep into my breast. I feel as if I could point to exactly where *that* wound is, the open wound. Memories of the dead. Why did you do this? Why did you fail to do that? There can never be any reparation for the wrong one has done.

Thoughts of women invariably also resulted in a sense of helplessness and exhaustion, deepening rather than alleviating Munch's despair:

The ancients were right when they said that love was a fire. After all, like a fire all that it leaves behind is a heap of ashes.

46 *Adieu (Atelier Scene),* 1890/1. Pencil. Oslo, Munch–Museet

This led finally to a state of near madness in which he again suffered hallucinations. He recorded an experience he had while walking along Ljabroveien:

I was walking along the road with two friends. The sun set. I felt a tinge of melancholy. Suddenly the sky became a bloody red.
 I stopped, leaned against the railing, dead tired. And I looked at the flaming clouds that hung like blood and a sword over the blue-black fjord and city.
 My friends walked on. I stood there, trembling with fright. And I felt a loud, unending scream piercing nature.

The account is almost clinical, the sole subjective element is the visual phenomenon of clouds. As if further to affirm the historical authenticity of the event, Munch created a quick drawing in a sketchbook. With minimal detail, it renders the physiological evidence: the street with its railing, the view of the city and fjord, and the man leaning against the railing. There is nothing to indicate, either in text or drawing, the highly personal nature of Munch's experiences. Without the evidence of his text, the drawing could depict virtually any man, unstable after too much alcohol, leaning over the railing, not to hear the primordial scream of nature, but to throw up. Just as the vignette drawings relating to his 'Saint-Cloud Manifesto' sought to render the 'sacredness' of procreation, but did so simply by depicting a man and a woman in bed, the scene on Ljabroveien was presented as if Munch were the witness. As such, it remains tied to the ethos of Naturalism despite Munch's vociferous demands for a subjective art. Intention still surpassed practice.

 The Ljabroveien drawing is one of several created in 1890 and 1891 that are visual interpretations of autobiographical events, rather as in 1889 the thumbnail sketches of life in the Munch home related to childhood memories. The later drawings, however, recall moments in Munch's relationships with women or in the tumultuous love life of Jappe and Oda. Among the earliest of them is one entitled *Adieu*; quite probably inspired by his separation from Milly Thaulow or by an incidental sexual encounter, it is a naturalistic rendering of a couple kissing in a studio.[60] The scene also corresponds to a text, another fragment of disjointed recollections in the artist's notebooks:

'Come here and see the beautiful cloud', she said. I went over to her. It was a blood-red cloud. 'It looks like a dragon', she said, 'in gold.' I pressed her to my body. Her head rested on me. We stood like that for a long time. A wonderful soft warmth passed through me. Softly I pressed her against me. She looked up, to one side. She had such remarkable, dark, warm eyes that seemed to appear as if behind a veil. We said nothing.
 She was warm and I felt her body against mine. We kissed each other for a long time. Total silence reigned in the large atelier. I pressed my cheek against hers, and stroked her hair. Her cheeks glowed. 'Beloved, say something', I said. But she did not answer. I felt a burning tear on my hand. I looked at her. Her eyes were brimming with tears.
 'What is wrong with you?' I asked. I took her in my arms as if she were a small child. She embraced me convulsively. 'My little girl,' I said, 'what is bothering you?' And I stroked her long hair. 'I am afraid you might be sick', I said. 'Say something.' But she said nothing.
 She stood on the floor, her hair in disarray. Her eyes sparkled through the tears. 'I hate you', she said.[61]

Unlike the Ljabroveien memory, the scene of the parting kiss is described in detail, suggesting it was at least partially fictionalized. Like the drawing, it is a completed study, intended not only for Munch's eyes. Continuing with

Naturalistic technique and using the texts to generate a realistic mood, he tried to overcome the anecdotal qualities of his imagery. The doctrine of empathy, so significant for the subjective Symbolism he sought, is evidence of his control, not over his own emotional life alone, but also over the emotive responses of others. Through art, life could be lived vicariously, with the uncertainties and personal pain of reality removed.

Late in 1891, Munch made his initial attempt at translating the experience of the kiss into a painting. Using the modified Neo-Impressionist technique he had developed in such paintings as *Rue Lafayette*, he presents the two kissing

47 *The Kiss*, 1891. Oil on canvas, 72 × 64 cm (28¼ × 25 in). Oslo, Munch–Museet

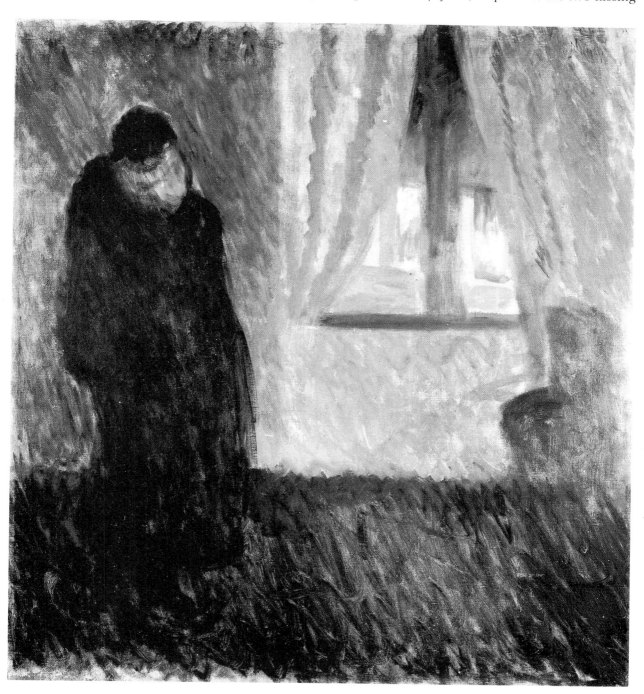

figures in an interior—no longer his studio, but perhaps a living room, as the chair suggests—near a window.[62] In technique as well as mood, the painting is related to various portraits of women from 1891, such as that of Anne Buhre. Apart from the light through the window, the colours are muted violets and browns, suggestive of a certain sombreness or possibly of the 'fog' surrounding figures in his Saint-Cloud manuscripts. The contrast of dark interior and light exterior—with the interior shadows serving as a protective environment for the embracing couple as well as being the general compositional arrangement—creates an impression similar to *Night*. With its emphatic accentuation of mood by means of unnaturalistic colour, its fusion of the man and woman into a single form and its neglect of all individual facial features with the result that the two faces also seem to melt into each other, this *Kiss* seems to be the first painting to fulfil Munch's intentions as described in Saint-Cloud: lovers depicted 'in that moment when they are not themselves, but only one of the thousands of sexual links tying one generation to another generation'.

Other drawings record aspects of the summer's romance of Jappe and Oda. In a quickly captured scene in ink, as well as in a more careful composition, they are shown gazing out at the fjord from the seashore path leading from Aasgaardstrand to Borre. A genre scene is suggested, particularly by the pencil drawing in which some object on the water or some event taking place seems to be the focus of the lovers' gaze as others walk away from them. The practices of Naturalism remain paramount; Munch had not yet found the solution which would transform the image into a symbolic and hierarchic one.

A more satisfactory solution that pointed to his later art was found in the second motif: Jappe sitting alone in a pensive pose akin to that of the figure in *Night*; meantime, a couple—presumably Krohg and Oda—accompanied by an oarsman enter a boat from a pier nearby. The drawing is again contained in the notebook recording the Jappe–Oda relationship, but the texts in no way correspond to the scene depicted, which may be an anecdotal event. A

48 Sketch: *The Lonely Ones*, 1891. Pencil. Oslo, Munch–Museet

49 Sketch: *Jappe at the Seashore*, 1891. Pen and ink. Oslo, Munch–Museet

50 Sketch: *Evening (Melancholy)*, 1891. Pen and ink. Oslo, Munch–Museet

further ink drawing alters the scene somewhat: the foreground figure stands with bowed head, or perhaps walks indecisively (the stooped gait recalls Munch's father on the path of death), and the shoreline suggests a greater sense of depth as it meanders slowly backwards beyond the pier where the two diminutive figures stand above a boat. In several other contemporary drawings, both in sketchbooks and on sheets of paper, Munch created variations of the shoreline, combining it with background trees and clouds that are similarly linear in character, with the result that all forms become flattened and silhouette-like. The drawings suggest that, in his search for a Symbolist style, Munch had shifted from the colouristic nuances and dissolving forms of Neo-Impressionism to the flattened forms with simplified outline

51 Sketch: *Evening (The Yellow Boat)*, 1891–2. Charcoal. Oslo, Nasjonalgalleriet

characterizing the Synthetism of Gauguin and his followers, including the Dane Jens F. Willumsen, whose works Munch had seen at the Salon des Indépendants.[63]

'So long as a thing reflects a human being, it does not matter whether it is Realism or Synthetism', Goldstein wrote to Munch in 1892.[64] The motif of Jappe seated at the seashore, which is compositionally as well as thematically akin to his *Evening* paintings of the 1880s, became such an image for Munch, surpassing in intent and significance whatever event in the Krohg–Oda–Jappe triangle may have served as initial impetus. His ability to empathize with the actors in the erotic melodrama partly accounts for this but, according to one of Munch's notes, the scene with Jappe in the classical melancholic pose was intended to represent a basic human emotion: 'Jealousy—a long, barren seashore'.[65] It is the type of universal human emotion advocated as the appropriate content of art in Munch's writings of 1890 to 1891, as well as by Decadence and Symbolism. The painting resulting from these numerous sketches—their number now testifying to the motif's significance for Munch and the intensity of his struggle with it—accordingly broke with Munch's previous style and revealed further experimentation in technique in his effort to generate a new art form in Norway, despite the resistance of the public and his painful realization that the initial result would be further alienation.

To the 1891 Autumn Exhibition Munch sent six works, among them a pastel entitled *Evening*,[66] the title that he had repeatedly used for contemplative seated figures during the 1880s. Later also entitled *Melancholy, Jealousy* or *The Yellow Boat*,[67] this painting took up once more the motif of Jappe on the seashore. The use of a totally unorthodox mixture of techniques—pastel, oils and pencil, with large areas of bare canvas—indicated the continuing influence of the works of Toulouse-Lautrec; the extreme simplification and flattening of forms reveals a dependence on Gauguin and Synthetism. However, Munch did not emulate the composition or stylistic qualities of any single work he may have seen in Paris, whether at the Salon des Indépendants or at Théo van Gogh's branch of Goupil's Gallery known to have been visited by other Norwegian artists.[68] As in most of his Symbolist art, his stylistic borrowings were predominantly the products of memory. Attempts to discover a one-to-one relationship between Munch's image of melancholy and that of Dürer's *Melancholia I* (1514), for example, or Gauguin's self-portrait as *Christ in the Garden of Gethsemane* (1889), are therefore doomed to failure—although Munch's painting does continue the tradition of melan-

choly imagery, including the associations of the melancholic figure with artistic creativity.[69]

Although on one level a representation of artistic inspiration, *Evening* was, as we have seen, primarily intended to function as an image of jealousy. The seashore with its pier, boat and barely indicated man, woman and rower is a mental projection of the jealous man posed in melancholy in the foreground. Munch organized the painting through a series of formal tensions between illusion and reality intended to parallel the tensions of jealousy, thereby totally subordinating form to content. The meandering shoreline suggests perspective depth, but it is not allied with devices such as aerial perspective or shading necessary to permit the illusion to function properly. Similarly, the head and hand of Jappe produce a three-dimensionality and a plastic presence absent in the rest of the painting. Jappe enabled Munch to relive his own emotions while discovering for them a visually symbolic equivalent to be empathetically interpreted by a sympathetic viewer.

The critical and commercial response to his new art proved unsympathetic, a fulfilment of Munch's fear that he was increasingly alienating the public. The National Gallery did purchase its first work from him, but it was one of the 'souvenir paintings' of Nice at night. Artists who had previously supported him, such as Werenskiold, objected that he 'leaves most of his things half-finished, if that, smears together oils and pastels, and then *does this* while leaving huge parts of his canvas totally bare, no matter what the mood may be; this empty canvas then is supposed to represent daylight, sunlight, an

52 Evening (Melancholy: The Yellow Boat), 1891–2. Pastel and oil on canvas, 73 × 101 cm (28¾ × 39½ in). Oslo, Munch–Museet

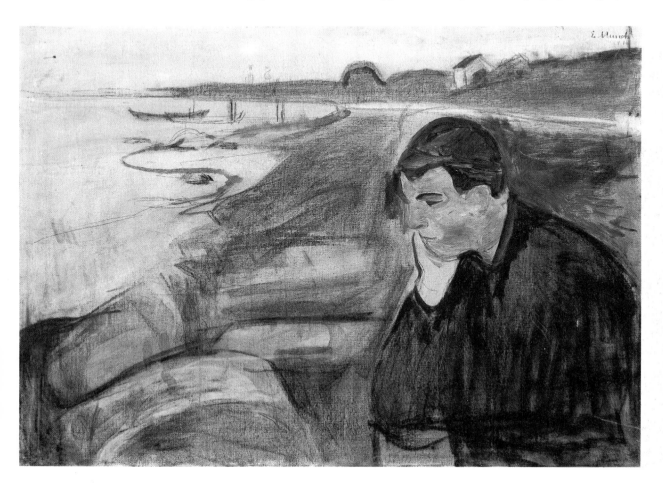

evening's dusk, moonlight or whatever'.[70] Most newspaper critics either totally ignored him or dismissed the paintings and pastels as ridiculous humoresques. One lone voice, that of Krohg, responded favourably, and also provided the public with an explanation of Munch's dramatically changing art. Writing in *Verdens Gang* and *Dagbladet*, Krohg discussed *Evening* in terms of French Symbolist art theory:

A long shoreline that moves inwards over the picture and becomes a delicious line, which is remarkably harmonic. This is music. Curving gently, it stretches downward towards the quiet water with a few small, discrete interruptions. . . .
 It may even be true that this is related most closely to music and not to painting, but in any case it is brilliant music. Munch should be given credit for being a composer. . . . It is an extremely moving picture, solemn and severe—almost religious. . . . All this relates to Symbolism, the latest tendency of French art.
 . . . After looking awhile at this picture and turning then to the others, even his own, it is as if there were a gaping abyss separating them. There are no connections, there is no continuing tradition. . . .
 Thus we have the remarkable case of Munch, who here at home has been considered the most irreformable of all Realists, the most impudent and slovenly of all the painters of ugliness; he is the only, the first one to turn to Idealism, the one to dare to take nature, the model and all else, and to subordinate them according to a mood, and to change them in order to reveal more.[71]

The emulation of music in painting had been a repeated and consistent concern of emotively orientated art at least since the time of Romanticism. It was a concern to which a knowledgeable Norwegian audience, newly attuned to the ideals of Romanticism through literature's Neo-Romantic Decadent tendencies, should have been receptive. Moreover, the description of Munch as now antagonistic to the ugliness of Naturalism would seem to negate the arguments of more traditional or academic critics. Krogh's defence sought to reconcile tradition and innovation, and to describe the art of the future in terms of the ideals of the past. As Krohg constantly reasserted, *Evening* marked a definite new path in Norwegian painting, a serious and quasi-religious new art intended to transform and convert its audience, not through the didactic moralizing of Naturalism's starving women and children, but by addressing the human soul directly, making it attuned to the refined nuances of its own gentleness and devotion.

 Before Krogh's article was published, however, Munch left Norway in order to fulfil the demands of his Fellowship. In the company of Christian Skredsvig, he went directly to Nice by way of Copenhagen (where he visited Goldstein and the painter Johan Rohde, who in all likelihood would also have introduced Munch to Mette Gauguin's collection of her errant husband's art), and Hamburg (where paintings by Arnold Böcklin particularly impressed him, as they did Skredsvig). Paris did not enter his itinerary. To fulfil his promise to visit either Paris or Florence, Munch went on a brief trip to Italy, then settled in the Mediterranean warmth of Nice.

 There the ideas for paintings he had initiated during the summer in Norway verged on becoming obsessions, totally obliterating the impressions of the southern French city resort surrounding him. In particular, the memory of his debilitating experience on Ljabroveien haunted him. Skredsvig later recalled:

For some time Munch had been wanting to paint the memory of a sunset. Red as blood. No, it actually *was* coagulated blood. But not a single other person would see it the same way as he had; they would all see nothing but clouds. He talked himself sick about that sunset and about how it had filled him with great anxiety. He was in despair because the miserable means available to painting were not sufficient. 'He is

53 Sketch: *Despair*, 1892. Charcoal and oil, 36.9 × 42 cm (14½ × 16½ in). Oslo, Munch–Museet

54 *Despair*, 1892. Oil on canvas, 92 × 67 cm (36¼ × 26¼ in). Stockholm, Thielska Galleriet

trying to do the impossible, and his religion is despair', I thought to myself, but nonetheless I advised him to try to paint it.[72]

After he had celebrated Christmas with a decorated cactus, roses and oranges, Munch haltingly sought to translate the vision into paint, in a work he entitled *Despair*. Using his pencil sketch as a guide, he altered the scene so that the figure leaning on the railing—Munch himself—was brought from middle ground to foreground near the edge of the frame. He shifted the spectator's point of view upwards, so that the street and railing took on the exaggerated perspective of the Paris balcony scenes. In the middle ground, he added two figures walking away. From his own *Evening* pictures of the 1880s he derived the pictorial formula of despairing solitude; the tension-filled contrast between a contemplative figure in the foreground and—not corresponding to the scale of traditional practices of perspective and therefore visually out of relationship with this figure—a pair of figures in the distance. Technique, including the simple black wooden frame, was an application of modified Neo-Impressionist strokes and the flattening devices of Synthetism. For colour he returned to his mixture of melancholy blues and greens, but cut sharply into these with a sky heavily painted in the screaming reds and yellows of his subjective experience, metaphors of his 'deranged mood at sunset'.[73]

Neither this nor other works created at the time seem to have satisfied Munch fully; to Goldstein he complained: 'Yes, my will exceeds my talents.'[74] At issue was a frontispiece requested by Goldstein for the new edition of *Vekselspillet* under the altered title *Alruner*, a reference to an ancient tradition that the mandrake root or *alrune* provided the basic ingredient for a love potion. Munch suggested using the motif of his *Evening* painting from the

1891 Autumn Exhibition: 'If I were home in Norway, I could simply copy the painting, but now it's pure chance whether or not I can create anything good.' In a sketchbook he returned to the composition of his pastel, but altered it in order to fit the horizontal format required by Goldstein's book. He made numerous variations of the image as if hoping that his 'chance' would arrive in the process of duplication. He flattened the *Evening* composition yet more, rejecting virtually all sense of shading so that the Jappe figure, the shoreline, stones and trees all appear as sharply delineated silhouettes. Something of the spatial tension apparent in *Despair* is generated by the curve of the shore being sharpened and the degree of slope in the line of trees and houses being increased, with the result that the two diagonals of shoreline and horizon seem to melt into virtually a single diagonal motion from bottom left to top right. Within this meandering triangular form is the figure of Jappe with his head propped in contemplative pose on his left hand. His body has been almost totally cut off, providing an image concentrated totally on the head. Further to increase this focus on Jappe's mental processes, Munch turned the figure so that it no longer gazes into the landscape; instead, with Jappe staring out of the picture, the landscape of Aasgaardstrand appears as a totally distinct entity, even less a physical presence than before.[75] As in Munch's experience on Ljabroveien, it is not the landscape or even the emotive sensations of twilight that provide the emotional response, but rather the human being experiencing it who projects into it his own state of mind and in the process distorts its physical features, fulfilling Munch's own programme for a symbolically subjective art.

In December Goldstein wrote to Munch:

You write that you cannot stop asking yourself with each picture: 'Why?' I think that is as senseless as asking yourself every morning: 'Why should I get up? Why should I live since I shall die?' After all, you paint because you cannot do otherwise. And every picture is really nothing more than the shedding of skin, a day that has passed. . . . I believe that by working at it daily, in the end your own nature will step forth in all its originality. Without being bound by any single form or a single movement of art. . . . Now, Munch, I want to say something else to you, speaking as a human being: You are really the only person for whom I have any respect. . . . You are the most liberating spirit I ever met. I assume flattery will not spoil you. Oh, whenever I think of all those 'artists' who value art more than their own humanity, then I get deathly ill. It is so reassuring just once to have met a true human being![76]

Munch laboured at the title vignette for over three months. He was once again searching for an original personal style while also wishing to give testimony to the sense of artistic communion he shared with the Danish poet as with no one else. 'It is odd', he wrote, 'to be together constantly with people and to be unable to discuss those things that most concern me.'[77] Yearning for companionship, he gave testimony to his personal loneliness and to the loneliness of his art.

Perhaps before returning to Norway via Paris and Amsterdam late in March 1892, Munch began to repaint *Evening*. Initially, he kept the seated figure in profile, but then painted over it so that only the melancholy head appears in the lower corner, as in the vignette. The change of posture must have occurred after Munch returned to Kristiania. Not until June did he send Goldstein the final vignette, with the composition as in the new painting, six months after the first attempt to find composition and form for the desired emotive content and symbolic message.[78]

Thiis described the new painting as representing

a summer landscape with Aasgaardstrand's curving shore, a low hill in the back-ground and in front of it a fragile pier on which a happy pair appear to be moving towards a moored boat. But right in the foreground of the picture in a corner sits a young man—the model evidently is Munch's friend Jappe. We see no more of him than his head, which is cut off by the frame in a Japanese manner. But this is enough. Turned away from the couple on the bridge, but following them with all the agitation of his senses, he stares blindly ahead of himself—jealousy's image made manifest. And it is as if, from this embittered, summarily rendered pallid face and its hate-filled eyes, there emerges a power that infects even the landscape with dangerous and gloomy colours, a worried violet, sulphurous yellow and poisonous green, and even the shoreline seems to be drawn in, helplessly attracted. The landscape has become the expression of a mood.[79]

Thiis was probably tutored by Munch to hint at Jappe's jealousy-dominated affair with Oda, and to interpret the painting as a symbol of the mood of jealousy. Through a methodology that extracted universally applicable emotions and ideas from personal experience, the demands of both Natural-ism and Symbolism were met.

Back in Norway, Munch attempted to write about the experience which symbolized jealousy in his painting:[80]

One evening I walked alone and lonely near the water. It sighed and swished among the stones. Long grey clouds were along the horizon. It seemed as if everything had died, as if it were some other world, a landscape of death.

But now, over on the pier, there is life. It was a man and a woman. And now there came another man with oars on his shoulders. And the boat lay below, ready to be taken out.

She looks like her. I felt something like a sting in my chest. Was she here now? I know that she is far away, and yet, and yet, those really are her movements. That is the way she habitually stood with her hand on her hip. Oh God, God above, have mercy on me. It must not be her.

There they go walking, she and he will be going over to the island. In the light summer night they will be walking between trees, arm in arm. They will be whispering to each other. . . .

The boat got smaller and smaller. The sound of the oars still echoed over the water. He was alone. The waves drifted towards him one like the other. And among the stones was the sound of swishing, swishing.

Shifting between first- and third-person narrative, in a choppy, telescopic style, the text reads much like his earlier Jæger-inspired pieces about Milly Thaulow. The woman in this text may be her, although the intensity of direct emotion and experience evident in his other writings about her is lacking.

In other writings at this time, Munch repeatedly used the image of the seashore and the repetitive rhythm of waves breaking on its stones. 'We understand each other', he observed about the beach, the sea and their juncture at the horizon, 'incomprehensible as existence, inconceivable as death, as eternal as longing.'[81] The seashore, particularly the meandering lines and stones at Aasgaardstrand, was a metaphor of his own perception of the human condition, life and death. The appearance and passing of each wave was an event caught in the eternal rhythms of time, a human life in the vastness of Monism's unity, and a passage of love growing in intensity only to die out. 'You are gripped by a remarkable sense of sadness. You are so alone in the great loneliness.'[82] Such a perception of existential isolation has a kinship with the feelings of jealousy—being alone while others are together—that originally engendered the depictions of Jappe on the seashore, as well as with the problems of artistic creation. This multiplicity and complexity of associations suggests why Munch had such difficulty with the vignette for Goldstein and why a simple repetition of the painting admired by Krohg in

1891 was not sufficient. To inject the richness of his own thought into the image, the image itself would have to be multiplied so that it no longer appeared as only one, but as a number of interrelated pictures involved in a pictorial act of mutual revelation and commentary.

From Nice, Munch had written to Goldstein that his collection of poems was one of the few books 'I truly can use, one of the few books I immediately incorporated into my little library, which consists of your book, the Bible, Hans Jæger's, and Dostoevsky's *Crime and Punishment*'. The remarkable little library may be ironically intended, but it does testify to Munch's continuing concerns with love, eternity, dogmas of Naturalism and subjective psychological insight. The letter concluded:

As I said, I believe that given enough time I will be able to make some nice drawings for your poetry collection. But I cannot do it except at the right moment. If we are able to issue a selection of truly good lyrical mood pieces, complete with drawings, that could be the beginning of a literary monthly periodical.[83]

While at Saint-Cloud they had already discussed the possibility of a periodical combining literary and artistic works, but this never came to be. However, Munch continued to recognize the kinship between his paintings and the poetry being written by Goldstein and others. Back in Norway in 1892, he was enthusiastic about the possibility of providing vignettes for a new edition of Krag's poems in June, and shortly afterwards he volunteered to provide vignettes for the other major poet of Norwegian Neo-Romanticism, Sigbjørn Obstfelder.[84] In a sketchbook, he proposed a variety of images, some emulating the vignette of Goldstein's book. It was an allegory of art in multiple images, not illustrations of specific poems, that Munch wished to create.

The drawings therefore all focus on the motif of poetic or artistic inspiration. Essentially Munch did not distinguish between the two; he subsumed literary and visual creation under the grander concept of art, having as an ultimate ideal a universally encompassing work of all the arts, the *Gesamtkunstwerk* envisioned by Richard Wagner and the Romantics. For Munch the arts were united above all in their inspiration:

When seen as a whole, art derives from a person's desire to communicate himself to another.
I do not believe in an art which is not forced into existence by a human being's desire to open his heart. All art, literature and music must be born in your heart's blood. Art is your heart's blood.[85]

Because art was formed by the dictates of emotional reaction and existential experience, the possibility of universal communication was its fundamental function. Art thus created was also similar to Goldstein's concept of *Kameratkunst*, an art of comrades, in which the most intimate sensations are communicated so that the alienation of individuals is broken down and replaced by a communal sense of comradeship. Art then becomes a process of intimate human interaction serving as a surrogate for the intimacy of love.

Goldstein wrote to Munch in July 1892:

I recently met the heroine of my poems again. Now she is married. I told her that if I had not already dedicated the collection of poems to you there would be no reason why it could not be dedicated to her. Now we talk together like friends, without a trace of eroticism. Just think about the women we loved, Munch! That is to say those that betrayed us, we owe many a beautiful impression to them. Just imagine what would have happened had they not betrayed us.[86]

86

For Goldstein, the inspirational link between his love affair and his art was obvious. Munch's vignettes and writings suggest that he saw an even closer relationship between the processes of love and art. In his thoughts the two became virtually identical experiences.

Jappe's melancholy and jealousy on the shores of Kristiania presented a situation that Munch interpreted, in the context of Goldstein's poems, as a metaphor of artistic creation. The pain involved in both situations is also similar; both artist and lover give of their 'own heart's blood':

Darkness settled deeply violet over the entire earth. I sat beneath a tree whose leaves began to wilt and turn yellow. Once she sat next to me. She lowered her head down towards me. Her blood-red hair enveloped me. It wound around me like blood-red snakes. Its finest threads wound down into my heart. Then she rose. I know not why. Slowly she walked towards the ocean. Further and further away. Then the miraculous happened. I felt as if invisible wires passed between us. I still felt the invisible strands of her hair envelop me. And so, after she disappeared across the sea, I still felt the pain there where my heart bled. Because the threads could not be broken.[87]

As in his *Evening* paintings, Munch uses nature as the paradigm of a frame of mind which serves as principal theme around which the causal events are elaborated. It is a time of transition, having its reality more in past and future than in the present. As a consciously impermanent transition, it causes longing, yearning and dissatisfaction, which translates into psychic pain.

Seeing pain and suffering in the very act of physical existence brings Munch close to Arthur Schopenhauer's pessimistic view of human existence, which attained its widest influence among the Symbolist generation. Schopenhauer postulated all of life as founded in the Will, which was a blind, incessant impulse, making life an endless striving for unattainable happiness. The only path to salvation from this pain is to destroy subservience to the Will to live; while death is the sole true salvation, temporary salvation can be achieved in the melancholy state of aesthetic contemplation. Intuitively capable of apprehending the eternity of Ideas, artists create works of art as expressions of an otherworldly, unchanging reality. Art and its contemplation therefore rise above temporal reality, liberate from the Will, and proceed towards unchanging eternity.[88]

Among the small framed pen sketches that comprise most of the vignette projects for Goldstein, Krag and Obstfelder, is one that shows a man's head in the left-hand corner—in profile reminiscent of Munch himself—with closed eyes and wrinkled brow; surrounding him is the indication of a shadow to separate him from the remainder of the scene. Standing near a tree, a man and a woman face each other; she reaches up towards the tree, as if to pluck a fruit from it. They are, of course, Adam and Eve in modern dress, with Eve preparing to tempt her top-hatted Adam. As in other paintings, the temptation scene is the thought projection of the non-participating artist who contemplates the initial actions of human sexual attraction, seeing them in terms of an ancient mythology of human existence.

The tree from which the woman plucks the fruit is, according to the Biblical account, the tree of the fruit of knowledge of good and evil, or alternatively, of the knowledge of life and death. In Schopenhauer's thought, as transmitted to the Symbolist painters of the 1890s, art should express a philosophy presenting a perception of the inner essence of human life and existence.[89] In his notes, Munch makes it clear that for him human existence is closely linked to the processes of sexual reproduction and erotic intercourse between women and men; this, as he repeatedly said, was 'what was holy'. The tree

55 Top right
Sketchbook: *Jealousy* and
The Voice, 1892. Pen and
ink. Oslo, Munch–Museet

56 Above right
Sketchbook: Study for
Vignette: *Melancholy
(Jealousy)*, 1892. Oslo,
Munch–Museet

57 Above
Sketchbook: *The Lonely One*
(Frontispiece for Vilhelm
Krag), 1892. Oslo,
Munch–Museet

then represents not only the knowledge of sexuality of which the man
becomes conscious through the woman, but also the knowledge of the essence
of life, the 'life spirit' which Munch had sought at Saint-Cloud. Moreover,
since the task of art is to depict this metaphysics of existence, the tree is also
the tree of art. As such it appears in several drawings of Jappe, Munch's alter-
ego, who remains in agitated contemplation in the foreground while next to
or behind him, as if growing out of his head, is the tree 'whose leaves began to
wilt and turn yellow'.

A similar tree appears in yet another vignette, this time next to a standing
figure who holds a hand over his heart to indicate both the pain caused by the
'threads' tying the man to the invisible woman and also the 'giving of your
heart's blood' which becomes art. The tree of art—and love—reappears in
drawings proposed by Munch as the title-page for Krag's poems. Standing
near the tree and gazing out over a vast quiet expanse of sea, is a woman
clothed in white, her back turned to the viewer to reveal cascading blonde

hair. She may be the 'May Day's Bride' of Krag's poems, but she is also a visualization of Munch's symbolic art. In some of the drawings, the lonely young woman gazes longingly across the fjord at the moon and at a boat. The scene is vaguely sensual, as if she is alone but waiting for her sexual mate to fill the space beside her. Munch repeated the figure in the first painting devoted to the motif of *The Lonely Ones*, a composition whose thought he had initiated the previous year while witnessing Jappe's conflicts with Oda.

Originally exhibited as *A Man and a Woman During a Summer Night*,[90] the painting applied the lessons Munch had learned from his vignette studies. The remnants of anecdotal content in the earlier drawings are removed, as is the vestige of Naturalistic illusionism. The figures appear to hover near the picture surface, while the fact that they are painted images is enhanced by vibrantly visible brushstrokes. Varying in texture throughout the painting, the brushstrokes testify to the physical process of making the painting, and by implication represent the intervening artist. Never had Munch applied the stylistic lessons learned from Synthetist 'idealist painting' more systematically.

The image projects a pregnant silence and tension. The man has the same stance as a figure in one of the initial *Evening* sketches, a pose of indecision and melancholy in which he seems at once to be attempting to walk forward and to be rooted to the spot as he turns slowly towards the woman. She stands, as in the title-page vignette for Krag, facing out towards the sea, a vast expanse of pallid blue reaching almost to the top of the painting. Other than the two isolated figures, there is no life in this 'landscape of death'; rocks fill the foreground area. As has been pointed out repeatedly, the composition closely mirrors Caspar David Friedrich's views of the Baltic Sea with two foreground figures on a bare seashore staring out into the infinity of nature.[91] Implicit in all Friedrich's Romantic nature scenes, however, is the simple faith of God's presence in nature, and of man's ability to communicate with God through nature; thus the psychological isolation of the figures is replaced by a deeper metaphysical communion.[92]

Mystical feelings of oneness with God in nature were alien to Munch, however. His figures do not identify with the stormy seashore, nor do they

58 Above
Sketchbook: Study for Vignette: *Despair*, 1892. Pen and ink. Oslo, Munch–Museet

59 Below right
Sketchbook: Study for Vignette: *Man under Tree (Melancholy)*, 1892. Pen and ink. Oslo, Munch–Museet

join together; man and woman each seek separate thoughts as indicated by their distinct attitudes. The woman is drawn towards the sea. Water is a frequent metaphor for life itself in the writings of Munch and the Neo-Romantics; as life it generates Schopenhauer's tortured sensation of yearning: 'Since all living things of this earth emerge from it and the infinity of the heavens is mirrored in it, its bright or dark mirror awakes in us the sensation of unending longing.'[93] In contrast, the man's melancholy attention is turned towards the woman, but he hesitates. She could bring him the promise of biological life contained in her element, the water. His alternative is, in Munch's words, the 'landscape of death', consisting of the moon-bleached stones on the seashore which Munch's imagination and his artistic activity mystically transform into wonderful creatures. 'During the pale summer nights', he wrote, 'forms take on fantastic tones; at the seashore, stones appear like trolls and they move in the moon's rocking reflection. Then one has to move in silent adoration.'[94] The painting thus continues Munch's thoughts on the nature of artistic creativity, again in an erotic context. For man the paths to the creation of a personal eternity remain mutually exclusive. He can join sexually with woman to give birth to a new generation of human beings, and thereby continue the pessimistic Schopenhaurean force of the Will. Alternatively, he can turn inward and reject the painful striving of the Will to live; then his intellectual processes create a new world of art which—like the stones—promises to be everlasting but lacks the blood of life itself. The illuminating element of art is the moon, not the life-giving light of

the sun; it reflects the sun's germinating warmth, but remains forever cold, forever artificially created in the mind of man without the aid of woman or love.

Munch spent the summer of 1892 in Aasgaardstrand and prepared for a one-man exhibition through which to give reckoning for the three years of his Fellowship. In his life, artistic activity and memories of the past combined

60 *The Lonely Ones.* Photograph of lost painting, *c.* 1893. Oslo, Munch–Museet

61 Right *Vision*, 1892. Oil and pencil on canvas, 72.4 × 55.2 cm (28½ × 21¾ in). Oslo, Munch–Museet

62 Below *The Swan: Vision*, 1892. Pen and ink, 18 × 11.5 cm (7¼ × 4½ in). Oslo, Munch–Museet

once again at the sites of his own and Jappe's romances, and the memories fused with his continuing preoccupation with the nature of life, death and art:

Down here at the seashore, I feel that I can find the image of myself, of my life. The remarkable scent of seaweed and water reminds me of her. In the dark green water, I recognize the colour of her eyes. . . . And life is like that silent surface mirroring the air's light pure colours. It conceals the depths with their slime and their vermin, just as death is hidden by the appearance of life.[95]

Elsewhere, using the metaphor of the ship of life striking a reef, he described the transition from the certainty of his father's reassuring faith towards the tortured sense of despair once the faith was lost and replaced by doubt; from the damaged, rudderless ship, he is hurled into the impenetrable blackness of the water among the slime and vermin, the abyss of death.[96]

Such imagery appears also in drawings and a painting created during the summer of 1892.[97] They show the wet, dripping head of Munch himself (or of a 'typical' bohemian artist) rearing out of the water. Above the head, a swan swims silently, oblivious to the depths and filth below:

I lay in mud among vermin and slime, I longed for the surface. I lifted my head above the water. Then I saw the swan—its shining whiteness. I yearned for its pure lines. I stretched out my hands towards it. It came closer, but did not come all the way towards me. Then I saw my mirrored face in the water. Oh, how pale I was, with slime in my eyes and slime in my hair. And I realized why it was frightened. I, who knew what was under the shining surface, could not be united with someone living among illusions. There on the shiny surface, the sky's pure colours were reflected.[98]

In other texts, the swan becomes the equivalent of the white-clad woman gazing out at the sea's horizon on the projected title-page for Krag's poems. She is the intermediary between the present and the future: she recognizes the water surface whose waves function as similes of time while she yearns for the infinity of the sky. Biologically, she accomplishes the transition through the birth of a child, the link in Munch's chain of generations.

For Munch, however, such biological immortality was an illusion hiding the reality of death, the slime beneath the surface. He thus existed in continual anxiety, without the certainty either of his father's Christianity or of woman's reproductive abilities. If the swan's world was to become his, it had to be in a different context, to be symbolically revealed in a further process of associations. In traditional iconography, swans could represent the innocence of a maiden, but they were also emblems of art and artistic immortality as the birds of the god Apollo. The head in Munch's drawings and texts recognizes this world of light, but in order to attain such immortality it must enter a world alien to that of its body which remains ensnared in the darkness below.

The painting *Vision*, completed late in the summer, was a final allegory of artistic creation in 1892. The message formulated was precise and simple, even if the means of formulating it were obtuse: he could achieve immortality in art, but it required the death of the body so that in his spirit an eternal world of beauty would be born from the moods of memories of love. Dr Christian Munch's puritanical ethics were translated by his son into an aesthetic gospel of salvation and self-sacrifice.

Chapter 5

KRISTIANIA AND BERLIN
1892–1899

'I am working on studies concerning love and death'

Kristiania's critics were very attached to tradition, ironically so since Kristiania was too young to possess a true tradition of its own. Their artistic standards were imported, and they used them to attack young artists of the 1880s and 1890s. But their particular vehemence was reserved for Munch. Perhaps this was because within the small community of Kristiania, Munch's uncompromising stance as a radical artist took on the quality of snobbish superiority. Perhaps too it was because, as the scion of a family closely linked with Norway's cultural past, he was judged more severely than others and was seen as a traitor to his own 'aristocratic' cultural origins. Perhaps, finally, it was because his link to the past promised the foundation of a tradition for the future. Whatever the underlying reasons, Munch was condemned for wasting the money that Kristiania's taxpayers had contributed to his twice-renewed State Fellowship.

This charge was first hurled by Bjørnstjerne Bjørnson—novelist, playwright, poet, ardent Norwegian nationalist, cultural propagandist, popular orator and severe moralist—who stood in fervent opposition to the 'sexual anarchism' of the literary left. To Bjørnson, Munch appeared an obvious target. Moreover, convinced of the Darwinists' dictum that the strong are the good, a conviction gaining renewed support from the 'master morality' preached by Nietzsche, Bjørnson found in Munch's repeated illnesses the proof that the 'Artists' Fellowships Are Gone Astray'. In December 1891 he wrote:

This probably means that Munch will stay in Nice rather than go to Paris, in other words, that he is of poor health and will stay in the health resort. When he received the fellowship for the third—n.b. THIRD—time, there were rumours that it was because he was inclined towards illness and continues to be. However, our few and extremely humble fellowships for artists should never be used as some form of health insurance. ... For a sick man, private means of support should be found. The fellowship should be awarded to someone who is able to make full use of it for his art.[1]

From Nice, Munch wrote a sarcastic public letter in reply:

Herr Bjørnson, don't you know enough not to trust rumours!
The last time I was abroad, I became seriously ill. ... I was awarded the fellowship again to make up in part for the lost time. ... You say, 'Munch stays in Nice while Skredsvig goes on to Italy; therefore, Munch must be sick.'
In the future, investigate a bit first before you make such charges, Herr Bjørnson! ... I should like to assure you that I am in remarkably good health, that I still have not availed myself of any treatment at this 'health resort'. And I would like to enlighten you in regards to Nice which, taken as a whole, is not a health spa at all. It is a rather large city on the Mediterranean and is sought out by painters because of its natural beauty. Should you need more information, I am at your service.[2]

Munch used ridicule to destroy his opponent's credibility. By showing him to be ignorant of widely known facts, Munch implied that he lacked the qualities necessary to judge and condemn either him or his art. In turn, Munch presented himself as speaking from injured righteousness. As artist, moreover,

he maintained that only he could 'determine where it is most advantageous to work'; he possessed a superior knowledge not available to laymen such as Bjørnson. The attitude is similar to the unwavering faith in salvation dominating Munch's childhood home. It also reflected Symbolism's contemporary doctrine that the artist was priest and prophet following a revealed path of aesthetic righteousness that could not be understood by the uninitiated.

Apparently without Munch's knowledge, Frits Thaulow had meantime written, in the name of all artists, in his defence. Addressing Bjørnson in the familiar form *Du* as if lecturing a child, Thaulow provided a mixture of chiding, scolding and conservative demonstrations of Munch's artistic qualities:

Your protest against Munch's fellowship is in error made in ignorance of the facts and through a failure to comprehend his art. . . .

Up in the corner of the exhibition [Kristiania, Autumn 1891] where his paintings were hung, it was as if the future had arrived. There was a unique power that always drew me back . . . here an art is being born that will kill ours—our good old, respectable, meticulous Realism. . . . 'He is the most interesting painter in Scandinavia', [the influential German painter Fritz von] Uhde told me in Munich.

Yes, this is our conviction, and this is what we see, because day in and day out we work with the difficult language of colours and lines. We have progressed a bit in the difficult task of developing our taste. We have paid our tribute! And you have not! Therefore you have no right to work for or against anything in terms of awards for painters. Here it is you who have gone astray . . . ![3]

Like Krohg, he recognized that Munch was introducing to Norwegian painting the 'objective' expressions of subjectivity that had come to characterize French Symbolist painting. Once again Munch was hailed by his fellow painters as the most gifted of Norway's youngest generation of artists, and as its uncontested leader and guide.

This exchange of letters inaugurated a debate in Norway concerning Munch's mental, physical and moral 'degeneracy' that reflected similar totalitarian attacks on art being waged throughout Europe. 'Degeneration and hysteria', recognized 'scientifically' in modern art and 'the upper stratum of the population of large towns' by psychologists and sociologists such as Caesar Lombroso and Max Nordau, were being interpreted as signs of a disease of society that would only be cured by violent means; by, according to Nordau:

Characterization of the leading degenerates as mentally diseased; unmasking and stigmatization of their imitators as enemies of society; cautioning the public against the lies of these parasites. . . . Let us show the public the mental derangements of degenerate artists and authors, and teach that the works in fashion are written and painted in delirium. . . . When our society then, after serious investigation and in the consciousness of a heavy responsibility, says of a man: 'He is a criminal!' and of a work: 'It is a disgrace to our nation!', the work and the man would be annihilated.[4]

Bjørnson, the vocal advocate of democracy, was unwittingly lending his intolerant voice to the most repressive tendencies of modern political and cultural life.

Munch's concern with his inner world, with sexuality and death, and with the irrational forces that bound together the experiences of primitive man and civilized Kristiania burghers, postulated a new world-view denying the rationality of the nineteenth century. Such a revolution could not be harmless. Munch's art after 1891 was seen as a threat, not only to art, but also to society's institutions, as serious a threat as contemporary doctrines of political anarchism.

These were the attitudes in Kristiania when Munch, recently returned from Nice, opened an exhibition of fifty paintings and pastels and ten drawings on 14 September 1892 in the Jeweler Tostrup Building near the Storting. According to one critic's preview:

In the ten days it is to be open, the exhibition will arouse much interest—and much anger. . . . For those who have followed Munch's development with understanding, and whose eyes have been opened to his paintings' symbolic character, for them this exhibition will be of extraordinary interest.[5]

Rejecting the possibility of sending paintings to the simultaneously held Autumn Exhibition (in which he never again participated), Munch presented to the Kristiania public and critics the achievements of the three controversial years of his Fellowships. As if to underline the provocative nature of his art, he added his earlier portrait of Hans Jæger.[6] It was the exhibition of a mature artist, ready to follow his personal path in art. It was a confession of faith, not an appeal for salvation. It was also a manifesto.

In the previous year, Krohg had described Munch's paintings as more like music than pictures. Similarly, Thaulow had argued that the artist could create a musical, nervously concentrated language of colours and lines rather than imitate nature. In France and Scandinavia various artists adhering to Symbolist ideals were emulating Whistler's practice of describing paintings as musical 'harmonies' or 'nocturnes'. In 1892 Munch followed suit, describing a portrait of his sister Inger as a 'Mood in Colours of Black and Violet', and other paintings as 'Mood at Sundown' (*Despair*) and 'Harmony in White and Blue' (*The Lonely Ones*). He chose the simile of identically tuned violins sounding in sympathy; his paintings should not narrate or imitate but, like music, should conjure forth empathetic moods through colour harmonies, lines and composition. The Tostrup Exhibition sought to make clear this concern with direct emotive communication for the first time to the Kristiania public.

The portrait of Inger is ambitious, life-size like the earlier portraits of Jensen-Hjell and Jæger, but lacking their anecdotal and temporal emphasis. Inger's frontal pose renders her hieratic and immobile. A year earlier, Munch had experimented on a smaller scale with such emphatic frontality in the portrait of Anne Buhre, but had broken the severity by generating a diabolic atmosphere of vaporous brushstrokes. Inger's portrait lacks such a sense of space. Only long, rapid brushstrokes tracking thinned blue and light-brown paint (their systematic directionality harks back to Neo-Impressionist technique, although the finesse of the pointillist method has been discarded) surround her as imprecise indications of wall and floor, but also to emulate a halo-like aura around the forms of her dress and head. All illusion of space, depth or volume is absent, except in her hands and head. Inger appears as a massive silhouette disturbed only by the spots of violet on her dress and by her head and hands. The dress, not the woman, is sovereign. The viewer is accosted by a covering hiding the woman's forms; the hands retreat in an enclosing grasp; the face is sternly set with lips tightly closed, eyes defiantly staring.

A more overtly symbolic painting depicted a gambling scene in Monte Carlo, with anxious players gathered around a roulette table, their forms emerging black from the viciously green atmosphere which reflects the poisonous green of table and lamp while colour vibrates in the flecks of red on a dress. Facial features are totally generalized; all sense of individuality is gone, everyone is absorbed by the game. To the right, however, an isolated man has turned away from the glaring table to stare out wide-eyed from the

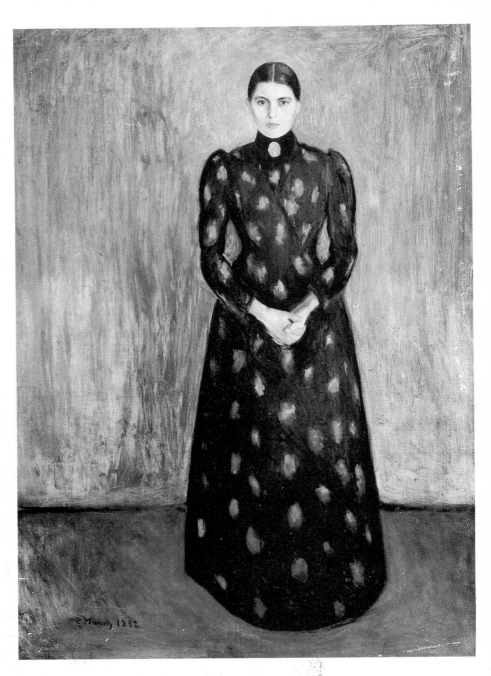

63 *Portrait of Inger Munch*,
1892. Oil on canvas, 172 ×
122.5 cm (67¼ × 48¼ in).
Oslo, Nasjonalgalleriet

painting, like the figures in Munch's *Evening* paintings, who project their
visions behind them. Behind him is the remembered 'gambling hell of Monte
Carlo'.[7] The anecdote of a man losing at roulette becomes a metaphor of
sinister oppression, compulsion and isolation.

The landscapes that Munch selected to exhibit likewise presented a process
of transformation from the visual to the visionary. Impressionistically ren-
dered scenes of Paris, Kristiania, Aasgaardstrand and Nice comprised the first
grouping; and at least three different versions of the Yellow Boat motif—the
original pastel, an oil directly imitative of its composition, and *Jealousy*,
based on the Goldstein vignette composition—represented landscape as an
emotive symbol of a state of mind.

In the exhibition listing, *Jealousy* is included among a grouping of paintings—*Man and Woman During a Summer Night, Mystique of a Summer Night, Night, Kiss, Evening: Jealousy* and *Despair*—which depict aspects of the dual mystique of sexual and artistic creation.[8] The first painting represents the initial stirrings of attraction between a woman and a man. The second painting—a view of the seashore in a nocturnal mystical summer vision that seems to transform stones and trees into living creatures—visualizes the mood of the night as the 'strands of love' are knit. *Night* then injects the theme of artistic contemplation and creativity, enveloping the melancholic artist in memories of life, love and death. *Kiss*, a new version of the motif now using a horizontal format, presents the moment of sexual union. Pressed harshly to the edge of the canvas as if propelled by their passion away from the daily life of the street seen through the large window, their bodies become indistinguishable from one another. Their faces also melt together to create a single strange, embryonic form. Within the dark blue mass of their united bodies appear a few disjointed streaks of red, symbolizing the tortured striving of sexuality.

Kiss and *Night* form a conceptual diptych of creation within the economy of Munch's grouping. According to Munch, they are the alternatives man faces: either he selects the redeeming melancholy of artistic contemplation, whose inactivity is resolved in the moment when the work is made visual; or he unites with a woman and gives up his individuality in the passionate act of

64 *At the Roulette Wheel II*, 1892. 72 × 92 cm (28¼ × 36¼ in). Private Collection

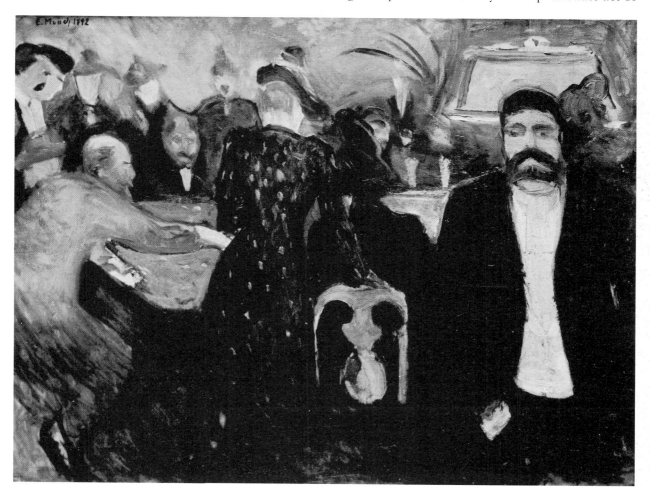

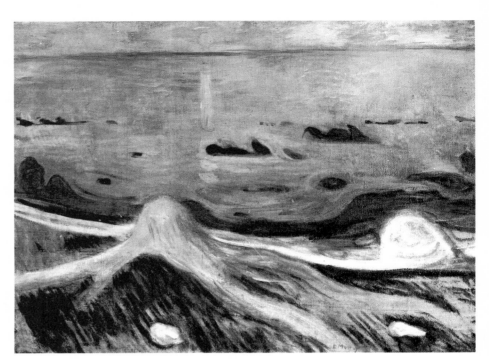

65 *Mystique of a Summer Night*, 1892. Oil on canvas, 100 × 140 cm (39½ × 55 in). Private Collection

generating new life within her womb, the biological equivalent of the artist's spiritually isolating environment of memory and thought. In either case, the act of creation is fraught with anxiety and danger to the individual while it forms the fulcrum of life, an alien element within the general blue ambience of death surrounding it.

'Women exist in the main solely for the propagation of the species', Schopenhauer wrote in *Parerga und Paralipomena* (1850), 'and live more for the species than for the individual.' Munch visualized an identical doctrine. After the act of impregnation, woman's role basically ceases. In the remaining two paintings of the grouping, she is characterized by her absence rather than by any active involvement in the man's life. *Jealousy* shows her as her lover imagines her with another man, about to leave for the warm, damp island of love; thus forsaken, the lover's thoughts cause the poisonous mood of the landscape while 'the wires of love' tie him to his absent beloved and render him incapable of activity as the insurmountable pain of yearning overcomes him. Finally, *Despair* renders the mood of total isolation, an 'insane mood' as the day dies leaving a sky transformed into blood and a landscape changed into an abyss of nothingness. Both art and sexuality thus lead to a state of isolation in which the individual must face the ultimate questions of life and existence, and suffer anxiety in the absence of divine revelation.

The grouping of these paintings at the Tostrup Exhibition marks Munch's first conscious attempt to take advantage of the interrelationship of themes that had increasingly characterized his work since 1890, and which he was soon to consider essential for its comprehension, especially in the face of continued rejection.

Most critics pronounced their anathema on everything displayed:

What is it that Munch paints? Some pallid and pale colours, just as washed out and wiped over as the undercoat on a house wall—tubercular colours, real consumptive patients of colours that never knew the nourishment of blood and the light of day. Or else, when the fever rises, shrill yellow stains, hectically red screeching splatters, smeared on to the canvas without significance or order. He paints his famous Yellow

Boat with a few grey-violet pillows and bunches of wool in the foreground supposedly to represent stones.[9]

The campaign initiated by Bjørnson against the 'unhealthy' aspects of Munch's work was continuing, and rejection became more widespread during the following months. In November 1892 a retrospective of Munch's work opened in Berlin. Thereafter the paintings travelled to six other European cities before Munch returned to Norway with them in July 1893. During that time his reputation became international, but so did his rejection by critics, artists and public.

The opportunity for the twenty-nine-year-old painter to have this unusual concentration of retrospective exhibitions was provided by a letter received late in September from Berlin. It was an invitation from a Norwegian painter of fashionable Nordic seascapes and sailing ships, Adelsteen Normann, for Munch to send his work to the Imperial German capital's most influential artists' society, the Verein Berliner Künstler.[10] For Munch, it could not have arrived at a more propitious time. With no fellowship, no promise of significant patronage and no students to provide financial support, his position in Norway held little promise. Moreover, the community of artists that had previously defended him—Krohg, Werenskiold and Thaulow—had made no response to the latest collective attack of Kristiania's critics. Munch stood alone.

Germany, in contrast, was a legendary promised land, at the time indulging in an adulation of all things Nordic. Numerous Scandinavian artists, Normann included, were working there successfully, their dramatic views of Nordic fjords feeding a seemingly insatiable European appetite for scenes from the tourists' land of the midnight sun. In the visual arts Norway was considered France's main contender as the leader of 'the moderns':

'After us, the Norwegians'; this prophecy of Meissonier's seems to be on the way to being fulfilled. The Norsemen are still, so to speak, learning to walk, but they will soon master the skill. It is from the North that a new monumentality can and will enter modern art.[11]

'Young Norway' was also influencing German literary fashion to an unprecedented degree. Ibsen and Bjørnson were celebrated as Europe's greatest writers,[12] and German authors assumed Nordic pseudonyms in order to gain a wider readership.

It was amidst such worship of Norwegian art and literature that Munch received his invitation. Chaired by Anton von Werner, the Kaiser's main artistic adviser, the Verein Berliner Künstler had direct associations with the German Imperial court. The invitation seemed to offer Munch acceptance and an unprecedented degree of acclaim. In Germany, perhaps, he would finally be understood, and his art would sell.

The promise was to prove deceptive. Although Munch continued to be ridiculed in Kristiania, the Naturalist painters had gained control of the major annual exhibitions, and Impressionism was sufficiently accepted for the National Gallery to purchase a painting by Claude Monet in 1891, the first public collection to own any of his works. In Germany, however, the French Impressionists remained virtually unseen, and the Kaiser advocated a maudlin idealism whose major criterion was that art should appeal to the broadest popular taste while conveying messages of German pride, power, loyalty and self-confidence.[13] As a result, just as had previously been the case in Norway, Naturalist and other non-traditional painters were generally associated with

radical leftist political movements, notably Socialism and anarchism, and were therefore anathematized. Munch was about to be numbered among such painters.

The true situation of painting in Berlin is indicated by an international exhibition organized in 1891 to celebrate the Verein Berliner Künstler's jubilee. The largest art exhibition ever held in Germany, it displayed 4,702 works, nearly half by German artists. Despite the personal intervention of the Empress, France was not represented at all. The Norwegian section was gravely depleted after twenty-nine Norwegian painters, including Munch, withdrew their works. The cause of their protest was Werner. He had first appointed Otto Sinding, a painter of Nordic winter scenes, as the representative of Norway's artists, then arbitrarily withdrew the appointment and named instead Hans Dahl, a mediocre figure painter resident in Berlin, whose 'infinitely repeated boisterous peasant wenches with their happy laugh and gay smile have nothing to do either with Norway or with art', according to Thiis.[14] Finally, Werner privately sent twenty-two additional invitations to other artists, most of them born in Norway but living in Germany or England. Angrily, the committee of Norwegian artists in Kristiania wired its decision to withdraw.[15]

When Kaiser Wilhelm II and a contingent of Prussian infantry, cavalry and a brass band opened the 'international' exhibition on the morning of May Day, Norway's artists were not there. Instead, they sent their works to Munich, Berlin's rival, where French artists also exhibited. There Von Uhde, one of Germany's leading Naturalist painters, on seeing *Night*, a portrait of Dr Munch and *Summer Night: Inger at the Shore*, pronounced Munch 'the most interesting painter in Scandinavia'.[16]

Von Uhde may have had a hand in the affair, but it is still difficult to establish why Normann invited Munch, the most radical of Norwegian artists, to Berlin or why the committee unanimously agreed. It may have been Normann's desire to demonstrate Norway's spiritual and cultural independence that influenced him, making Munch a symbol of Norway's youth and freedom and his radical art only a secondary consideration.

Munch's first Berlin exhibition opened on 5 November 1892. Hung by Munch himself in the skylit rotunda serving as the Verein's hall of honour in a

66 Edvard Munch
Exhibition, Berlin 1892–3

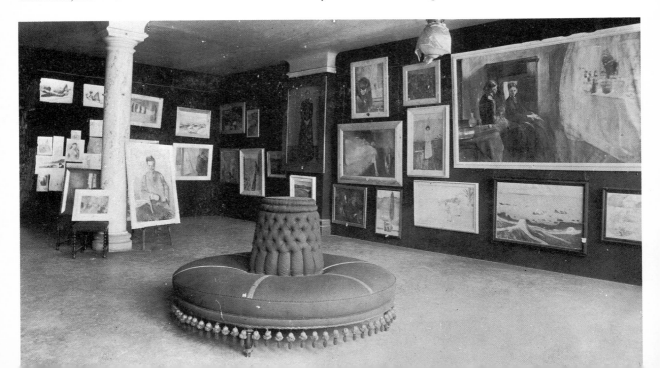

converted beerhall on Wilhelmstrasse, it was contracted to remain open for two weeks. In less than a week, however, the exhibition was forced to close and the paintings were removed from the walls with such haste that several were seriously damaged. Ignorant of Munch's art, members of the organization reacted with outrage when they saw the paintings, and a committee of thirty-one petitioned Werner to close the show immediately. However, since Munch was the invited guest of the exhibition committee, only the committee could close the exhibition. Undaunted, the marine painter Hans Eschke, a personal friend of Werner, and thirty others demanded that a new exhibition committee be elected at an extraordinary meeting of Verein members. The meeting, to which nearly 250 artists came, took place on Saturday 11 November. The result was a vote of 120 to 105 to close the exhibition. The exhibition committee resigned. Munch wrote home: 'Well, I never thought there would be so much commotion. . . . It is unbelievable that something as innocent as painting could cause such an uproar.'[17]

In support of Munch, forty-five artists walked out of the Verein on that Saturday and at midnight formed a new group, Freie Vereinigung Berliner Künstler (The Free Association of Berlin Artists), under the leadership of the engraver Karl Köpping. Within a few days, they dispatched an explanatory letter to the German newspapers:

Without wishing to take any position whatever regarding the artistic tendency expressed in Munch's paintings, we condemn the closure of the exhibition as a measure absolutely contrary to common decency. We wish to affirm this in public, and as emphatically as we can.[18]

At issue were the practices of polite society, not art. Werner, however, considered this letter a major personal insult, and reported the events to Kaiser Wilhelm. In his other role as director of the Berlin Academy's Institute for Fine Arts, he demanded that the Prussian Minister of Culture take disciplinary action against the three faculty members who were among the signatories. Werner's request was refused, but the three were placed under such pressure by their Academy colleagues that they resigned within a month.[19]

The 'Munch Affair' was gleefully reported in German newspapers, bringing Munch publicity of a sort he would never otherwise have attained. Immediately he was invited by the art dealer Eduard Schulte, who represented many of Germany's younger artists, to exhibit in his galleries in Cologne and Düsseldorf, and he arranged for another showing of his work in Berlin to open immediately after Christmas. He had become, in the words of the painter Lovis Corinth, 'the most famous man in the whole German Empire'.[20]

The *Frankfurter Zeitung* mocked the exaggerated attention given to the whole episode:

Telegram from Berlin, 9 November [1892]: Art is endangered! All true believers raise a great lament! Call forth the rescue squads! Even Anton von Werner has ridden out to battle, like George the Dragon Slayer, against that Nordic dauber and poisoner of art, Edvard Munch, and from overworked critics' columns drips the wisdom and comes the horror that fills our papers. And what is the ground for this fear-inspiring lamentation? An Impressionist, and a mad one at that, has broken into the herd of our fine solidly bourgeois artists. An absolutely furious character.[21]

The criticisms now mixed Bjørnson's vision of diseased art with the phobias of a jingoistic German Empire that feared the possible effects on its health and purity of any French-inspired art. The closing of the Verein Berliner Künstler

exhibition was both a patriotic and socially hygienic act, and as such did not fall under laws of either artistic freedom or common courtesy.

The *Berliner Tageblatt's* theatre critic, Theodor Wolff, responded to the attack. Three years earlier, he had been among the group of writers who had organized the association Freie Bühne (Free Stage) as a means of by-passing official theatre censorship and of providing a vehicle of expression for Berlin's various literary cliques, especially the radical Naturalists. Wolff viewed Munch's art as the art of an innovator whose freedom of expression was being denied by the Berlin community of artists:

In art, everyone has a right freely to give vent to his opinions. When theatre directors and theatres rejected those whose opinions were not in accord with theirs, we protested. Today we protest again. One does not counteract an artistic or spiritual movement, not even the lowest and most disreputable one, with violent repression.[22]

The call for full artistic freedom was joined with an appreciation of the art that pointed less to the ideals of Naturalism, however, than to the beginning of an influx of Symbolist, Decadent and Neo-Romantic ideals into Berlin's literary and artistic world.

The Freie Bühne's periodical—carrying the name of its sponsoring association—likewise made its pages available for Munch's defence. The painter Walter Leistikow's report on the 'Munch Affair', like Wolff's review, betrays an admiration for Norwegian Neo-Romanticism and for Symbolism:

In the exhibition, there were paintings that were so beautiful, so profound, so intense . . . so entirely written with all his soul. . . .I liked best his dusk-filled interiors, so mysterious and silent. Through a large window, the moonlight blinks and filters blue. Outside, the fjord with boats and steamers far, far away, no more than a dream, no more than a sigh—tones—music—. Inside, a man alone, pushed to the corner of the sofa, in his mouth a glowing cigarette. . . .
All this has been precisely observed, has been experienced, has been felt deeply and intensely! If someone can speak like that, or paint, or sing—I am uncertain how to describe it—in him a poet's soul is alive. With a poet's eyes, he sees the world he loves.[23]

Like Krohg in Norway, Leistikow concluded that Munch's paintings broke the barriers between the genres of art. In the pictures themselves, a *Gesamtkunstwerk* seems to be created that fuses visually the qualities of painting, music and poetry. Once again the conviction is voiced that the artist alone—with his 'poet's soul'—can judge his work. As the isolated individual divorced from the social concerns of his time, he generates his images from the intensity of his feelings.

These subjectivistic doctrines were even more emphatically pronounced in Berlin in a periodical founded in October 1892, shortly before Munch's scandalous exhibition. Under the guidance of Stefan George, who had translated Baudelaire into German and participated in the Symbolist soirées of Mallarmé in Paris, the *Blätter für die Kunst* ('Pages for Art') demanded a renewed spiritually orientated art founded in the unique sensations of contemporary man:

We seek not the invention of anecdotes, but the representation of emotive moments, not observation but presentation, not entertainment but impression. . . .
Artistic value is possessed by that work which seeks to extract a new, unknown aspect from people or things and that knows how to present the possibility of it.[24]

The readers and poets of George's *Blätter für die Kunst* saw in Munch's

paintings an 'intimate art that seeks to use all possible sensations: sensations of tone, colour, smell, taste and touch'.[25] The paintings portrayed a sense of harmonic cohesion and unity that reflected the totality of man, not solely the divorced vision of the eyes. The illusionism of artists such as Werner reflected an atomized existence, 'an inner sterility, a monstrous combination of expertise in details with indifference to the whole, the terrible abandonment of man in a desert of particulars, restlessness, malice, unequalled spiritual apathy, avarice, frigidity, and violence' such as were considered the fundamental characteristics of 'our era'.[26] Munch's 'intimate art' was deemed the necessary alternative to the age's materialistic atomization and lacklustre bourgeois ideologies of capitalism and imperialism. The task of art and artists was to restore man's inner cohesion and to clarify humanity's oneness in being with the cosmos and cosmic forces, and Munch's art appeared as a response to these demands. In contrast, the established artists of the Verein Berliner Künstler maintained their disapproving attitude. On 21 March 1893, by a vote of 77 to 39, they turned down Munch's application for membership.[27]

Ironically, the proposed path to restored cosmic unity was by way of increased artificiality. Whether variants of Seurat's pointillist technique or Gauguin's Synthetist approach, Munch's paintings of 1892 were flat, and reduced the individuality of forms so as to achieve an harmonious cohesion of the planar canvas surface. Symbolism's orientation towards the non-illusionistic flatness of a coloured surface became a metaphor of universal Monistic harmony and cohesion. Also related to his faith in Monism was Munch's decision in 1892 to group his paintings so as to enhance their mutual interdependence. Isolated paintings did not correspond to a world-view in which the essential truth was the harmonic unity of all. In the months following the Tostrup Exhibition Munch had eight additional exhibitions in Germany and Denmark. Each provided the opportunity to survey his entire artistic development, providing the possibility of altered perceptions, altered arrangements and new insights into the needs of his Monistic concerns. Reminiscing many years later, he compared these repeated confrontations with himself to a revelation:

I placed them together and found that various paintings related to each other in terms of content. When they were hung together, suddenly a single musical note passed through them all. They became completely different to what they had been previously. A symphony resulted.[28]

By 1893, Munch was deliberately expanding his 'symphony' by creating new paintings thematically and compositionally related to the others. In March, he revealed to the Danish painter Johan Rohde:

I am currently occupied with making a series of paintings. Many of my paintings already belong to it, by the way, such as *Man and Woman at the Seashore*, the red sky and the picture with the swan. Up to now, people have found these quite incomprehensible. When they are seen together, however, I believe they will be more easily understood. Love and death is the subject matter.[29]

As the paintings combined into the cycle devoted to themes of life, love and death, their totality expressed the belief that individual moments, situations and experiences were but the inferior parts of Monism's eternal, constant unity. Munch wrote:

Small pictures in isolating gold frames have been sold to adorn the bourgeoisie's walls for so long, that now people believe painting is just a business like any other, no

different from making shoes or working in a factory. When I paint, I never think of selling. People simply fail to understand that we paint in order to experiment and to develop ourselves as we strive for greater heights.[30]

Both the Naturalist writers of the Freie Bühne and the Symbolist-orientated poets of George's *Blätter für die Kunst* could identify with aspects of the vitalistic Monism present in Munch's art. Munch, however, became most closely associated not with these two camps, but with an international bohemian group that began meeting regularly in 1892 in a wine cellar nicknamed Zum Schwarzen Ferkel (At the Black Piglet). The name was supplied by the Swedish dramatist August Strindberg, who arrived in Berlin only a few months before Munch and who formed the centre around which the fraternity of Scandinavian, Polish and German writers, artists and critics collected. Vitalism and Monism were their common faith, but the subject which was their mutual obsession was Woman. Strindberg described the bohemian cenacle as:

a collection of damned souls, because among them there was not a single one who did not drag along the burden of an adverse fate. Curses fell thickly among them, and hatreds hailed heavily. Often at night passers-by would stop at the window broken by flying bottles as screeches and howls poured out through it. And people passed by, saying: 'What a hell!'[31]

The description may not be totally accurate, but it captures the atmosphere of the Schwarze Ferkel. With women absent but a constant topic of discussion, the atmosphere was charged with a vicarious but intense eroticism generating feelings of violent jealousy. It was an atmosphere almost duplicating that of Jæger's Kristiania Bohème, in which Munch must have relived the entire intellectual and, to a lesser degree, emotional experiences of a decade earlier.

Among the egocentric, argumentative geniuses of the Schwarze Ferkel, one played a role similar to Goldstein's in Saint-Cloud. Perpetually exchanging experiences and ideas, Munch and the Polish novelist Stanislaw Przybyszewski became enmeshed in each other's lives. They addressed each other as 'brother', 'Edzin' and 'Stachu', and their homoerotic relationship aroused the ire of Strindberg. All three were confused by their feelings as they continued to struggle with their attachments to women.

Przybyszewski wrote a novel trilogy, *Homo Sapiens*, which meshed the actual experiences of the Berlin bohemians with fictional events to create a mythology of sexuality, jealousy, violently intense psychological turmoil, dreams, hallucinations and religious convictions. As in Munch's art, its insistent attachment to events actually experienced by the author derived from Naturalistic articles of artistic faith, as did the deterministic emphasis on struggle between man and woman or men and men in a Darwinistic battle for survival which only the strong could win. Homo sapiens, Przybyszewski's trilogy argued, was governed not by reason, but by passions, instincts and biological drives which determined his every action, in the process destroying all religious, political or artistic promises of salvation or of a reformed better humanity. This vision of human life was given coherence by Przybyszewski's personal mysticism, evolved from Polish Catholic traditions, Cabbalistic and Hermetic literature, and remnants of Gnosticism, that concentrated on hallucinatory visions of extreme emotions and fevered ecstasies.

Between Munch and Przybyszewski a system of mutual encouragement evolved that Munch later described as 'an atmosphere of reciprocal influences' which were being transmitted 'in a metaphysical manner', spiritually or psychically. In Przybyszewski's novels Munch's paintings recurred, and in the

vocabulary of Munch's paintings Przybyszewski's anti-aesthetic artistic doctrines found a new form. Munch's hallucinatory experience on Ljabroveien, which had already inspired the 'experiments' of several drawings, a painting and various texts, and been the source of a poem by Vilhelm Krag, reappeared in Przybyszewski's *Overboard,* the first of the trilogy, as a hallucination induced by the sufferings of Love:

But how I suffered! Have you ever seen the heavens scream? No? Well I have, you know! I saw the heavens scream. It seemed as if the sky opened up into the world. All of heaven transformed into an unending series of stripes; deep red, ranging towards black. Coagulated blood—no! a cesspool reflecting the sunset, and besides a filthy yellow. Ugly, disgusting, but superb![32]

The emotion recorded by Przybyszewski differs remarkably from the sense of melancholic despair emanating from a recognition of human isolation, suggested in Munch's texts and his 1892 painting. In Przybyszewski's account a harsh vocabulary emphasizes ugliness and distortion. For this art practised by Munch and himself Przybyszewski suggested the title 'Psychic Naturalism';[33] it contained virtually all the characteristics associated a decade later in Germany with Expressionism.

In reworkings of his Ljabroveien experience at this time, Munch altered the composition along the lines of the vignettes for Krag, Obstfelder or Goldstein. Instead of facing into the landscape, the figure turns towards the viewer as in *Evening: Jealousy,* thus repeating Munch's now established formula for a visionary scene. In a pastel drawn on a piece of cardboard, the composition is altered even more drastically. The foreground figure now appears in the centre of the image, hands raised to the head, mouth and eyes open wide in a gesture of extreme shock. The diagonal of the railing and street is pushed more to the right so that it disrupts a greater portion of the picture plane with an indication of exaggerated depth. In the background Munch's two 'friends' display a stiff composure in total contrast to the animated fear of the foreground figure. Both figure and landscape are now tinged in blue-green with streaks of brown and rendered in quickly drawn strokes of pastel with no attempt to create the smooth, delicate colour transitions of previous work. Similarly, the sky appears in garish stripes of undulating and alternating red and yellow wounded by a pale blue in the centre. The curving lines of the sky, echoed in the curves of the figure's body, dominate. It is as if, in their essential form and colour, there were no distinction between landscape, sky and figure, and that all were fused in the symbolic flatness of Munch's pictorial representation of Monistic unity. Cutting into this dissolving flatness, however, is the diagonal that divides the image into two unequal parts generating a schizophrenic, insurmountable split between the forced rush into depth and the surface-adhering figure, landscape and sky. There is no resolution of the space-surface tension, no harmonizing of colours, no disguise of the crudity of colour application. Munch's style has changed. In Berlin, it attained a visual equivalent to Przybyszewski's proto-Expressionist prose rather than Symbolist poetry. It is a disjointed image corresponding to the staccato rhythms of Munch's revised version of the text describing his experience:

I was walking along the road with two friends. The sun set. The sky became a bloody red. And I felt a touch of melancholy. I stood still, leaned on the railing, dead tired. Over the blue-black fjord and city hung blood and tongues of fire. My friends walked on and I stayed behind, trembling with fright. And I felt a great unending scream passing through nature.[34]

As if thinking of Munch's new work, in *Overboard* Przybyszewski deprecated the bloodlessness of contemporary art:

All this depiction of moods is so shallow, so meaningless. . . . If only they were moods that, no matter how naive, present something of the naked life of the soul. . . . I want life and its terrible depths, its bottomless abyss. . . . Do you mean to say that that depth, that vertigo-producing abysmal gulf, the great struggle of the sexes, the eternal hatred between them—can you say that that is naturally comprehensible?[35]

To explain his concept of 'Psychic Naturalism' Przybyszewski identified an 'individuality' hidden in each human being. Closely related to Freud's later concept of the unconscious, this was 'what is eternal in a human being' and it preceded all logical thought and intellectual awareness:

Edvard Munch is the first to undertake the representation of the soul's finest and most intense processes, precisely as they appear spontaneously, totally independent of every mental activity, in the pure consciousness of individuality. His paintings are virtually chemical preparations of the soul created during that moment when all reason has become silent, when every conceptual process has ceased to operate: preparations of the animalistic, reason-less soul as it winds and curls upward in wildest storms, and shrinks in dusk-filled states of retreat, and screams in wild cramps of pain, and howls for hunger.[36]

Przybyszewski's vocabulary points to the basic characteristic of this pre-logical process: it is sexual with phallic rising and falling and passionate desires. The mystery of sex was what survived the nineteenth-century onslaught of Naturalism, science, Darwin and Nietzsche against the traditional mysticism of life, against divine creation, against God and against the Christian concept of an after-life. In the forces of sexuality Przybyszewski discovered a new mystical principle serving as a mysterious primal force for all existence. Answering Monism's call for unity, he announced:

In the beginning was sex. Nothing outside it. Everything contained in it. . . . Sexuality is the primal substance of life . . . the eternally creative, the transformatory and destructive force.[37]

Contemplating his series of paintings for which he began studies in March 1893, Munch echoed Przybyszewski's desire for 'the grandiose revelations of the most intimate and innermost realms of the human soul; they are flashes of lightning in the great unknown, casting a harsh but momentary light into the strange land of the unconscious.'[38] The series, Munch wrote, represents 'moods [and] impressions of the life of the soul, and together they represent one aspect of the battle between men and women, called love.'[39] The tone of this statement indicates a shift in emphasis from Munch's earlier conceptions of the woman to man relationship. Previously, as at Saint-Cloud, his primary concern had been to represent sexual love as an instrument through which humanity gains immortality, with each generation forming a new link in the chain of being that joins past, present and future. For Munch and Przybyszewski in Berlin, however, the battle became the basic content of the relationship of the sexes, with all other aspects subordinated to it. The result of this focus was not absolute misogyny, however, but a confusing mixture of fear, hatred and adulation, of almost masochistic submission and harshly ascetic resistance to women.

Into the male fraternity of the Schwarze Ferkel few women gained admittance. Dagny Juell was an exception. A Norwegian music student,

67 *The Scream*, 1893. Pastel on board, 74 × 56 cm (29¼ × 22 in). Oslo, Munch–Museet

daughter of a doctor friend of Munch's father, she was twenty-seven years old, tall, slender and blonde. She believed herself to be descended from Norway's ancient kings and was an ardent believer in Jæger's doctrines of free love. On the evening of 9 March 1893, she arrived at the Schwarze Ferkel innocently arm-in-arm with Munch. 'One day she stepped into the Ferkel at Munch's side', recalled Strindberg's self-appointed biographer, chronicler, and functioning aide-de-camp in Berlin, the Finnish writer Adolf Paul:

Blond, thin, elegant, and dressed with a sense of refinement ... she tempted a man's robust strength without destroying through too much 'unmotivated' fleshiness the fashionable, decadent, nervous glorification of the head! A classic, pure profile, her face overshadowed by a jumble of curls! ... Laughter that inspired a longing for kisses, simultaneously revealing two rows of pearl-like white teeth awaiting the opportunity to latch on! And in addition, a primeval, affected sleepiness in her movements, never excluding the possibility of a lightning attack![40]

By attributing to her the qualities of a crouching cat or vampire, Paul mythologized Dagny in an attempt to release himself from her powers. The process was a common one in the Schwarze Ferkel: it absolved the men of responsibility and assuaged damaged male egos. Munch himself only perceived a woman in terms of the roles she took on in relationship to men: in sexual terms, social and family terms, or, in direct relationship to his profession, as depersonalized muse. For Munch, Dagny ultimately became a maternal muse:

She moved among us freely and proudly, encouraging us, constantly comforting us, as only a woman can, and her presence alone was sufficient to calm and inspire us. It was as if the simple fact that she was nearby gave us new inspiration, new ideas, so that the desire to create flamed up fresh and new.[41]

However, this description of 1901 postdates Munch's experiences with Dagny in Berlin and was also an attempt to defend her from charges of licentiousness after she was murdered in Tiflis that year by a Polish student who felt he was fulfilling the wishes of his idol, Przybyszewski. The life-sized portrait Munch painted of Dagny in 1893—almost a pendant to his portrait of his sister—offers a different image. Dressed in blue and surrounded by an ambience of blue, Munch's symbolic shorthand for the worlds of death and art, Dagny is seen frontally, her arms held behind her back. Only her smiling face and hair glow to emerge from the blue-violet tinged tones otherwise covering the canvas. Gazing directly into the viewer's eyes, she appears to invite him to enter her unique world. Servaes, a sympathetic critic who occasionally participated in the Schwarze Ferkel discussions, wrote of the painting:

It is something of the most noble *crème* of modern woman that Munch has captured, something of an unquenchable drive towards fulfilment, of desire for constantly finer differentiation, for life as an individually unique person, and yet for giving this individuality to a man, thereby fully to unfold and intimately enjoy this magic of personality.[42]

Carefully painting a series of concentric halos around her head to symbolize the attractive force emanating from her, Munch cast Dagny in the role of 'modern woman'. A sexually saturated image of artistic inspiration—life amid a blue ambience of death—this view of Dagny became eternally fixed, reappearing in other paintings but never again in the crystallizing genre of portrait.

In the same way, the 1892 portrait of Inger Munch had forever fixed his sister's image for Munch. Inger would be injected into other paintings, but always according to the same visual formula. Late in life, when Inger lived nearby and had aged significantly, Munch portrayed her in a woodcut—still showing her as she had appeared in that painting. Other portraits, such as that of Jæger, underwent similar repetitive transformations. For Munch and the remaining Schwarze Ferkel habitués, Schopenhauer was right: life, particularly life in the production-orientated bourgeois society of the late nineteenth century, was pain, and as pain had to be overcome; in art was salvation from life, from pain, from change. Art became a fortress of solitude against the penetrations of the outside world, a series of images of melancholic disinterest.

Dagny Juell was 'the element that caused the circle around the wine table to explode', wrote Paul.[43] Within days of her arrival virtually every one of the literary, artistic and scientific geniuses of the Schwarze Ferkel was in love with

68 *Portrait of Dagny Juell Przybyszewska*, 1893. Oil on canvas, 158 × 112 cm (59 × 44¼ in). Oslo, Munch–Museet

her: Munch, Strindberg (who contemplated breaking his wedding plans with another woman), Bengt Lidforss (who had known Dagny in Sweden), Przybyszewski (who nicknamed her 'Ducha'—Soul), and others. She played on their emotions and their jealous rivalry. Where previously heated discussions of the nature of woman, art and sex had dominated the conversations, now jealousy became dominant, not as a topic of discussion but as a real, overpowering emotion. The result was predictable. Animosity transformed into perpetual hatred the mutual love of friends and the fellowship of shared artistic convictions.

The bohemian cenacle of fervent writers, painters and scientists was unable to bear the strain. By the end of May, less than two months after Dagny's materialization, the men were desperately fleeing north, south and east. Strindberg eloped with Frida Uhl to the Helgoland; Munch sought out his paintings as they travelled to exhibitions in Dresden and Munich. Przybyszewski alone remained, courted Dagny, and went to jail, having given refuge to a Russian anarchist in the home he shared with his common-law wife, Martha Foerder, and their child. Love and a woman, not as the artists had perceived them but in their harsh reality, had triumphed over artistic fellowship and creativity.

The time seemed propitious for Munch in Germany. The critics of Dresden and Munich were kinder to Munch's art than those of Berlin, although true positive response was still lacking; his exhibitions were bringing in a small income and he sold several of his paintings to German collectors: 'All in all, I think I will make out well here in Germany, provided I am a bit frugal. I have a mass of rich friends down here', he wrote home, and sent money to his fatherless family.[44] Again, in spite of his father's fears that the profession of artist was impractical, the eldest son was fulfilling his traditional role of providing for the family whose head, even in absentia, he now was.

Munch felt that although German art consisted largely of depictions of 'seductively languishing women or battle scenes with rearing horses and shining cannon balls' that only cause revulsion in the viewer,[45] there were exceptions:

For example, Böcklin, whom I would almost rank above all other modern painters, Max Klinger, Thoma. Among musicians, Wagner; among philosphers, Nietzsche. France has an art that is greater than Germany's but no artists greater than these I named.[46]

These artists were also admired by Krohg, so Munch's taste for them probably predates his arrival in Germany. They were the artists of the generation of Naturalists, of Krohg's age or even older, who were the German precursors of Symbolism. They were also the artists whom the Schwarze Ferkel most admired, the 'great old men' who showed the way to 'the great young ones'.[47]

For Munch moreover, Klinger, Böcklin, Nietzsche and Wagner were also prototypes. Denounced by their contemporaries, they had stood alone, with only their faith in their artistic mission for consolation. However, they had all gained widespread acceptance and admiration at precisely the time Munch arrived in Berlin, and thus seemed to herald an optimistic fate for their melancholic Norwegian colleague. Despite Symbolism's doctrine of the isolated artist, maybe art could provide a living wage. Germany seemed the artist's promised land after all, and Munch's grandiose plans for a series of paintings devoted to the themes of love and death seemed very appropriate.

69 *Self-Portrait Beneath a Woman's Mask*, 1892–3. Oil on board, 69 × 43.5 cm (27¼ × 17¼ in). Oslo, Munch–Museet

In the spring of 1893 Munch announced his concern with these themes by altering a self-portrait painted a year before.[48] Rendered frontally, with careful attention paid to facial features that stand out in plastic three-dimensionality against an otherwise flat canvas, the original portrait was identical in its effect to that of the contemporary portrait of Inger. Around this image Munch now placed an ambience of harsh red, within which appear squirming black lines. He let streaks of the red cut into the forms of his body and, floating above or within this bloody red environment, at the very top of

the canvas, he painted a crude caricature of a woman's face, a mask with garishly painted lips, coarsely rouged cheeks, staring black eyes and with bat-like wings attached. The effect in this *Self-portrait Beneath a Woman's Mask* is similar to that in *Vision*, except that the peacefully floating swan has been replaced by the horrifying mask and the reflective blue surface of water by agonizing red. The idyllic swan of Symbolist and Neo-Romantic feminine muses, with its associations with mythological swan maidens or the swans of Apollo,[49] has been demonized. Similarly the watery milieu of *Vision*, which represented both the mirroring function of art and life's beginnings, is substituted by the interior of a bloody, sperm-filled uterus, the initial appearance of life that has been pierced by the artist's head. The result is a vision of enslavement in Schopenhauer's 'satanic hell of sexual attraction'. The 'slime and vermin' that Munch had earlier found under the water's shimmering surface now actually appears.

Such graphic symbolism, while certainly paralleling Przybyszewski's or Strindberg's literary vocabulary, may also have been a reaction to Rohde's criticism of his symbolic paintings. When Munch had announced to him his plan for a series of paintings, the Danish artist responded:

Such a picture as the one with the head in the water with swans [sic], I consider downright bad. I really have no idea what you intended to say with it. I also do not think much of the picture with the young man and the red evening sky.[50]

Despair and *Vision*, however, were precisely the paintings Munch viewed as most significant for his evolving series on love and death; they were the two images to which, from 1891 to 1893, he constantly returned in his writings, paintings and drawings. The self-portrait is a restatement and clarification of *Vision's* theme of artistic inspiration and the role of the artist, just as the pastel version of *Despair* made more overt the original mood of anxiety.

Similarly, Munch took up again in Berlin the motif of *Night* that had embodied his thoughts on life, death and art during the months spent in melancholic isolation at Saint-Cloud. In a drawing he depicted himself again in his pose of despondence, seated in front of his fireplace. While earlier he had been satisfied with this image and had let the blue ambience suffice as a symbolic reference to thoughts of death, this time he attached another image beneath it. Like the predella panel on a medieval altarpiece it depicts a corpse, not the corpse of the dead Christ as in its religious precursors, but the corpse of a woman with a foetus resting on her. Gases rise up from the rotting bodies, moving towards the area of the fireplace, and from there into the space where Munch, the artist, sits. The drawing again articulates Munch's Monistic belief in the metamorphosis of matter, much more overtly now than ever before, and his concern with the interaction of the worlds of death and of art.

The symbolic devices Munch inaugurated with his self-portrait and his reinterpretation of the *Night* motif function by associating two different, otherwise dissociated realms of reality. In Synthetist Symbolism and its related Decadent concepts of art, symbolic effect was achieved primarily by formal means of composition and colour, and by the process of associative meanings that could be generated by combining this abstract symbolism with a particular scene or motif. *Night* and *Jealousy* both concentrated on the theme of melancholy by making use of the traditional image of a figure seated with his head propped in his hands; this isolated individual was then combined with sombre colours thought to be inhibitory or sad. In this way, an 'art of memory' resulted that depended on the viewer's ability to recall the

70 *At the Fireplace: Metamorphosis,* 1893. Pen and ink with pencil. Oslo, Munch–Museet

situation from his own experience or, preferably, from art since this would be purer; and it depended on the colours and composition possessing a power to affect the viewer's unconscious responses located, according to the popular conception of the time, 'in the nerves'.

Munch did not reject this type of 'unconscious symbolism' in 1893; rather he fused it with a more palpable presentation of the symbolic image. *Night's* colouristic intimation of death through the colour blue was combined with a depiction of a rotting corpse whose vapours seem to enter the chamber of the artist-thinker. Objects derived from nature and from the artist's experience are juxtaposed, but in such a way as to induce the recognition of a visionary, not Naturalistic, world that defies laws of logic or nature and forces the viewer to read the images as symbolic. The practice harshly combines Munch's Naturalistic bias with his visionary intent.

The altered self-portrait was never exhibited by Munch, nor was the revised image of *Night* translated into a painting. Apparently, he remained dissatisfied with the symbolic devices he was developing. They were experiments, not solutions. The same sense of dissatisfaction is seen early in June 1893, when Munch returned to Berlin from his exhibitions in Dresden and Munich. He was organizing an exhibition of the Freie Vereinigung Berliner Künstler that

112

had formed in November 1892. To this renegade exhibition in the summer of 1893, he sent no new images, only a pastel copy of *Night* and several other small pastel drawings in tones of blue.[51] Most critics ignored the 'Secessionist' exhibition outrageously located in the Hohenzollern Panorama building whose murals none other than Werner had created. Even the few critics who took note of the show felt Munch was repeating himself, as indeed he was. 'To be honest, I've had enough', wrote Servaes. 'Now I know what Munch can do, and perhaps also what he cannot do. Now I want to see what else he can learn to do.'[52]

After the closing of the exhibition, late in the summer of 1893, Munch returned to Norway. The time in Germany had been one of debilitating turmoil, jealousy, anxiety and love, making concentration impossible. Now he entered a period of truly feverish and inventive activity. Within three months he had completed seven new paintings for his cycle devoted to love and death, and a month later he exhibited twenty-five new paintings and pastels in addition to numerous watercolours and drawings. Isolated in the village of Nordstrand on the Kristianiafjord during the autumn, he found the energy, determination, inventiveness and optimism to create as he had never before, with a defined goal: he set out to 'clarify life and its meaning to myself

71 *The Voice*, 1893. Oil on canvas, 87.6 × 107.9 cm (34½ × 42½ in). Boston, Museum of Fine Arts, Ernest Wadsworth Longfellow Fund (see p. 122)

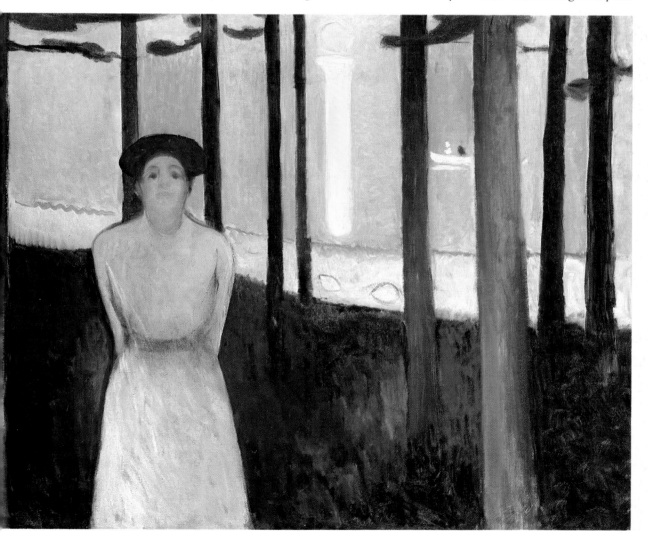

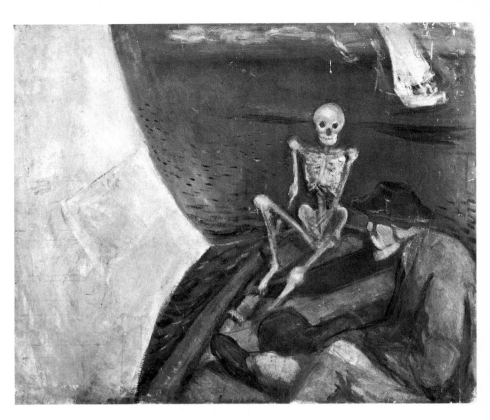

72 *Death at the Rudder (Yellow Sunset)*. 1893–4. Oil on canvas, 100 × 120 cm (39¼ × 47¼ in). Oslo, Munch–Museet

. . . and intended to help others explain life to themselves'.[53]

Munch's cycle of paintings was first presented to the public as six works, 'Studies for a Series: Love', when his third Berlin exhibition opened on 5 December 1893, in rented rooms on the fashionable avenue Unter den Linden. 'The exhibition is all set and I hope it will succeed', he wrote home a few days beforehand:

I hope too that I will be able to sell a little. I have numerous benefactors down here. There will probably be a horrible outcry over the exhibition, but surely that will not last too long. It is in a marvellous gallery and the pictures look extremely good, but probably the Germans will not understand it anyway. If only I can earn some money, it would really not matter.[54]

At the entrance to the exhibition, greeting viewers as they came up the steps to the second-floor gallery, was a large painting, described as *A Death* in the exhibition list. The motif of death entered Munch's art with an unprecedented directness, not only in this painting, but in several others at this exhibition.

The stooping, bearded form of his dead father reappeared in *Yellow Sunset*, seated in a boat being steered by a golden skeleton. The skeleton is an obvious emblem of death derived from Western European traditions; the painting was a modern variant on medieval Dance of Death imagery, such as several German artists were also exploring at the time (most significantly Klinger, with his two series of prints entitled 'Concerning Death', and Josef Sattler, who was among the artists supporting Munch at the Verein Berliner Künstler). Munch thus attached himself to a theme having artistic currency in Berlin, creating a virtual cliché in the manner of Böcklin's hybrid world of skeletons, centaurs and dragons. Once again he revealed his frustrated longing for popularity and acceptance. Nonetheless, the convictions of

114

Monism remained. *Yellow Sunset* presents Death as the guide who cheerfully, carefully and quietly steers the vessel of life towards its ultimate goal—both the sail and the skeletal figure of Death reflect the harsh yellow light of the life-giving sun. Death transforms, it does not terminate, life.

A similar message of life's continuity in death is conveyed by *The Dead Mother*, simply entitled *Death* in the exhibition list. It depicts a woman's corpse, her features echoing those of the corpse seen at the bottom of the Berlin *Night* drawing.[55] The crypt in which she rests is painted in deep tones of death's blue while through a large window is a lush green stretch of grass with trunks of birch trees, all illuminated by intense sunlight to create an ideogram of spring growth. In Monistic terms again, although the individual dies, the force of life is maintained; the body's substances decompose, return to nature, and continue the eternal, vital metamorphosis of material existence.

Death and *Yellow Sunset* complement the large painting introducing the exhibition. Its title, *A Death,* suggests that a particular event is depicted, and the fact that the figures in the painting are all easily identifiable as members of the Munch family confirms this. With Laura, Inger and Edvard in the foreground, Andreas at the left near the door, and Dr Munch with Karen Bjølstad standing at the right near a chair on which a figure is barely visible, the scene returns to memories of Sophie Munch's death, although it is far from a true reconstruction of the event, such as *The Sick Child* had been almost ten years earlier. Instead of showing himself as an adolescent, and his sisters and brother as even younger, Munch depicts everyone as they appeared in his art in 1893. The image of Inger fuses the 1892 portrait with her portrait in *Evening Conversation*, the painting of 1889 finally completed and exhibited in 1893 as *After Sunset*. Laura's image is derived from her appearance in the 1888 *Evening*, also included in the 1893 exhibition (perhaps because it too was altered?). The other figures may well derive from such sketches of

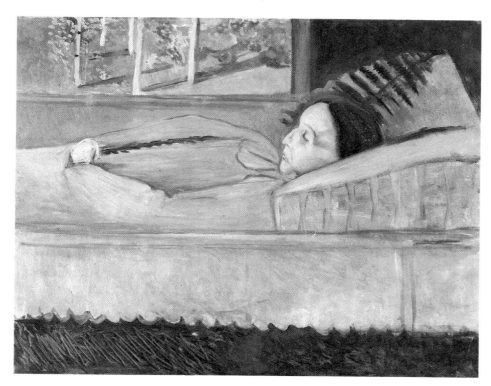

73 *The Dead Mother*, 1893. Oil on canvas, 73 × 94.6 cm (28¾ × 37¼ in). Oslo, Munch–Museet

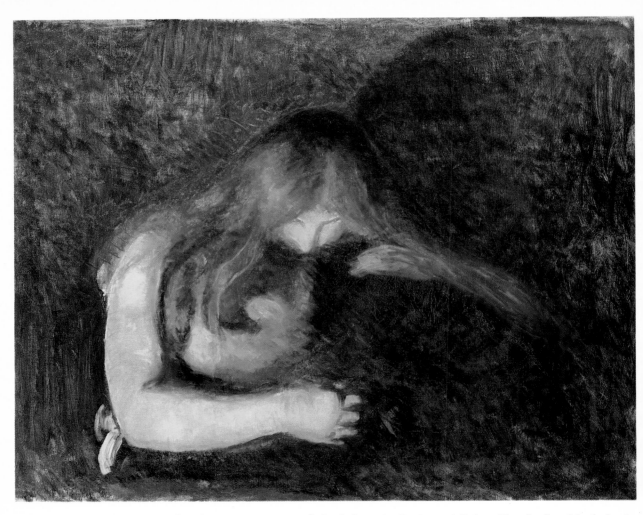

family scenes as Munch had done in Paris and Saint-Cloud after his father's death. It is the state of mind of the survivors that is depicted, not the mood or the specifics of death.

In *The Sick Child*, too, Munch had attempted to visualize not the emotion of the dying girl but the mood of hopeless despondency felt by the witness to death. The painting had been doomed to fail as his own technique, magnificent as it was, did not match his ambition. In 1893, technique and image fused more readily although the working process continued to testify to difficulties in conception. A quick pencil and pastel sketch rendered the initial image, with the figures already precisely placed as in the final painting; either lengthy and careful preparatory thought or lost sketches must have preceded it. Several of the figures were also sketched separately; then Munch duplicated the arrangement again, more carefully and precisely now in charcoal, placing a paper frame around the composition so that it could be included in his exhibition as testimony to his creative process. Empty space dominates, surrounding and engulfing the figures, who are frozen in their positions. The 'cut-out' figures with their hieratic poses, as well as the vast expanse of the blank paper, suggest that Munch was continuing to adapt the lessons of Post-Impressionist painting and print-making he had learned in Paris. Reminiscences of Toulouse-Lautrec's scenes from the Moulin Rouge or of Félix Vallotton's stark woodcuts have been arranged into a scene of existential isolation. Each figure alone confronts the terror of death and dying. In a pioneering study of the goals and premises of nineteenth-century art, Hermann Beenken wrote of Munch's painting:

74 Above *The Vampire*, 1893. 74 × 98 cm (30¾ × 38½ in). Göteborg, Konstmuseum

75 Opposite *The Scream*, 1893. Oil and gouache on board, 91 × 74 cm (35¾ × 29¼ in). Oslo, Nasjonalgalleriet

116

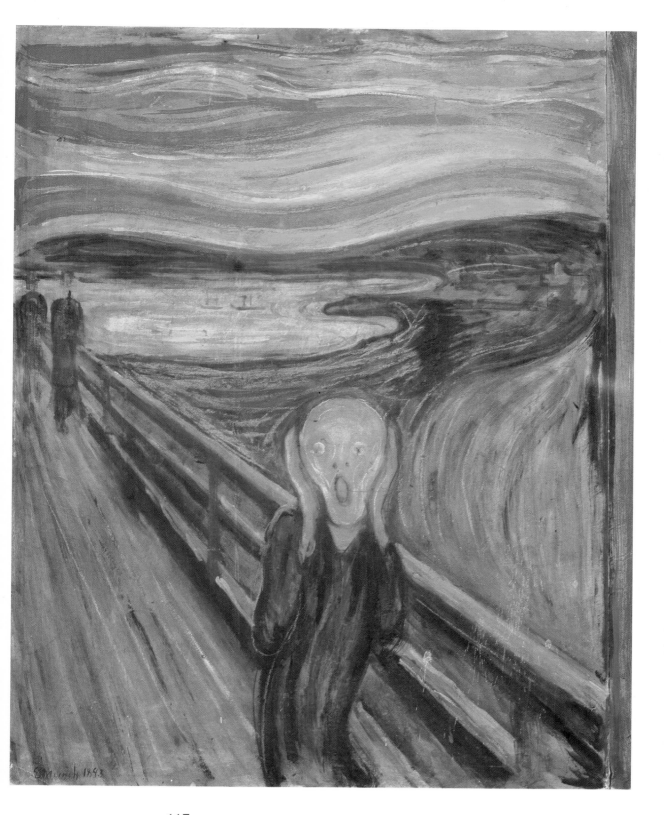

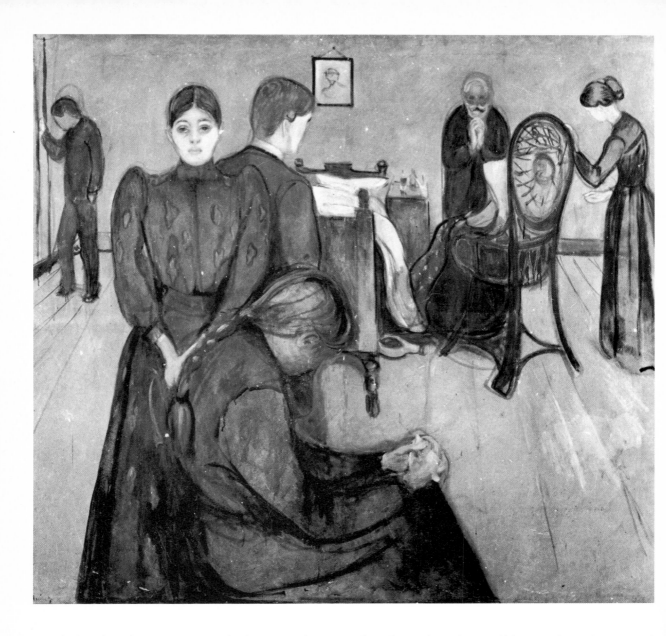

76 *Death in the Sickroom*,
1893–4. Casein on canvas,
150 × 167.5 cm (59 ×
65¾ in). Oslo,
Nasjonalgalleriet

Here death is something nameless that only makes itself known through its actual presence. All sense the silent presence of an existence that otherwise is not among them, and that now permeates and transforms everything, even life itself. ... No longer does death take possession of a person, the person takes possession of death, making it into his own personal death.[56]

Munch continued to alter the sketched compositions, adding colour in a pastel study on canvas. Finally, in the large canvas, he employed a technique new to him: casein.[57] As artists throughout Europe were rejecting both Naturalism and the traditional emphasis on oil painting's viscous surface, they began to use media with a less overtly sensual appeal. Since 1890, Munch had used paint extensively thinned by turpentine; in Berlin, he joined others in experiments with casein and tempera. For the Symbolists these had several advantages over oil paint. First, their mat pale surfaces and colours recalled the qualities of traditional fresco painting; secondly, unlike oil paint, they readily soaked into the canvas weave. With the fabric itself tinted, a unity of image and support was achieved which simultaneously de-emphasized the image itself. It was a Monistic and spiritual art whose very images were

deprived of sensual appeal in the effort to visualize ideas and moods, not objects.

Of the paintings in the exhibition, *A Death* attracted particularly favourable critical response. For the first time in his life Munch was starting to attain a degree of recognition among professional art critics and to have his work seriously analysed as art. The Berlin correspondent for the influential *Frankfurter Zeitung*, Willy Pastor, noted that in Munch's work 'the beginning is the result and the result is at the beginning'. He pointed to the framed study for the painting which revealed greater detail and greater apparent care in execution than did the final painting:

A quick colour sketch, harmonic but schematic and without expression: this was the starting point for the work of all previous artists. Ultimately a world of forms worked out in greater and greater detail would be brought into it.

The artist of today knows all these forms; they are something given even before he starts. He convinces himself of their existence in a quick first sketch. As if in the flashing focal point of a magnifying glass, he lets the innumerable lines of the external world come together here and ignite. But with the flame that rises up, he shines into the interior of his own soul, deeper and deeper he gazes into the chasms that gape there.[58]

Pastor attempted to present Munch not as an isolated artist but as one fitting into a tradition extending from Millet in France to Böcklin in Germany, or from Naturalism to proto-Symbolist Neo-Romanticism. Uniting them all was the shared modern sense of nature. Millet and Naturalism presented the external world to the viewer directly to make it comprehensible to the senses without any intermediary devices. Concerned with the inner driving forces of these appearances, Böcklin placed symbolic forms into his landscapes to represent his own emotive reactions to a scene.

In Munch's *Storm*, painted after the experience of a fierce storm during the summer in Norway,[59] Pastor saw a median point between pathologically

77 *Death in the Sickroom,* 1893. Charcoal. Oslo, Munch–Museet

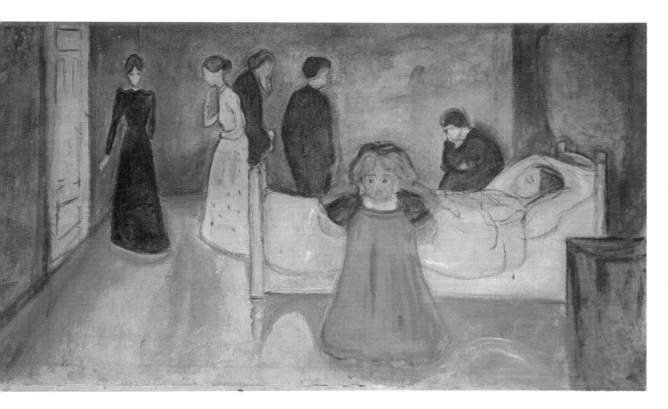

graspable emblems and the non-figurative Monistic art of the future that would permit any aspect of the experienced world, because of its absolute substantial unity with the human being, to function as an emotive symbol. Böcklin had also painted a storm, using it as the setting for a picture of a murderer plagued by his conscience. He needed such additional devices in order that an antagonistic audience might comprehend the meaning of his paintings, but, Pastor felt, the stormy landscape should have sufficed. According to him, Munch's *Storm* also represents:

a specific event in order to depict the threat and anxiety embodied in a powerful storm. The scene takes place near the ocean. Out of a festively illuminated beach villa, the forms of several women have just come. One of them, totally dressed in white, is rushing out ahead of the others. Is she a bride? Do the brightly illuminated windows indicate a marriage feast? And is the bride fearfully waiting for her groom? . . . The picture does not answer these questions. Munch has deliberately veiled the entire scene in the darkness of night. The human forms are not supposed to be distinguishable, their facial expressions are not intended to speak: the storm and the powerful language of nature are what is essential.

Munch understands this language, his pantheistic spirit speaks it fluently and clearly. Is it his fault when so-called art lovers are unable to get along without a translation?[60]

78 Opposite *Young Woman Embracing Death*, 1894. Casein on canvas, 128 × 86 cm (50½ × 34 in). Oslo, Munch–Museet

79 Above *Dead Mother and Child*, 1893. Oil on canvas, 100 × 90 cm (39¼ × 35½ in). Bremen, Kunsthalle

No previous critic had described Munch's intentions so closely. Munch sent a copy of the review home to his family, and others were passed around among his patrons and friends in Berlin. In response, Przybyszewski wrote encouragingly to his 'dear brother Edzin' that 'it is very, very good; in short, precise words your art cannot be better described. You see, someday it will all come, everything will turn out right.'[61] Przybyszewski had already planned to use his own article on Munch, published in the *Freie Bühne* in January 1894, as the lead essay in an anthology dealing with Munch's work. Servaes also

agreed to write an essay, and frequently visited Munch's studio to gain insight into his work. A young engineering student who was writing a novel and seeking to transfer his professional loyalties to art criticism, Julius Meier-Graefe, contributed a second essay. Maximilian Harden, editor of the periodical *Die Zukunft* ('The Future'), apparently was to contribute an article as well; when he failed to do so, Pastor's essay was incorporated unchanged into the book. After numerous delays, Ibsen's publisher, S. Fischer, released the book in July, too late however to generate the hoped-for publicity for Munch's 1894 exhibitions in Hamburg, Dresden, Frankfurt and Leipzig.

Of the paintings Munch exhibited in December 1893, the ones all four critics in Przybyszewski's anthology most consistently praised belonged to the studies for the 'Love' series. There were six works in all, some of them completed, others still in progress: *Dream of a Summer's Night, Kiss, The Face of a Madonna, Love and Pain, Jealousy,* and a final version of *Despair*. *Jealousy* was the painting developed in 1892 from the vignette for Goldstein; the others (with the possible exception of *Kiss*) were all new paintings, except for *The Face of a Madonna* which was a pastel study. They differed widely in style and technique as Munch continued to suit his formal vocabulary and its means to the content of his images. Feathery, quasi-Impressionist brush-strokes form the ambience of *Love and Pain; Dream of a Summer Night* emphasizes broad flattened forms; and *Despair* uses a complex mixture of oils, pastels, casein and charcoal on a cardboard panel.

Later called *The Voice, Dream of a Summer Night* was Munch's first attempt to represent symbolically the psychology of puberty. His portrait of Inger in her confirmation dress in 1884 had done so in a more Naturalistic manner, and his interest in adolescence remained constant thereafter. In 1889, under the title *A Model's First Pose,* he had shown a young girl seated on her bed: a shy, naked adolescent self-consciously posing for her male portrayer. The influence of Jæger's erotic titillation that treated young girls only as charmingly amusing pupils for the doctrine of free love is apparent, but by 1893 it was transformed into a sincere sense of compassion, both in *Dream of a Summer Night* and in a painting entitled *Puberty*.

The latter duplicates the scene of *A Model's First Pose*. However, by accenting the girl's adolescent angularity, her overly long arms self-consciously crossed in front of the pubic area, and her widely staring, fearful eyes, Munch created a study of adolescent anxieties such as he may have recognized in his own sisters' troubled puberty. He intensified the mood of terror by projecting a large, almost blatantly phallic shadow on to the wall behind her, making hidden sexual implications explicit.

Przybyszewski provided the most detailed analysis of all the paintings in the 'Love' series, certainly reflecting Munch's own thoughts.[62] Of *Dream of a Summer Night* he wrote:

The objective scene is nothing more than an accessory, but the mood is intensely effective. It is the longing of puberty. It is born suddenly, it grows, expands, dissolving into formlessness; it rolls here and there and sinks together and screams out for shape and form. And then it can happen that the sky and the earth dissolve into each other, and that the trees turn into green telegraph poles, and everything rotates in a whirlpool, and the blood boils and the eyes. This is the longing of becoming and beginning, the entire painful longing of growing up . . . the fear of tense expectation: the intense listening-into-yourself, half horror, half pleasure in the sensual subterranean areas of sexual arousal.

This description incorporates aspects of *Puberty,* and in the process some-what distorts Munch's original intended meaning. Set in the mystic light of a

Norwegian summer night, traditionally the time of courtship, *Dream of a Summer Night* is more an image of feminine attraction. A young man's 'longing of puberty', not the young woman's, is depicted as each viewer is transformed in the confrontation with her into a lover gazing into her deep eyes. Munch himself recorded an incident during his own adolescence when, to gaze into a girl's eyes, he had to stand on a stone; the painting transformed this anecdote into a more universal commentary on the beginnings of sexual attraction. In a series of drawings based on the painting, the lips and body of the girl disappear completely. Only the eyes remain as unfathomable emblems of the initial force bringing man and woman together in Munch's evolving drama of love.

The Kiss reiterated a theme and composition on which Munch had worked

80 Above *The Kiss, c.* 1893. Oil on cardboard transferred to canvas, 99.5 × 81 cm (39¼ × 32 in). Oslo, Munch–Museet

81 Right *The Young Model (Puberty),* 1894. Lithograph, 40 × 27.5 cm (15¾ × 27½ in). Oslo, Munch–Museet

82 Above *Starry Night*,
1893. Oil, charcoal and casein
on canvas, 135 × 140 cm
(53¼ × 55¼ in). Wuppertal,
Von der Heydt – Museum
der Stadt (see p. 137)

83 Opposite top *Woman in
Three Stages (Sphinx)*,
1893–5. Oil, charcoal and
casein on canvas, 164 ×
250 cm (64½ × 98½ in).
Bergen, Rasmus Meyers
Samlinger (see p. 138)

84 Opposite bottom
*Evening on Karl Johan's
Street*, 1893. Oil on canvas,
85 × 121 cm (33½ ×
47½ in). Bergen, Rasmus
Meyers Samlinger

for three years, beginning with the anecdotal drawing *Adieu*. In paintings of the embracing couple, he continuously sought to extract the incidental temporal aspects of the drawing so as to have them function as more universal symbols of lovers 'in that moment when they are not themselves', as he had written in Saint-Cloud. In Nice in 1892, he completed the large painting *The Kiss* (included in the Tostrup and Verein Berliner Künstler exhibitions), which presented the sexual alternative to *Night's* depiction of an artist's sterile generation of new life. The new painting, on cardboard rather than canvas, reduced the overt associations with *Night* by focusing almost entirely on the embracing couple, minimizing the concern with the interior setting while also avoiding the sense of space and Impressionistic atmosphere whose remnants were still present in the Nice painting. Munch also now used a vertical format, the rising and upward movement simultaneously implying spirituality and phallic erections. The fused form of the man and woman has been placed in the centre. The window pushed to the left appears as a single harsh accent of light, space and viscous pigment in the otherwise dark, uniformly coloured surface painted with thinned, watery pigment; more than anything else it is the directionality of brushstroke, aided by scratches produced with the brush

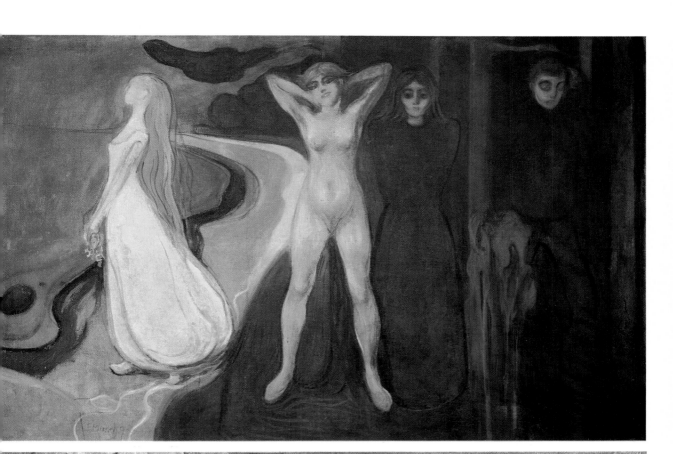

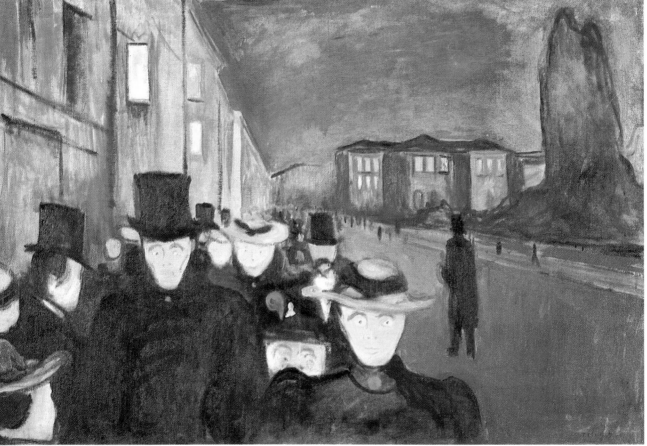

handle in the pigment, that defines the presence of the figures, preventing their total absorption either into each other or the ambience surrounding them. In no previous painting had Munch applied his insistence on a Monistic unity of surface so harshly and drastically.

Przybyszewski wrote:

We see two human forms whose faces have melted together. Not a single recognizable facial feature remains; we see only the site where they melted together and it looks like a gigantic ear that became deaf in the ecstasy of the blood, it looks like a puddle of liquefied flesh: there is something repulsive in it. Certainly this manner of symbolizing is unusual; but the entire passion of the kiss, the horrible power of sexuality, painfully yearning longing, the disappearance of the consciousness of the ego, the fusion of two naked individualities—all this is so honestly experienced that we can accept the repulsive-unusual.

Przybyszewski's commentary is apt, not only for the intermeshed figures but for the entire painting. Munch totally subsumed formal concerns to the message to be conveyed. The form of the two kissers functions much like the image of Munch himself in his *Self-Portrait Beneath Woman's Mask*, while the interior space behind the woman serves as a shelter for spermatozoal shapes with embryonic faces. Realities are juxtaposed—exterior and interior, society and individuals, public and private, present and future, light and dark—in a grand Monistic mingling whose vital principle was synthesized in sexuality. In sexuality the ecstasy of life mingled with pain and anxiety; life was generated, but individuality was lost, and in submission death was approached.

The meanings projected by *The Kiss* were echoed and amplified in the third painting of the 'Love' series. According to Przybyszewski:

It is a woman in a nightshirt and in the characteristic attitude of absolute submission so that all sensations of her organs become eurhythms of intensest lust. A madonna in a shirt on crumpled sheets and with the halo of the approaching martyrdom of birth. A madonna captured in that moment as the mysterious mystique of the eternal passion of regeneration lets a flood of beauty beam in the woman's face as all sublimity enters her consciousness and the cultural man with his metaphysical desire for everlasting life meets the beast with his passionate destructive drive.

There exists no one work that corresponds precisely to this description; it seems likely that Przybyszewski fused two Munch images, one a pastel depicting a reclining model, the other a charcoal sketch showing the same model in a similar pose but totally naked and with a halo drawn around her head. What Przybyszewski described was an image in the process of transition, to receive final formulation at the time of the 1893 Berlin exhibition or shortly thereafter. Servaes' description of *The Face of a Madonna* in Przybyszewski's anthology is of the painting now known as *Madonna*:[63] 'It is the moment shortly before the greatest ecstasy of love and the most sacred submission. Woman, approaching her most holy fulfilment, attains a moment of supernatural beauty so that the male lover, experiencing this view, can attain the vision of a madonna.' Direct ancestor of the image was the nude *Hulda* (1886), which had accompanied Jæger to prison. Naturalistically rendered, *Hulda* depicted a woman's body as hedonistically orientated, lacking thoughts beyond physical pleasure; it was a celebration of Milly Thaulow. By 1890 Munch's feelings had changed; not her breasts and hair, but her lies, infidelity, destruction of his innocence and ability to generate

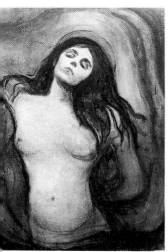

86 Sketch: *Madonna*, 1893. Charcoal, Oslo, Munch–Museet

87 *Madonna*, 1894–5. Oil on canvas, 91 × 70.5 cm (35¾ × 27¾ in). Oslo, Nasjonalgalleriet

88 *Ashes*, 1894. Oil on canvas, 121 × 141 cm (47½ × 55½ in). Oslo, Nasjonalgalleriet

insane states of jealousy became the focus of his attention. The Schwarze Ferkel milieu further contributed to this alteration of viewpoint. Munch came to associate directly the destructive forces of a woman's love with her ability to generate new life. As *The Kiss* also illustrated, the 'spirit of life' was revealed in the 'horrible cosmic power' of sex.

In his novella *Totenmesse* ('Requiem Mass'), Przybyszewski fused extraordinary sensuality with religious vocabulary to propagate a Monistic gospel that equated spirituality and sexuality, and celebrated the physiological immortality resulting from sexuality. It was a paean to Dagny written while Munch worked on the painting *Madonna* as well as on a poetically descriptive text to accompany it:

The pause as all the world stops in its path. Moonlight glides over your face filled with all the earth's beauty and pain. Your lips are like two ruby-red serpents, and are filled with blood, like your crimson red fruit. They glide from one another as if in pain. The smile of a corpse. Thus now life reaches out its hand to death. The chain is forged that

binds the thousands of generations that have died to the thousands of generations yet to come.[64]

The painting also emphasizes that woman is a link in the chain of biological immortality. Naked, she is surrounded by a vague, fluid-like ambience whose colour suggests the form of a womb acting as an archetypal enclosure. Her features are no longer those of an anonymous Berlin prostitute, but reminiscent of Dagny or possibly her sister, then expecting a child.[65] The frontal pose forces the viewer's participation, transforming him—as in *The Voice*—from voyeur into sexual partner. A frame originally transformed the image into a triptych with sperm on one side and a cowering embryo on the other.[66]

Munch has symbolized the moment of conception, as past and future are joined, by resorting again to the juxtaposition of two distinct realities. The woman is depicted in a moment of sexual ecstasy from the viewpoint of her lover looking down at her as their bodies are fused. He would see neither his nor her genital areas but, where hers would be, the stylized spermatozoa of the—no longer extant—frame begin to appear. The other element in this secular triptych of eternal life is the embryo, the 'red fruit' of the woman to which she gives birth after her union with man. All three components of the symbolic message are valid in the Naturalistic terms which Munch continued to employ; together they also generate a new, symbolic reality.

The concept of suffering in love became yet more explicit in the fourth painting of the series, *Love and Pain*, which was likewise the culmination of years of effort to attain an appropriate universality for an intensely personal experience. In describing the 'final' version (Munch created numerous copies of it throughout the 1890s) Przybyszewski also suggested the new title, *Vampire*, which Munch used after the 1893 exhibition:

A man who has become submissive, and on his neck a biting vampire's face, the background, a remarkable and chaotic mixture of blue, violet, green, yellow spots of colour melting into each other, flowing, layered next to each other, and sharp like small crystalline forms. There is something horribly peaceful, bereft of passion in this painting; an immeasurable fatality of resignation.

In 1932 Munch wrote to Thiis that the first sketches for *Vampire* were contemporary with *The Sick Child*—1885 to 1886—but his memory deceived him. The first drawings of the motif date from 1890 and correspond to an 'intermezzo' Munch wrote in one of his notebooks:

He sat with his arm around her body. Her head was so near to him. It seemed so remarkable to have her eyes, her mouth, her breasts so near to him. . . .

And he laid his head between her breasts. He felt her blood stream through her veins. He listened to the beat of her heart. He buried his face in her lap. She lowered her head down over him and he felt two warm, burning lips on his neck. A shudder passed through his body, a shudder of voluptuousness. And he pressed her convulsively to him.[67]

In the painting what began—in Munch's words—as 'simply a woman kissing a man on the nape of his neck' becomes an image of demonic, oppressive eroticism and sexual antagonism.[68] The transformation is documented in numerous drawings, a pastel, several watercolours and a variety of semi-poetic texts recording Munch's constant melancholic contemplation of his initial experience with Milly Thaulow. As in *The Kiss*, the specifics of an incident had to be abstracted. In the painting, the deep blue colouring, together with the flattened rendering of the man's and woman's forms,

translate the scene from the ordinary to the demonic. The sharp colour contrasts of red hair and green-yellow skin are caught in an intense light that casts a massive, engulfing shadow over the two forms, completing the construction of an ominous, threatening silence.

The final effect not only surpasses the anecdotal quality of the 'intermezzo', it also seems counter to Munch's intentions in studies related to the painting. In these, the confrontation of the man (Munch himself) and the woman (a Berlin prostitute) remains, but its nature is different: the man gently bends towards her breasts to find not destruction but comfort. According to Munch's written recollections, the prostitute became a substitute for 'Mrs Heiberg' after she ceased to bring the comforting nearness of her body to him. Munch quickly discerned the prostitute's gestures to be empty ones, however, and felt revulsion:

She bent down towards him so that her cheek touched his. Slowly he moved his head away so that their mouths would not meet. He moved away. How repulsive he thought she was.[69]

A woman's closeness was an ambivalent experience for him, certainly partly because of the middle-class, 'cultural aristocrat's' feeling of revulsion towards the lower class represented by the prostitute.[70] The sketch containing the Berlin prostitute reaffirms this, but places the blame firmly on the woman. As Munch gently bows towards her massive breasts, she is rigidly stiff, unmoved and unmoving, and gazes through narrow eyes from a mask-like face not unlike that of the *Self-portrait Beneath Woman's Mask*. No contact other than physical is made: the two remain alien. His experiences with prostitutes could only have increased Munch's sense of isolation and alienation, mirroring in a personal sphere his public role in the world of art. Love and pain, as he suggested in his original title, were closely associated for him.

The proportions of suffering and joy in Munch's pictorial litany of love become yet more unequal in the next painting, *Jealousy*. The unfamiliar title was attached to a familiar painting, the last of the depictions of Jappe seated alone at the seashore. Perhaps Munch reworked the painting somewhat for the 1893 exhibition, but essentially it was the sole one created before his arrival in Berlin that was suitable for inclusion in the 'Love' series. Like the other works in the cycle, it represented a deeply personal experience transformed into a universal one, and provided a commentary on the analogy of sexual and artistic creation. Moreover, its emphatically Synthetist style matched his concerns in 1893, while earlier versions of *The Kiss*, for example, still adhered to a more Impressionist orientation that made new paintings necessary.

'All the stupid, stiff and barren brooding of passion transformed into the insane idiocy of despair is contained in this picture', Przybyszewski wrote, using a vocabulary whose vulgarity does not suit the Symbolist musicality of Munch's picture. 'In this way', he continued, 'a landscape is imaged in the mind of a hominid who loses his little bitch of the most intimate natural selection to someone else; this is the wild, primeval battle for the woman today changed into no more than cultured tristesse, cowardly, stupid, resigned brooding.'

The sense of violent archaism befitting a style unlike that of Munch's *Jealousy* was found by Przybyszewski in the last of the paintings in the series, a new and final version of *Despair*. As with *The Voice* and *Vampire*, Przybyszewski's description inspired Munch to change the title, this time to *The Scream*:

On a bridge, or something like it—it really does not matter exactly what is depicted—there stands a fantastic creature with mouth agape. The hero of love must not exist anymore: his sexuality has crawled out of him and now it screams through all of nature for a new means of manifestation in order to do no more than live through the same torture, the same battle all over again. There is something horribly macrocosmic in this picture. It is the closing scene of a horrible battle between mind and sex out of which the latter came triumphant. ... The mind has been destroyed, and sex, the primevally eternal, screams out for new victims.

Painted on cardboard in a totally unorthodox mixture of oils, pastels and casein, *Despair* imitates the composition of the pastel created earlier in 1893, but the lines have become more fluid so that the figure loses all characteristics of human anatomy, twists like a worm, bends to the curves of the fjord landscape, and cuts through the railing into a whipping curve. The last remnants of a Decadent melancholic pensiveness were destroyed, to be replaced by intense agitation and loss of balance. Coming as the termination of a thought process inaugurated in 1890, *Despair* is autobiographical, but it is an autobiography that transforms a drunken experience of agoraphobia on Ljabroveien into a visual symbol of schizophrenic anxiety. On one of the stripes in the vibrant sky, Munch scratched in pencil, 'Can only have been painted by someone gone mad', the final chapter in his pictorial mythology of love.

Munch expanded the 'Love' series during 1894 and the following years, but these six paintings remained the essential core to which the new images would add thematic variations. Munch expected this cycle to be the masterpiece of his life, and he worked on the individual panels feverishly during the early months of 1894, rushing to complete his life's task, attempting to elude the early death he feared. Also encouraged by the favourable reviews of his exhibition by Przybyszewski, Servaes and Pastor, with money—admittedly borrowed—available, Munch rented rooms large enough to function as studio and sleeping quarters on the second floor of Frau von der Werra's pension at Albrechtstrasse 9. When not working, he spent much of his time with Przybyszewski and Dagny, who had married in September 1893 after Przybyszewski abandoned his common-law wife and infant son. The final version of *Madonna* was only one of many paintings Munch created with the encouragement and under the influence of the newly formed bohemian home that winter and spring in Berlin. It was a period of furious creativity, similar to those of 1885 and of 1891 to 1892, but in quantity and quality far surpassing them.

In order to evolve his 'Love' series beyond the images of the first six paintings, Munch turned to earlier pictorial projects, specifically to his proposed vignettes for books of poetry by Goldstein, Krag and Obstfelder. Previously he had lacked the formal means and conceptual framework to translate the drawings into successful paintings. Now the painful gap between conception and execution was finally closed, and optimistically Munch announced once again: 'This time the public will be able to understand my paintings better.'[71]

The painting *Separation* demonstrates both the rapidity of Munch's progress and his ability to draw together disparate thoughts from earlier sketchbooks to arrive at a new conception. When Servaes visited Munch early in 1894, he saw 'a dimly lit landscape with a naked man and a naked woman':

As if rooted to the ground, the man stands stiffly beneath a tree; the woman, with cat-like, slow steps, turns quietly and calmly towards the sea. The red-gold glory of her

89 *Young Man with Prostitute*, 1893–4. Charcoal and watercolour, 50 × 47.5 cm (19½ × 18½ in). Oslo, Munch–Museet

131

90 *Separation*, 1894. Oil on canvas, 97 × 128 cm (38¼ × 50½ in). Oslo, Munch–Museet

hair almost touches the ground, and the man stares as if bewitched at the magically undulating flood. One strand has freed itself and reaches like a halter towards him from the woman's head, entwines itself around his neck, falls upon his chest, grows fast with a thousand roots into his heart. Perpetually, the red-gold coils chain him to the withdrawing woman. Vainly he places his hand on his convulsion-filled heart.[72]

This description refers either to a lost work or, more likely, is Servaes' transcription of Munch's own thoughts on a painting still in progress. By April 1894 an anonymous critic wrote in Kristiania's *Morgenbladet* of a related study: 'One sees in one picture a woman dressed in mystical white and standing in a garden while a melancholy man is placed under one of the trees.'[73] The final painting fuses both these images, as well as incorporating elements from earlier drawings. The melancholic man reinterprets the 1892 representations of an artist-poet's melancholic process of creation. The man grasping at his heart as it beats in convulsion and bleeds is not only the deserted lover, but also the artist. His art is 'his own heart's blood' that drips on to fertile soil to sprout forth in a blood-red plant: Goldstein's *alrune*, the mandrake that was both the flower of painful love and the flower of art.

The woman, meantime, turns away towards the sea—another visual metaphor of both life and art, as Munch indicated in his various *Vision* images and texts. The appropriateness of this symbol may have been reinforced in Munch by Przybyszewski's readings in Cabbalistic texts. When Munch, in his Berlin writings, refers to the sea's horizon and the question of what lies behind it, he is echoing the Zohar's metaphor of the creative deity as a shoreless sea that draws life from the matter beneath its depth while renewing its spirit from above.[74] The 'new mysticism' that Munch had discovered in Monism was being embroidered by more traditional mystic thought.

The motif of anxiety, as in *The Scream*, appeared again in *Evening on Karl Johan's Street*. An often used setting for Munch's paintings and experience, Kristiania's major thoroughfare embodied the individual's terrifying sense

that the anonymous faces in the encroaching crowds represented an insurmountable threat. It is a scene related to Munch's recollections of 1890, recording his crazed searches for Milly Thaulow and the threat of 'the horrible face of mental illness'. Turning to another painting, Munch combined the mask-like faces of *Karl Johan's Street* with the setting and exaggerated perspective of *The Scream* to create *Anxiety,* a transmigration of motifs and compositions testifying to Munch's perception that all the paintings derive from and compose an essential unity. Even in repetition, the concepts of Monism were present.

The new paintings also expanded on the meanings of the initial six by shifting aspects of them into new contexts. For example, the pale young woman clothed in white in *The Voice* reappeared in *Separation* facing the sea, the shared setting of both paintings. More ambitiously, the concept of woman herself having to approach death in childbirth—one of the meanings projected by *Madonna*—was expanded into a new tripartite painting in casein, *Young Woman Embracing Death.* 'In the centre', according to Servaes, 'Death [is] kissing an eager woman, a symbol of that death-anguish which is aroused by highest love and approaching birth. But then, so as to be definitely clear, on the one adjacent dark violet stripe Munch painted twitching sperm, and on the other, two staring embryos with large heads and emaciated bodies.'[75] Within the relationship of the sexes, for Munch the potential of death was multiple: both man and woman could suffer a metaphoric death as they lost the conscious sense of individuality in the ecstasies of intercourse, the man could die psychologically in the debilitating anxiety of despair, and the woman could suffer physical death in childbirth or, as did Munch's own mother, from the indirect effects of pregnancy. In the context of the times, Munch's was an extraordinarily compassionate statement on woman's role, not the purely misogynist one Strindberg, for example, propagated.

The optimism of the winter and spring of 1893 to 1894 that engendered Munch's remarkable creative outburst slowly ended. He exhibited in Hamburg and Frankfurt, but other exhibitions he had hoped for did not materialize. Money once again became scarce, despite the help being given by a young German nobleman, Baron Eberhard von Bodenhausen, who was sent

91 *Separation Triptych, c.* 1895. Pencil and ink. Oslo, Munch–Museet

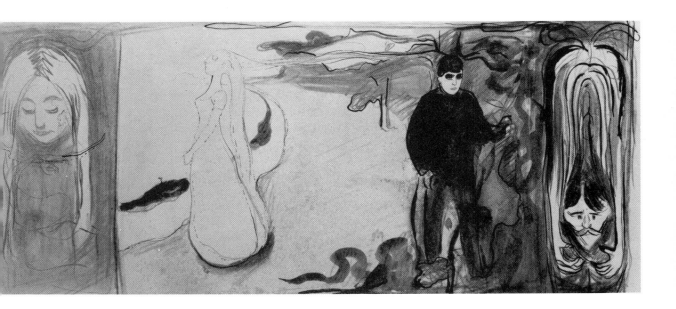

92 *Evening on Karl Johan's Street*, 1892–3. Pencil and charcoal. Oslo, Munch–Museet

to Munch by Przybyszewski in April. Canvas for additional paintings ran out; his family needed money; Norway's relationship with her sister-state Sweden deteriorated so much that war seemed more and more likely; his brother Andreas, recently finished with his medical training, was planning to marry a woman the family deeply disliked and distrusted. Using money earned from a portrait of Bodenhausen, Munch returned to Norway in May with Dagny and Przybyszewski, whose money ran out even before his. He settled in Feltveldt, where Przybyszewski visited him in early July:

I stayed a week with Munch. He has wonderful new pictures, among them a variant [of an earlier work—which one is not known] that is absolutely grandiose. He made a portrait of me absolutely fabulous in its powerful psychic presence. He's a most congenial guy, but life is miserable for him right now. In Kristiania he hopes he will be able to make some money.[76]

The money was not forthcoming, however, and Bodenhausen's generosity

alone saved Munch's entire summer's production from being confiscated by an irate landlord. The letters of both Munch and Przybyszewski testify not only to financial difficulties, but to the sense of absolute isolation both of them felt in Kristiania. However, by the end of the summer Munch had expanded the 'Love' series to at least seventeen paintings.

In September, Munch went to Stockholm where Helge Bäckström, Dagny's brother-in-law, had made arrangements for an exhibition.[77] He took with him sixty-nine paintings to provide a full review of his career, but in the rush to leave Norway forgot to clear out his atelier, a task he hurriedly asked his brother to perform for him. Again he hung the paintings himself, subdividing the exhibition into five sections: 'Paintings from Paris and the Riviera'; 'Portraits'; 'Figure Studies, Interiors and Landscapes'; 'Mood Paintings'; and 'Studies for a Series of Mood Paintings: Love'. Emphasizing the paintings from France and his skill in portrait-painting, Munch continued to keep at least one eye on the marketability of his works, but he also sought to clarify the serial nature of his more ideological imagery.

For the first time, he attempted to present his images of death in a coherent manner: within a subsection of his mood paintings seven were devoted to death and dying: *Spring*, *The Sick Child*, two versions of *A Death* (now called

93 *Portrait of Stanislas Przybyszewski, c.* 1893. Oil on canvas, 62 × 55 cm (24¾ × 21¼ in). Oslo, Munch–Museet

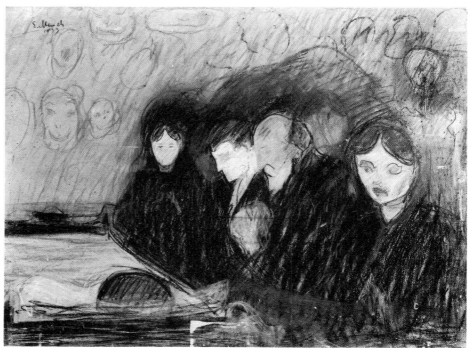

94 Right *The Deathbed (Fever)*, 1893. Pastel on board, 60 × 80 cm (23½ × 31½ in). Oslo, Munch–Museet

95 *The Deathbed (Fever)*, 1893. Ink and pastel, 11.5 × 17.7 cm (4½ × 7 in). Oslo, Munch–Museet

Death in the Sickroom), *Death and Springtime, Death and Life*, and *Fever*. Using casein and tempera, as had been his practice throughout the summer, and leaving strong strokes of charcoal visible through the painting, in *Death and Life* Munch combined the view of the dead woman (here exhibited as *Death and Springtime*) and *Death in the Sickroom*. The various family members are again seen reacting to a death, but now the corpse is most emphatically visible. The central focus of the scene, however, is a young girl in the foreground, her hands raised to her head and her mouth opened in a scream that expresses both the horror and incomprehensibility of death in the midst of life. *Fever*, already completed in its pastel version for the 1893 Berlin exhibition, presented a similar emotion, but from the viewpoint of the sick person as Munch recalled his own repeated illnesses, his family gathered around his bed while murmuring desperate prayers, and his own hallucinations of ghosts, skeletons and devils grasping for his young doomed soul.

Fifteen paintings comprised the 'Studies for a Series of Mood Paintings: Love'. To unite conceptually the paintings of his series, Munch now organized them in sequence to present a narration of events in a love affair, and provided them with a plot outline:

The paintings are moods, impressions of the life of the soul, and together they represent one aspect of the battle, between man and woman, that is called love.
 From its beginnings, where it is almost rejected, then paintings . . . of Kiss, Love and Pain, where the battle has then begun. . . . The woman who gives herself, and takes on a madonna's painful beauty—the mystique of an entire evolution brought together: woman in her many-sidedness is a mystery to man—woman who simultaneously is a saint, a whore and an unhappy person abandoned.
 [Then] Jealousy—a long empty shoreline.
 The woman's hair has entwined and entangled itself around his heart.
 The man is very disturbed by this battle . . . insane mood—nature to him appears as a great scream in which blood-red clouds [are] like dripping blood.[78]

The series, judging from Munch's description, thus fell into distinct but interrelated sections: the stirrings of erotic attraction; the initial encounters

and sexual embraces; the woman as madonna and mystery; jealousy with its aftermath of despair.

Three paintings formed the initial phase of the evolution of love. The mystical view of a *Starry Night*, rendered in Whistlerian tones of blue, green and silver, sets a contemplative and melancholy mood, and its nocturnal view of the Kristiania Fjord again recalls Munch's identification of the sea as both the Cabbalistic source of life and a simile for artistic creation. The painting is a synthesis of the message of *Vision* but uses colour and the associations of evening to carry the hieroglyphic intent.[79] *Man and Woman* or *Eye in Eye* presented the participants of Munch's tale of love standing beneath a tree in a garden, gazing steadfastly into each other's eyes. Then Munch introduced the first of the paintings from the 'Love' series in the previous year's Berlin exhibition: *Dream of a Summer Night*, now retitled *In the Forest*.

Munch's text, 'How Love Grew', provides a poetic commentary on these three paintings:

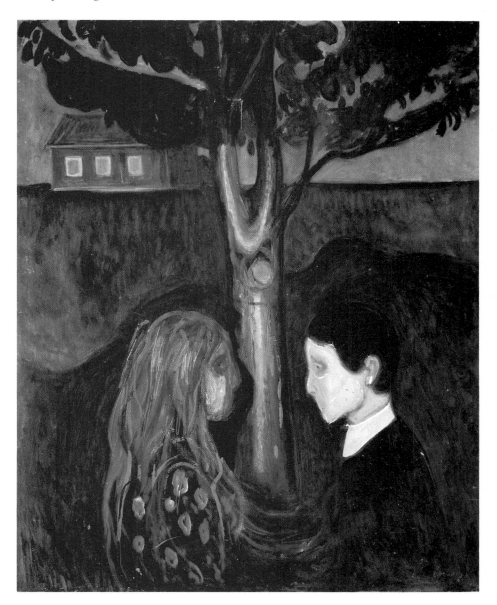

96 *Eye in Eye*, 1894. Oil on canvas, 137 × 110 cm (54 × 43¼ in). Oslo, Munch–Museet

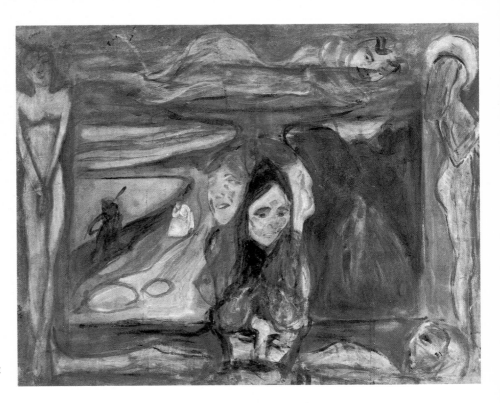

97 *Symbolic Study*, 1893.
Gouache, 56 × 68.5 cm (22 ×
27 in). Oslo, Munch–Museet

A summer's night.
 Nature presented to you of her beauty, and then the summer night shone nobly golden on to your face and hair.
 Only your eyes remained dark and sparkled with a mystic glow.
 And Nature was beautified by you. . . .
 The stones took on life and began to move. In the forest's damp darkness, creatures were born. . . .
 The moon turned yellow. A golden column appeared in the water and grew and swelled. It melted in its own glowing light, and the yellow flowed over into the water.
 Our eyes met, and then invisible hands wove fine wires that passed through your large eyes and into my eyes, and bound our hearts together.[80]

In the Stockholm exhibition the motif of 'woman as madonna and mystery' was represented by *Madonna* and *Young Woman Embracing Death*. A third work, entitled *Sphinx* in the catalogue (and there accompanied by a line from Gunnar Heiberg's recent play, *The Balcony*: 'All others are one, only you are a thousand'), coalesced woman's many-sidedness into three female personifications. The white-clad maiden again gazes out towards her element, the life-giving sea. In the centre is a restatement of the *Madonna* theme, a naked, red-haired and grinning woman with her legs spread wide apart who harshly confronts the viewer. The third figure seems an aged, pale image of Inger Munch with eyes downcast, clothed entirely in black, her hands behind her back in a gesture of withdrawal. To their right, separating their world from the sombre world of the man-artist, are a tree and a blood-red *alrune* (Munch used this title for the painting in 1903) which gains its bloody nourishment from the earth where rotting bodies lie. Beyond stands a man in an indecisive posture of melancholy, his left hand raised to his head, his right apparently reaching towards the sprouting plant.[81]
 Munch had previously used much of this symbolic content; the image summarizes the triple statements of universal genesis, sexual generation and

138

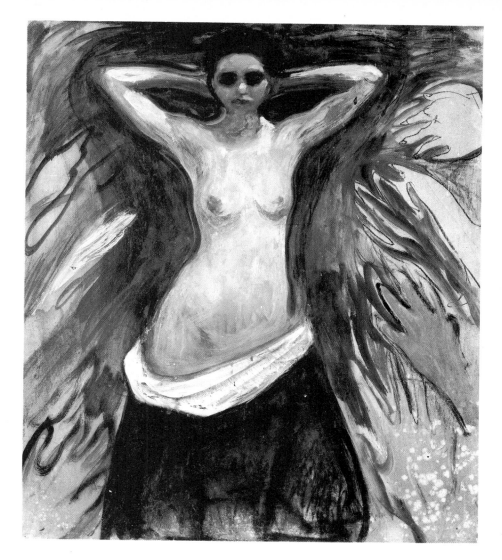

98 Above right *Hands*,
1893–4. Casein on canvas,
91 × 77 cm (35¾ × 30¼ in).
Oslo, Munch–Museet

99 Right *Symbolic Triptych*,
1893–4. Pen and ink. Oslo,
Munch–Museet

its psychology, and artistic creation. From the description quoted above, the following part applied to this painting: 'The mystique of an entire evolution brought together: woman in her many-sidedness is a mystery to man—woman who simultaneously is a saint, a whore and an unhappy person abandoned.'[82]

This verbal description was more readily formulated than the synthesizing image he required, however. Initially the theme appeared in the frame of a diptych, the *Symbolic Study* seen by Servaes in 1894, 'in which the silent and stormy courting of the man is depicted'. In the frame there are 'three naked female forms, one of them yellow, the second green and the third violet: it is woman as she plays in her different colours'. Munch combined his colour iconography with a theatrical language of gesture: pale yellow indicates innocence and joy as in spring flowers and, here, the virgin woman demurely folds her hands and lowers her eyes; green, the colour of mature life, as in summer grass, appears embodied in the right-hand nude, her head surrounded by a halo and her hands clasped in a gesture of prayer, the woman 'sainted' by her motherhood; and reddish-violet, the colour of passionate life, clothes a naked woman writhing sensuously while horns sprout diabolically from her head, as if she personified Schopenhauer's view of sexuality as hell. The theme was restated in the frame's central vertical with three intertwined women's heads, one grinning temptingly and with red hair, one looking upwards expectantly and with blond hair, and the third gazing pensively downward and with black hair. Their breasts rest heavily on a man's head, personification of a bearded artist; it is he whose thoughts have concretized into the images surrounding him, including the final one, a corpse of faded green resting in the frame's lower horizontal. The creation of life, of love and of art, as well as the interactions between the components of time—past, present, future, or death, life and immortality—all functioned as a knot tying together and clarifying the fifteen distinct components of the 'Love' series.

100 Above right *Art*, 1893–5. Pen and ink, 24.4 × 30.3 cm (9¾ × 12 in). Oslo, Munch–Museet

101 Opposite top *Metabolism Frame*, c. 1895? Ink and watercolour, Oslo, Munch–Museet

102 Opposite centre *Metabolism*, 1893–4. Pen and ink, 22.8 × 32.3 cm (9 × 12¾ in). Oslo, Munch–Museet

103 Opposite bottom *Vampire*, 1894. Drypoint and aquatint, 28.5 × 21.5 cm (11¼ × 8½ in). Oslo, Munch–Museet

Throughout 1894 and 1895 Munch was occupied with attempts to unify his entire thoughts on art, life and love into a single painting. He explored diptych and triptych formats, with their religious associations.[83] By the time his exhibition came from Stockholm to Berlin, to the gallery of Ugo Barroccio at Unter den Linden 16 early in March 1895 (Munch himself returned to Berlin in October 1894), he had composed a—now lost—triptych, fusing four paintings: *Time*, *The World*, *A Marriage* and *A Swan*. The swan was presumably a version of *Vision* or, more probably, considering the nature of Munch's imagery at the time, an isolated female figure clothed in white and gazing out over the waters of the fjord as in the proposed title-page of Krag's

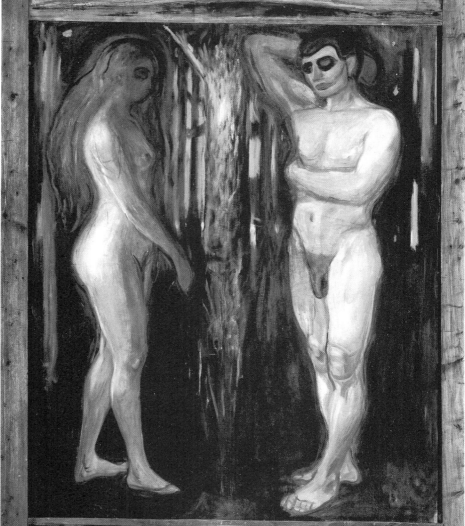

104 Right *Metabolism*, 1894–5 and 1918. Oil on canvas, 137 × 110 cm (54 × 43¼ in) (excluding frame). Oslo, Munch–Museet

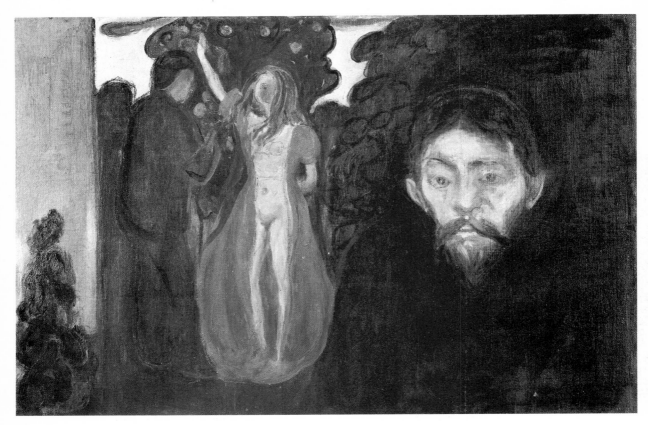

105 *Jealousy*, 1895. Oil on canvas, 67 × 100 cm (26½ × 39½ in). Bergen, Rasmus Meyers Samlinger

poems. The identity of the other images is revealed in a drawing of a triptych, its left field (*A Swan*) empty. The centre picture, *The World*, restates the theme of the 1894 painting *Hands*: a woman tantalizingly presenting herself to the passionately grasping hands of men surrounding her; in the economy of Munch's thought, it is woman who, to fulfil her biological function, indiscriminately seeks her partner. *A Marriage* has the woman now demure, clothed, her role accomplished, but next to her a horned man deprived of strength, his body undulating within the force-field emanating from the self-consciously supreme woman; while less overt and graphic, it is a variation on the painting *Ashes* (also entitled *After the Fall* in a reference to Adam and Eve), concerning which Munch wrote:

> The passion was extinguished when they rose again.
> She stood over him very erect and put her hair in order, having the posture of a queen. There was something in her expression that frightened him. He did not know what it was.[84]

After impregnation, woman is triumphant and man is reduced to a useless, dejected and rejected creature.

When combined with its predella panel, *Time*, the triptych became a unified representation of art, the spiritual emanation from the past—the corpse that also feeds life appearing in the caricatured fragment of a woman's torso—and the disembodied head of the artist. Art was the product of dying to one's bodily self, an ascetic sexuality of the spirit whose sterile but immortal fruit was rooted in the dead past of memories.

In the drawing he entitled *Art*, Munch depicted a plant sprouting from a mound composed of two writhing women pressing on a man's genitals; his

142

eyes are closed to see only inside himself while his mouth is open as if in pain. Like a caricature of Munch's *Madonna*, this poet-artist is shown at *his* moment of conception in the androgynous birth of art. Such representations of rotting corpses that seem sexually alive while they nourish sprouting plants appear repeatedly in Munch's drawings during the mid-1890s as representations of art, but also of the Monistic metamorphosis of life through death that had been 'revealed' to Munch at Saint-Cloud.

Among the paintings of the 'Love' series exhibited in 1894 and 1895 in Stockholm and Berlin was one entitled *Vignette*. It was probably the concluding statement on the series. Later entitled *Metabolism* or *Transformation of Matter*, it was described by Munch as:

the picture of life as well as death, of the forest that sucks its nourishment from the dead, and of the city that grows back beyond the tree tops. It is the picture of life's powerful, fruitful forces.[85]

Munch reworked large areas of the image after 1903, probably around 1918, but originally it showed a naked woman and man standing in a forest on opposite sides of a sprouting green plant within whose leaves was the embryonic form of a child. The child-bearing plant had its roots in a carved frame among a human and animal skull; in the upper field of the frame a city with the silhouetted buildings of Kristiania appeared. The motif of death and regeneration was thus combined with the man–woman relationship; above the head of the melancholic man, who holds his arms in a gesture similar to that of the *Madonna*, is the city, an artificial creation of his intellect, an urban allegory of art. The diverse themes of love, eternal life and artistic creation were united in a single image, and thus the paintings on the motif of death, so far kept separate from the 'Love' series, were thematically related to the remainder of the series.

By 1895, Munch had resolved the major issues of the series of paintings he wished to present to posterity as his most significant artistic accomplishment, but he continued to clarify earlier motifs. *Jealousy*, for example, was now depicted in terms of three people in a garden setting. An Adam and Eve

106 Top *'American Woman' (Portrait of a Young Woman)*, 1894. Drypoint. Oslo, Munch–Museet

107 Above *Young Woman and Death*, 1894. Drypoint. Oslo, Munch–Museet

108 Right *Compassion*, 1894. Drypoint and aquatint. Oslo, Munch–Museet

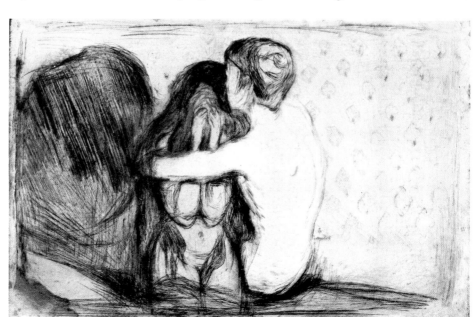

situation whose composition had been sketched out in 1891 to 1892, the picture shows the jealous man in the foreground, his features an amalgam of the faces of Przybyszewski, Dagny's sister's husband and the painter Paul Hermann. In the background, visualizing his thought, a woman clothed in a red dress opened to reveal her naked body reaches into a tree for an apple to offer to another man. Munch also immediately composed a text, later revised and extended, to comment on the image:

A mystical gaze, that of the jealous one. In these two piercing eyes are concentrated as many mirror images as in a crystal. There is something warning of hate and death. There is a warm glow that recalls love, an essence of her, something they all three have in common, a wisp of the woman they shared. The gaze is searching, filled with hate and filled with love.[86]

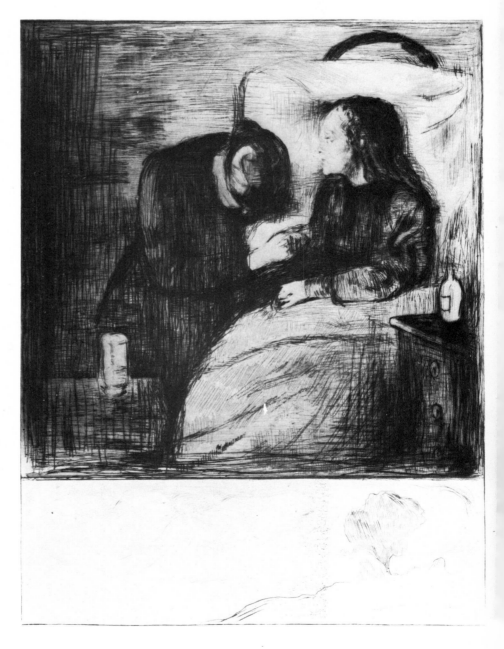

109 Right *The Sick Child*, 1894. Drypoint, 36.1 × 26.9 cm (14¼ × 10½ in). London, British Museum

110 Opposite *Self-Portrait with Cigarette*, 1895. Oil on canvas, 110.5 × 85.5 cm (43½ × 33½ in). Oslo, Nasjonalgalleriet

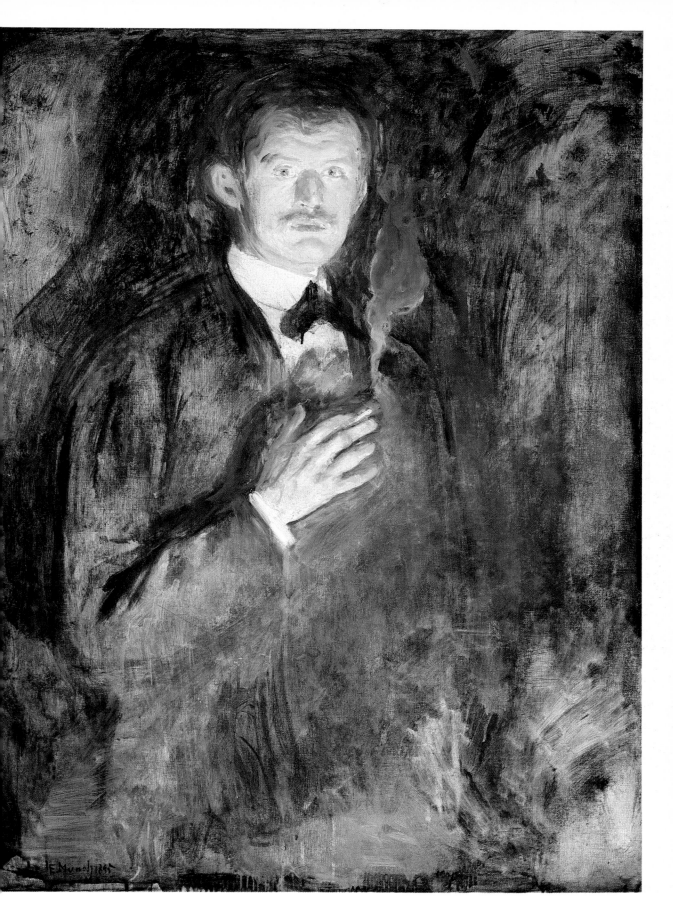

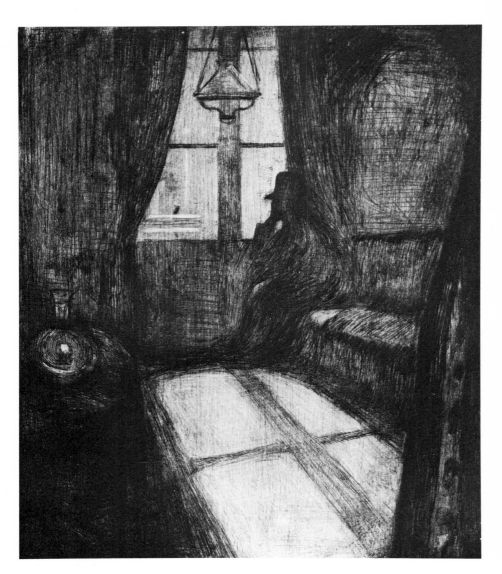

111 *Moonlight*, 1895.
Aquatint and drypoint. Oslo,
Munch–Museet

During the winter of 1894 to 1895 Munch embodied his philosophy of artistic creation in another self-portrait. In conception it is closely related to the Saint-Cloud *Night*. Both paintings show the artist alone surrounded by a hazy environment of blue, and illuminated by a reddish-yellow light that enters from the world outside. Both make the same essential statement concerning artistic creation in a world removed from everyday life, within the blue atmosphere of death. Moreover, when Munch exhibited the self-portrait for the first time in Berlin, he paired it with the portrait of Dagny, permitting the two to fuse into a diptych of biological and artistic creation and eternal life. It was also the last self-portrait in which he cast himself in the role of an 'aristocrat of the nerves' who in quietly melancholic and superior meditation gives birth to his art. However, despite his artistic withdrawal, life would not leave Munch alone, and life in Berlin early in 1895 proved harsh.

When Munch arrived in October 1894, he wrote to his aunt: 'I have a large number of acquaintances here, but nonetheless I have the feeling that I will soon have had enough of Berlin, and that I will either go to Paris or home to Norway. Berlin is, in any case, not an art centre by a long shot.'[87] The

146

superior tone of dissatisfaction hid pecuniary difficulties, and Munch requested that his sister sell a pair of his boots to obtain travel money. Nonetheless he held out the promise: 'I hope I can soon send a bit of cash.' By mid-November, he reported that he had painted a portrait and money was forthcoming from Stockholm, so 'you see, things are beginning to look better in terms of income'. To obtain more money, following the advice of Bodenhausen, he began to learn the techniques of printmaking. Prints would be cheaper than paintings, they would be available to a larger clientele, and they seemed to promise—yet again—popularity.

To learn the technique of drypoint engraving, Munch returned to the practices of Naturalism, sketching portraits in cafés and in the Schwarze Ferkel directly on to the plate with a burin. The extreme sketchiness, the uncertain scribbling of lines and the number of proofs that exist, suggest that

112 Below *Self-Portrait*, 1895. Lithograph, 45.5 × 31.7 cm (17¾ × 12½ in). London, British Museum

113 Right *Madonna*, 1895. Drypoint, 36 × 26.5 cm (14¼ × 10½ in). Oslo, Munch–Museet

114 Overleaf left *The Lonely One*, 1896/7. Hand-coloured mezzotint, 28.5 × 21.5 cm (11¼ × 8½ in). Chicago, The Art Institute

115 Overleaf right *The Madonna*, 1895–7. Hand-coloured lithograph. Chicago, The Art Institute

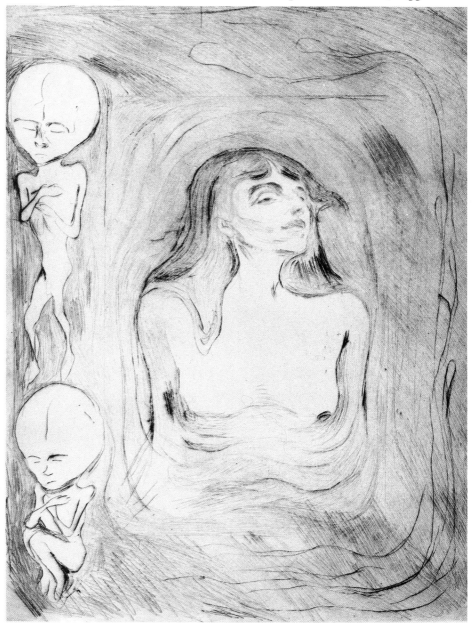

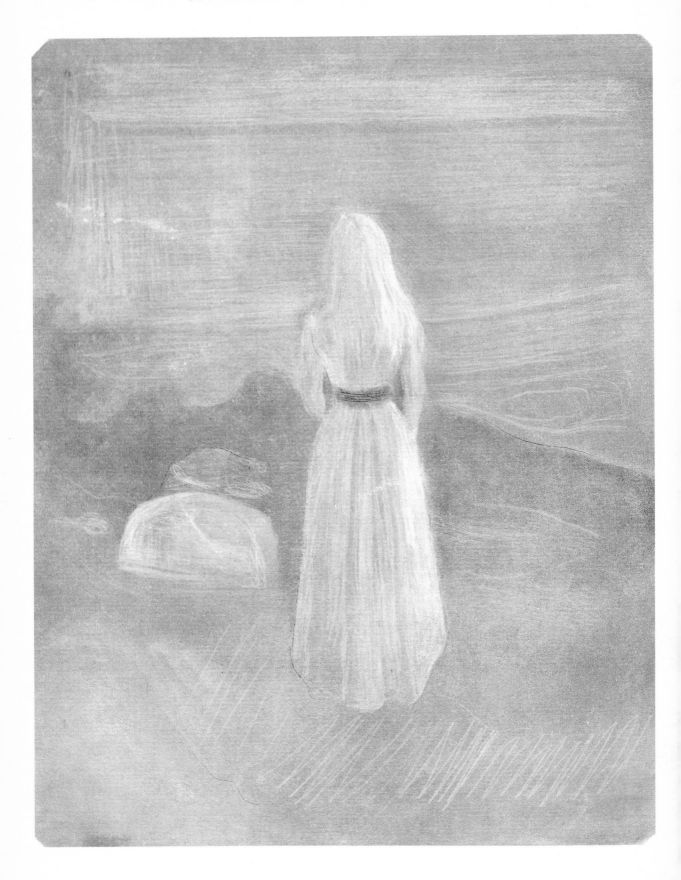

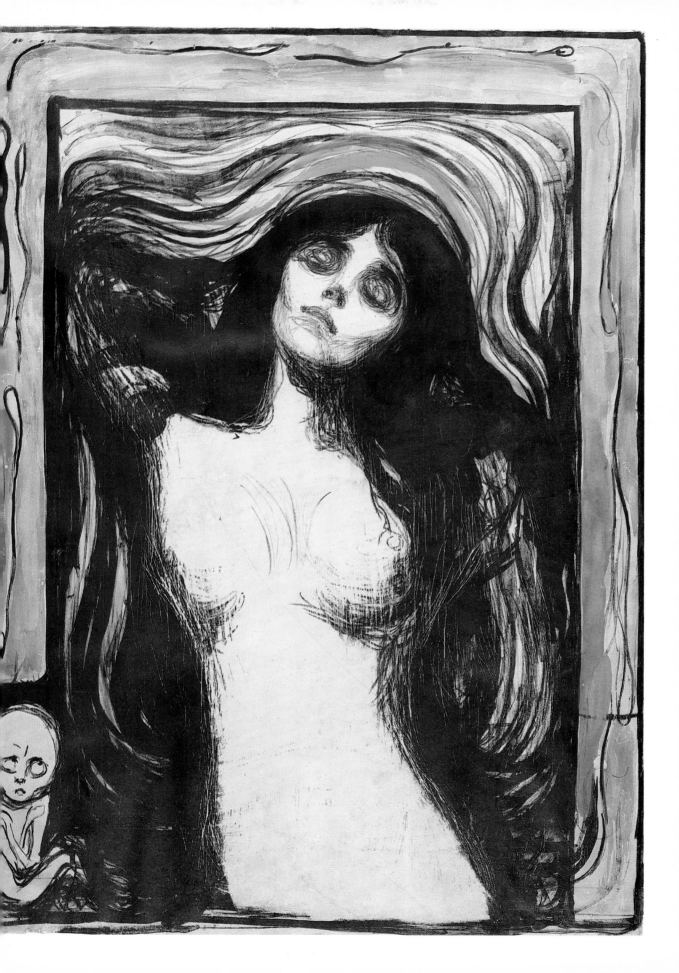

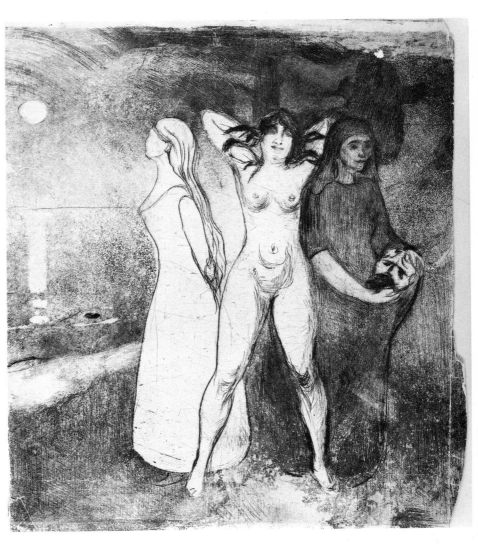

116 *Three Stages of Woman*,
1895. Drypoint and aquatint,
28.5 × 33 cm (11¼ × 13 in).
Oslo, Munch–Museet

The Portrait of an American Woman (probably Annie Neumann-Hofer, who frequented the Schwarze Ferkel with her husband, the editor of the *Magazin für Literatur*) was Munch's first.[88] 'I am in a very good mood as far as my work is concerned', he wrote home again, 'and I've begun engraving in order perhaps later to bring out a little collection.'[89]

As soon as he had mastered the technique, Munch started to represent the motifs of his 'Love' series for his 'little collection': *Young Woman Embracing Death*, and a new *Vampire*.[90] He also expanded his painted imagery in *Compassion*, which shows a young woman seated naked on a bed and weeping, and next to her a naked young man who is trying to comfort her.

Thiis, who joined Munch in Berlin during the winter of 1894 to 1895, recalled that he was attempting to translate *The Sick Child's* complex layering of paint and glazes into patterns of finely scratched and rouletted lines in a drypoint.[91] Not satisfied with his original image, beneath the scene of the grieving mother and dying child Munch placed a spring landscape with a single tree reaching into a cloud-filled sky, a formulation transferred from his Metabolism images. However, he was not satisfied with the appearance of the print either; he reworked it during the following years, the image becoming increasingly darker, with only the girl's head glowing pale against her pillow.

In 1896, when he took up the motif yet again in a colour etching and a lithograph, it was this focus on the girl's head that he presented, a highly concentrated synthetic amalgam of his original painting. The idea of the sick child would not leave him; he also started on a new painting of the theme, the first of five variations he was to create at roughly ten-year intervals.

Just as Munch rapidly learned drypoint engraving, so too he taught himself the technique of lithography around Christmas 1894. His first surviving experiment succeeded, although its forms appear more three-dimensional or Naturalistic than the corresponding paintings. *The Young Model*, exhibited in 1895 as *Puberty*, was drawn with lithographic crayon directly on to the stone. The emphasis on technique—and through it on the ideational quality of the image also apparent in his paintings after 1890—is transferred into the print medium.

While working on these prints, Munch's finances once more began to falter. He moved from his pension to cheaper rooms in Charlottenburg, but only

117 Right *The Kiss*, 1895. Etching and aquatint, 32.9 × 26.3 cm (12½ × 10¼ in). Oslo, Munch–Museet

118 Below *The Scream*, 1895. Lithograph. Oslo, Munch–Museet

after walking the Berlin streets alone for three nights and days without money for food or rent. Meier-Graefe and Bodenhausen aided him, and sought out a new patron, a young German count closely related to the Imperial family and already helping Przybyszewski maintain his unorthodox household. Count Harry Kessler became one of Munch's most faithful advocates for the next fifteen years, obtaining numerous commissions for him, the first being a lithographic portrait.

The Kessler portrait taught Munch above all the virtues of empty space in his prints. His sources are diverse, ranging from Japanese woodcuts to Degas. Drawings by the Belgian Symbolist Fernand Khnopff, exhibited in Berlin during 1893 to 1894, may also have inspired him, as may woodcuts by Félix Vallotton being shown in Germany while Munch's exhibition was taking place at Ugo Barrocio's gallery.

Munch dramatically fused the examples of others with his own experimentation in a lithographed self-portrait based on his winter self-portrait. The blue and green atmosphere surrounding the artist in the painting is replaced in the lithograph by a surface of deep, rich black, perhaps modelled on the similar effects achieved by Redon, whose works Kessler had pointed out to Munch in April, as well as by Vallotton. From the felt-like blackness, there emerges ghost-like the pale, frontal face of the artist, as if he were a bodiless vision. The blackness combined with the high, white collar he wears, also alludes to clerical garb, perhaps in reference to his own ancestors or to his name (the word for 'monk' in Norwegian is *munk*), but certainly it is also a gesture of acceptance of the Symbolist proclamation: 'Artist, you are a priest. Art is the great mystery; when your efforts lead to a masterpiece, then it is as if a ray of divinity descended from heaven down to your altar.'[92] The

119 Opposite top *Melancholy*, 1896. Woodcut. Oslo, Munch–Museet

120 Opposite bottom *Into the Woods*, 1896. Woodcut. Oslo, Munch–Museet

121 Below *The Empty Cross*, 1898. Watercolour, 43 × 63 cm (17 × 24½ in). Oslo, Munch–Museet (see pp. 165–6)

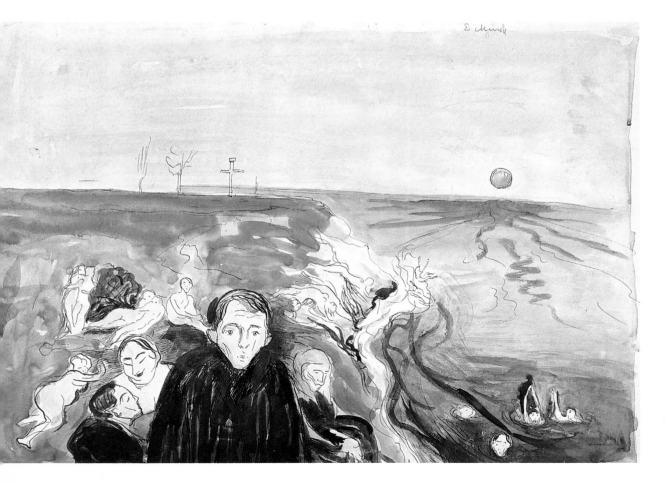

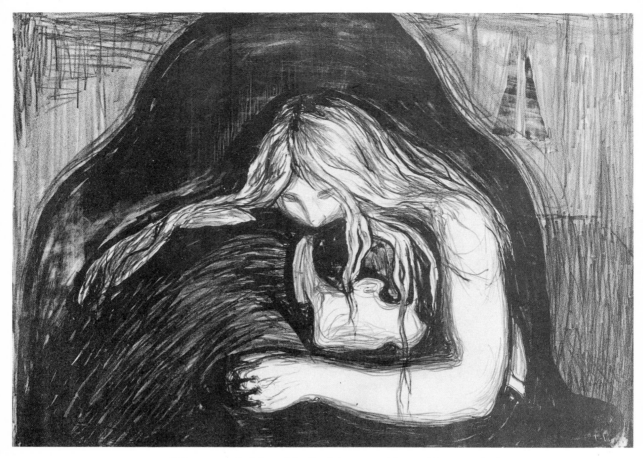

122 *The Vampire*, 1895.
Lithograph. Oslo, Munch–
Museet

lithograph is Munch's final image of himself as Symbolist artist, a concept he clarified even further by placing himself behind a barrier formed by a skeletal arm and hand, while up above, as if inscribed on a monument, he placed his own name and the date '1895'.

In June 1895, Meier-Graefe and Bodenhausen released a small portfolio of eight engravings by Munch, many of them based on those paintings that had found the most positive critical response in Germany. *Night*, described as *Moonlit Dusk*, was included after Munch had had several requests for copies; the print could more easily meet such demands. The paintings Munch chose to reinterpret in this portfolio were all works from the 1880s or very early 1890s, works that preceded his full acceptance of Symbolist perceptions, scenes from the Kristiania Bohème, and 'morning moods' of young women gazing out of sunlit windows.[93] Meier-Graefe's accompanying text argued that Munch was a good investment:

Almost without exception, Munch has limited himself in this publication to works which can be understood with the most mundane everyday view. Their value resides in excellent technique and a good eye for the external world, not in the 'crutch' of fantasy. . . . So buy [his] pictures—I am speaking here not in his interest, but in yours. . . . Buy them and cover them with gold.[94]

The publication was a commercial venture, not an artistic one. It failed.

Nonetheless, Munch inaugurated yet another ambitious project, that of converting his 'Love' paintings into a series of engravings and lithographs.[95] *Madonna* and *Sphinx*—with the 'forlorn' stage of woman holding a man's

head in her hands and close to her womb, the first time Munch had made use of the Salome motif so popular among Symbolist artists—already existed as drypoint engravings, as did a version of *Kiss* showing the couple naked rather than clothed. Having learned the technique of transfer lithography, however, Munch turned to this easier method to recreate the other images, beginning with *The Scream*. Printing it on paper he had hand-coloured to a violet tone, Munch transposed the striated undulations of his painting into thick, broad lines of black ink that printed as if the spaces between them were gouged out. With the lithographic impression lacking colour, he also reverted to printing his *Madonna* on a pale, sickly bluish-grey tinted paper. Once the image was transferred to the stone, he further worked it, using an etching needle to break up dark masses with refined pale linear patterns. After it was printed he continued to work over the image with watercolour. In the process he altered the image's implications, particularly through the embryonic creature on the frame. With its green-tinted body and lugubrious eyes it looks more dead than alive, as if Munch wished to point to a new anxiety, the anxiety of life faced by the newborn. When print and painting were exhibited during October 1895 in Kristiania (where Munch had returned in the summer), the poet Sigbjørn Obstfelder registered this shift of meaning:

For me the essence of his art is his Madonna picture. This is the earth's madonna, woman who gives birth in pain. . . . What Munch sees is woman as the one who bears the world's greatest miracle in her womb. He returns to this idea over and over again.[96]

Birth, not conception, is emphasized in Obstfelder's commentary, the moment when the protective environment provided by woman is replaced by the threatening redness of life. The anguish of birth parallels the interior– exterior, death–life contrasts Munch registered in his paintings. As if to supplement the iconography of existing paintings, walls and windows were inserted into scenes originally lacking them, as in *Vampire*. In the prints of the 'Love' series, the setting of seashore or windowed interior served as a device through which to unify the diverse images.

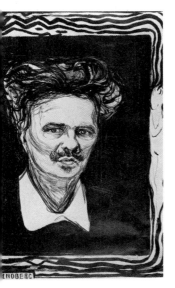

123 *Portrait of August Strindberg*, 1896. Lithograph. Oslo, Munch– Museet

Munch's period of inventiveness and productivity ended when he left Berlin for Kristiania in June 1895. Of nearly twenty paintings from that period only about a quarter had been translated into lithographs. The exhibition he arranged for October caused the expected distress among critics, many of whom resurrected Bjørnson's accusation that Munch's art was 'a sick mind's similarly unhealthy and repulsive nightmares',[97] threatening the public with the infection of insanity. The attack became yet more vicious when a young doctor of psychology, Johan Scharffenberg, using the ideas put forward in Nordau's book *Degeneracy*, responded to a lecture by Obstfelder at the Students' Organization. Pointing to cases of mental illness and physical weakness among Munch's ancestors, Scharffenberg 'proved' that Munch's art was the result of insanity such as other Decadents manifested, and that his art therefore was demonstrably degenerate. Among the audience was Munch himself, silent and despairing, doubting his own worth. Obstfelder and others came to his defence in lectures and articles, but for the popular Norwegian mind the verdict on Munch's art had finally been proclaimed. Nonetheless, following Werenskiold's advice, the National Gallery purchased his blue self-portrait, providing the artist with much-needed money, enabling him to rent a studio, but not restoring his ability to work. The taste of Norway and the bitterness of his rejection proved insurmountable. When the French Symbolist critic and writer Thadée Natanson came to Kristiania, praised Munch's

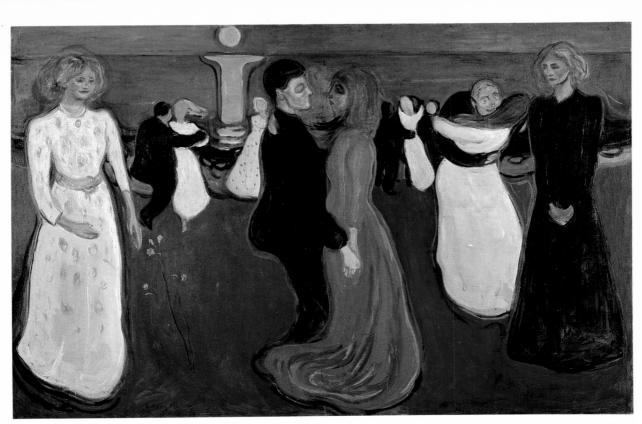

124 Opposite top *The Dance of Life*, 1899–1900. Oil on canvas, 125.5 × 190.5 cm (49½ × 75 in). Oslo, Nasjonalgalleriet

125 Opposite bottom *Summer Night*, 1902. Oil on canvas, 103 × 120 cm (40½ × 47¼ in). Vienna, Kunsthistorisches Museum

126 Above *Portrait of Albert Kollmann*, 1901. Oil on canvas, 81.5 × 66.5 cm (32 × 26¼ in). Zurich, Kunsthaus (see p. 176)

exhibition in the periodical *La Revue Blanche*, and in December published the lithograph of *The Scream* with a French version of Munch's text, the impetus to leave Norway and to go to a true 'art centre' sent Munch to Paris. Before he left, however, his brother Andreas, only recently married, died; his unpopular wife, so the family argued and never ceased to believe, had caused his death.

Meier-Graefe had prepared various members of the Paris art world for Munch, who arrived in February 1896. He had established contact with the German art dealer Samuel Bing, whose new gallery 'L'Art Nouveau' was supporting the work of the Nabis painters, while also advocating a renewed style of interior design exemplified by rooms fitted out by the Belgian architect and designer Henry van de Velde. Bing commissioned the Nabis artists to design stained-glass windows for the gallery; Munch also submitted a design, a view of a Paris boulevard, but it was not executed. More successful were the attempts to have Munch's work displayed. Ten paintings, some from the 'Love' series, were accepted at the Salon des Indépendants, and then shown again at Bing's gallery. The French critics, however, were no more generous than those of Berlin or Kristiania, being particularly offended by Munch's 'what in good French is called a lack of talent'; Munch's 'caprices' were, according to Camille Mauclair, 'simply poorly drawn, poorly presented, and lacking in tonal quality' and his prints were 'infantile'.[98] Quite uncharacteristic of Parisian critics were Yvanhoe Rambosson's comments in the Symbolist periodical *La Plume*:

The most interesting collection in the Salon is that of M. Edvard Munch. . . . Without going so far as to say that M. Edvard Munch has presented something definitive, I am convinced that he has entered into a highly personal pilgrimage. His thought—highly tortured—frequently finds a manner of expression which is highly unique and impressive. . . . Munch achieves an effect of terror by a combination of lines that, although they remain aesthetic, are actually physically disagreeable.[99]

To generate publicity for the 'Art Nouveau' exhibition in June 1896, *La Revue Blanche* turned to Strindberg, now in Paris. In a highly subjective interpretation, he wrote about eight of the 'Love' paintings, noting that he was doing so while awaiting the composer who would set Munch's paintings to music.[100] In other respects, however, Strindberg viewed Munch's art totally in terms of his own phobias as he entered a severe crisis he called his 'Inferno'.

Munch and he met frequently, and Strindberg sat for a lithographic portrait, part of a planned series on contemporary authors—among them Obstfelder and Przybyszewski—never completed. Strindberg's head is seen against the same deep black into which Munch had placed himself earlier, but it appears much more massive, with his ample hair writhing like a nest of Medusa's snakes. Przybyszewski had observed,[101] quite correctly, that Strindberg would never rid himself of an obsession with women, and Munch surrounded him with a frame of jagged and writhing forms—male and female—that coalesced into a naked woman on the right. The inscription beneath deliberately reads 'A. Stindberg'—a mountain of hot air.

A temporary cooling of their friendship followed, and matters were made worse by the news from Berlin that Przybyszewski was in prison on suspicion of having murdered his former common-law wife Marthe Foerder along with her children. Strindberg once again saw the sinister hand of Dagny, his Aspasia, at work. But the information proved false. Marthe was indeed dead, possibly a suicide, but the children were not. Przybyszewski, guilty only of remorse that ultimately led him to reject Dagny, was soon released. Strind-

127 Top *Portrait of Sigbjørn Obstfelder*, 1896. Lithograph. Oslo, Munch–Museet

128 Above *The Urn*, 1896. Lithograph. Oslo, Munch–Museet

berg, however, became only more convinced of Przybyszewski's guilt and fantasized that he had used gas to kill her, a method he feared would also be used on himself by Munch. He fled, eventually to a doctor's care in Ystad. Shaken by the experience, Munch went to Knokke-sur-mer to recover. But the crisis continued to affect him. His system was breaking under the strain and excessive use of alcohol only exacerbated his mental state.

The psychological crisis experienced with Strindberg was not the only result of their meeting in Paris. Through him, Munch came into contact with the English composer Frederick Delius and the circle of critics and artists collected around William François Molard, an employee of the French Ministry of Agriculture, son of a Norwegian mother and married to the Swedish sculptress, Ida Molard-Ericson. Through his wife, Molard's home at rue Vercingetorix 6 attracted the Scandinavian artists visiting Paris, but the most significant artistic acquaintance was one who by chance moved into the same house in 1893: Gauguin.

By the time Munch arrived in 1896 Gauguin was back in Tahiti, but his art and the critics Julien Leclercq, Yvanhoe Rambosson and Thadée Natanson—writing for *La Revue Blanche*, *La Plume* and the *Mercure de France*—remained, giving support and encouragement to Munch.[102] Additional contacts with French art and artists were arranged by Julius Meier-Graefe. Through him, Munch obtained an edition of Lautrec's lithograph series 'Elles' of 1896, and quite possibly also met the artist whose influence had been so significant for him six years earlier. As resident Paris critic for various German periodicals, Meier-Graefe had also developed close contact with French publishers of artists' graphics. Encouraged by Meier-Graefe, Ambrose Vollard invited Munch to contribute to his first album of *Les Peintres-Graveurs* in the spring of 1896. The Société des Cent Bibliophiles commissioned illustrations for Baudelaire's *Les Fleurs du Mal*, a project aborted when the society's president suddenly died.[103] Despite the failure of this project, the Parisian concern with the *peintre-graveur* rekindled Munch's interest in graphics.

Munch also continued to seek ways of introducing colour into his graphics and adopted varying techniques with remarkable ease. He explored the favoured eighteenth-century technique of reproducing paintings, the mezzotint, in a gentle, softly tinted recollection of the title-page for Krag's poems, perhaps inspired by the presence of both Krag and Obstfelder in Paris. The technique must have been too time-consuming for Munch to apply to his more elaborate compositions; instead, he returned to the lithograph for most of his work in 1896. Broad, flat areas of black rendered with lithographic ink, with details etched out in tender but cutting white lines, characterized restatements of paintings such as *Death in the Sickroom*; these dark masses were set off sharply against the pregnant spaces of white or coloured paper, and sometimes watercolour was added. He soon also mastered a newly refined technique, multi-coloured lithographs, as in a depiction of the head of the *Sick Child*. Before the year was over he had made forty-five prints, more than doubling his previous total.

Towards the end of 1896 Munch resurrected the plan to create a series of prints taking up the themes of the 'Love' series. Initially choosing the lithograph as his means, he returned to such Berlin themes as *Ashes* and *Anxiety*, but also attempted to find new symbolic images. *The Urn* presents a massive ash crater from whose lip, amid flickering wing-like flames, a woman's head appears as a paraphrase of the rebirth of the mythological phoenix and as embodiment of Munch's concepts of metamorphosis and of

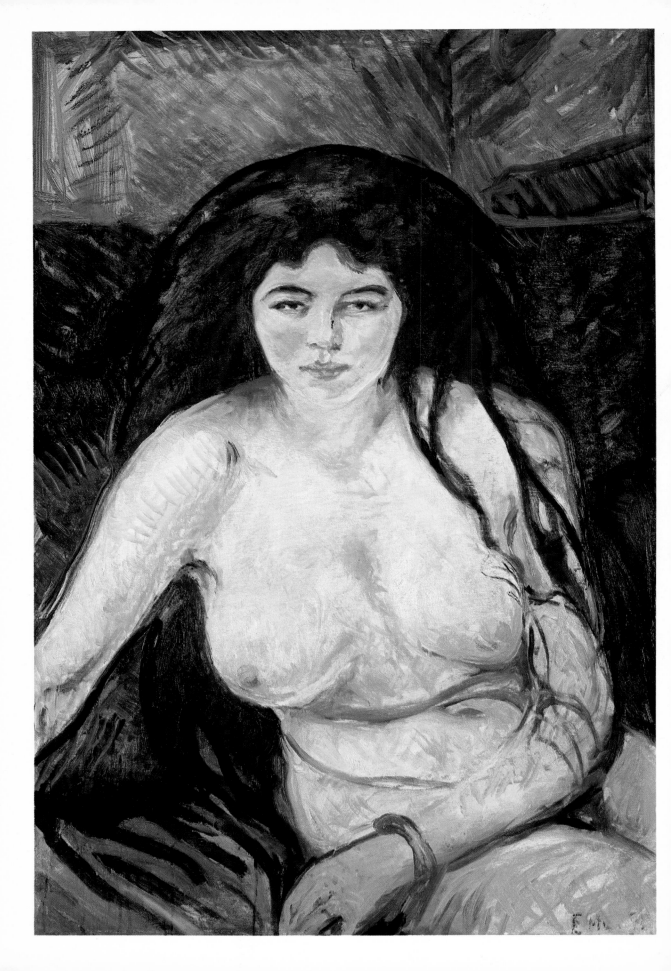

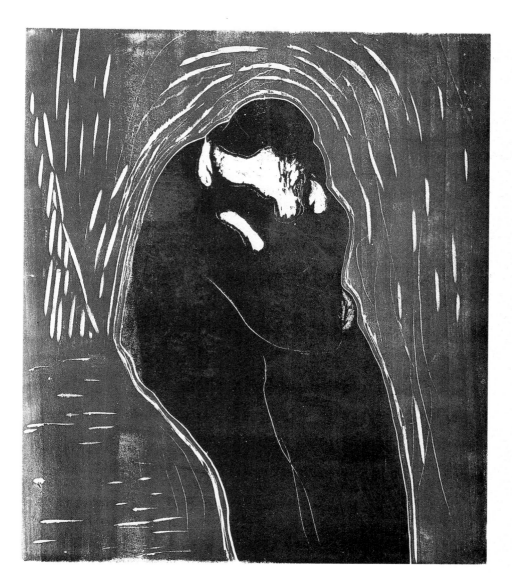

129 Opposite *The Beast*, 1902. Oil on canvas, 94.5 × 63.5 cm (37¼ × 25 in). Hannover, Kunstmuseum (see p. 176)

130 Above right *The Kiss*, 1897/8. Woodcut. Oslo, Munch–Museet

biological eternal life attained though sexuality.

During the course of the year, one other technique was revealed to Munch, perhaps through Molard's collection of Gauguin's graphics. It was the woodcut, whose renaissance Gauguin had helped to pioneer, although several other artists simultaneously began using the neglected technique. In Germany Joseph Sattler—Munch's teacher of transfer lithography—devised a Dürer-like technique for his symbolic, quasi-medieval dances of death. In France, Bernard was producing medievalizing woodcut images, Vallotton was producing stark images accented sharply as black-and-white forms, while Paul Herman began printing woodcuts that used the natural wood grain as part of their configuration, just at the time when he came to know Munch. Munch had already achieved the basic effects of woodcut—the broadly gouged striations, the simple contrasts of precisely defined black-and-white forms—in lithographs such as *The Scream* and *Deathroom*; what he discovered now was the medium most suited to fulfilling these formal demands. *On Man's Mind* picks up the confrontation set up in *Vision* and the *Self-Portrait Beneath a Woman's Mask*. The naked form of a woman presses down on a

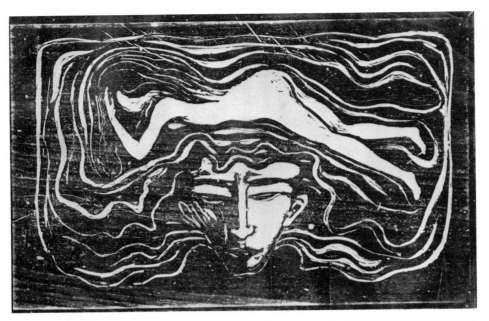

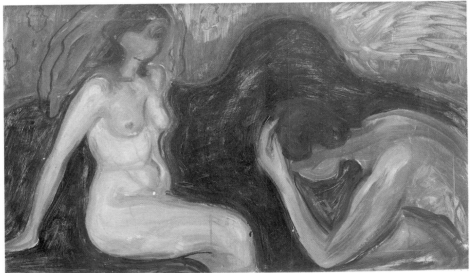

131 Above right *On Man's Mind*, 1898. Woodcut. Oslo, Munch–Museet

132 Right *Man and Woman*, 1898. Oil on canvas, 60.2 × 100 cm (23¾ × 39¼ in). Bergen, Rasmus Meyers Samlinger

man's head while her hair flows outward to engulf him in its tentacles. Printed in blood red, using a rough pine board from which to gouge the image, the woodcut summarizes Przybyszewski's perception of Mind and Sex in persistent conflict, seeking to engulf each other. In Paris, as Strindberg had already made clear, the ideas and jealousies of Berlin continued.

By the time of another Kristiania exhibition in the autumn of 1897, Munch had gathered twenty lithographs and woodcuts treating the two motifs of love and death into a portfolio, entitled 'The Mirror'.[104] Beginning with the death themes, it moved backward to metamorphosis, then to love, and finally to melancholy in which art is conceived as man's alternative to woman's child. Munch wished to accompany the portfolio with his prose poems. He continued to rework other symbolic motifs from Berlin. He invented new variations on such motifs as the first encounter between man and woman, as she guides him into the forest of love. But the cycle of prints, worked on for over two years, remained incomplete, as if its author feared that its termi-

162

nation could only be a bad omen for his own existence.

In Paris in 1896 and 1897, Munch's work essentially split into two, the prints and the paintings. His prints continued to explore the symbolic presentation of a Monistic philosophy of love and creation, but his paintings turned almost exclusively to a stylized Naturalism. A depiction of a seated model seen from the back, first sketched in crayon and watercolour, then painted in oils, lacks all symbolic content. The return to nature seemed to promise release from the world of sexual strife that still existed in the prints. Even *Ashes*, in which a naked seated woman gazes calmly from blank eyes at the collapsed figure of a man, seems more a decorative study of two models,

133 *Man's Head in Woman's Hair*: The Mirror, Part II, 1896–7. Hand-coloured woodcut. Cambridge, Mass., Fogg Art Museum, Harvard University

134 *Seated Model*, 1897.
Pencil with crayon and
watercolour, 62 × 47.7 cm
(24½ × 18¾ in). Oslo,
Munch–Museet

bereft of the sexual dominance of the Berlin painting. Similarly, *Fruitfulness* celebrates the lushness of nature, previously always associated with the metamorphosis of death, by depicting saturated green leaves and grass, a properly trimmed fruit tree, an overflowing bowl of fruit, a pregnant woman and a contented man.

Munch's precise movements and activities during the years 1897 to 1900 are far from clear. Numerous letters, 'diaries' and other documents from the 1880s and earlier 1890s were preserved by him and his family and later published; from these years, however, there is relatively little. The paintings of 1897 and 1898 suggest a world from which demons have been exorcized and replaced by an effusive optimism. However, the optimism was a deliberately created delusion. While he had been extraordinarily productive in drawings, paintings and graphics despite the turmoil of his life during 1890 to

1896, the activity slackened in 1897 and 1898. A crisis is hidden behind the dearth of information.

Several allegorical self-portraits of 1897 to 1898 support this conclusion. Munch still casts himself as Symbolist and Decadent melancholic, but contemplative quiet is no longer the condition of creation. Instead, pain—both physical and psychological—dominates. In the guise of the archetypal poet Orpheus, Munch strums a lyre and from his fingers gush streams of blood. For the cover of the periodical *Quickborn*, which in 1898 published a joint Munch–Strindberg issue, Munch showed the *alrune* being nourished by the artist's heart's blood. Munch grasps convulsively at his bleeding side and throws his head back in pain, a gesture recalling the *Madonna* giving birth in suffering. In a number of drawings and watercolours entitled *The Empty Cross* in 1898, the allegory of artistic suffering was rendered in more complex terms. In the foreground stands a monk—another reference to the 'monk' of his name—who stares away from the sexual scenes derived from Munch's earlier paintings, away from an empty cross and a blood-red sun, and asks an unanswerable 'Why?' 'The bohemians' time came with its free love', Munch wrote in a commentary to the sketch. 'God was overthrown, as was all else. Everyone raced about in an insane dance of life. A blood-red sun stood in the sky. The cross was atoned for. But I could not rid myself of the anguish of life, and the thought of eternal life.'[105] The Munch-monk-artist takes on the agonies of a mankind that cavorts in an ecstasy of flesh and ignorance. Life was a secularized way of the cross traversed by everyone but on which artists suffer most. Munch identified with the gospel of artistic suffering preached by Strindberg in Paris, and in the allegorical self-portraits of 1897 to 1898 he assumes Christ-like dimensions as a victimized surrogate for the remainder of mankind.[106]

The sketches of *The Empty Cross* could easily act as illustrations to

135 *Self-Portrait with Lyre*, 1897. Pencil with ink, watercolour and gouache, 68.8 × 53 cm (27 × 20¾ in). Oslo, Munch–Museet

136 Above *The Flower of Pain* (Cover design for *Quickborn*), 1897. Pencil with pastel and ink, 50 × 43 cm (19½ × 17 in). Oslo, Munch–Museet

137 Right *Fruitfulness*, 1898. Oil on canvas, 120 × 140 cm (47¼ × 55 in). Private Collection

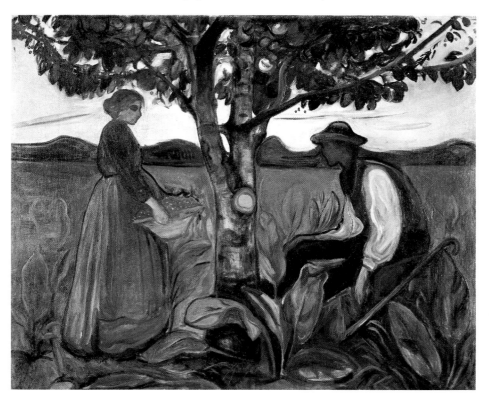

Strindberg's writings from his 'Inferno' crisis, whose most intense period Munch had experienced in Paris. There was a choice, according to the Swedish playwright, 'between the laurel wreath of immortality gained through art, or the alternative in voluptas, sensuality and depravity'.[107] In *The Empty Cross*, the monk is flanked by two familiar figures: on his right, the prostitute who proffered ineffectual compassion; on his left, the resurrected image of Dr Christian Munch. Neither choice, however, brings relief from the psychological anguish engendered by life itself.

Munch wrote a letter at this time confirming his pessimistic view of life:

It is an unhappy event when an earth mother meets someone such as me, who finds the earth too miserable to breed children: [I am] the last generation of a dying race. . . . I have been given a unique role to play on this earth: the unique role given to me by a life filled with sickness, ill-starred circumstances and my profession as an artist. It is a life that contains nothing even resembling happiness, and moreover does not even desire happiness.[108]

The 'earth mother' was the cause of much of the mystery, turmoil and artistic uncreativity marking the period from 1898 to 1902, with repercussions that ultimately led to a severe nervous breakdown in 1908, totally altering Munch's life. Directly or indirectly, she affected every aspect of his life—his world view, his artistic goals and his art. It was she whose presence Munch and his family sought to hide by destroying letters and documents, resulting in the strange gap in the information on his life between 1897 and 1900. They were the most tumultuous years of Munch's bizarre romance with Tulla Larsen, a tall, red-haired, extraordinarily beautiful woman six years younger than him, daughter of Kristiania's most prosperous wine merchant, rich, a hanger-on of the remnants of the Kristiania Bohème, and eager to marry. The two met no later than 1898; Gunnar Heiberg introduced them. The romance developed remarkably quickly, with Tulla apparently being the guiding and driving force, and continued on a rough path through Europe's major cities and most fashionable spas. Exhausted, Munch entered a sanatorium in 1899, but the chase resumed in the new century until a violent end was reached in 1902.[109]

A member of what Munch bitterly described as the 'money aristocracy', Tulla was his social equal and she was single. The impediments to (or protections from) marriage present in Munch's earlier involvements with women were absent. Marriage plans were made (although later Munch denied any participation in them) and Tulla became known as his fiancée, although again Munch later insisted the term was one she alone used. Whatever his intentions, he found her fascinating and actually believed her to be the product of his own art, his own idea become flesh:

I have seen many women that have thousands of shifting facial expressions, like a crystal. But I have never met one who so decidedly has only *three*—but these extremely strong ones . . . exactly as in my painting of the three women. . . . You have an expression of deepest sorrow . . . like medieval weeping madonnas. I have never before seen such an expression of effusive happiness [as yours] . . . And then there is your face filled with desire, and that is what frightens me. That is the sphinx's annihilating countenance, and that is where I see woman's most dangerous characteristics.[110]

Munch wanted Tulla to offer him her love in the guise of the maternal madonna and the sunlit maiden, but he would not submit to her sexual desires since that would destroy his artistic creativity. This was his great

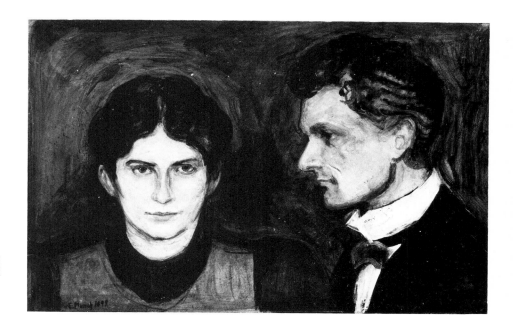

138 *Portrait of Harald and Aase Nørregaard*, 1899. Oil on canvas, 49.5 × 75 cm (19½ × 29½ in). Oslo, Nasjonalgalleriet

139 *Nude with Red Hair*, 1898–1902. Oil on canvas, 120 × 50 cm (47¼ × 19½ in). Oslo, Munch–Museet

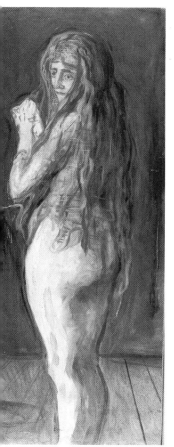

anxiety; her refusal to agree with him aroused in him feelings that can only be described as panic, a phobia of unprecedented intensity in his phobia-filled life. With her long red hair, Tulla could only be either an angel or a persecuting devil.

In the absence of other evidence, however, it is tempting to conclude that the optimistic imagery in Munch's paintings of 1898 has a source in the beginnings of the love affair with Tulla, before his sense of persecution set in. If this is so, then the continuation of the Naturalistic tendencies inaugurated somewhat earlier in Paris may also have been motivated by a desire to accept the world's actual presence rather than to go on rejecting it. Using Tulla as his model, he painted *Nude with Red Hair*. She appears bony and angular, her flesh and hair rendered in broad strokes of viscous paint that hark back to his Naturalist works of the 1880s, as do the vertical and horizontal patterns scratched with his brush handle to create a webbed network over the hair and facial areas. Gestures and posture are not overtly symbolic. Only in the heavy outline enclosing the body, and in the flat ambiguity of background wall and floor, do practices of the Berlin or Paris years reappear, serving now as contrast to the pitifully naked, three-dimensional figure. The conflict between the emphasis on reality, the harsh opposition of red and green, remnants of the vocabulary of the 1890s, and the persistent threat—as in the emphasis on the 'diabolic' red hair—of a symbolic content, inject the painting with a previously rare psychological intensity; it is a precariously balanced result not frequently achieved thereafter.

Such practices could be more readily applied in portraits. In 1899 Munch depicted Aase Carlsen Nørregaard in a double portrait with her husband Harald. Munch's main concern is a sensitive rendition of their relationship: their faces are rendered carefully and precisely to emphasize three-dimensionality; all symbolic aids are avoided; and the woman gazes forthrightly out of the picture and the man turns towards her as if only through her does he gain access to the world.

The calm and tenderness of this portrait, however, contrasted with Munch's own growing sense of desperation. The world was once again proving false. Norway's critics continued to attack him, the more vehemently

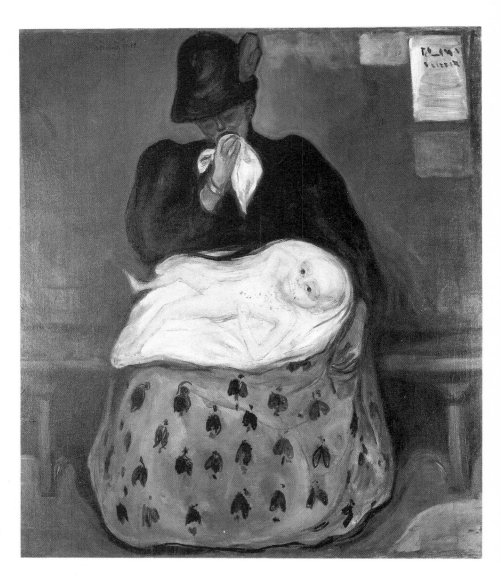

140 *Inheritance*, 1897–9.
Oil on canvas, 141 × 120 cm
(55½ × 47¼ in). Oslo,
Munch–Museet

as French and German critics praised his continuing efforts. In 1899 he painted his recollection of a woman and her syphilitic child in a Paris hospital, and used the scene to express his own rekindled anxieties about his family's inheritance of sickness and insanity. His sister Laura, still suffering the effects of being deserted in love, was institutionalized for schizophrenia, and Munch painted a portrait of her. Entitled *Melancholy,* it derives from studies begun in 1895 and returns to his earlier visual formulas of isolation: the single seated figure staring blankly ahead, the empty room, a potted plant and a window looking out onto the greyness of a frozen fjord. What distinguishes this painting from earlier ones is the colour. Red and harsh yellows dominate, suggesting—along with the jutting corner walls of the room—conflict, terror and anxiety. Just as ten years earlier Goldstein had posed as Munch's alter-ego, so now Laura appears to visualize his psychological turmoil as the affair with Tulla dragged on into the winter of 1898 to 1899. The setting of Laura's portrait is not her sanatorium; it is Munch's own rooms rented in a large, wooden yellow house situated between the towns of Nordstrand and Ljan just south of Kristiania:

141 *Melancholy (Laura)*,
1898. Oil on canvas, 110 ×
126 cm (43½ × 49½ in).
Oslo, Munch–Museet

There in two rooms I walked back and forth, back and forth, then went out on long
walks, then back and forth again on the rug until it was time to go to bed—how I
hated the bed, my rack of torture. There I lay and waited for sleep, that only came
briefly before I woke up again, and so I lay and waited for morning . . . then another
long day, then another sleepless night.

I was afraid of people and avoided them, not wanting to see anyone. The
neighbours ate on the floor below—the melancholic, the epileptic, and the hostess
who stayed in bed because of lameness.

When the winter sun stood near the horizon it shone through the windows, and
flamed up red and yellow in my room. The yellow walls became flame and the
brownish wooden floor was blood. The light and colours stabbed like a knife into my
soul and my body in which the blood flowed sick—Melancholy: the lack of proper
blood circulation. I ran out to escape from the unhappy creature that had settled in my
room, out into the fresh air. . . . These eternal walks from which I return bathed in
sweat.[111]

The despairing melancholy of Saint-Cloud had returned. One by one his
fellow boarders died, and Munch anxiously awaited the return of spring,
hoping it would restore his health before he too died so horribly. He
continued to register his anxieties in his paintings, but they recorded his

increasing weakness, his loss of the control that his art demanded.

In *The Red Vine*, painted in the autumn and winter of 1898, there is a sense of terror akin to *The Scream* or *Evening on Karl Johan's Street*. The foreground figure with gaping eyes, the sharp perspective of the path into the distance, the emphasis on the colour red: all these echo Munch's earlier practices in attaining a similar mood of anxiety. The handling of forms and paint is looser than before, however. As in works of 1893 to 1894, colour is applied very thinly and permitted to drip down the canvas, but brushstrokes now move almost at random, no longer following structured patterns. The entire composition threatens to fall apart and the use of techniques or situations from previous works results less in a sense of unity than in a pastiche that relies for its strength largely on its predecessors. There is agony in the painting, but it is the agony of strength dissipated. The winter of 1898 to 1899 not only marked a psychological crisis but also an artistic one, a desperate search for a style and content that would supplant those associated with the 'Love' series.

The long Nordic winter during which Munch suffered his sleepless nights finally ended in March 1899. Tulla's interest in Munch did not, however. Munch fled the country. She followed. The chase continued. He returned to Norway to spend the summer in Aasgaardstrand. Tulla remained there as well, to continue to offer the temptation of her vitality as an alternative to a life of sickness and art's demanding detachment. The temptation was strong, but Munch resisted:

142 *The Red Vine*, 1898. Oil on canvas, 119 × 121 cm (46¾ × 47½ in). Oslo, Munch–Museet

143 *Evening on Karl Johan's Street*, 1896. Hand-coloured lithograph. Private Collection

How beautiful life is, after all. Life that—despite everything—remains a Canaanite land filled with wine and honey for me, and which I shall never be able to enter. I can only observe how beautiful it must be.[112]

His own life, so Munch was convinced, could contain nothing resembling happiness since that would destroy his creative roots. Tulla's persistent pursuit interfered with his ability to follow his calling, and the torture of not working only contributed to further inactivity. The sole solution was flight. In the autumn of 1899, seeking release and restoration, Munch committed himself to the sanatorium of Kornhaug, isolated in Norway's Gudbrandsdalen, far from human contact and art. From there, as winter snows erased the browns and greens of the surrounding mountains, Munch wrote to Tulla to explain his sudden disappearance:

My dear friend!
Here is the first of the small letters I will send from time to time . . . I hope you will get to know me properly.

Once you understand me, you will understand how impossible it was, the way you were with me, and how it would slowly kill me were my loneliness taken away from me. Then you will also understand that the marriage which still may come to pass must be the kind that I indicated.

We must live as brother and sister. You must primarily view my love for you as a brother's love. Perhaps after a while, your love will also become a different kind, that is, a sister's love—and without that, everything is impossible—with me.

You could make engravings. And I would get books for you, so that you could cultivate your spirit, which currently is totally undeveloped.

144 *Golgotha*, 1900. Oil on canvas, 80 × 120 cm (31½ × 47¼ in). Oslo, Munch–Museet

So—listen to me, and be open towards everything. . . . Learn to be resigned, because with pressure and force you have begun in me the opposite of what you wanted.
Best regards,
Your Edvard[113]

At Kornhaug Munch returned to the theme of the love relationship that had formed the focus of his cyclical imagery during the 1890s. He depicted the three stages of woman personified in Tulla in the dance of a summer night on a Norwegian seashore, *The Dance of Life*. The couples dancing in the light of the moon represented life's continuing changes, the white, red and black symbolizing innocence, sensuality and bereavement in the women. In his style, too, using extremely thinned paint and highly flattened, outlined forms, Munch deliberately created an image similar to the initial paintings of the 'Love' series. However, as in *The Red Vine*, the paint handling is less sure; the canvas is filled with traces of conflict in numerous, partially covered alterations, and in the extremely erratic brushstrokes whose sole order is supplied by the forms of the figures. Hurried completion of the large, programmatic painting was his paramount concern, and while this (in conjunction with the multiple outlines radiating away from each figure) produced a certain and appropriate sense of movement, it testifies more to the desperation of an artist seeking to ban the ghosts of his anxiety concerning the sensuous Tulla.

The Dance of Life is also more closely associated with the events of Munch's own life than were the images in the 'Love' series. Munch himself dances in the centre in the arms of the red-clothed woman. He wrote:

I danced with my first love; it was the memory of her. The smiling, golden-haired woman enters and wishes to pluck the flower of love, but it will not let itself be picked.

172

And on the other side is she dressed in black, gazing in sorrow at the dancing couple —an outcast, just as I was cast out by her dance. And in the background, the raging mob storms about in wild embrace.[114]

The 'mob' is even more apparent in a preparatory study for the painting; there the dancing couple is clothed symbolically in black, stiffly enacting a quiet musical pantomine of sorrowful reserve as the others hectically swirl about in their passion. They dance the dance of 'sister and brother' that Munch wished for. In the final painting that has changed, very probably in response to the pressure of events that proved Munch's ascetic hopes futile. The 'first love' with her dark hair has been painted over, the memory of her spiritual presence supplanted by the bloodily red hair and dress of Tulla. Similarly, the most fervent of the embracers on the right, his face the green colour of jealousy, has taken on the ridiculed, distorted features of Heiberg, whose role as initiator of the Tulla–Munch relationship forever branded him Munch's particular nemesis.

From the safety of the sanatorium's windows, Munch watched the new century arrive. He greeted it with the painting *Golgotha*, in which he once more affirmed his gospel of artistic suffering whose sole solution could be in art itself. The image shows an artist, his face an amalgam of Przybyszewski and Munch himself, crucified as a twentieth-century Christ while a carousing crowd mocks him. 'When I paint illness and grief', he wrote, 'it is a healthy solution. It is a healthy solution according to which others can learn and live.'[115] Art should provide the message whereby others would be converted, but for the artist persecution for his prophecy would never end. Only his prophecy would live, and for it he must sacrifice his life in isolation.

Munch left the Kornhaug sanatorium early in 1900. The letters to Tulla had not been convincing and her pursuit resumed. Munch fled to Berlin, then to a sanatorium in Switzerland, and back to Norway in the autumn. There was no time or strength for work. The new century did not begin well.

Chapter 6

YEARS OF CRISIS AND SUCCESS
1900–1914

'I have been faithful to the Goddess of Art'

During the decade and a half from 1900 to 1914, Munch's life, his habits and his art radically altered. The main cause of this was Tulla Larsen. The impact she had on the middle-aged artist exceeded even the effect of Milly Thaulow on the young Munch. The physical and psychological turmoil of his life continued to determine both the content and style of his art. In ironic contrast to the course that led from one sanatorium to another, to alcoholic hallucinations and nervous breakdown, and ultimately to self-imposed reclusive isolation, Munch's reputation, critical success and financial prosperity progressively improved. The years of crisis were capped by success.

In fragmentary reminiscences, written between 1905 and 1909, Munch recounted the events of his tumultuous relationship with Tulla after he left Kornhaug in 1900. Bitterness and resentment predominate as he imagines Tulla 'in the arms of that loathsomely obese Gunnar Heiberg', and Munch becomes the suffering victim when he shows her compassion:

> She goes on to Berlin. Then I get a letter from her in which she tells me that she is near death, totally overcome by tuberculosis.
> In a desperate state of despair, not knowing what to do, I rushed to her despite my own illness, and I let her pay for the trip—the rich woman—since I myself was penniless and poor. In despair I wrote, proposed marriage.
> I meet her healthy in a foreign land—so it was a lie: the tuberculosis. I suspected I was deceived.
> Together we went to Italy to see what I could do. I broke down again, and fled to a nerve-sanatorium and then to Norway. Afraid of people, sleepless.[1]

In Munch's writings about Tulla, the proportions of fact, imagined fact and fictional embroidery on fact are even more difficult to determine than in the texts about 'Mrs Heiberg'. In 1929, in the front of one of the ledgers in which he entered his recollections, Munch was to write:

> These diary entries ... are partly actual experiences, partly poetic experiences. I do not intend to present my experiences through them. They are intended to seek out the hidden powers ... within the machinery that is called a human life, and their conflict with other human lives. When I collect these now, they will be marked by my current spiritual state. ...
> How difficult it is to determine what is unauthentic, what is concealed deceit, self-deception, or the fear of showing myself in my true light.[2]

This conscious structuring of the entire Tulla episode is evident in another piece:

> In the first Chapter:
> When I repeat over and over again the first days' impressions, I must also think of the repulsive aspects: the dance with Skredsvig when I lay in a fever in the middle of the night, the constant insensitive remarks about how sickly I was, the comparisons between her and my sister, and how ashamed I was for her when I heard her use crude expressions and tell indecent jokes. ...
> And so there remains my work, my art, for which I sacrificed my happiness, that is, what others call happiness—prosperity, a wife, children. What is art? Actually, the reflection of what is unsatisfactory in life. It is the appearance of life's passion to

create—life's eternal movement—crystallization, since all movement demands form. A human being is a crystal that has received an Idea, its soul. . . . Death is the entry to life. Death is the transition towards a new crystallization.

Everything lives and moves, from the masses of earth to the air's atoms. Everything desires to live. And the more are destroyed, the more live.

Therefore, her happiness was dependent on my destruction. . . .

And now that I chase about among men like a true wildman, there is peace in her soul and she can enjoy life. I, however, continue to go about in the mist-filled spring air and continue to be filled with desire. . . .

Is this all that life can be for me, to see but not to enter the promised land.[3]

During 1900 Munch's creative activity virtually ceased. The paintings begun during the winter at Kornhaug were completed, but in the chaos of travel and anxiety engendered by Tulla, there was neither time nor strength for art. There were no exhibitions of his work that year, as there had been every year since 1883.[4]

In November Munch returned to Norway, apparently without Tulla, and settled again in Nordstrand, just south of Kristiania. In an effort to regain his strength and self-control, he turned to nature to paint a series of forest and fjord scenes set in the melancholy moodiness of dusk in late autumn, winter and early spring. The fjord seen from the elevation of Nordstrand and Ljan supplanted the sinuously curving shores of Aasgaardstrand which had been the recurrent setting of the 'Love' series. The times of day and year retain the subjective moody quality that originally fascinated Munch, as in *Starry Night* of 1893, but the views show a recognizable topography free of symbolic associations. Munch's highly synthetic style, closely related in its effects to contemporary Art Nouveau, creates a firmly defined and controlled formal structure, still retaining previous personal techniques. In intent and in style, the works fit between the overtly symbolic paintings of the 1890s and a naturalistic attempt to recapture external reality. By rejecting his obsessive concern with the relationship of the sexes, and instead concentrating on artistic control of nature's forms, Munch sought to reassert and reaffirm the artistic mastery which the turmoil of 1900 had threatened to destroy. His need for immortality attained through art triumphed over Tulla's baleful impact.

The winter months early in 1901 were punctuated by the destruction of Munch's painting *The Lonely Ones*, a major work of his earlier development as artist. It was on its way to an international exhibition in Munich. The inactivity of the previous year was over and Munch was able to work again. Even the news that Dagny had been killed did not interrupt his activity. For the summer he returned to Aasgaardstrand, to paint there the first version of *Girls on the Pier* as a replacement for his burned painting which had been owned by Olaf Schou. He also finished his series of nocturnal landscapes with *Summer Night*, an evocative view of the fjord as the midnight sun reflects golden in the blue and violet waters. Underlying the calm silence is a pregnant sensuality which affirms Munch's faith in the life of nature which overcomes all death, the process he called 'crystallization'. His own artistic life he reaffirmed yet again by displaying seventy-two paintings in October in Kristiania, excluding from the collection most of the love-orientated works of the 1890s.

After the exhibition closed, Munch left Norway for Berlin to seek the money and patronage his native country continued to refuse him. 'I have returned to my old ways down here, and can live in peace, something that was impossible in Kristiania where I know too many people', he wrote home to his aunt, and he added: 'Tulla is quiet now.'[5] To an exhibition of Scandinavian

art in Vienna, he sent two of his 'most drastic paintings', *Anxiety* and a recent winter fjord scene, which the Viennese painter Carl Moll purchased. He made plans to exhibit in Berlin early in 1902. He met Hermann Schlittgen again and painted a life-sized portrait of him. Ten years earlier Schlittgen had frequented the Schwarze Ferkel, and it was he apparently who introduced Munch to the man who would bring him in Germany the commercial success that had eluded him for over twenty years: Albert Kollmann.

A mysterious figure, Kollmann was a believer in the occult, and numerous of his friends attested that they attended his funeral several times only to have him reappear very much alive, even after his apparently final death in 1915. After amassing a significant fortune through the ownership and then sale of a department store, Kollmann dedicated himself to art. He acted as the publicist of various painters, but primarily the German Impressionists who, in 1898, had formed the Berlin Secession with Max Liebermann as president, thereby bringing together into a single organization the opposition to Anton von Werner's Verein Berliner Künstler and academy that had continued to smoulder since the 'Munch Scandal' of 1892. Munch, however, did not join the group as a regular member until 1904. Kollmann abandoned his Impressionist friends after 1901 to devote himself totally to the new 'prophet from the north'.

Munch immediately painted his portrait. Glaser saw in it a shift in Munch's artistic direction towards a 'passive resolution of the ego in the given objects of nature. . . . The artist disappears behind the work. The portrait frees itself from its creator. . . . More and more decisively, Munch simply and honestly takes the people as they appear in front of his easel, as model, as a corner of nature which he gives form.'[6] Glaser's description is apt, although the emphatic contrast between the green background and Kollmann's red hair reveals Munch's continued use of colour symbolism in depicting the man he called his Mephistopheles. In addition, his characteristic turpentine-thinned paint applied in rapid brushstrokes preserves visible tracks of the picture's formation.

As Munch's psychological and artistic crises abated in 1901 and 1902, external reality, even the conflict-ridden form of woman, became a measure of his ability to counteract the internal turmoil of his life. In response to the paintings of this period, Thiis concluded that Munch 'is the only great painter of the female nude that we have in the history of Norwegian art'.[7] While in his graphics Munch opted to create a new version of *Puberty*, he painted a dark-haired, heavy-breasted nude, her eyes fixed in an intense stare. The title, *The Beast*, is not Munch's (he described it as *Seated Nude with Black Hair*) but it does suggest how readily—if unintentionally—the image brings with it baleful associations from his earlier art, particularly *The Vampire*. More significant in terms of Munch's concerns in 1902 is the emphatic three-dimensionality of the figure, a total denial of Symbolism's two-dimensional projected images that acted as visualizations of ideas.

Under the guidance of Munch himself, Glaser wrote shortly before the First World War that 'subsequent analysis of Munch's artistic development indicates that 1902 was a universal border. But the division must not be considered binding in the strict sense . . . that a new epoch set in as a self-conscious effort by the artist.'[8] The effort *was* self-conscious, however, and deemed necessary by Munch for his psychological and artistic health.

The year 1902 forms a dividing line between earlier and later concerns in yet another way. Encouraged by Kollmann, Liebermann invited Munch to exhibit in the March to April exhibition of the Berlin Secession. Liebermann

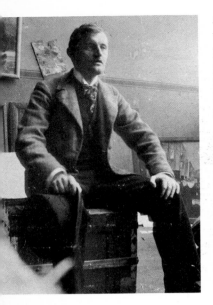

145 Edvard Munch in his Studio, Lützowstrasse, Berlin, 1902

146 Edvard Munch
Exhibition, Leipzig, 1903

asked for 'all of that so-disdained Cycle of Paintings dealing with Love and Death', Munch wrote triumphantly to Aubert in Kristiania.[9] Expanded to include a total of twenty-two paintings, 'Frieze: The Presentation of a Series of Images of Life' (a title suggested by Kollmann) marked the culmination of Munch's decade-long efforts to clarify life for himself and others through his art. During the next two years, he also exhibited the completed 'Frieze' in Kristiania, Prague and Leipzig—where he had it photographed for a brochure. The four walls subdivided the cycle into 'The Seeds of Love'; 'Blossoming and Fading of Love'; 'The Anxiety of Life' and 'Death'.[10] Essentially the concept remained that of the 1890s 'Love' series, with the motif of death attached. The exhibition, in Berlin as well as when it travelled with slight alterations to the other cities, accompanied by Munch's graphic variants of the paintings (now including colour impressions of *Madonna* and *Vampire*), was a testimony to an aspect of Munch's work that had been terminated.

Critics reviewing the exhibition of the Secession with its 332 paintings and sculptures paid only slight attention to Munch's 'Frieze' hung in the Sculpture and Entry Hall up near the ceiling. Their attention was drawn by novelty: Liebermann painting not his usual landscapes or scenes of Dutch life but a melodramatic *Samson and Delilah,* and Klinger previewing his polychromatic sculpture of *Beethoven* in a painted plaster version. As a result, Munch was often only included among lists of non-Germans participating in the exhibition, and it was questioned why he should be honoured with the space of the entrance hall since what he displayed had mostly been seen before.

Munch was beginning to be accepted alongside such artists as Van Gogh and Gauguin as a representative of pioneering years, rather than as an artist concerned with contemporary problems. This view was put forward in 1900 by Meier-Graefe in a monumental evolutionary history of modern art;[11] it was certainly not the view of more academically orientated critics, but even they, while decrying the 'confusion of Munch's efforts', could praise some of his most colouristically and psychologically radical paintings: *The Scream, Anxiety* or *Death in the Sickroom*.[12]

Kollmann's influence, however, prevented Munch from being ignored. A critic close to the Secession artists, Karl Scheffler, retrieved Munch from critical neglect by proclaiming him to be food for the future. Art, he argued, was seeking a new dramatic content; for German artists to benefit from this they should use 'the new discoveries of our revolutionized emotional life while building on the results of Impressionism':

Munch . . . is a typical product of our ruling spiritual fever. He . . . belongs among those who pit themselves against their gruesome, incomprehensible fate with hate and intense disdain. . . . There has never been a painter with a greater desire for a lyrical mode of expression; but his unhappy intellect, not knowing how to forget, shows him . . . the grimacing skull beneath every face. . . . Revealed by his works we sense a man . . . brooding and prowling in an atmosphere of doubt, constructing himself philosophic systems, and driven on by the anxieties of life to unimaginable activity. No wonder that someone such as this has no use for tradition and established values.[13]

Similarly, in the popular and usually quite conservative periodical *Die Kunst für Alle* ('Art for Everyone'), Hans Rosenhagen chided the average visitor to the exhibition for not understanding the most classical of modern painters, Edouard Manet and, in conjunction with this honoured name from Impressionism's past, Edvard Munch:

And with Edvard Munch too they have no idea what to do. They see his life's work

organized as a frieze in the first room of the exhibition primarily as a mockery of traditional values rather than as a revelation of new values of beauty. . . . They do not recognize that through a synthesis of brutal Nordic joy in colours, influences from Manet and a tendency towards the visionary something totally unique has been created. Whoever creates such works has the right to the greatest respect.[14]

Such reviews were a novel experience for Munch, and precisely the sort of advertisement he had hoped to obtain ten years earlier from the Verein Berliner Künstler. Now, however, the recognition promised greater future success. Under Kollmann's guidance, Munch's art was being presented as a highly promising investment, the work of a modern master still alive and creating. Nor were Kollmann's efforts futile. The optician Dr Max Linde from Lübeck whom he introduced to Munch bought the painting *Fruitfulness* for 1,000 Kroner, and immediately started a short illustrated monograph on him, *Edvard Munch und die Kunst der Zukunft* ('Edvard Munch and the Art of the Future').

In his recollections, Munch wrote with a slight note of apprehension: 'Three horrible years had passed. New life, new hope. His great, completed Frieze hung in the Berlin Exhibition. After three years' illness he began finally to live again.'[15] In June 1902 he returned to Norway, confident in his new German contacts and Kollmann's continued efforts as agent, apologist and salesman of his art.

There, however, his new-found optimism was shattered. Tulla returned into his life, to leave a final physical and psychological scar:

And then he heard from a friend that in Munich she [Tulla Larsen] had spread horrible rumours about him: that I had lived from her, used her money, and then abandoned her like a heel.

I heard that she had written letters to my family and told them that I had behaved like a scoundrel. . . .

His three years were destroyed. He had come like a wandering minstrel to the rich woman's door.

'Open your door', he had said, 'You are so pretty. I am exhausted and longing for love. Won't you give me from the richness of your table of love?'

'Sit down, minstrel', said the rich woman. 'I will give to you from my table of love.' And so he partook of heart. But there was poison in the food. And he was seated at a table with death, illness and poison.

So it was for her that you destroyed three years of your life.[16]

Hidden behind Munch's somewhat clumsy poeticizing and self-pity are the events of the summer in Aasgaardstrand. Accounts are confusing. What is clear is that Tulla made a final attempt to bring about a reconciliation between herself and Munch through the intercession of Sigurd Bødtker, Krohg and others. According to one version of the events, she threatened or feigned suicide to bring Munch, filled with compassion, to her, and as he struggled to keep her from shooting herself, the revolver went off. In an alternative version, written by Munch himself, she says she will go so far away that he will never see her again. He collapses on to a stool, a revolver in his right hand:

'What do you intend to do with that revolver?' she asks.

He does not respond, holds the revolver in his firmly closed fist.

'Is it loaded?'

He does not respond, stares into space without seeing anything.

'Answer me, is it loaded?'

A powerful shot and the room fills with smoke.

M. gets up, blood dripping from his hand. He looks around in confusion and lies

147 *Eva Mudocci*
(Madonna: The Brooch),
1903. Lithograph. Oslo,
Munch–Museet

down on the bed. Blood drips from his left hand, that he holds high into the air.

She goes about stealthily and mops up the blood from the floor and brings in a washbasin. She hides the blood-red handkerchief next to her breast.

Suddenly he looks at her with a cold expression in his eyes: 'You parasite. Don't let me bleed to death. Get a doctor!'[17]

Whoever held the gun when the shot was fired, the ring finger of Munch's left hand lost two joints, and he went alone to hospital on 12 September. Perhaps in deference to Dr Karl Schleich, a member of the Schwarze Ferkel who pioneered the discovery of local anaesthesia, Munch rejected narcotics and remained conscious during the operation on his finger, later describing it in his writings. Following the advice of Bødtker and Heiberg, and fearing for her

148 *Salome*, 1903.
Lithograph. Oslo, Munch-
Museet

own life, Tulla left Norway for Paris. Within a year she had married the painter Arne Kavli.

Munch fled to Germany. There he stayed briefly at the home of Dr Linde and began a series of commissions for him: a portfolio of graphics, a frieze of paintings for the children's room and portraits of the family, to be carried out during the next two years.[18] At Linde's, Munch also met the retired judge, Gustav Schiefler, who had catalogued the prints of several German artists, including Liebermann, and now suggested the same for the nearly 180 prints Munch had completed: the catalogue remains the standard listing of Munch's graphics.[19]

Restless and tense after his experience with Tulla, Munch resumed his nomadic life. He travelled on to Berlin to meet Kollmann in December and to collect his 'Frieze' paintings once more to take them to Leipzig. From there, in March 1903, he went to Paris, where Kollmann and Linde suggested he should exhibit at least once a year. He exhibited eight paintings at the Salon des Indépendants, was repudiated by the Norwegian community that included Tulla and Krohg, and suddenly formed a close friendship with the English violinist Eva Mudocci, who specialized in concerts of Scandinavian music performed in 'antique peasant costumes'.[20] Although there were, in Munch's words, 'snowshowers on the spring blossoms', she seemed to bring to Munch the 'sisterly love' he sought, and she became the only woman other than Aase Nørregaard with whom he maintained peaceful contact.

In a lithograph of Eva, he returned to his earlier practice of injecting symbolic significance into his portraits. With her long, flowing black hair loosened over her shoulders, head tilted slightly and eyes half-closed, she recalls the madonna depictions of the 1890s and Munch applied this title to the work. However, unlike the earlier madonnas, Eva's role seems to be that of an artistic or spiritual muse: she remains clothed, and all focus is on the spiritual centre of the head with its melancholic eyes.

In a second portrait, Munch also returned to an earlier allegory of artistic creation. Entitled *Salome*, it depicts Eva in a madonna-like pose while her hair falls over the emaciated head of Munch to create a contrast of vibrant life and weakened health. Around 1895 Munch had used this motif in several triptych drawings representing the various stages of woman's relationship to man, and in the initial state of the engraving of *Sphinx* the dolorous, dark female figure is shown holding a man's head. Similarly, in 1898 in a self-portrait set off against a flaming red, infernal environment, his own head is enveloped by a woman's hair. The updated version of Salome, the daughter of Herodias who demanded the head of John the Baptist in payment for her sensuous dance in front of King Herod, was used by Munch consistently in the context of allegories of artistic creation, and accordingly appeared also as the projected cover for the print series 'The Mirror' in 1897 to 1898. If the intent of the image is to signify creativity, then Munch was countering the more frequent Symbolist interpretation of Salome as the epitome of the seductive, death-dealing woman. Observed more closely, the women bending down towards the artist's head so that their hair surrounds it while their hands support it resemble a stylized womb shape, as if the artist were returning to a protective environment such as existed before birth and tortured physical existence. It therefore also heralds a state akin to death, according to Munch's thought, and repeats his earlier visual comments on the source of artistic inspiration. Caressing the severed head or spirit of the artist, woman thus engenders a form whose function is to protect, preserve, encourage and also nourish in a manner analogous to the biological functions of the womb for an embryo.[21]

The idyllic images of Eva contrast sharply with a series of caricatures Munch also inaugurated in 1903 and completed in 1905. The members of the Kristiania Bohème's depleted ranks are depicted as crude animals—Gunnar Heiberg as a bottle-shaped pig, Sigurd Bødtker as a prancing poodle—and texts accompany the acid images: 'Gunnar Heiberg sailing along with his fat little paunch, winking with his piggy eyes: a cross between a pig and a toad.'[22] In several of these drypoint engravings Munch cast Tulla in the role of Salome, but this time it is a totally destructive role. She appears either naked or with her dress cut low, wearing a feathered hat, her lips turned upward in a grimacing smile of malevolence. She carries Munch's head, or the head of a bearded artist, holding it away from her, playing with its eye sockets, leaving it totally unprotected.

The presence of Tulla in Paris proved overpowering, although the two never met, and he left the city in such haste in April 1903 that he abandoned all his paintings there. To Dr Linde he wrote: 'Here, sad to say, too many Norwegians now. I must leave otherwise I predict great disaster.'[23] Linde offered him refuge in Lübeck. During a two- or three-week stay, Munch created three large etched views of Lübeck, a portrait of Dr Linde and the portrait of the four Linde sons which has often been described as one of the masterpieces of child portraiture. Glaser wrote:

Others would have had the children move, would have given them something to occupy them. Munch rejects such superficial means. He simply lets the children stand in front of a door. ... These four children stand as human beings with a clearly determined character in front of the viewer. The posture alone, with its totally unartistic self-presentation, characterizes each one. It is marvellous how nature, even without the use of external magnification, is intensified into monumentality.[24]

Through careful observation of habitual postures and gazes, 'Uncle Munch' gained an intuitive knowledge of each of the boys' personalities and trans-

149 *Portrait of the Linde Sons,* 1903. Oil on canvas, 144 × 179 cm (56½ × 70½ in). Lübeck, Behnhaus

150 *Gruesomeness*, 1905. Drypoint. Oslo, Munch–Museet

lated these into the painting with such precision that to later viewers who knew the boys as men it seemed as if he had predicted their individual futures and fates. In his ability to paint and paint well with an imagery that could be measured in its correspondence to a visible model, and in his increasing number of landscapes and portraits, Munch found reassurance that he was regaining control over his physical and psychological health. Despite the painful reminders of Tulla in Paris, in his art he remained the master.

After a visit to Berlin, where he met Eva, Munch returned to Aasgaard-strand for the summer. 'I sail, paint, swim, and am well—here I drink little alcohol',[25] he wrote to Linde, and he also prepared for exhibitions in Kristiania, Hamburg, Berlin and Vienna. Money from Linde, from the German dealers Cassirer and Commeter with whom he now had contracts, and from a Norwegian government grant relieved him of pecuniary worries and permitted him to fulfil his duties towards his aunt and sisters. Beginning in the autumn, however, and extending through the spring of 1904, hectic and sudden trips to Lübeck, Berlin, Paris, Hamburg and Weimar point to a restlessness and erratic behaviour such as characterized other times of psychological stress in his life. The discipline of work, aided by alcohol again, was suppressing the turmoil still raging inside him.

While fulfilling his various commissions at Linde's home during 1904, Munch also painted a self-portrait. Like his other contemporary portraits, it is life-sized and shows Munch full-length, wearing a blue smock, a vest, a high white collar and a tie. Thus neatly and conservatively dressed, he clasps his paintbrushes in front of him and gazes resolutely outwards, his deep blue eyes fixed on the external world. It appears the antithesis to the blue self-portrait completed in 1895, where he posed as the archetypal introspective Symbolist and Decadent. Here the figure is clearly defined and the surroundings, while brushed in with heavy strokes in thinned paint, lack the earlier mystery. He is a gentleman living among Germany's social élite. The painting also serves as response to his Norwegian detractors' claim that both he and his art were ill or insane. In terms of his own aroused and agitated psychological state, however, it was an image of self-delusion, the artist's public persona behind whose façade hid the private reality.

After a peaceful summer in Aasgaardstrand where he completed several paintings for Linde's frieze, Munch went to Copenhagen to arrange an exhibition. While there, he was provoked into a fight with the writer Andreas Haukland. Newspapers reported his 'scandalous' behaviour. In it all Munch felt he saw the pernicious hand of Tulla and her Norwegian cabal. He escaped to his hut in Aasgaardstrand, then left for Hamburg to fulfil a portrait commission. Later he recalled:

In the midst of his attacks, he painted the portrait of a woman, finishing it all during one morning. Had fortified myself with alcohol. A woman in white dress, calm, clear, painted with broad strokes, a good likeness. One of my best paintings. In the afternoon, another attack . . . hallucinations.
An American doctor sat in the restaurant. During the afternoon, I began to have hallucinations. 'It will end badly with him', said the doctor to the innkeeper.[26]

In his art he sought the evidence for the calm his life seemed not to grant him. Increasingly, he found refuge in alcohol, which only aggravated his mental turmoil. While in Hamburg, he attacked a German naval officer, who then challenged him to a duel. Munch apologized the next day, arguing that he had been drunk and was having hallucinations, but only the German fleet's departure for Morocco saved him from a gunshot wound that would certainly

have been more serious than the one inflicted in 1902. Understandably, Munch began to fear for his sanity and life.

However, during 1904 portrait commissions continued to come in from German industrialists, bankers and aristocrats; Kollmann continually attempted to convince museum directors to buy Munch's work; the Deutscher Künstlerbund (German Artists' Association) and the Berlin Secession invited him to become a regular member; and critics praised his work as a new Nordic monumental art setting the example for the future. 'I possess the cold joy of power now that Germany has been conquered for my art and that, at least away from home, there is an interest in it', Munch wrote to Jappe.[27] His reputation was also spreading further east, to Vienna and then to Prague where he was invited by the Secessionist Manes group of artists in February and March 1905.

For the last time he brought his 'Frieze of Life' together, but reduced it to fifteen paintings since otherwise it would fit no single room in the Manes building; in addition, he displayed over sixty paintings and forty-six prints.[28] He was received with the honour usually accorded an old master. If the Prague critics did not share the inviting artists' enthusiasm and considered Munch an indigestible novelty, in this instance their reactionary stance was viewed more as a virtue than as offensive. William Ritter's detailed essays about the exhibition in the *Mercure de France* and the *Gazette des Beaux-Arts* generated much desired publicity in Paris, where Munch's continuing participation in the annual Salons des Indépendants was failing to bring significant attention.

The reason for Munch's inability to conquer Paris, the German critic Arthur Moeller van den Bruck argued, was Munch's Nordic soul. The French had led modern painting to all its finest points of development, with one exception:

The French had long ago given up their fantasy . . . and traded it for scepticism—thus their art too was sceptical, enjoying only those things that were objective, precise, real . . . but they mistrusted, if they did not totally reject, everything which was unfathomable, inessential, mysterious. Whereas it continues to be Germanic to have an inner eye for the inner being, to understand the universe not critically but to feel it fantastically—and nowhere was this power more strongly preserved than there where the Germanic essence was most strongly preserved, in the North, in Scandinavia.[29]

Van den Bruck had welcomed Munch to the German colony in Paris when the Krohg-associated Norwegians there had rejected him.[30] A staunch German chauvinist, in cultural terms at least, he propagated a new art founded on principles of Nietzsche's philosophy of the 'super-man' and Darwin's concept of the struggle for survival in which only the fittest survive. The inequality of men was enthusiastically affirmed, and suffering, battle and self-conquest were perceived as the conditions of human greatness. 'Struggle is magnificent and more worthy of men than self-indulgence in smug comfort', he wrote in a critique of modern literature that praised Przybyszewski as one of the most promising poets of the era. 'Struggle gives us, especially when it is of the spirit and passions, our greatest kings and heroes.'[31] The rule of a satiated and sullen bourgeoisie was the enemy of such spiritual élitism and individualism, however, and it had to be countered by an aesthetic aristocracy whose determined, masculine will could overcome the corruption of liberalism.

Van den Bruck's mystical and mystifying aesthetics and world view were shared by large segments of the German population. Cultural discontent and

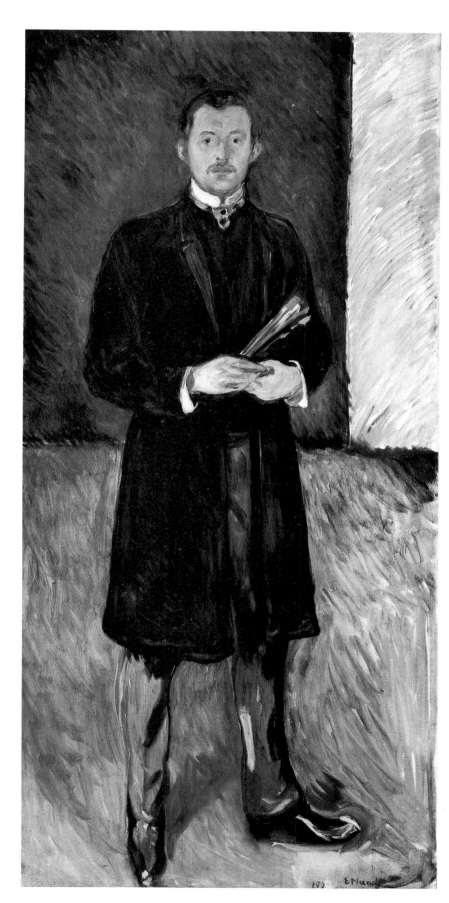

151 *Self-Portrait with Brushes*, 1904–5. Oil on canvas, 197 × 91 cm (77½ × 35¾ in). Oslo, Munch–Museet

malaise as well as a loathing for everything 'average' characterized the merchants, industrialists, bankers, judges, minor aristocrats and the artists who formed Munch's major support. It was a significantly different element of society from the few bohemian outcasts defending his art in Norway; these were patrons who moved freely in royal and Imperial courts and were the very pillars of social and economic success. It is ironic that it was precisely they who most intensely joined Van den Bruck in expressing the conservative revolutionary ethic antagonistic to the materialistic well-being of the German Empire. They yearned for a purified spirituality, cleansed through struggle, and which would give emotive expression to the modern soul. Viewing their own time as an era of transition, they yearned to shape the future into a millennial 'third kingdom' whose culture would exceed all that preceded it. Monumental greatness in art and spirit, rather than humanity's corporal and material welfare, would be its concern.

It was an ideology that appealed to Munch. As he contemplated the values of life in the context of his Prague triumph and his persecution at the hands of a Krohg-Larsen Norwegian cabal, he concluded that life was a struggle from which the strong would emerge triumphant, thus proving their moral and artistic worth. Only through the 'vice' of compassion had Tulla attained her temporary triumph over him. Nonetheless, he continued to create; this was proof of his superiority. His life's mission to 'help others clarify the meaning of life for themselves' was reaffirmed. This too was the Munch in whom Germany's conservative revolutionaries perceived a prophet testifying to their vision of the future:

In everything he has created, Munch has returned to the essential truths of life, accepting them in their entire simplicity but also in their imminent power ... has worked out their archetypal qualities, and fused them together into this absolutely powerful mythology of life.... already through the mysticism of his race, which lives on in him undiminished, he is attached subterraneously to the glowing chain of things. But in his eye—heated to the point of glowing, like that of a mystic—it no longer appears in terms of monsters and the feats of gods but as human bodies and human fate. From his pictures emerges the very will to show humanity: see, there you are, man, still quivering from the hour of your birth. And the power with which this is shown, the power and strength of this Scandinavian rooted in the peasant but nonetheless aristocratic, this power seems to add: Now be strong and endure.[32]

Such rousing encouragement for Munch as a new 'light from the North' was not totally novel. Already among the writers of the Schwarze Ferkel Munch had been hailed in a similar way. Julius Langbehn's immensely popular book *Rembrandt als Erzieher* ('Rembrandt as Educator'), published in 1890, was a major source for all these thoughts. It had praised individualism as the basic German characteristic ('German' being rather loosely defined to include Rembrandt, Leonardo da Vinci and Oliver Cromwell) and suggested that among Germans the salvation from modern materialism would be achieved through art. The means of attaining this new art was by incorporating Impressionism's innovative technique into a more individualistic, subjective and spiritual art achieved by a genius of 'German' blood.[33] In Munch, it was felt, French technique was wedded with 'German' stock.

German artists began to emulate Munch's work as they sought a style and content suitable for the inauguration of the twentieth century. In Dresden the young painters who in 1905 organized into a group calling itself Die Brücke (The Bridge) invited Munch to participate in their exhibitions. Pleased to be recognized as the guide to their artistic future, Munch accepted; however, objections raised by Kessler and Schiefler finally convinced him to stay with

older rebellious institutions such as the Secession or with successful art dealers such as Commeter or Cassirer.[34] Munch was to remain a prophet, not a participant, in the aesthetic battles of Imperial Germany.

Despite his critical success and acceptance of a new ideological identity, Munch's life continued to be marked by crises, turmoil and disappointment. The Linde children's frieze, delivered in January 1905, was too large to fit into the intended room, and failed to please the Lübeck maecenas. Moreover, Linde had requested landscape motifs, and instead Munch painted variations on his 'Frieze of Life' themes of sexual attraction, love and melancholic loneliness (significantly not the anxiety of *The Scream* or the motifs of death). The rejection was a major disappointment to Munch, although Linde bought a single large painting from him for the same price. Munch exhibited the frieze in Berlin; then, as if to pronounce the paintings a failure himself, he painted over them and reworked them repeatedly during the next thirty years, never finding a satisfactory resolution.[35] The trip to Prague and further portrait commissions provided a partial compensation for his damaged pride, but constant travel was increasingly disturbing him. Hoping for 'an entire year of total peace' to grant him 'new life', Munch returned to Aasgaardstrand in June 1905.[36]

Instead of peace, however, he found an atmosphere of political crisis as the century-old unpopular union between Norway and Sweden was dissolved on 7 June 1905. Civil war between the sister nations seemed imminent. Munch's plan to isolate himself in his wooden hut in Aasgaardstrand proved impossible and he was caught up in excited discussions of the year's momentous events. Finally, he threatened those who approached his hut with a rifle or revolver. In a brawl with the painter Ludvig Karsten, virtually the only Norwegian to model his art on Munch's, he broke his wrist. He later wrote: 'My sickness became more acute. Attacks of rage came more and more frequently. Alcohol should calm me down, and it did so at least in the mornings. But during the afternoons, when one otherwise would remain dulled by drink, I became more and more agitated.'[37] To disguise the virtual psychological collapse and constant alcoholic trance with which he met Norwegian independence, Munch returned to his self-portrait in the pose of self-assured, forthright prophet, and transformed the date 1904 into 1905. Through the fiction of his art, he attempted to rearrange life.

Munch fled Norway in July. After spending several months near Copenhagen, he went to Chemnitz to carry out his commission for portraits of the Esche children, a project which Van de Velde and Dr Linde had prepared for him. Linde described Munch to the hesitant Mrs Esche as a

solemn, quiet person with a noble disposition and very amiable with children. . . . The best thing is to let him do as he wants. Then slowly he thaws out, and his Nordic reserve wears off. Then you meet a marvellous, many-sided, gifted person and learn to value him. Munch can spend weeks in observation without putting brush to canvas. 'I paint with my mind', he often says in his broken German. He always works in such a way that he spends a long time absorbing what he sees, then suddenly gives it form with an elemental power and tortured haste.[38]

Munch spent October with the Esche family, painting seven portraits in all, but his health and psychological state continued to deteriorate. He left the Esches for Weimar to carry out a commission he had received during the summer from the Swedish collector Ernst Thiel for an allegorical portrait of Friedrich Nietzsche.

The portrait of Nietzsche proved more difficult than that of the Esche children. The image of nature, which Munch could borrow either from actual

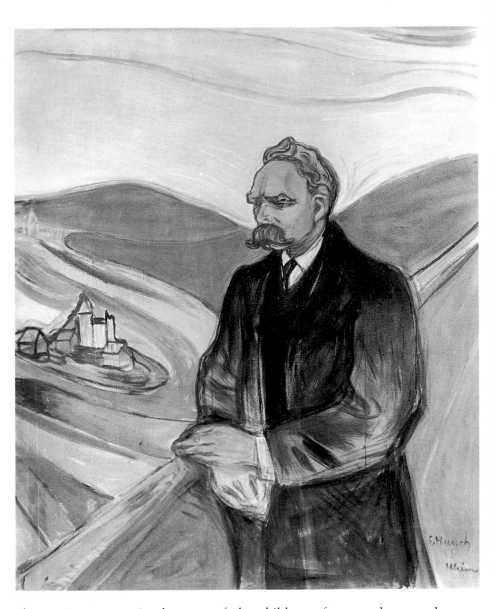

152 *Allegorical portrait of Friedrich Nietzsche*, 1906. Oil on canvas, 201 × 160 cm (79 × 63 in). Stockholm, Thielska Galleriet

observation or—as in the case of the children—from a photograph, was insufficient to carry out the desired task of creating a large, symbolic painting. Munch's initial thoughts returned to the formula for artistic inspiration worked out at Saint-Cloud. In several drawings, and in a letter to Thiel, he attempted to show the philosopher seated near a window, head propped in his hand.[39] The final portrait, however, broke with his Symbolist and Decadent iconography, much as did the self-portrait with brushes. He described his idea to Thiel at the end of December:

I have chosen to paint him monumentally and decoratively. I do not think it would be right for me to present him illusionistically, since I have never seen him with my *outer* eye. Therefore I have indicated my point of view by painting him somewhat over life-size. I have depicted him as Zarathustra's poet among the mountains in his lair; he stands on his verandah and looks down into a deep valley while the sun rises over the mountains. One can think of the place [in *Thus Spake Zarathustra*] where he speaks of standing in the light but wishing to be in shadow, but it is also possible to think of much else.[40]

Considering the significance of Nietzsche for those with whom Munch associated in Germany, from Strindberg and Przybyszewski to Van den Bruck and Kessler, and Munch's predilection for finding role models either in his friends or in fictional or historic personages, it is possible to view the Nietzsche portrait as an idyllic self-portrait or a representation of Munch's goal of returned health. The composition of the figure standing near a railing and overlooking a valley landscape is dependent on *The Scream*. With its lines descending from left to right as a metaphor for his anxiety, however, *The Scream* is emotionally the antithesis of the firm stability and calm projected by the Nietzsche painting's monumental forms. Nietzsche is not overcome by the sunset or the dizzying perspective of the precipice, but calmly surveys and accepts it. 'I believe that artistically the painting has brought me progress', Munch wrote as he thanked Thiel for the payment of 5,000 Marks in July 1906, but his self-styled 'nerve crisis' continued.

Munch applied his practice of borrowing composition and associated content from his earlier art in other works of 1906. *Self-Portrait with a Wine Bottle* shows him seated in the restaurant of the Hotel Russischer Hof in Weimar at the time of the Nietzsche portrait. Both the sharp perspective organizing the composition and the use of antagonistic colours such as green and red derive from paintings of the 1890s, including *The Scream*. Glaser saw in it a companion image for the melancholic portrait of Laura Munch:

He appears wedged between the two rows of tables, one of which butts against him almost painfully, and he cannot rise against the energetically accented verticals of the painting. Thus the portrait likeness is subordinated to mood. Colouristically too the painting is seen so much as a totality that the form of the seated man is pushed back, to exist only as a portion of the composition. The green of his suit is answered by the green of the wall, which is broken only in the middle—where his head is—by a large red spot, and this corresponds to the strong red colour of the tie, giving the picture its determined tone . . . of a melancholic, absolute isolation.[41]

If Strindberg's novel *Inferno* and dramatic trilogy *To Damascus* are accounts of the author's persecution mania transformed into psychologically perceptive art, then Munch's Weimar self-portrait is their equivalent in painting, the expressive depiction of a man trapped by psychological forces, seeking release in alcohol, and finding only further anxieties and hallucinations. His art was his refuge, but it tended to mirror the breakdown that he was trying to ward off.

The theme of girls standing on a pier and gazing into the water during a summer night, first painted in 1901, Munch also repeated with constant variations of composition and technique five times during the following years, as well as in several prints. The calm original images are transformed into faceless girls, intense colours and exaggerated perspective lines inducing moods of trepidation.

To seek release from the demons tormenting him, Munch followed the advice of Linde, Esche and Kessler to undergo a cure in one of the Thuringean spas near Weimar and to drink milk instead of alcohol. At Bad Elgersburg and Bad Kösen he quietened down, but not until after periodic lameness attacked his arms and legs indicating to him the drastic nature of his psychic state and growing alcoholism:

While at Kösen I repeatedly felt small attacks of lameness, especially at night. My legs and arms would be numb frequently. During the days, I felt a sort of pressure in my right leg. I limped a little. Then there were the strange attacks and notions I had.

One day I am sitting in the spa's restaurant and am eating breakfast with a

Dutchman, a habitual guest. 'I can hypnotize you', I suddenly say. 'No, I don't want to', he responds. 'You will see.'

Then I mix together in a bowl some mustard, pepper, tobacco ash and vinegar. 'Eat this', I say and gaze fearfully at him. 'If you don't, I'll shoot you on the spot.'

The Dutchman got up and left. On the same day, he departed from the hotel.

I asked the doctor for advice. 'You will have attacks of lameness more and more frequently. Feet, arms, finally it will affect your head, a stroke.'[42]

Fear of insanity, lameness and death marked the passage of time for him in the spas. He avoided human contact, and the sound of Norwegian being spoken filled him with terror, but slowly his health improved in the spring. He made plans to paint his own equivalent of Rodin's *Gates of Hell* and for a frieze for Max Reinhardt's Kammerspielhaus (Chamber Theatre) in Berlin.

The commission in Berlin, lack of money and somewhat restored strength caused Munch to leave Bad Kösen for Berlin, Weimar and Jena. He successfully executed portrait commissions and also created sketches of stage designs for Reinhardt's production of Ibsen's *Ghosts,* a play whose theme of hereditary illness had long intrigued Munch and caused him to identify with Osvald, the artist son of a syphilitic father. The cost to his health as a result of his dependence on alcohol was devastating, however:

I felt these frightening pains near my heart. I was frightened. In the morning, felt dizzy when I got up. Quickly something to calm me. Rang for service. Port wine, a half bottle—that helped. Felt better. Then some coffee and a bit of bread. Renewed anxieties. Out into the street, to the first restaurant, one drink, two drinks—that helped. Out into the street. Everything will be alright. . . .

I drank and drank yesterday like all days, and went to bed in a stupor.[43]

In great fear that he was going to share Laura Munch's fate, Munch returned to Bad Kösen in November 1906. His German patrons' advice that he enter a sanatorium for medical treatment went unheeded. His self-prescription was work and milk. His 'nerve crisis' worsened.

Gathering his strength, he undertook a trip to Berlin in January 1907 to portray Walter Rathenau and to design stage sets for Reinhardt's perform-ance of *Hedda Gabler.* The space at the Kammerspielhaus intended for his new frieze was not yet prepared, and so Munch went on to Stockholm to paint Thiel's portrait as well as sell him several other paintings. He quickly returned to Germany to find refuge in the North Sea resort of Warnemünde that reminded him of Aasgaardstrand. The 'Reinhardt Frieze' now finally took form; the twelve paintings in tempera on unprimed canvas were hung in the theatre at the end of December 1907. 'The motif is derived from the shore outside my house in Aasgaardstrand—Women and Men during a Summer Night', he wrote home from Warnemünde.[44] Again he adapted his style to a new format and technique, presenting images far simpler than the original models.[45] Lacking the symbolic vocabulary of the 1890s 'Love' series, the 'Reinhardt Frieze' is both more monumental and more deliberately decora-tive. The figures appear anonymous, lacking virtually all facial characteristics and frequently melting into each other as coalesced group forms. The certainty of compositional placement in the paintings of 1893 to 1895 gave way to loosely organized compositions where the empty spaces of shore, stones and water take on an abstract reality akin to the red spot of the Weimar self-portrait, but lacking its emotional force.

Despite his prodigious ability to work, Munch's health was shattered. The incidents at Aasgaardstrand preyed on his mind. Beginning in 1905, he made

drawings, lithographs and paintings of his hut's interior, himself bleeding on the bed, Tulla standing nearby and, on a foreground table, either a book, a glass, a straw hat or a platter of fruit. In Berlin in 1907, he exhibited one of the paintings as *Still Life: The Murderess*. Created with thinned oil paint slashed on to raw canvas, its brushstrokes seem to wander aimlessly over the surface in dots, zigzags or long drawn lines like analogues of his own restless life. Still the motif plagued him, and he began two repetitions of the scene, now with the actors naked and the setting bereft of specific detail. He replaced the thinned, running and dripping paint he had favoured almost consistently since the 1890s, with a heavy impasto, much of it squeezed directly from the tube on to the canvas. For the loosely ordered, slashing brushstrokes of the preceding years he substituted a more ordered paint application, although it still expressed a personal language of pent-up emotion and intensity.[46] In the largest of these paintings, *The Death of Marat*, completed in 1908 (Munch's obsession with size as an index of significance had not abated), Munch is seen naked, stretched out in a crucified pose on the bloodied diagonal of his bed. Wedged between the bed and the tilted form of a round table with hat and fruit on it is the harshly frontal, stiff figure of Tulla, her hands and legs bloodied, her red hair falling loosely over her shoulders, as she casts a deep shadow on the wall behind her, painted green as were the walls of *Death in the Sickroom*.

The painting is the past made present in several senses. Motifs of the 1890s—*Ashes* and *Vampire*—return in a new more garish and anguished setting. Earlier experiences are translated into a personal mythology which takes the place of the facts. 'My and my beloved maiden's child, *The Death of Marat* (I had to be pregnant for nine years)—is a difficult painting. Nor for that matter is it a masterpiece, more of an experiment. You may tell the enemy that this child is now born and baptized'. So Munch wrote to Christian Gierløff in Norway with bitterly sarcastic humour.[47] To Thiel he admitted the personal cost of the completed paintings: '*La Mort du* [sic] *Marat* is being exhibited by me in Paris. The picture with the same motif *A Woman Kills a Man* that you saw is also finished but not on exhibit. It will take a long time to regain my strength again after that painting.'[48]

Completion of the paintings and their exhibition in Berlin and Paris—where Munch accompanied them—acted as an exorcism. Calm seemed restored to Munch's life when he and the paintings returned to Warnemünde in March 1908. 'Here I have regained a sense of peace', he wrote to Thiel. 'Fresh air and good financial affairs have done great things for me. I live on oatmeal, milk, and bread and fish. I began with this diet after my nerves had gone bad both in my eyes and my stomach. Now I am as if reborn.'[49]

A new triptych of the ages of life now replaced the obsession with Tulla: men as seen in youth, maturity and old age on the sun-drenched shores of Warnemünde's nudist beaches. Painting out of doors, naked in an effort to absorb the healthy rays of the sun, Munch limited his colours to intensely bright yellows, roses and greens that contrast sharply with the dark and bloody tones of the *Death of Marat*. With its frontally posed, naked marching men, the work is an ode to masculinity and virility such as other Germans and Scandinavians were painting at the time and whose homoerotic overtones are difficult to ignore. The motif, not the sentiments, was new, and proclaimed as loudly as the letter to Thiel a radical shift in Munch's manner of life as he renounced alcohol, company, turmoil and women. The attempt was temporarily successful. 'I am well bodily', he wrote to Thiel. 'Only the nerves are not quite in order. . . . I avoid almost everyone—a sort of fear of other people is

one result of the old history.'[50]

However, even as he painted his optimistic *Bathers Triptych*, the themes of the 'Frieze of Life' continued to haunt him. He used the green room and broad brushstrokes of *The Death of Marat* painting in six paintings of 1908 treating motifs of jealousy, passion, prostitution and—again—the murderess, but also a weeping woman and consolation. The paintings focus on the passions themselves, with harsh and distorting colours leaving grimacing faces red, green or yellow. The mode of painting is similarly harsh: foot-long vertical strokes of green, yellow or brown form a repeated structural unit, much as in Neo-Impressionism but lacking its finesse; or quickly brushed impasto strokes swirl, undulate and duplicate geometric patterns within the claustrophobic space generated by Munch's exaggerated perspective. Set in the brothel, *Zum süssen Mädel* ('At the Sweet Girl's') focuses on the erotic interactions of men and women in the alienated environment of the green rooms. There is hate and jealousy, and the women murder the men; compassion is offered innocently by the men to weeping women, much as Munch condemned himself for having been compassionate towards Tulla. If thoughts of eternal life, whether spiritual or biological, previously mitigated the destructive activity of women in the 'Love' series, here there is only destruction. Woman uses the battle of the sexes solely to wreak her horrible deeds on her unknowing victims. In his altered perception, immortality either no longer mattered or did not exist for Munch; there was only anxiety, pain and merciless annihilation.

The feelings of persecution only increased as 1908 progressed. From Norway came mixed good and bad news. Thiis became director of the National Gallery and inaugurated a series of purchases of Munch's paintings despite public protest. The Bergen collector, Rasmus Meyer, also began to buy Munch's paintings. So the market for his art was slowly improving even

153 *Consolation (The Green Room)*, 1907. Oil on canvas, 90 × 109 cm (35½ × 43 in). Oslo, Munch–Museet

154 Right *Self-Portrait: Salome Paraphrase, c.* 1898. Watercolour, india ink and pencil, 46 × 32.6 cm (18 × 12¾ in). Oslo, Munch–Museet (see p.181)

155 Below *The Lonely Ones*, 1906. Tempera on canvas, 89.5 × 159.5 cm (35¼ × 62¾ in). Essen, Folkwang Museum

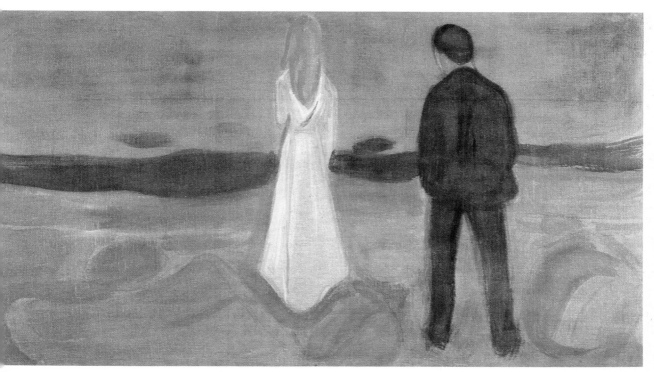

156 *Bathers Triptych*, 1907–8. Oil on canvas. *Youth*, 206 × 100 cm (81 × 39¼ in). Bergen, Rasmus Meyers Samlinger; *Maturity (Bathing Men)*, 206 × 227 cm (81 × 89¼ in). Helsinki, Ateneum; *Old Age*, 200 × 97.5 cm (78¾ × 38½ in). Oslo, Munch–Museet

in his homeland. But in May, Aase Nørregaard, she who once had been his blonde bohemian love, died; in a letter of condolence to her husband, Munch permitted his sorrow to show:

You know that I know what you have lost. You feel that you have lost everything of spring and summer, and there is no word that can bring comfort. You know as well that I have lost much, my best woman friend, and that others too have lost much. It is a loss for Norwegian art.[51]

Seven years earlier, in 1901, Dagny Juell had been shot in Tiflis by a student follower of her husband. Apart from his family, the women with whom he had felt any rapport were virtually all dead, with only Eva Mudocci appearing from time to time for a few days as her concert tours permitted. Prostitutes and female hotel personnel instead became more frequent company for Munch, affirming the state of mind that the 'green room' paintings had fixed pictorially.

The stay in Warnemünde ended abruptly in September 1908. Munch's

anxieties had become unbearable. Fearing that he would be interned in a German insane asylum, and suspecting everyone of spying on him, of stealing his notebooks, of intending to deliver him to the police, Munch fled Germany as hurriedly as he had fled Norway three years earlier. According to his 'reminiscences', on the boat train he met his alter-ego, the equivalent of the Beggar to Strindberg's Stranger in *To Damascus*. The man, whether or not he actually existed outside Munch's imagination, joined him in his train compartment:

'Good day again', he said and looked at me. 'I saw you on the boat. Do you have far to go?'

'Oh, no. Only to Copenhagen. I am nervous. Have been extremely nervous for a long time, and must try to correct that.'

'Clinic?'

'Don't know.'

'Nervousness is bad. Long cure. Diet. Schizophrenic existence.'

Strange bird. He is interested in me. 'I am an artist', I say, 'and you?'

'Psychoanalyst, from Vienna.'[52]

The psychoanalyst promised to follow Munch. Another passenger, returning from an Esperanto congress in Berlin and full of hope of future universal human understanding and compassion, stared Munch directly in the face, then suddenly made the sign of the cross, saying: 'God help us all'.

Once Munch arrived in Copenhagen, the feeling of persecution intensified. He felt he was being followed, and imagined that newspaper reports about the hunting of wild quail referred to him. He heard constant scolding: 'Bird hunter, woman hunter!', and was convinced that everywhere everyone was talking about him. He deadened the pains in his chest by drinking:

I sit and drink one whisky and soda after another. The alcohol warms me up more and, especially in the evening, excites me. I feel it eating its way inward, inward to the delicate nerves. And tobacco too. Cigars, lots of strong ones. Nicotine's and tobacco's funeral pyre eats its way into the canals of my arteries, cavorting in the labyrinths of the brain, the finest workshops of thought, and in the chambers of the heart.

My most delicate nerves are affected, I feel it. And the finest of them all has been attacked. I realize it is the very nerve of life. It is burning.

Well, let it burn. Because then all pain will end. Anxiety will end.

Whisky and soda. Whisky and soda. Burn up the pain. The anxiety. Everything. Then it is all over.[53]

On 29 September he fled Copenhagen for Taarboek, where Goldstein lived.

157 Opposite top *Self-Portrait in Weimar*, 1906. Oil on canvas, 110.5 × 120.5 cm (43½ × 44½ in). Oslo, Munch–Museet

158 Opposite bottom *Girls on the Jetty*, 1905. Oil on canvas, 84 × 129 cm (33 × 50¾ in). Hamburg, Kunsthalle

159 Below *The Death of Marat*, 1905–8. Oil on canvas, 150 × 199.5 cm (62 × 78½ in). Oslo, Munch–Museet (see p. 191)

His legs hardly carried him. The next morning he woke with his hand numb. 'I stumbled about on the floor with my right side lame. I hobbled about on my right leg. My left arm hung limp. I could not hold on to anything. A stroke.' Goldstein wanted to take him to a doctor. Munch refused. Instead he rented rooms at a nearby hotel where he drank through the night. Two days later, he began stumbling in towards the city, finally arriving there after being refused a drink and meal in a restaurant along the way. In a small hotel, he rented two rooms, so that he could escape from the one into the other. Another sleepless night was spent drinking. He heard voices speaking Norwegian outside his windows; a woman's voice threatened to kill him with a revolver. From the other window, similar sounds indicated that he was surrounded.

If only the morning would come. If only I had a gun.
 In the morning I called up a waiter. 'What is going on out there,' I said. 'Get Goldstein.'
 Goldstein came, bent down over me in bed.
 'You know, Goldstein, it's a miserable thing to attack me while I am sick. Get me a revolver.'
 The doctor came. 'He has to go to the hospital.'
 I refused, went down into the café. Voices everywhere. Around me. Talking to me. Mocking me: There he goes! There he goes! I clearly heard a man say it. Then I heard a woman's voice.
 I could stand it no longer.
 'Take me to a nerve clinic', I said to Goldstein.[54]

On 3 October 1908, Munch entered the clinic of Dr Daniel Jacobsen, who apparently had a reputation for treating artists (possibly only acquired after he treated Munch). Munch spent the first few days sleeping while nurses guarded him, preventing him from leaving or, according to him, from leaping out of a window. Slowly the voices abated, then ceased. A month later, with the aid of two nurses, he was able to walk about out of doors, his psychological strength increased not only because of the doctor's treatment and care, but also because he received the Royal Norwegian Order of Saint Olaf, 'like a hand reaching out to me from my homeland'.[55]

As his paintings were being sent from Warnemünde to Kristiania by way of Copenhagen, he organized an exhibition of over two hundred paintings and graphics at the Art Association beginning on 22 November. His stay at the clinic generated publicity for the exhibition, and it was well attended although poorly reviewed. The months in the clinic in no way dampened Munch's enthusiasm for his art nor his ability to control numerous simultaneous exhibitions in Denmark, Sweden and Germany. It was in his art that he sought refuge and release from his emotional turmoil; the routine at the clinic seemed to be a secondary treatment according to his letters and other writings:

It was a truly brutal way that I took when I finally decided to mend myself. But it had to happen. After all, life became a hell for me, and I became a burden to those around me. I hope it announces a new era for my art.[56]

For his art he found new images in his surroundings in Copenhagen. The clinic became his studio, and its nurses and doctor and visitors his subject matter. He also drew and reproduced in lithographs the animals at the zoo, perhaps seeing in their situation an analogy of his own, caged in Dr Jacobsen's clinic. The imprints of external nature rather than the hallucinations of his tortured soul once more came to the fore as cures for his art, as

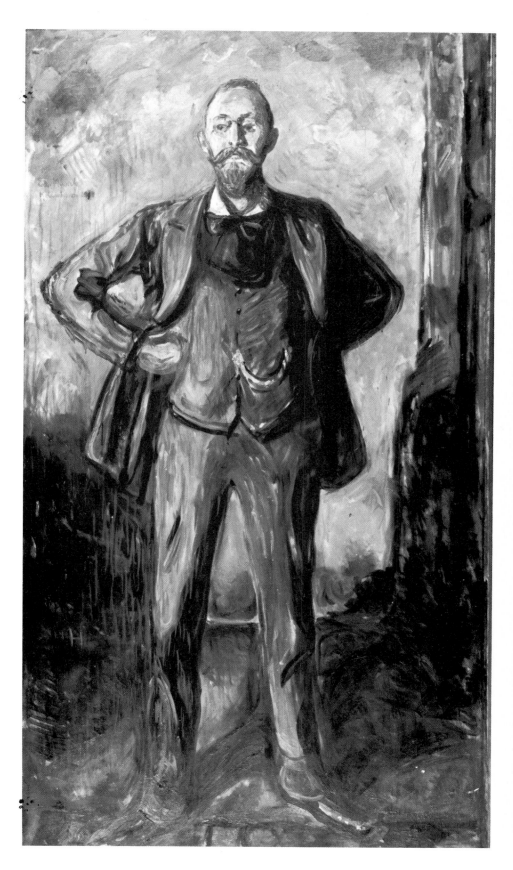

160 *Portrait of Dr Daniel Jacobsen*, 1909. Oil on canvas, 204 × 112 cm (80¼ × 44 in). Oslo, Munch–Museet

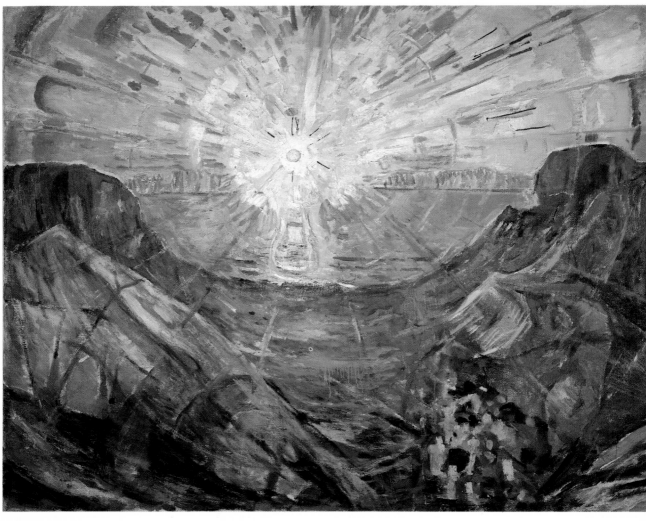

161 *The Sun*, 1912–13. Oil on canvas, 163 × 207 cm (64 × 81½ in). Oslo, Munch–Museet

the means to explore new techniques and styles. The activity of painting functioned therapeutically for him as never before: through it he tested his sanity.

Portraits of Dr Jacobsen were the first proof that Munch's art remained unimpaired. He portrayed the doctor three times, once his head alone, and twice the full figure standing with feet wide apart and arms akimbo, looking self-assured and authoritative—first in a small preparatory painting, then full scale, posed like Henry VIII in Holbein's portrait. The technique, with paint brushed on in lengthy, parallel strokes constantly shifting in direction and with isolated streaks of colour acting as abstracted echoes of the figure, retains but simultaneously alters aspects of Munch's manner of painting during the previous ten years. It is in the colours that the major difference occurs. Bright reds, yellows and greens form the dominant tones that appear intensified by the black indications of shadows. Munch wrote in his 'reminiscences':

I painted the portrait of the doctor. When I painted, I was the master. I felt that I dominated him, who had dominated me. I painted the nurses who made my bed. I drew pictures of animals. There was no weakness in my art, far from it. To the guardian spirits of art I had remained true, I thought, therefore they do not abandon

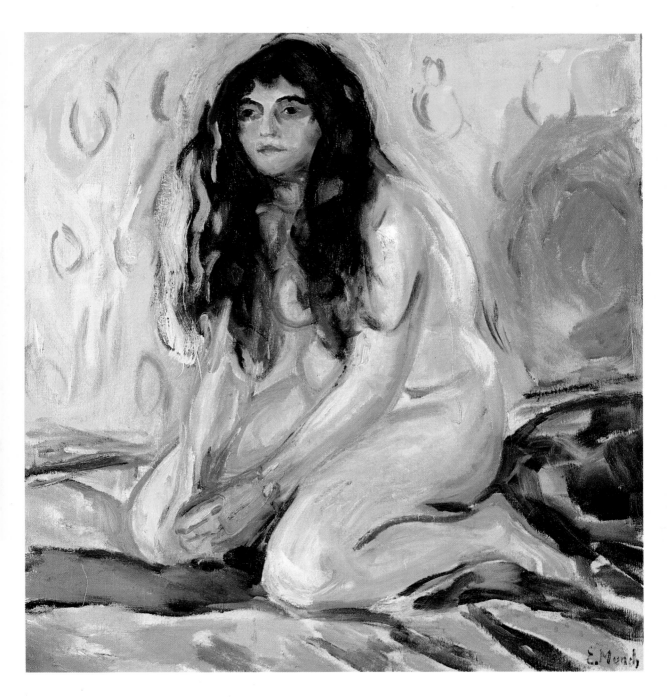

162 *Kneeling Nude*, 1920–3.
Oil on canvas, 82.5 ×
78.7 cm (32½ × 31 in).
Washington DC,
Smithsonian Institution,
Hirshhorn Museum and
Sculpture Garden

me now. Before coming to the clinic, in Berlin, I read in a book on nerves that so long as the will to work is not weakened there is hope of recovery. That is how it was. The pictures I painted were among my best ones.[57]

While in the clinic Munch developed a fable entitled 'Alpha and Omega', a series of twenty-two lithographs providing a bitter but ironic commentary on the relationship between women and men.[58] Munch showed initial drawings for the series to Schiefler during the summer of 1908 in Warnemünde, but he had first explored its motifs, particularly that of a man drowning a woman, as early as 1896. Tulla was thus not the initial cause of the satirical print series, but was the final cause for the translation of a

number of drawings depicting 'The First Human Beings' into prints, with Schiefler acting as a sort of midwife by advising Munch to create the lithographs. Both drawings and prints are testimony to woman's infidelity, her need to copulate with whoever or whatever is available, so Munch believed, in order that the race be preserved. In 'Alpha and Omega', the woman wakes an innocent Alpha, who loves Omega, as they sit silently observing the moon reflecting in the water or as they walk into the depths of a forest on the island they inhabit. Omega's sensual drive for procreation, however, causes her to seek additional company from the animals of the island: a snake, a bear, a hyena, a tiger, a deer and a pig. Omega rides off on the back of the deer, leaving Alpha alone and melancholy on the beach, where one day Omega's bastard children appear with human faces and animal bodies, and Alpha reacts in despair as sky and sea turn the colour of blood. When the deer brings Omega back, Alpha kills her; on her dead face is the expression of the loving woman, then Alpha is killed by her children and the animals.

The cycle of prints 'seriously and jokingly tells the eternally recurring story', Munch wrote in explanation to Nilssen, 'that we ludicrously have to experience anew constantly'.[59] The print series is a parody, seriously intended, of the 'Love' series with the conclusion as pessimistic as the 'green room' paintings. It was a summary of concerns that had been Munch's for twenty years and that had formed the most significant parts of his life's work. It was also a temporary farewell to those concerns which Munch felt could be left behind in Dr Jacobsen's sanatorium along with the last remnants of his nervous disorders and alcoholic addiction.

A similar leave-taking occurred when Munch decided in 1909 to sell separately various of the twenty-two components of his 'Love' and 'Death' series that composed the Frieze he had exhibited in Berlin, Kristiania, Leipzig and Prague between 1902 and 1905. While Munch had also exhibited several of the paintings of the Frieze separately during that time, his intentions remained that they be sold as a unit.[60] During the time at the clinic, however, he broke up the Frieze, selling major paintings from it to Kristiania's National Gallery, to the collector Olaf Schou (who in turn donated the paintings to the National Gallery in 1909 and 1910), and to Rasmus Meyer in Bergen. Munch realized that its components would forever have to be seen separately. It had

163 *The Human Mountain*, 1909 and later. Oil on canvas, 298 × 419 cm (117¼ × 165 in). Oslo, Munch–Museet

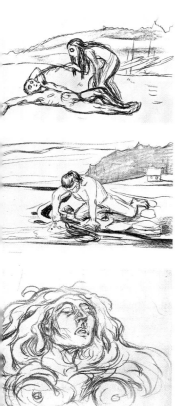

become a part of his past. Moreover, by isolating its components he prevented it from carrying his Monistic message of life, love and death to an audience. Its message was deliberately crippled, to continue only demonized and gynophobic in the 'green room' paintings and the satirical perception of woman's need for coitus in the lithographs of 'Alpha and Omega'.

As a last testimonial to his renewed health before leaving the clinic in April, Munch turned once again to a self-portrait. The setting of a room with a window is similar to both *Night* and the *Self-Portrait with a Wine Bottle*. *Night,* however, carried an iconography of Symbolist and Decadent creative melancholy, and the *Self-Portrait with a Wine Bottle* viewed the artist as isolated, suffering and anxiety-ridden; in the Copenhagen self-portrait, isolation remains the major factor but it is no longer forced. Munch sits erect and attentive in a chair near an open window. He opens the space around him, and—although controlled by a closable window—permits the exterior present world to enter his own environment. Confidence was restored, as he wrote to a Norwegian friend: 'I have experienced several dangerous early autumn storms, and they took away from me manhood's best time: the mid-summer. Here in the autumn several heavy branches were shaken from the tree. But I have an unbelievably great ability to heal, so perhaps this too will mend.'[61] In the painting, the mending is taking place. Intense sunlight pours through the window, as if to answer Osvald's plea in his last words in Ibsen's *Ghosts*: 'Mother, give me the sun. . . . The sun . . . The sun.' With his face still half in shadow, his hand still seeming to tremble, Munch is depicting his own transition from his past to the sunlit future. The colours continue to present this evolution. Behind the shadowed half of his face, applied in lengthy, brick-like vibrating strokes of paint, the colour is a bright, intense yellow-orange,

164 Top *Alpha and Omega: Alpha's Awakening*, 1908–9. Lithograph. Oslo, Munch–Museet

165 Centre *Alpha and Omega: Omega's Death*, 1908–9. Lithograph. Oslo, Munch–Museet

166 Above *Sphinx*, 1909. Charcoal, 43.3 × 63 cm (17 × 24¾ in). Oslo, Munch–Museet

167 Right *Self-Portrait in Copenhagen*, 1909. Oil on canvas, 100 × 110 cm (39½ × 43¼ in). Bergen, Rasmus Meyers Samlinger

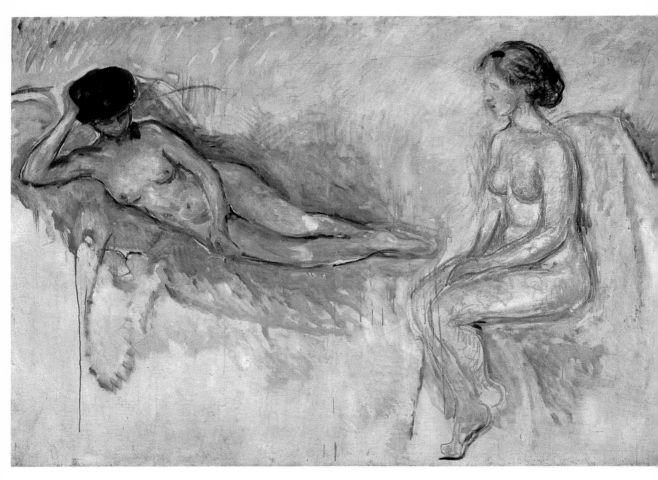

168 *Two Nudes, c.*
1911–15. Oil on canvas,
110 × 160.5 cm (43¼ ×
63¼ in). Oslo,
Nasjonalgalleriet

similar to the heated background of Dr Jacobsen's portrait. On a colour wheel, this painted analogy to the sun's light appears directly opposite the blues, purples and violets composing Munch's suit jacket, whose dark colours seem to ward off the heat generated around him. By the time the colours reach the window, they have become a restful deep green. In Copenhagen, in 1909—the name and date intrusively inscribed like magic formulas along with Munch's signature on the painting, an emphasis on time and place found in no other self-portrait—his 'nerve crisis' was brought to a close.

Repeatedly during his stay in the clinic, Munch had expressed the wish to return to Norway: 'Norway, where one day I must return since nature certainly is important for my art'.[62] As Thiis and Nilssen were hanging his massive exhibition in Blomquist's gallery in Kristiania in March 1909, Munch's letters to them constantly apologized for the fact that the newer paintings were all created on foreign ground. But the fear of confrontation with his 'enemies' in Kristiania and of a recurrence of his attacks and hallucinations prevented him from following his wishes, although Dr Jacobsen even volunteered to accompany him. Previous critical attacks, especially those against his 'Frieze of Life' in 1904, also made him anxious about the reception his collected works would receive at the exhibition, so he made no attempt to be in Kristiania for it. Perhaps because taste had changed in Norway as well as elsewhere, perhaps because his art had changed and the most recent paintings had become more realistic as well as neutral in subject matter, perhaps because he now was a Knight of the Order of Saint Olaf, the

exhibition was a success—critically (not all critics were negative), in terms of attendance and in terms of sales.

In April, Munch, hesitatingly, expressed a desire for a house, peaceful and large, along the Norwegian coast away from Kristiania. 'There I could rest my ravaged body—My nervousness is better, but a sense of weakness has entered in so that I can only go for brief moments before dizziness sets in.'[63] Finally, at the end of the month, he gained enough courage to leave the shelter of the clinic, to return to the country of his enemies, friends and family. But his anxieties and bitterness remained: 'Intimidatingly the Norwegian mountains loom before me.'[64] They would loom, but also protect, for the rest of his life.

He returned to Norway with his cousin, the painter Ludvig Ravensberg, who accompanied him from Copenhagen and during the trip told Munch about the competition for paintings to be hung in the Kristiania University

169 *Workers Walking in the Snow*, 1910–12. Oil on canvas. Oslo, Munch–Museet

Aula. Within a few weeks Munch had written a letter to the commission overseeing the competition and announced that he would participate. Settling in the southern Norwegian coast town of Kragerø, he immediately worked out two motifs for his new monumental project. *History* depicted an old man seated beneath an oak tree in the landscape of Kragerø overlooking the sea and telling a story to a young boy. The other study, *The Human Mountain*, took up the earlier theme of metamorphosis, depicting a mass of humanity striving upwards, reaching into the sky and towards the sun. In 1897 the lithograph *Funeral March* had shown a writhing mass of humanity, apparently with corpses at its base, raising a coffin up into the sky. *In the Land of Crystals* had depicted a corpse in a coffin lifted from the earth towards the sky, from death to new life. *The Human Mountain* carried the theme of Monistic immortality underlying the 'Love' series and other Frieze paintings into Munch's new world of non-alcoholic creation. Repeated is a triple image of women, men contemplating them and the intermingling of naked human bodies, but the goal has changed. It is not a non-organic land of crystals, a metaphor for the world of art, but the sun, whose praise Munch sang in his Warnemünde triptych and whose healing powers were made manifest in the Copenhagen self-portrait. In the foreground of the proposed painting is a madonna or sphinx with Munch's facial features, the body build of a man and the nourishing breasts of a woman. The androgynous creator of the 1890s was here made rather awkwardly visible.

The committee rejected *The Human Mountain,* but requested Munch to submit a full-scale version of *History* by August 1911 for one of the side walls. Munch responded by presenting not one, but thirty works, including four large versions of *History, The Researchers* (later known as *Alma Mater*) and *The Sun*, now isolated as it shines above the rocks of Kragerø's shore, implicitly imparting its vital force to all the remaining scenes of the project. Munch was combining a massive, folk-like conception of the human figure intended to lend it monumentality, a gently generated landscape space with simplified trees, rocks and other features, and in *The Sun* a rendition of the irradiating forces and light that approaches abstraction.

Munch's sun-worship was part of a highly popular quasi-religious conception of the time that recognized the sun as the source of all health; particularly in Germany and Scandinavia, a cult of the sun had emerged that had resulted in much-publicized nudist bathhouses, campsites and beaches such as the one at Warnemünde. In Germany, many of the artists and writers whom Munch knew were advocates of the cult, associating it with a politically conservative 'return to nature' which rejected the modern metropolis and yearned for the hardened, sun-drenched bodies of warriors living free in the land.[65] Nietzsche's *Zarathustra* is an overt source, and its pathos was also echoed in various literary works with which Munch could have been familiar, including one contemporary with Munch's *Sun*: Theodor Däubler's *Nordlicht* ('Northern Lights'), published in 1910 and consisting of 30,000 verses. A copy of the book, whose publication was overseen by Van den Bruck, was sent to Munch by the author and in it he could read of a cosmic mysticism similar to his own Monistic cosmogony. Däubler's epic tells of a mythical time when the earth was united with the sun; the earth or the feminine principle now seeks reunion with the sun, which is the masculine and spiritual principle; all existence is a 'return to the sun', and all creativity has its source in the male principle.

Injecting the sun imagery into the context of his own life, while also tracing its history in his art, Munch wrote:

170 Oslo University Aula Decorations, 1909–12. Oil on canvas. a. *History*, 455 × 1160 cm (179 × 456¾ in); b. *Alma Mater*, 455 × 1160 cm (179 × 456¾ in); c. *The Sun*, 455 × 780 cm (179 × 307 in)

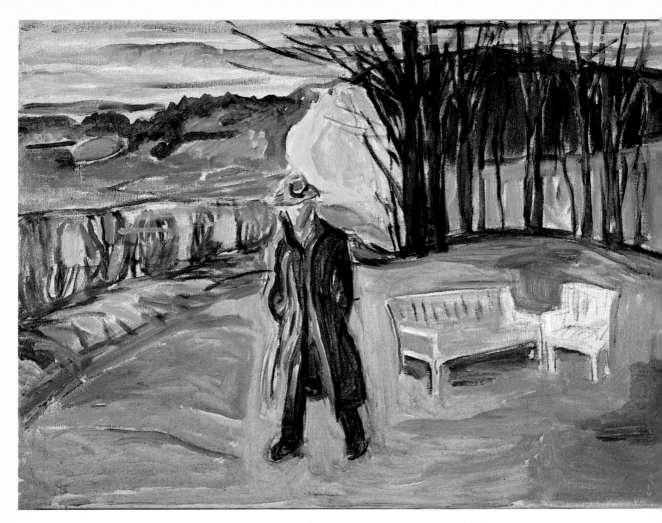

171 Above *Explosion in the Neighbourhood*, 1944. Oil on canvas 60 × 80 cm (23½ × 31½ in). Oslo, Munch–Museet (see p. 224)

172 Right *Patterns of Observed Vision Disturbances*, c. 1931. Watercolour. Oslo, Munch–Museet (see p. 223)

A straight line leads from *Spring* to the Aula Paintings. The Aula Paintings are humanity as it strives towards the light, the sun, revelation, light in times of darkness.

Spring was the mortally ill girl's longing for light and warmth, for life. The sun in the Aula was the sun shining in the window of *Spring*. It was Osvald's sun [in Ibsen's *Ghosts*].

In the identical chair in which I painted the sick girl, I and all those I loved, beginning with my mother, once sat winter after winter, sat and longed for the sun—until death took them away.[66]

Munch's Aula paintings had precedents in work such as *Fruitfulness*, which Dr Linde had purchased, and in his idealized portrait of Nietzsche. In their style they sought to fuse Naturalistic observation with simplification in order to arrive at a sense of unchanging monumentality. At the root of the stylistic process remain the various tendencies of the 1890s, ranging from adaptations of Neo-Classicism to the Synthetism and Art Nouveau that Munch himself adapted or helped to create. Fundamental to this was the conscious search for a modern style whose forms would clothe the concepts of the time in their characteristic and eternal appearance. As presented by Van den Bruck, it also suited the ideology of conservative revolution.

Impressionism's concern with the multiplicity of sensual stimuli was condemned as 'liberalistic art anarchy' and replaced by firm, clearly delineated and idealized human and landscape forms rendered in a massive scale. An archetypal simplicity, bereft of historic specificity and of traditional symbols, was sought so that the sense of the monumental, heroic and eternal would be clearly manifested.

Following such criteria, Munch's Aula paintings display simple forms organized hieratically with strong emphasis on the central axis, relatively muted colours, precisely measured space and idealized figures either nude or in a-historical dress loosely modelled on the 'eternal' costumes of peasants or workers. Munch intended the paintings to be 'typically Norwegian and universally human'; all sense of the temporal and accidental was subordinated to archetypal demands. Ideologically, the Aula images are a reactionary construction seeking to replace the complexities of modern urban life, of modern education and scientific efforts with a world in which heroic individuals who remain close to the soil function calmly and majestically within a never-never world perceived from the hermetically sealed confines of Munch's studios and lands in Kragerø, Hvitsten and Ekely. They were an attempt to overcome the pains and struggles of life, not just through art, but by projecting life itself into the imagined realm of a never-existing, romanticized and prehistorical, mythical past intended to function as a model for the future.

When he submitted his thirty sketches and full-scale cartoons of the Aula decorations, Munch also presented the jury with a written justification of his imagery and style:

My intention was that the decorations should represent a complete and self-sufficient world of ideas, and that their pictorial expression should simultaneously be peculiarly Norwegian and also pan-human.

In regards to the hall's Greek style, I feel that between it and my manner of painting there are numerous points of contact, especially in the simplification and the manner of treating surfaces. As a result, the hall and its decorations will 'work together', even if the pictures are Norwegian.

While the three main paintings—*The Sun*, *Researchers*, and *History*—shall be solemn and imposing like the strings of an orchestra in the hall, the others shall have a lighter effect, brighter and like wind instruments in passage to the hall's entire style, like a frame around them.[67]

The majority of the jury, which included Thiis and Erik Werenskiold, voted for Munch's proposal; Lorentz Dietrichson, the University representative and a professor of Classical literature, rejected it, since it was 'the opposite of Greek art. . . . The clear air of Antiquity that should move among these pictures is nowhere to be found. . . . Clearly this is related to that movement away from Classical studies and away from Antique art which is so characteristic of today's domestic culture, and which here bears one of its fruits'.[68] The Danish painter Joachim Skovgaard and Thiis countered this; both discovered a 'Homeric greatness of style', particularly in *History*, which Thiis especially praised because the symbol of learning was not 'brought a long way from distant and ancient concepts':

He has derived his inspiration . . . in the evening light of a Norwegian fjord landscape with a simple and natural picture of life. With the aid of his feelings, he has lifted it from the realm of genre and the ordinary to the sphere of the monumental and eternal. . . . There is a royal greatness that has descended over this old man in the patched folk-like clothes and there is a Homeric sense of peace. These elevate the hall and its imitated Greek architecture to the level of antiquity and an epic. This old man in this situation and in this landscape becomes the concept of history, i.e. the living process of transmission.[69]

Dietrichson's veto prevented the acceptance of Munch's proposed wall-paintings. He suggested that 'rather than place [the depiction of the University's national task] into inexperienced and uncertain hands—however remarkable they might be in other ways—it is better that we wait until that time comes, and the knight will ride forth who knows the magic words that can wake the princess in the sleeping forest.' Dietrichson's plea was praised by the conservative *Aftenposten*, which had consistently opposed Munch, but otherwise was met by derision in the newspapers, which published numerous letters demanding that the jury's majority vote be accepted. A committee was set up to raise funds for the purchase of the paintings and their ultimate donation to the University. Consistently, however, the executive committee of the University rejected appeals to have Munch's paintings displayed *in situ*, for fear that they might 'damage the architecture'. Only after the Rector of the University was replaced by Professor Frederik Stang (a member of the committee to purchase Munch's Aula paintings), was permission granted to display the paintings, in June 1911. 'The exhibition', Thiis reported, 'was visited by thousands of people and support for Munch was greatly increased.'[70]

It was non-Norwegian support that ultimately obtained for Munch the permission to complete the decorative programme of the University Aula. On 30 January 1912, he was invited to participate in an exhibition organized by the artists' group Sonderbund of Düsseldorf. 'The exhibition attempts to present a survey of the movement that has been called Expressionism', they wrote.[71] The term was one beginning to be applied that year to the newest developments of modern art in German-speaking areas of Europe. Highly subjective and individualistic in their approach, Expressionists strove for simplified forms and enhanced colour in order to facilitate intuitive empathetic reactions in their audience. The aims are directly related to Munch's and, along with Van Gogh, Gauguin and Cézanne, he was proclaimed a precursor of the young Germans. The kinship had already been recognized in 1907 when the Dresden artists of Die Brücke invited Munch to exhibit with them as they pioneered Expressionism there. Expressionist artists in Berlin, Munich, Vienna and Prague similarly paid homage to Munch by imitating

aspects of his style and iconography. August Macke, one of the members of Munich's Blue Rider group of artists, wrote reverentially to him:

Our 'concepts of a style', conceived with the best of intentions, have had to bow before your great art. . . . I believe it must be a great joy to you, that today your work is viewed with very, very great respect by a large number of the youngest and most vital artists among us. In the great struggles that we now have, you stand above the parties. We 'Young Ones' have inscribed your name on our shield.[72]

The Sonderbund Exhibition, which moved to Cologne after Düsseldorf refused to make its Palace of Arts available, was the first large exhibition to bring most of the German Expressionists (along with kindred artists of other nationalities) together as a recognizable avant-garde artistic movement. In all, 160 artists from nine countries presented 577 paintings, fifty-seven sculptures and numerous examples of crafts. Munch was given the exhibition's largest gallery to display thirty-two paintings. Approaching his fiftieth year, he found himself being heralded—and condemned—as the prophet and spiritual guide of a radical new avant-garde.

Munch's own attitude towards his new-found admirers was less receptive, at least initially when he was introduced to lithographs by the Brücke artists in 1907. In his diary, Schiefler recorded that Munch had described the artists as insane, but then quickly realized the irony of condemning them on the same grounds he was condemned, and added: 'May God protect us, we are entering difficult times.'[73] Munch visited the Sonderbund Exhibition, and met up with many of the young artists there. To Nilssen he wrote of impressions and conclusions received from the massive exhibition, the first significant art other than his own he had seen since entering Dr Jacobsen's clinic in 1908:

The main section is Van Gogh, Gauguin, and Cézanne. Three rooms of Van Gogh! 86 pictures, of the greatest interest. I am almost ashamed to have been honoured so highly—but then, it was their opinion. Hopefully, they won't regret it. . . .
 The trip has shaken my faith in life in the country as the sole path to salvation, and I have once more developed a taste for the city. . . .
 Here is collected the wildest of what is being painted in Europe. I am actually classical and pale in contrast. The cathedral of Cologne is trembling in its foundations.[74]

Munch had become Classical, and simultaneously joined the young who proclaimed him their leader into the promised land of artistic immortality gained in his lifetime.

The lure of the city and the adulation of the German art community were strong temptations for Munch, but concern for his nerves caused him to return to the refuge of Kragerø where he could work in isolation. The Aula paintings continued to absorb most of his energies, but he also painted portraits of his visiting admirers (among them, Glaser and his wife) and his sister Inger, scenes of the Kragerø landscape as well as of a vitally charging horse pulling a sleigh—quite possibly another concealed self-image of restored strength and vigour—with amazing rapidity and artistic strength during 1912 and 1913. From the isolation of Kragerø he was able to control his involvement in the events of the world surrounding him; carefully screening visitors, selectively writing letters or making telephone calls, and also making quick trips to Sweden, Denmark or Germany (but not Kristiania), he cautiously protected himself from the attacks he had suffered throughout the previous decade. Continuing to believe that in struggle was the measure of his manhood and artistic worth, he did not reject confrontation, but he chose its terms.

In Germany, he remained in the arena of protest as the Expressionist artists seceded from the Berlin Secession in 1913, objecting that their work was not being displayed or properly valued in the group whose leaders in 1892 had been Munch's defenders against the Verein Berliner Künstler. Munch's letter of resignation from the Secession is dated 5 August 1913. He was invited to join the protesting painters and sculptors, and was promised a hall of his own in their unsponsored Autumn Exhibition of the Freie Secession (Free Secession). Munch sent new versions of the Aula paintings, half the size intended for the Kristiania University. Glaser, who reviewed the exhibition, later recalled:

Whatever else was to be seen disappeared next to these works. The man who for so long had been condemned returned to Berlin in triumph. The exhibition became the celebration of his fiftieth birthday. The call for more paintings by his hand resounded. The Art Gallery Gurlitt placed its rooms at his service. Two months later [February 1914] we saw an imposing selection from the artist's life's work. This exhibition became the determining factor. The press, that previously was so self-righteous in its rejection, now could not find sufficient words of enthusiastic praise. And the public communicated a degree of interest such as it does on only rare occasions. The exhibition became a sensation. Finally total victory. No one capable of any judgment could any longer doubt that Munch had earned his place in the ranks of the great of our time.[75]

The enthusiasm was even communicated to Norway. The earlier rejection of the Aula paintings was officially reversed by a vote of 3 to 2 on 29 May 1914. Glaser and Kollmann arrived from Germany to offer their congratulations to the triumphant artist, and to be photographed sheepishly seated in an automobile in the streets of Kristiania with him: it was a time of triumph such as Munch had never experienced before. The major public painting commission in Norway for the foreseeable future was his. His art filled an entire room at the National Gallery, an honour no other Norwegian painter could claim. His fiftieth birthday was celebrated in an issue of the periodical *Kunst og Kultur* and by laudatory newspaper articles. The demand for his graphics, portraits and landscape paintings continued unabated. 'Norway truly is an odd country', he wrote. 'First I starve and have to struggle like mad for twenty-five years to sell anything at all in Norway. Then finally I manage to sell quite a bit, and even my friends start complaining.'[76] Artistically victorious, Munch still smarted from the wounds of battle, and he never forgot them. It was his German patrons and advocates who continued to hold his particular affection, and it was with them that he inaugurated plans for the first lengthy book on his art. Glaser was to start writing it immediately after his return to Germany. After thirty-five years of struggling as an artist, after combating critical attacks and psychosis, Munch had achieved success. Even his Norwegian 'enemies' had succumbed to the triumph of his art.

Chapter 7

THE STRANGER TO THE WORLD
1915—1944

'We do not die, the world dies from us'

'The realization that God has guided you through all your tribulations is truly wonderful to contemplate', Karen Bjølstad wrote to Munch in 1915, and she assured him: 'It is because you truly are an "artist through the grace of God" so that everything is granted to you in abundance.'[1] Her commentary on Munch's career placed it into a sacerdotal context, but also attributed his new-found success in Norway to patterns of divine grace and predestination that recalled the teachings of Dr Christian Munch's Lutheranism. Such mystical faith in a divine plan, whether it was that of Jesus or the allegorical goddess of art, had always been a guiding vision of Munch's career. As he purchased or rented the varied estates of Skrubben in Kragerø, Ramme in Hvitsten, Grimsrød in Jeløya and in 1916 his final home of Ekely in Skøyen, in addition to the hut he continued to maintain in Aasgaardstrand, what he reaped was only the due long owed his genius and talent by society, as he perceived it.[2] The fruit, livestock and vegetables he raised in the fields surrounding his houses enabled Munch to nourish and care for the members of his family. The dual duties to family and profession, both divinely ordained, now finally would be properly fulfilled. He had laboured long in the vineyard of art; prosperity was his just wage.

However much Munch believed that his success was determined by fate or God, it was also directly dependent on the prosperity Norway gained in reward for her neutrality during the First World War. Munch was not oblivious to the irony. As he completed his Aula paintings, he adapted one of their images—two women plucking apples from a tree—for the poster of a Nordic Art Exhibition in Copenhagen. To the idyll of two blond nudes on a sunny island with abundant food, Munch added a background scene of a ship listing on a dark, stormy sea to provide an obvious visual contrast between prosperity and disaster. The exact meaning Munch intended for his *Neutralia* is not as apparent.[3] It is frequently thought of as a condemnation of neutral Scandinavia's wartime profiteering at the expense of its own seamen's lives, but in fact lends itself more readily to a celebration of neutrality rather than its condemnation. The two nudes, the tree, the fruit and the sun are the four major components of Munch's metamorphosis imagery first evolved during the 1890s. The natural order of transubstantiating immortality is posed in antithesis to an image of fruitless death akin to the battles on lands and seas surrounding the neutral Nordic countries. Viewed in this manner, the poster becomes a call to peace and prosperity under the eternally unifying aegis of Munch's 'great erotic sun'.

The pacifism underlying *Neutralia* contrasts with Munch's earlier celebration of conflict, as well as with his initial attitude to the outbreak of war in 1914. Understandably, his loyalties were divided between France, the source of his artistic style, and Germany, for years virtually his adopted country.[4] Ideological and emotional identity with Germany, however, soon galvanized his sympathies. As German Imperial armies marched into Belgium and France, Munch worried that the copper plates of his engravings might be melted down as war material but otherwise was enthralled by the military glory of the Kaiser's troops. 'How remarkable are the power, effort and

sacrifice I see revealed now by Germany!' he wrote enthusiastically to Dr Linde and expressed the certainty that 'so much greatness and magnificence absorbs all your thoughts. It must be uplifting!'[5]

Within a year, these romantic visions of armed splendour were dissipated. *Neutralia* demonstrates this as do lithographs simply entitled *The Tree* which repeated the message of metamorphosis through the massive trunk of an ancient tree, rooted in the decomposing mound of men's bodies and surrounded by a barren landscape dotted with crosses and ruined buildings. Sun and tree provide a continuum of life as does the form of a young nude materializing above a smoking cannon-shaped urn in yet another lithograph inscribed (in French) 'The United States of Europe'. Here Munch projected a post-war world of fraternal co-operation, typically less in political than in cultural arenas. 'The flame of culture dies and lives again', he wrote. 'Bled to death, [Europe] will pass its flame to America where it will once again live and die, and then live again in the lands of the Orient. When will it happen? The United States of Europe are the only means of keeping the flame alive.'[6] The flame as Munch perceived it was dying, however. The world and values he knew were collapsing.

From the neutral retreat of his gardens, Munch observed the process as millions died in trenches and the mechanics of destruction heralded a new age. For these experiences, the allegorical imagery of Munch's art knew no adequate representation. Trees rooted in corpses, landscapes with water the colour of blood, and scenes of crowds panicking as they face an unknown doom were insufficient when compared to the reality of modern warfare's devastation. Similarly, woodcut illustrations for Ibsen's *The Pretenders* could point to historical parallels of political intrigue and military violence, but brought under the control of literary narrative and historical certainty. The world in which he lived was becoming increasingly alien to Munch, and in its dependence on numbers and masses in politics and warfare was antagonistic to his own existential celebration of the individual. His self-imposed isolation became increasingly more justifiable, and he desperately avoided all direct contact with life outside his art. When he purchased the Ekely property, he arranged that his sisters and aunt come and inspect it, prepared an itinerary for their visit and provided them with food; he himself hid.[7]

He sought refuge in his art. In the old wooden house at Ekely he collected the memories of his life: the wicker chair on which Sophie sat as she died, suitcases filled with letters, notebooks containing his varied writings, boxes of drawings and prints, and his paintings previously stored by German, Danish and Norwegian dealers. From Germany, too, came the plates and stones for his prints; he created new issues of them, worked over the copper and wood plates and the lithographic stones, and experimented with colour variations. Recaptured by the erotic imagery of his youth, he also reverted to its style in new prints of such past motifs as *Into the Forest* or *Three Girls on a Pier*. The forms he drew emulated the style of the 1890s and perpetuated its values; but the acidic colours contradicted their moody tranquillity. The unity achieved in former years was no longer attainable. Desperately he attempted to retrieve his past. He mounted the prints in a massive folio volume, apparently resurrecting the unfulfilled concept of 'The Mirror', and expanded the series with additional drawings. Simultaneously, in a ledger he organized with pins and paper clips the loose sheets of paper containing his poeticized fragments of autobiography and his metaphysical and artistic thoughts from the 1890s. Organizing them loosely according to 'Childhood—Art—Philosophy—Mental State—Moods—Reminiscences of Youth—Love—Passion—Death'

(to which he adhered only fitfully) he described them as 'The Madman's Jottings'.[8]

Settling in Ekely in 1916 once again gave Munch the opportunity to survey his life's artistic production and to try to become reacquainted with himself, and with almost forty years' of his drawings, paintings, prints and writings. The experience was overwhelming. To the challenge of his own prolific productivity he responded only with duplication. He painted new, larger versions of *Fever, Woman in Three Stages, Kiss, The Dance of Life* and *Jealousy*.[9] Other paintings, such as *Metamorphosis*, he altered, notably portions that critics had previously perceived as offensive. The series on 'Love' and 'Death' was newly resurrected, its exhibition prepared, and Munch set out to fight once more the battles of his dead youth.

As the exhibition opened, he published a declamatory defence of his life's work in the newspaper *Tidens Tegn*, thereby for the first time entering into a public debate with his critics. Comparing them to their French and German colleagues, he took Norway's critics to task for failing to recognize the value of his art before 1910. With an eye to contemporary events, particularly anti-German feelings, he emphasized his art's Norwegian roots:

I have worked on this frieze, with lengthy interruptions, for roughly thirty years ... and first exhibited it here in the city in 1892. Some art critics have tried to demonstrate that this frieze is influenced by German ways of thought and by my contact with Strindberg in Berlin. This information I have given is hopefully sufficient to put an end to these assertions.

The very mood and content of the frieze's various components is the direct result of the 1880s conflicts and constitutes a reaction against the realism that was then rampant.

I conceived of the frieze as a series of decorative paintings that together should be a metaphor of life.[10]

Bitterly he decried the lack of support he had received while 'the task took hold of me with such tenacity that I have been unable to escape from it'. He bemoaned the failure of patrons to provide a space in which to have the frieze properly displayed, and justified his new versions of the paintings:

It cannot be considered completed, since there were constant lengthy interruptions as I worked on it. Because I have worked on it for so long, naturally no single technique is continued throughout. I consider many of the pictures to be no more than studies, and of course my intention is to unify it all only when there is a proper space for it.

Now I am exhibiting the frieze anew. I do it first of all because I believe it is too good to be forgotten. In addition, during all these years it has been so important to me that I myself am anxious to see it all together again.[11]

Despite his stated intentions, Munch did attempt to provide visual unity, particularly to the erotic motifs. He gave all the scenes an identical setting: a seashore lined with pine trees. He also strove for a greater unity of technique and style than was evident in the twenty-two paintings seen at the 1902 Berlin Secession. He applied paint to canvas in extremely thin washes; all sense of volume was denied the outlined figures and forms, causing them to fit together like puzzle pieces in a claustrophobically spaceless ambience. As he had done in his prints, Munch also altered the colours themselves; deprived of atmospheric moodiness, they are muddily transparent greens, blues and browns contrasted with flashes of biting yellow, glowing violet and deep red. The parts do not coalesce, and in comparison to their models the new paintings of old themes frequently appear like rough caricatures, unfinished,

crude and tragically lacking in conviction. Similarly, by combining portions of his Linde Frieze and Green Room series into the thematic context of the Frieze of Life, Munch destroyed the conceptual unity of the original work without providing a sufficient substitute. Distorted fragments of his own past are what he exhibited in 1918; in competition with himself, he lost.

Despite Munch's article, critics unanimously rejected his painful attempt to reconstruct his youth. The paintings had been seen before, they complained, as they sarcastically ridiculed the symbolism and bemoaned Munch's failure to recognize that art had changed since 1900. He reacted bitterly and hysterically to the unified chorus of attack. Within days, he published a second article, 'Concerning the Criticism'. His frieze was unlike other friezes, he proclaimed; it did not depict a life biographically; it could not be finished until there was a room for it; it was like Michelangelo's Sistine Chapel, which also embodied thoughts rather than serving as wallpaper. One critic received particular attention: 'That desperate bastard of an impossible artist and impossible critic to whom *Aftenposten* awarded its vacant job of driving the manure cart that has carried dung from its Augean stables to the garden of art for the past forty years.'[12]

Contributing to Munch's embittered outbursts was his hope of gaining other commissions for monumental paintings through the exhibition. Its combination of older and newer paintings devoted to similar themes was to demonstrate his continuing capacity to master serial images on a grandiose scale. The new painting technique—thin washes applied in large, flat areas—had a kinship to his past art; however, the technique was designed to be viewed only at a significant distance, from where large boldly coloured forms would gain greater impact than renderings of detail or volume. In their refusal to recognize these 'decorative' intentions, the critics appeared violently to distort the major virtues he sought in his most recent painting. Munch's faith in his artistic fate was not destroyed, despite all attacks. At Ekely, he constructed large wooden enclosures as outdoor studios in which to hang the monumental new versions of his Frieze of Life paintings. The studios became a grandiose collective notebook whose components he could shift at will, adding and subtracting paintings until virtually none of his work was excluded from his life's frieze.

'The Aula paintings and the earlier Linde Frieze and Reinhardt Frieze were important studies in monumental painting', he wrote, 'and after the Aula paintings I could not simply shelve such concerns. I felt the need to continue my experiment. I have continued to work on the Aula paintings and the Frieze of Life as well as on other monumental work.'[13] He duplicated motifs from the Aula, and created a massive version of *The Human Mountain*, the motif intended as the central panel but rejected by the jury. Its numerous figures groped upwards towards the sun in a living pyramid having its base in the androgynous portrait of Munch with a woman's body; new canvases were tacked on to it and a final formulation became impossible.

Munch equated his persistent refusal to finish his major projects with the promise of continued life. Fearing death, he relied on his fate as artist to recognize the need to complete his mission, and thus set himself goals which were unattainable or, if attained, were renewable. The constant repetition of *The Sick Child* in ever newer versions 'correcting' previous versions is indicative of this, but even more so is his practice of painting over a work, scratching and gouging away the old image until it became a shadow overlaid with its own duplicate. In 1903 to 1904 he had painted a *Dance of Life* for inclusion in the Linde Frieze. When the painting was rejected by Linde, he

began to rework it. He added new figures and hid others under thin washes of colour or filled portions of a form with heavily impastoed paint, until the painting became a visual record of two decades of artistic action. In 1921 he created its duplicate on commission, then painted a larger new version to hang in his outdoor studios in defiance of the effects of rain, snow, sun and wind. Meantime, at the National Gallery he spent several days copying his original *Dance of Life* to hang it with his other Frieze paintings at Ekely and, later, to paint over portions of it again. His art could find no end.

The duplicating process also permitted a process of psychological distancing to take place. As he accepted his earlier formulations for a motif, the paintings embodying them could be viewed as experiences whose existential value was secondary to the artistic issues of form and colour raised by them. Obsessive replication emptied compositions such as *The Kiss* or *The Vampire* of demonic power. Essentially, Munch transformed the paintings devoted to erotic themes from first-person narratives to third-person accounts, and became the neutral witness to his own past experiences.

Munch first manifested this altered attitude as he struggled with his Aula compositions. In a group of etchings, he investigated the sexual interactions of a man and woman in terms of such familiar motifs as a woman posed as an enticing cat or the Vampire transformed into a man viciously biting into a woman's exposed breast.[14] A masochistic tone also seems to emerge in the jealousy motif, now presented as a young couple contrasted to an older man isolated in the foreground; the jealousy generated in the relationship is now less that of two men involved with the same woman, as in earlier prints and paintings, and more that of the older man (whose features are recognizably Munch's) towards the youth and affection of young lovers. With their impressionistic drawing style searching out contrasts of volume, shadow and light, the prints appear much like private mementos to emotional impotence and sexual frustration in a manner unlike any of his earlier explorations of the relationships of women and men.

This erotic detachment even characterized new themes in works devoted to sexual motifs. Primary among these is that of the seducer; these scenes pair an

173 *Dance on the Shore*, 1903–4, 1907 and 1916. Oil on canvas, 90 × 315 cm (35½ × 124 in). Oslo, Munch–Museet

older man and a young woman, both naked, but give no indication of emotional interaction or of sexual fulfilment. They are portrayals of sexual and amorous possibilities, but these are denied to the participants, who are promised alienation rather than affection. As he turned to variations on the traditional *topos* of artist and model around 1920, the sense of tensions and frustrations also dominated, while the paintings became paintings of paintings rather than records of events. The third of his *Bedroom* images is a diptych that fuses a self-portrait painted somewhat earlier in 1919 with a depiction of a model dressing in Munch's bedroom, a variant on earlier paintings. With the forms brushed on to the canvas in large areas of thin, dripping paint, the Bedroom paintings apply Munch's formulations for 'decorative' art, but the composition heralds a dichotomy of two distinct worlds, that of the artist and that of the model, in which there can be no unity. Living according to the rules of a monk, Munch wrote, he could focus his energies on art, but only by avoiding all human contact, from which 'events might arise against which I have no armour'.[15] His fate was to be an artist, and to fulfil that determined role he had to reject all access to human tenderness. In ascetic loneliness, he could observe life only through the protective screen he wove through his art.

Although the models he used ceased to possess sexual or emotional allures for him, ironically Munch turned with increasing frequency to representations of the female nude. Previously in his art, these most commonly took on symbolic or expressive significance; now they were depicted more as objects of contemplation—flowers to be seen but not touched for fear of their thorns, according to Munch.[16] Erotic comment was avoided. Naturalistic in effect, these representations contain an attention to detail lacking in other contemporary works, as if the women demanded a visual intensity of observation and contemplation so as to bring Munch an almost clinical knowledge of their alien presence. The visual dissections of the women posed seated, kneeling or reclining on unkempt beds were then contrasted to backgrounds filled with intense visual excitement. The space between two nudes, the empty expanse of canvas against which they are set and the dripping flow of viscous paint could achieve a reality totally subordinating the neutral presence of the figures. The broad volumes of women's bodies also took on a massiveness which filled and dominated a canvas, only to be set against vibrant backgrounds of patterned yellows and greens against which float amœboid forms like embryonic visions. Often posed weeping, the nudes also kneel or recline in ambiences of glowing red suggesting the enclosing walls of the interior where they were painted. While the gestures of the figures were dramatic and emotionally charged, it was in the rendition of the surroundings that Munch attained the greatest sense of empathetic identity and power. His reality, not that of the models, was supreme.

Munch had always concerned himself with representations of nudes, both female and male. Beginning with the years in Kragerø and continuing into the 1920s, however, the motif appears with unprecedented frequency. While male nudes continued to be emblems of virile strength and most commonly were posed out of doors, in the salvific rays of the sun, the women lacked any such references. Enclosed in the environment of his bedroom—at Ekely Munch furnished only a living room and an adjacent bedroom, leaving all other rooms free to be inhabited by his art—the nudes exist totally in the realm of the artist, as subjects for his visual contemplation and manipulation, and as the virginal sisters of his art. (The intensity and detachment of Munch's visual explorations, according to one of his models, could cause

174 *The Bedroom III*, 1919–21. Oil on canvas, 120 × 200 cm (47¼ × 78¾ in). Oslo, Munch–Museet

extreme embarrassment and unease, even for women accustomed to posing for artists, thus possibly accounting for the frequency of weeping women in the series of nudes.[17]) Deprived of all but aesthetic content, the nudes provided Munch with an ideal means of testing his control of his talents as he felt increasingly the effects of age. As demonstrations of colouristic moods, embodied in the varied physiognomies of models such as Anna, with heavy black hair and robust body forms, and the 'Gothic Girl' Birgitte Prestøe, ethereal, slender and dignified, they continued to demonstrate his faithfulness to his goddess of art and bore testimony to the resistance of temptations offered to her ascetic 'monk'.

Munch's concern with the nude, the classic subject of sculpture, may also have been motivated by the rivalry between him and the sculptor Gustav Vigeland. They were together in Berlin in 1895, and there shared the admiration of Przybyszewski, who praised the representations of the psychology of love in both their works. Like Munch, Vigeland explored the relationship of the sexes in a series of images, *Man and Woman*, on which he worked for over a decade. Unlike Munch, however, Vigeland soon achieved popular acceptance, was given commissions for public monuments, and was invited to create the new sculptural programme of the reconstructed Trondheim Cathedral, site of the coronation of Norway's kings. While Munch wished for a home into which to place his Frieze of Life, Vigeland found patrons willing to support his project for a monumental series of sculptures representing varied phases of life from birth to death and centred around a vast symbolic fountain. To bring Vigeland's project to fruition, the city of Kristiania donated the spreading lands and waters of a park, complete with houses, studio and museum; in ironic contrast to Munch, who observed: 'After finishing the Aula Paintings, I felt ready to test myself on great monumental projects, but my homeland had nothing to offer to me.'[18] Munch found the situation particularly unjust since he believed Vigeland's

175 *Workers in the Snow*,
1911. Woodcut. Oslo,
Munch–Museet

Frogner Park sculptures to be no more than a plagiarism of his frieze
concepts.

In the Frieze of Life lay Munch's greatest hope for a monumental project
exceeding even the Aula paintings in magnificence and extent. In its content,
he argued, he represented universal values which demanded the mass audi-
ence that only public buildings could provide. It would form the basis for a
new art of the people:

Why can art not belong to everyone again, as it did once? In public buildings and in
the streets? Frescoes? Architecture has been renewed with simple walls and spaces.
Small pictures are no longer needed as much. . . .

But the large surfaces also demand life and colour. It is necessary that someone go
to the artist so that he can fill all these surfaces.

Why should a new wall painting not develop as it did during the Renaissance? Then
art belonged to all the people. We all own the works of art. A Painter's work need not
disappear like a rag in a house where only a few people see it.

Is this not the time for such an art? It is said that earlier there was religion in art.
Religion is always among the people in new forms and varying art. To develop a great
monumental painting, it is necessary to give all of one's soul to prevent it from
becoming purely decorative.[19]

220

With no actual public commissions being offered, Munch worked on potential ones. In 1914, the centenary of Norwegian independence from Denmark prompted him to design a national monument and to suggest that Vigeland do the sculpture while he paint a new Frieze of Life. More realistic seemed the possibility of murals in a town hall in Kristiania, for which a competition was announced in 1915. For it, he envisioned workers based on motifs of snowshovellers such as he had often depicted since 1909.[20] 'Now it is the workers' turn', he proclaimed repeatedly; they were the people for whom he would paint his frescoes. Towards the end of the First World War, as the reality he had known and painted seemed to be destroyed, it was the revolutions of Russia and Germany that seemed to announce a new order fulfilling his dreams of a society in which his new people's art could flourish. 'Often I believe that something wonderful will come of all this', he wrote to Glaser after Germany's surrender at Versailles and the founding of the Weimar Republic. 'As long as there is proper organization; now that seems to be true, and Germany has just such a highly educated and organized social democracy.'[21]

Although it seems close to Marxist praises of the proletariat, Munch's ideology of workers is more naïve and romantic, and has greater kinship with Moeller van den Bruck's conservative 'socialism'. As heroic individuals felling trees, sowing grain, digging in gardens, harvesting cabbages or playing with children, Munch's workmen shared in the gifts of nature so as to appear new embodiments of the Nietzschean heroes portrayed as bathers in Warnemünde. Like artists, they granted order and productivity to nature, and existed outside the proprietary limits of middle-class values, becoming outcasts in the very society they laboured to support. In the unskilled labourers returning from or going to their factory jobs, Munch saw a sense of communal identity and fraternity through which the antagonisms of industrial society might give way to the spiritual harmony of individuals. It was this

176 *Kiss on the Shore*, 1915. Oil on canvas, 78 × 100 cm (30¾ × 39½ in). Oslo, Munch–Museet

hope he transmitted to Glaser as they surveyed the wreckage of the German Empire; in the revolutions of the time the mystical faith in a prosperous future according to the laws of nature emerged. The prophecies of Munch's *Neutralia* and his United States of Europe would be fulfilled in the peaceful triumph of the masses and in a monumental art created for them.

As he waited for the City Hall project to materialize, Munch was commissioned to create paintings for the workers' dining rooms at the Freija Chocolate Factory in 1921. He projected two friezes, one depicting activity in nature and modelled on the Frieze of Life, the other devoted to the life of the worker. The former was carried out; the workers' frieze would also have been based on earlier compositions, with the *Return Home* as a central panel flanked by scenes of workers in front of Oslo's Trinity Church and greeting their little daughters outside the factory door. It was the worker out of doors whom Munch persistently depicted, the worker in moments of leisure; the labour of modern industry, even if in a model chocolate factory, never was a reality to him and thus was also alien to his art.

The Oslo City Hall project was revitalized in 1928 (Kristiania was renamed Oslo in 1925) when a committee of ten artists and critics proposed that a room be reserved for Munch in the building when it was finished. Munch planned a new 'Cycle of Paintings Concerning the Life of Labour in the City' and in a newspaper interview confirmed his interest in the project. He dreamed of additional friezes devoted to the history of Oslo which would surround the images of workers shown in the process of constructing the town hall. To facilitate the work on this monumental project, he constructed a winter studio in Ekely, but the plans went no further. Frequently ill and suffering from cysts in his right eye, he complained: 'Now they come to me. I should make a monumental painting. Now that I am old and sick. I do not have the strength. When I was strong, they had no use for me.'[22] Not until after his death was the City Hall finally constructed; a single painting by Munch hangs in one of its rooms.

Frustrated plans, insufficient strength and the inability to free himself from his past mark Munch's last two decades of life. He failed to understand the political, social and artistic developments of the time. He even perceived the cysts in his eye less as a medical problem than as a reflection of his own past. Studying their patterns, he described them as birds of prey that served as mirrored images of his own soul: 'My soul is like two wild birds, each pulling in a different direction.' Printed in large block letters with a crayon so that his weakened eyesight could discern them, the text appears in the large portfolio volume Munch had used in 1916 as a repository for drawings, prints and texts largely related to the 'Mirror' series. Now with coloured crayons and charcoal he added further writings and illustrations to his 'Madman's Jottings' and provided an alternative title: 'The Tree of the Knowledge of Good and Evil'.[23] Many of the texts are transcriptions of his earlier writings; some attempt to formulate a mystical, poetic myth of life and creation elaborating on the tenets of vitalism:

The earth shot flames towards the peripheries of the universe
The flames shrunk back into ashes again
Eyes I saw—blue and shining
Dark but filled with glowing flashes
Asking
Seeking
Yearning
Willing

177 The Frieze of Life in
Munch's Studio, Ekely, 1925

They searched towards the peripheries
Released from the earth—the children of man
Only to fall back
To blend their ashes with Mother Earth
Why? To what end?
Willing, determined, they rose and fell
Sparks and glow in the darkness of night
God is in all
All is in us (God)
We are brothers in the mighty game of life!
The game is willed, dared, and played
To be willed and dared and died again and again.[24]

His art and the thoughts formulated through it absorbed him more and more
as the threat to his sight increased. The patterns of the cysts, after taking form
as birds of prey gnawing at his heart, slowly dissolved, and brought the
promise of further creative activity. In watercolours whose charm belies the
pathos of their creation, Munch recorded the process of returning clarity in
his weakened vision. Again he took up the themes of his earlier paintings;
motifs of jealousy, couples at the seashore and women on a pier were
transformed into patterns of intense, almost garish colours celebrating his
improved sight. With renewed energy, he accepted portrait commissions,
took short trips to Kragerø, Bergen and Aasgaardstrand, revived the project
of the workers' frieze for the City Hall and the University Aula's *Alma Mater*
once more, and slowly seemed to accommodate himself to the world in which
he lived. As he celebrated his seventieth birthday, he received congratulatory
messages from all over Scandinavia and Germany, was awarded the Grand
Cross of the Order of Saint Olaf, saw the publication of Thiis's and Pola
Gauguin's books on him (the first in Norwegian), and only his own objections
prevented a torchlight parade in his honour. It was, in many ways, the
highpoint of his life.

Among the congratulatory telegrams was one from Joseph Goebbels

178 *Spiderweb*, 1943.
Woodcut 52 × 42 cm
(20½ × 16½ in). Oslo,
Munch–Museet

179 *Self-Portrait with
Damaged Eye*, 1935.
Charcoal and oil, 90 × 72 cm
(35½ × 28¼ in). Oslo,
Munch–Museet

speaking for the German people, but soon the events unleashed by the regime he represented brought a different message: Munch's works were among those considered degenerate and were removed from museum collections and auctioned to raise money for the German state. Confused by it all, Munch urged Thiis to make sure the prices of the paintings were high, as a sign of his gratitude for past German support. The world surrounding him had become more than ever alien to him. Norway was invaded, German troops encamped near Ekely in armoured cars, and Oslo's National Gallery condemned his work in the exhibition 'Art and Non-Art'.

Munch lived alone. In the house at Ekely he was surrounded by the results of six decades' devotion to the goddess of art; he raised chickens, potatoes, fruit and livestock; he read the letters friends had sent him in the past. Strangely, he also found respite from the anxieties that once beset him. Above all, he yearned for peace. The war, however, outlasted him and he died, alone, on 23 January 1944. Among his last works was a self-portrait painted in reaction to the explosion at Filipstad whose force broke the windows at

180 *Self-Portrait Between Clock and Bed*, 1940–2. Oil on canvas, 150 × 120 cm (59 × 47¼ in). Oslo, Munch–Museet

Ekely. The world had broken into his art.

'I was born dying', Munch observed. He had recorded his long wait for the arrival of death in his self-portraits. In them he portrayed his art's beginnings in 1880; his maturity as the mystical prophet of death, love and art; his sufferings as a new Marat; and his triumphs over his enemies whether imagined or real, whether physical or psychological. In 1940, he posed himself between the clock ticking away the seconds leading to death and the bed awaiting him. Bright patterns of blues, yellows and greens act in harmony while stripes of intense red and black provide the counterpoint to the white of his bed. He himself stands tall and gaunt, his ill-fitting clothing revealing his aged shrivelled body; his mouth is turned downward in displeasure, but behind him supreme hang his paintings. 'Joy is the friend of sorrow', he wrote with trembling hands into his large book of the Knowledge of Good and Evil, 'Spring is the herald of Autumn. Death is the birth of life.'

NOTES

Chapter 1

'*I was born dying*': Manuscript T2759 (EM III). Munch Museum Archives.

1. Pola Gauguin, *Edvard Munch*, 2nd edn (Oslo 1946), pp. 313–14. Additional details concerning Munch's death are recounted in *Edvard Munch som vi kjente ham: Vennene forteller* (Oslo 1946).

2. Curt Glaser, *Edvard Munch*, 2nd edn (Berlin 1922), p. 12. Glaser met Munch in October 1913 when Munch was visiting Berlin on the occasion of an exhibition there. The two had been corresponding since the previous year, and Glaser began to collect material for his book immediately after their meeting, much of the documentation being provided by Munch himself during a lengthy visit to Oslo by Glaser in 1914. As was his frequent practice concerning books about himself, Munch read at least major portions of Glaser's manuscript and specifically approved its content. Completed by 1915, the first edition of the book was not published until 1917.

3. Curt Glaser, 'Besuch bei Munch', *Kunst und Künstler*, 25 (1927), pp. 203–9, as reprinted in Erhard Göpel, *Edvard Munch. Selbstbildnisse und Dokumente* (Munich 1955), pp. 43–6.

4. As reported by Erich Büttner, 'Der leibhaftige Munich', in Jens Thiis, *Edvard Munch* (Berlin 1934), p. 98.

5. Information concerning Munch's family, ancestry and childhood is largely derived from Jens Thiis, *Edvard Munch og hans samtid* (Oslo 1933), pp. 3–62. As with Glaser's monograph, Munch provided documentation and other aid for this study. Drafts of Munch's letters to Thiis regarding the book are preserved in the Munch Museum Archives. The book will hereafter be cited as Thiis, *Munch* (1933).

6. Rev. John Bowden, *Norway: Its People, Products, and Institutions* (London 1867), p. 55.

7. Three hundred years after its foundation, on New Year's Eve 1924, Kristiania's name was changed to Oslo in affirmation of the city's medieval Norwegian origins and to play down its Danish associations. The census of 31 December 1865 listed 57,382 inhabitants for the city.

8. As quoted by Thiis, *Munch* (1933), p. 61.

9. Manuscript T 2759 (EM III), Munch Museum Archives, probably written *c*. 1905–8. Similar statements appear in *Edvard Munch: Tegninger, skisser og studier*, Oslo Kommunes Kunstsamlinger Catalogue A-3 (1973), p. 3, and in K.E. Schreiner, 'Minner fra Ekely', in *Munch som vi kjente ham*, pp. 9–13. A professor of anatomy befriended by Munch, Schreiner read many of Munch's manuscripts after the painter's death and quoted them in his article, including Manuscript T 2759. For fragments translated from Schreiner, see Ragna Stang, *Edvard Munch* (London 1979), p. 31.

10. Manuscript T 2759 (EM III). Munch Museum Archives.

11. Munch wrote numerous times about his walk in the city with his mother shortly before her death. One of the earliest of these recollections is contained in an illustrated notebook, Manuscript T 2761 (EM I), Munch Museum Archives, which contains other childhood memories. The date of this notebook is debated. In his perceptive unpublished thesis, 'Refleksjon og visjon: Naturalismens dilemma i Edvard Munchs kunst, 1889–94', Oslo University 1968 (hereafter referred to as Nergaard 'Refleksjon'), p. 138, Trygve Nergaard suggests that the drawings in this notebook date from 1892–3. Arne Eggum, 'The Theme of Death', in *Edvard Munch: Symbols and Images*, Exhibition catalogue, National Gallery of Art, Washington, D.C., 1978 (hereafter referred to as Washington Catalogue 1978), p. 149, proposes 1888. Since Munch habitually re-used notebooks and sketchbooks, both dates might be attributed to aspects of Manuscript T 2761.

12. Draft of a letter to Jens Thiis, *c*. 1932–3. Munch Museum Archives.

13. Laura Munch, Letter to her children, dated 12 January 1868, in *Edvard Munchs brev: Familien*, ed. Inger Munch, Munch-museets skrifter I (Oslo 1949) (hereafter referred to as *Brev*.), 12, p. 19.

14. Inscription dated 15 February 1929, Manuscript T 2787, Munch Museum Archives. For a similar statement, see Munch's letter, dated 5 March 1929, to Ragnar Hoppe, in Ragnar Hoppe, 'Hos Edvard Munch på Ekely', *Nutida Konst* 1 (1939): 17.

15. Manuscript N. 154, Munch Museum Archives, *c*. 1890 or 1892. For the similar text of Manuscript T 2761 (EM I), Munch Museum Archives, see Reinhold Heller, *Edvard Munch: The Scream*, Art in Context (London and New York 1973), p. 18.

16. About 1892, Munch inaugurated a project to depict his childhood memories in a series of drawings and paintings. The project was never completed, being exhibited only in 1893 as a series of drawings entitled 'A Human Life'. For a discussion of the project, see Eggum, *Theme of Death*, Washington Catalogue 1978, pp. 145 ff.

17. Letters dated 26 September 1861 and 10 October 1861 respectively, *Brev*, 4, p. 10, and 7, p. 13.

18. Draft of a letter to Jens Thiis, *c*. 1932–3. Munch Museum Archives.

19. *Ibid*.

20. 'The four well-situated, nice, and sweet daughters of P.A. Munch were filled with compassion for Uncle Christian, whom they loved above all and [for whom] they constantly asserted their love. ... Once in a while, my father received some candy from them – imagine how it would have been if instead they had honoured him with 30 Kroner, he would hardly have rejected that.' Draft of a letter to Jens Thiis, *c*. 1932–3. Munch Museum Archives.

21. Edvard Bull, *Arbeiderklassen: Norsk historie*, 2nd edn (Oslo 1947), pp. 112–19. Many Norwegian workers and farmers sought a solution to their economic situation by emigrating to America. Beginning in the 1860s, emigration reached a highpoint in 1882, when some fifteen out of every 1,000 inhabitants left, and did not end until World War I. Only Ireland had a greater rate.

22. 'Edvard Munchs erindring om Sophies død', in *Brev*, 82, pp. 89–90.

23. Manuscript T 2771, dated 5 February 1890, cited in OKK Catalogue A-3, p. 2.

24. Hans Try, *To kulturer, en stat 1851–1884*, Vol. II, *Norges historie*, ed. Knut Mykland (Oslo 1979), p. 61.

25. Manuscript T 2770, dated 2 February 1890.

26. Munch's thoughts on existence relate closely to Existentialism, and he himself recognized kinship with aspects of Kierkegaard's philosophy. Probably this relationship is fortuitous, although there is some possibility that it reflects Kierkegaard's influence on progressive Lutheran priests in Kristiania, at least one of whom Munch records hearing. For discussion of Kierkegaard's significance in Norway, see Valborg Erichsen and Harald Beyer, *Kierkegaard og Norge* (Oslo 1924).

27. *Brev*, p. 47.

Chapter 2

'*My ideas ripened in the Bohème*': Draft of a letter to Broby Johansen, dated 11 December 1926. Munch Museum Archives.

1. Draft of a letter to Jens Thiis, *c*. 1932–3. Munch Museum Archives.

2. Letter to Harald Nørregaard, undated (1931). Munch Museum Archives.

3. Erik Werenskiold, as cited by Leif Østby, *Norges kunsthistorie*, 2nd edn (Oslo 1962), p. 160.

4. Jens Thiis, *Norske malere og billed huggere i det nittende århundredet*, Vol. II (Bergen 1907), p. 103.

5. Thiis, *Norske malere*, Vol. II, p. 1.

6. Arne Eggum, 'Munch's Self Portraits' (Washington Catalogue 1978), pp. 11 and 17 contends that this self-portrait was created in 1883 not 1881, under the teaching of Christian Krohg. The painting, however, relates very little to the portraits Munch painted in 1883, which Krohg corrected or supervised. Facture in the self-portrait is far more hesitant than in Munch's Krohg-influenced portraits, and colours remain far less bold; Krohg also taught Munch to focus his studies totally on the head of the subject to create a simple but intense composition in which the portrait head fills well over half the area of the canvas; in the self-portrait, however, Munch's head is small in comparison, placed high in the rectangular surface, and the psychologically inconsequential mass of his shoulders fills most of the area as a result. Compositionally and colouristically less refined than Munch's 1883 portraits, the self-portrait has traditionally been dated 1880, and this date, rather than 1883, as suggested by Eggum, seems the more correct, although Munch may later have touched up small areas such as the ears.

7. Diary entries dated 10 December 1881 and 13 February 1882, in *Brev*, 39, pp. 51–2.

8. Draft of a letter to Bjarne Falk, undated (1882), in *Brev*, p. 55.

9. Christian Krohg, 'Den Bildende Kunst som Ledd i Kulturbevegelse',

Kampen for tilværelsen, 2nd edn (Oslo 1952), pp. 15–17.

10. Edvard Munch, draft of an unaddressed letter, *c.* December 1882. *Brev,* 43, p. 56.
11. Gunnar Heiberg, 'Høstudstillingen', *Dagbladet,* 22 December 1882.
12. Draft of a letter to Jens Thiis, *c.* 1933–4. Munch Museum Archives. Munch also frequently sought to deny Krohg's significance for him, arguing that Hans Heyerdahl influenced him more, as Thiis, *Munch* (1933), pp. 80–1, was compelled to report.
13. As cited by Edvard Bull, *Arbeiderklassen norsk historie,* 2nd edn (Oslo 1947), p. 123.
14. Letter to Karen Bjølstad, dated 24 September 1884 by Dr Christian Munch, *Brev,* 45, pp. 58–9. Significantly, the letter is addressed to Munch's aunt, not his father, although it was obviously meant to be read by the latter as well.
15. Reviews in *Morgenbladet* and *Nyt Tidskrift,* as cited by Thiis, *Munch* (1933), p. 98.
16. Thiis, *Munch* (1933), p. 164.
17. Herman Colditz, *Kjærka, et Atelier-Interiør* (Copenhagen 1888), p. 75.
18. Thiis, *Munch* (1933), p. 134.
19. Edvard Munch, *Livsfrisens tilbivelse* (Oslo n.d. [*c.* 1929], p. 10.
20. Frits Thaulow, letter to Dr Christian Munch, 5 March 1884. *Brev,* 44, pp. 57–8.
21. It has become commonplace to assume that Munch saw, and was influenced by, French Impressionist paintings during his brief visit to Paris in 1885. However, Jens Thiis, *Munch* (1933), p. 137, drawing on Munch's own recollection, observed: 'What Munch could have seen of Impressionism could not have been much, if anything at all.'
22. 'S.S.' in *Morgenbladet,* as cited by Thiis, *Munch* (1933), p. 106. Munch apparently painted the portrait after Jensen-Hjell agreed to pay for paint and canvas as well as for a dinner at the Grand Hotel's café. See Pola Gauguin, *Edvard Munch,* 2nd edn (Oslo 1946), p. 56.
23. Hans Aanrud, 'Et farligt Ord', *Christiania Intelligentssedler,* 16 July 1890, as cited by John A. Dahle, *Litteratur og lesing omkring 1890* (Oslo 1974), pp. 114–15. The 'dangerous word' referred to in Aanrud's title is 'Bohemia'.
24. The most extensive discussion of Munch's association with Jæger is by Arne Brenna, 'Hans Jæger og Edvard Munch', *Nordisk Tidskrift,* 52 (1976), 89–115, and 188–215.
25. Hans Jæger, *Syk kjærliket* (Paris 1893; 2nd edn, Oslo 1969). Concerning the identity of the characters in Jæger's novels, see Brenna (*op. cit.*), p. 101.
26. Manuscript T 2759 (EM III), written *c.* 1908. The identity of 'Mrs. Heiberg' was established by Trygve Nergaard, 'Refleksjon', p. 77 and note 163.
27. Draft of a letter to Jens Thiis, *c.* 1932. Munch Museum Archives.
28. Similarly, Munch's composition, light effect and other formal qualities have frequently been compared to Rembrandt, most persistently by Gösta Svenæus, *Edvard Munch: Das Universum der Melancholie* (Lund 1968), pp. 64 ff., but the works from which Munch's painting is thought to derive are all paintings he could not have known in 1885.
29. The streaks of paint are readily discernible in an early photograph of the painting (Pl. 21). In its current state, *The Sick Child* is much reworked, notably in the right-hand third which is painted over in broad, rough strokes of brackish dark green, and in the addition of a sketchily rendered glass in the lower right to replace a more carefully painted one now hidden under a film of paint slightly to the left. Although remnants of the dripping colour are still visible today, they lack their original intensity, an effect due possibly to the instability of Munch's medium or a deliberate attempt to remove them. The time of these changes is uncertain. The photograph can be dated to 1893; Munch's 1894 engraving of the theme repeats the original composition as does the 1896 painting, suggesting a date *post quem* for the changes. By the time the painting was published by Jens Thiis, *Norske malere,* Vol. II, p. 414, in 1907 the alterations had taken place. The changes to *The Sick Child* were first systematically studied by Karen Hellerstedt, 'An Examination of Edvard Munch's *Sick Child*', unpubl. MA thesis, University of Pittsburgh, 1971. Leif Einar Plather, 'Det syke barn og Vår: Røntgenundersøkelse av to Munch-billeder' in *Kunst og Kultur,* 57 (1974), pp. 103–15, discusses change observed through X-ray photographs. The most extensive discussion of the painting and its alterations is by Arne Eggum, 'The Theme of Death', Washington Catalogue 1978, pp. 143 ff.
30. Anonymous, 'Kunstudstilling', *Morgenposten,* 184 (28 October 1886), p. 2.
31. Andreas Aubert, 'Kunstnernes 5te Høstudstilling', *Morgenbladet,* 569 (9 November 1886), p. 1.
32. U.E.P., 'Kunstudstilling', *Morgenbladet,* 545 (28 October 1886). The 'Incohérents' were a short-lived group of Parisian artists specializing in parody.

33. Manuscript T 2771. Munch Museum Archives.
34. *Ibid.*
35. Hans Jæger, 'Udstilling', *Dagen,* 253 (20 October 1886). The article was originally submitted to *Dagbladet* but rejected. See Brenna, 'Jæger og Munch', *op. cit.,* p. 95, and Eggum, 'Theme of Death', *op. cit.,* pp. 143 ff.

Chapter 3

'I took my leave of Impressionism and Realism': Edvard Munch, *Livsfrisen tilblivelse* (Oslo *c.* 1929), p. 10.

1. For the chronology of various events surrounding the publication of Jæger's novel, see Odd Einem, 'Inledning', in Hans Jæger, *Fra Kristiania-Bohemen,* 2nd edn, Vol. I (Oslo 1950), pp. 5–10.
2. The painting is described by Jæger, 'Fra distrikts fængslet', *Impressionisten,* no. 1, 1–86, p. 4. See Reinhold Heller, 'Love as a Series of Paintings and a Matter of Life and Death', in Washington Catalogue 1978, pp. 103–4, for further discussion of the image and its significance for Munch. Arne Brenna, 'Hans Jæger's fengselsfrise', *St Halvard* (1972), pp. 238–66, discusses the arrangement of Jæger's cell.
3. Carl Nærup, *Skildringer og stemninger fra den yngre litteratur* (Kristiania 1897), p. 90, as cited in *Norsk litteraturkritikk fra Tullin til A.H. Wisnes* (Bergen, Oslo, Tromsø 1970), p. 177. The essay was originally published in 1895.
4. Manuscript T 2761 (EM I). Munch Museum Archives, *c.* 1890–3. In his writing style, Munch closely emulates Jæger, particularly in the disregard of lengthy description, emphasis on nondescript conversation, unpredictable mixture of subjective reactions and objective narrations and lack of dramatic or significant action. Jæger developed the style as a means of Naturalistic narration in which traditional qualities of art and beauty are minimized so that the resulting text would be 'ugly' in its presentation of prosaic truth. In Munch's novel fragments, however, it is difficult to determine if the effects are conscious or due to a lack of proficiency. It can be stated categorically, however, that his major talent was visual rather than verbal, although Brenna, *op. cit.,* argues he was Jæger's most faithful disciple in his writings.
5. Manuscript N 18. Munch Museum Archives.
6. Manuscript T 2761 (EM I). Munch Museum Archives.
7. Hans Jæger, 'En dag av mitt liv', in Jæger and Haakon Nyhuus, *Kristiania-Billeder* (Kristiania 1888), pp. 5 ff.
8. H-k, 'Høstudstillingen', *Aftenposten,* October 1888, as cited by Thiis, *Munch* (1933), p. 148.
9. The significance of *Evening* in Munch's formal and iconographic development is discussed with great perception by Trygve Nergaard, 'Refleksjon', *op. cit.,* pp. 21–3. Nergaard also points out that figures, now painted over, originally appeared in the middle ground, and that their presence would have reduced the dramatic tension of the painting. Munch appears to have rejected them in the process of creating his picture, still following the Naturalist practice of creating an image directly on a canvas without detailed preparatory sketches and then making corrections in the process of painting.
10. Hans Jæger, 'Vor litteratur: Albertine og naturalismen', *Impressionisten,* 4 (April 1887), n.p.
11. Christian Krohg, 'Det ene fornødne i kunsten', in *Kampen for Tilværelsen,* 2nd edn (Oslo 1952), p. 16.
12. Christian Krohg, 'Tredje Generation', *ibid.,* pp. 171–4.
13. Julius Lange, 'Studiet i Marken. Skilderiet. Erindringens Kunst', in *Udvalgte Skrifter,* Vol. III (Copenhagen 1903), p. 162. See also Trygve Nergaard, 'Despair', in Washington Catalogue 1978, pp. 113–42.
14. *Caspar David Friedrich in Briefen und Bekenntnissen,* ed. Sigrid Hinz (Munich 1968), p. 92. Friedrich's aphorisms on art were published originally by Carl Gustav Carus, *Friedrich der Landschaftsmaler* (Dresden 1841). They derive largely from manuscripts preserved by J.C.C. Dahl, the Norwegian landscape painter befriended by Friedrich who left his collection to Oslo's National Gallery. Dahl's collection and association with Friedrich in turn aroused the interest of Andreas Aubert, one of Munch's few critical supporters – although with constant reservations – during the 1880s, and since the two were personally acquainted, the possibility that Munch knew of Friedrich's ideas and work as early as the 1880s cannot be dismissed, although it is also unverifiable. For further discussions of Munch's relationship to German Romanticism, see Reinhold Heller, 'Edvard Munch and the Clarification of Life', *Allen Memorial Art Museum Bulletin,* 29:3 (Spring 1972), pp. 121–9; Heller, *The Scream* (London and New York 1973), pp. 23–5 and 72–3; and Robert Rosenblum, *Modern Painting and the Northern Romantic Tradition* (New York 1975), pp. 101 ff.
15. Munch's pithy summation of his art was published by him in the pamphlet *Livsfrisens tilblivelse* (Oslo *c.* 1929), and there dated 1890. The earliest citation of it appears to be by Christian Krohg, 'Edvard

Munch', in *Kampen*, pp. 164–6, originally published in 1892.

16. Lange, *op. cit.*, pp. 162–4.
17. Henrik Ibsen, letter to Georg Brandes, 1886, as cited by Michael Meyer, *Ibsen: A Biography* (Garden City, N.J. 1971), p. 558.
18. Friedrich Nietzsche, *Thus Spake Zarathustra*, tr. Walter Kaufmann, *The Portable Nietzsche* (New York 1954), p. 436.
19. Knut Hamsun, *Sult* (Oslo 1953), p. 1.
20. Carl Nærup, *Illustreret norsk Litteraturhistorie, Sidste Tidsrum 1890–1904* (Kristiania 1905), p. 93.
21. As cited by Thiis, *Munch* (1933), p. 159.
22. The Munch Museum is planning publication of the exhibition listing, of which I was kindly provided with a copy. For further discussion of Munch's technique and intentions in *Spring*, see Reinhold Heller, 'Edvard Munch's *Life Frieze*: Its Beginnings and Origins' (unpubl. thesis, Indiana University 1968), pp. 101–5. The painting's relationship to Hans Heyerdahl's *A Worker's Death* (Trondheim 1888) as a more 'academic' alternative to Krohg is emphasized by Nergaard, 'Refleksjon', *op. cit.*, pp. 47–8. While initially working on *Spring*, Munch created a significantly more complex composition, as recently revealed by X-ray studies of the painting. The mother–child relationship, with the girl seen in profile and her attendant to her left, was identical to *The Sick Girl* composition, and one or more additional figures – notably a man with features similar to Dr Munch's – also were in attendance on the patient. For discussion of these changes, see Leif Einar Plather, 'Det Syke Barn og Vår', *Kunst og Kultur*, 57 (1974), pp. 108–15.
23. In December 1889, while visiting Halfdan Strøm and other painters in Skagen, Munch was pushed – apparently as a joke – into a partially frozen stream. A rheumatic illness resulted and proved nearly fatal, leaving Munch ill for over two months. See *Brev*, pp. 60–1.
24. Johan Sverdrup, speech delivered to the Storting, 1880, as cited by Trygve Nergaard, 'Despair', in Washington Catalogue 1978, pp. 114–15, which also discusses the significance of Sverdrup's programme of governmental support for the arts.
25. Andreas Aubert, 'I Anledning af Edvard Munchs Udstilling', *Dagbladet*, 19 May 1889. Aubert wrote the article 'on request' shortly after the Munch exhibition closed on 12 May. Aubert's and Krohg's articles appear to have been written in support of Munch's application for a State Fellowship. Both point to his colouristic proficiency while advocating further study in draftsmanship as taught by Léon Bonnat in Paris, thus providing justification in terms both of promise and of need for a fellowship. See Nergaard, 'Refleksjon', *op. cit.*, note 218, p. 128.
26. Karen Bjølstad, letter to Inger Munch, 1889, *Brev*, 52, p. 63. 'There was something about him that impressed both Laura and me – something inexplicably restless-nervous [*urolig nervøst*].'
27. Manuscript T 2771. Munch Museum Archives. The texts were written early in the 1890s. See also the unpublished paper by Sarah G. Epstein, 'Edvard Munch and Children', 1979, which contains reminiscences by Adele Ipsen, daughter of Aase and Harald Nørregaard.
28. Manuscript T 2781. Munch Museum Archives. The text dates from *c.* 1893; see Nergaard, 'Refleksjon', *op. cit.*, p. 123, note 186, and Eggum, 'Death', Washington Catalogue 1978, pp. 167–8.
29. For comparisons to Manet and Degas, see Ingrid Langaard, *Edvard Munch: Modningsår* (Oslo 1960), pp. 44–6, and Thomas Messer, *Edvard Munch*, The Library of Great Painters (New York 1970), p. 52. The most thorough discussion of Munch's stylistic dependence on Krohg is by Kirk Varnedoe, 'Christian Krohg and Edvard Munch', *Arts Magazine*, 53:8 (April 1979), pp. 88 ff.
30. This discussion of *Music on Karl Johan's Street* is largely dependent on the perceptive analysis by Nergaard, 'Refleksjon', *op. cit.*, pp. 92–4.
31. The device of dripping paint was used in *The Sick Child*, but in a more systematic pattern over the image than the seemingly random, accidental drips Munch uses here in the landscape portion of the painting. It is a technique otherwise not adopted by Munch until the summer of 1893. The painting is not mentioned by critics until 1893, when an anonymous article, 'Munch og Strindberg i Berlin', *Morgenbladet*, 7 December 1893, describes the painting as new. Also see Nergaard, 'Refleksjon', *op. cit.*, note 49, p. 110.
32. Laura Munch, letter to Karen Bjølstad, dated 18 July 1889. *Brev*, 53, p. 66. Arne Eggum, 'Major Paintings', Washington Catalogue 1978, p. 33, incorrectly asserts that the final painting was created between the hours of nine and eleven p.m., thus totally distorting Munch's working methods at this time with their emphasis on memory.
33. See Heller, 'Life Frieze', *op. cit.*, pp. 109–10; Thiis, *Munch* (1933), pp. 71–2.
34. Manuscript T 2771. Munch Museum Archives.

Chapter 4

'*Art must be created with your heart's blood*': Manuscript cited in *Munch: Tegninger, Skisser og Studier*, OKK Kat. 3 (Oslo 1973), p. 5.

1. I have previously discussed material in this chapter in 'Edvard Munch's *Night*, The Aesthetics of Decadence and The Content of Biography', *Arts Magazine*, 53:2 (October 1978), pp. 80–105.
2. Edvard Munch, draft of a letter to Aase Nørregaard, *c.* February 1890. Munch Museum Archives.
3. Emanuel Goldstein, letter to Edvard Munch, dated 5 July 1892. Munch Museum Archives. The Goldstein–Munch relationship is most extensively discussed by Trygve Nergaard, 'Emanuel Goldstein og Edvard Munch', *Louisiana Revy*, 16:1 (October 1975), pp. 16–18, to whom I owe much of the information concerning Goldstein, his poetry and his art theory. The Munch Museum has long projected a complete publication of the Munch–Goldstein correspondence.
4. Munch's letter of 8 November 1889 speaks of visiting the Centenary Exhibition and the Wild West show of 'Bilbao Bill', *Brev*, no. 58, pp. 68–9. Numerous other artists of the time, including Paul Gauguin and Rosa Bonheur, were fascinated by Buffalo Bill and the Indians he brought to Paris. See Dore Ashton, *Rosa Bonheur* (New York 1980).
5. The most extensive discussions of the Café des Arts exhibition are contained in Wladyslawa Jaworska, *Gauguin and the Pont-Aven School* (Boston 1972), and John Rewald, *Post-Impressionism: From Van Gogh to Gauguin*, 3rd edn (New York 1979), pp. 255 ff.
6. G.-Albert Aurier, 'Concurrence', *Le Moderniste*, 10, 27 June 1889, as cited by Rewald, *op. cit.*, p. 261.
7. G.-Albert Aurier, 'Le Symbolisme en peinture, Paul Gauguin', *Mercure de France*, II (March 1891), p. 161.
8. Félix Fénéon, 'Un autre groupe impressionniste', *La Cravache*, 6 July 1889, repr. in Fénéon, *Au-delà de l'impressionnisme*, Françoise Cachin, comp. Collection miroirs de l'art (Paris 1966), pp. 109–11.
9. Hermann Bahr, 'Die Decadence', *Studien zur Kritik der Moderne* (Frankfurt 1894), pp. 20–1. The essay was written in 1891.
10. See Théophile Gautier, 'Charles Baudelaire', in Charles Baudelaire, *Les Fleurs du mal* (Paris 1868), p. 17. The essay is dated 20 February 1868.
11. G.-Albert Aurier, *op. cit.*, p. 163, as trans. in Herschel B. Chipp, *Theories of Modern Art* (Berkeley and Los Angeles 1968), p. 92.
12. Gustave Kahn, 'Réponse des Symbolistes', *L'Evènement*, 28 September 1886, as cited by Sven Loevgren, *The Genesis of Modernism: Seurat, Van Gogh, and French Symbolism in the 1880s*, rev. edn (Bloomington, Indiana, 1971), pp. 82–4. I have altered the translation to be more faithful to the French original. Loevgren's account of the relationship between the doctrines of Symbolism and Neo-Impressionism is very perceptive.
13. Circumstantial evidence – Gauguin's relationship by marriage to Frits Thaulow, his association with other Scandinavian painters, his earlier insistence that 'all the Norwegians' visited one of his other exhibitions – suggests that Munch would have seen Gauguin's Café Volpini exhibition. However, there is absolutely no evidence of Gauguin's influence until 1891, by which time Munch had several additional opportunities to see works by Gauguin and his followers. In terms of his immediate development he may as well not have seen the show.

 Henri Dorra, 'Munch, Gauguin, and Norwegian Painters in Paris', *Gazette des Beaux-Arts* (November 1976), pp. 175–9, in contrast, argues for very specific derivations of Munch's work from Gauguin's in the Volpini exhibition, but they are contrary to Munch's work habits in which such direct and conscious borrowings never played a significant role.
14. For details concerning Munch's movements in Paris, Meudon and Saint-Cloud in 1889–90, see Heller, 'Night', *op. cit.*, p. 104, note 97.
15. Karen Bjølstad, letter to Edvard Munch, dated 5 December 1889, *Brev*, 66, p. 74. For further aspects of the events and correspondence surrounding Munch's father's death, see Heller, 'Night', *op. cit.*, pp. 89–91.
16. Manuscript T 2770 (EM II, typescript, p. 4). Munch Museum Archives. The entry is dated 4 February 1890.
17. This and the following observation made by Munch at the time of his father's death derive from Manuscripts N 5–16, Munch Museum Archives. The paper on which these were written is of a type identical to the stationery used by him during December 1889, suggesting that these reminiscences also date from this time, although they appear to have been revised later. See Heller, 'Edward Munch's *Life Frieze*: Its Beginnings and Origins' (unpubl. doctoral thesis, Indiana University, June 1969), p. 75; and Nergaard, 'Refleksjon', *op. cit.*, pp. 9–10.
18. Inscription dated 16 September 1880, *Bibelen eller Den Hellige Skrift* (Kristiania 1857), Munch Museum Library. The Bible, originally belonging to Dr Munch, was presented to Edvard in 1874 with the dedication: 'Blessed are they who hear God's word and keep it. Never forget this!' The only passage marked in the Bible – when and by whom is not known – is Isaiah 44: 21–3.
19. These allegorical images of his dead father are further discussed in Heller, *The Scream* (London 1973), pp. 58–60.
20. See p. 34 above.

21. Manuscript T 2770 (EM II, typescript, pp. 4–5). Munch Museum Archives.

22. Letter to Emanuel Goldstein, dated Nice, 22 January 1891. Munch Museum Archives.

23. Emanuel Goldstein, letter to Edvard Munch, dated Copenhagen, 15 July 1892. Munch Museum Archives.

24. Letter to Emanuel Goldstein, *c*. 1901. Munch Museum Archives.

25. Hugo Falk (i.e. Emanuel Goldstein), 'Hinc illae lacrymae', *Vekselspillet: Psykologisk Digt* (Copenhagen 1886), p. 2.

26. Emanuel Goldstein, 'Til Hende', *Vekselspillet*, p. 21.

27. Emanuel Goldstein, letter to Edvard Munch, dated 30 December 1891. Munch Museum Archives.

28. Emanuel Goldstein, 'Kammeratkunst', *Købenbavn*, 8 February 1892. Goldstein planned to publish a pamphlet under the title 'Art of Comrades', and a work with this title is listed in the original inventory of Munch's library, but is now missing from the Munch Museum Library. It has not been possible to locate other copies either in Denmark or Norway. The article here cited was made available to me by Trygve Nergaard.

29. Hjalmar Christensen, *Unge Nordmænd: Et kritisk Grundrids* (Kristiana 1893), p. 69.

30. Arne Garborg, *Trætte mænd* (Oslo 1970), p. 14.

31. Manuscript T 2760 (Violet Book, typescript pp. 40–1), entry dated 8 January 1892. Munch Museum Archives. When published in the catalogue *Edvard Munch: Tegninger, skisser og studier*, Oslo Kommunes Kunstsamlinger Katalog A-3, Munch Museum, 1973, p. 4, the year was incorrectly given as 1890.

32. Ernst Haeckel wrote profusely. His attempts to found a 'scientifically sound' alternative to traditional religion are most succinctly presented in *The Confession of Faith of a Man of Science* (London 1895). Munch's ideas also bear comparison to Ludwig Büchner's *Force and Matter* (1st edn 1855).

33. The text from 1890 was incorrectly dated 1892 in *Munch: Tegninger, op. cit.*, p. 4.

34. Edvard Munch, *Livsfrisens tilblivelse* (Oslo *c*. 1929), p. 17. Concerning the date of this text and its variants, see Heller, 'Life Frieze', *op. cit.*, p. 53–9.

35. Manuscript T 2770 (EM II, typescript, pp. 4–5). Munch Museum Archives.

36. See Heller, 'Night', *op. cit.*, pp. 88–9, for further consideration of *Night's* kinship to Henry's theories.

37. Hermann Bahr, 'Die neue Psychologie', *op. cit.*, p. 106.

38. Concerning Munch's debts to Whistler and Lautrec, see Heller 'Night', *op. cit.*, pp. 80–2, 93–4.

39. Manuscript T 2760 (Violet Book, typescript, pp. 11–12). Munch Museum Archives. The entry follows one dated 2 January 1891.

40. Manuscript T 2761 (EM I, typescript, pp. 29–30). The manuscript bears no date, but probably was written *c*. 1891–2. *Munch: Tegninger, op. cit.*, pp. 10–11, provides a date of 1891.

41. Sketchbook T 127, Munch Museum. The sketchbook also contains drawings dating from Saint-Cloud in 1890, and this seems the most likely date for the definition of Symbolism, but as there are drawings from 1894 interspersed among the earlier ones a definite date cannot be demonstrated.

42. Emanuel Goldstein, 'Kammeratkunst', *op. cit.*

43. See Heller, 'Night', *op. cit.*, pp. 101–2.

44. Edvard Munch, letter to Karen Bjølstad, *Brev*, 79, p. 88.

45. The painting is signed and dated 'E. Munch 91'. Arne Eggum has suggested that this date is incorrect, and that the painting corresponds to the one discussed by the critics of 1890. On stylistic grounds and the proximity of the time to the impact of Seurat's and Pissarro's Neo-Impressionist art on Munch, 1890 would seem to be the proper date for the painting; but the possibility that Munch finished or retouched it in 1891, then attributed the latter date to it, cannot be rejected.

46. Félix Fénéon, 'Le Néo-Impressionnisme', *L'Art Moderne*, 1 May 1887, p. 139, as cited by Fénéon, *Au-delà de l'impressionnisme, op. cit.*, p. 93.

47. Manuscript T 2770 (EM II, typescript, pp. 3–4), Munch Museum Archives.

48. Andreas Aubert, 'Høstudstillingen: Aarsarbeidet IV: Edvard Munch', *Dagbladet*, 5 November 1890, no. 355, pp. 2–3. Compare the similar conclusion of the critic of the *Kristiania Intelligenssedler*, 9 October 1890, who describes the seated figure of Night as 'a "Decadent" in the true sense of the word; he relives his life in his thoughts, while he stares blindly into the dark waters of the Seine outside, which have softly closed over so many wasted lives'.

49. Nils Vogt, in *Morgenbladet*, as cited by Thiis, *Munch* (1933), p. 178.

50. Arne Garborg, 'Idealistiske reaktion', *Tankar*, Vol. II, p. 104.

51. Knut Hamsun, 'Fra det ubevidste Sjæleliv', *Samtiden* I (1890), pp. 325–34, as reproduced in Hamsun, *Artikler 1889–1928*, Fakkelbøkene (Oslo 1965), pp. 41–2.

52. Knut Hamsun, *Paa Turné: Tre foredrag om litteratur* (Oslo 1960), p. 51.

53. Edvard Munch, letter to Karen Bjølstad, dated Nice, 20 January 1891, *Brev*, 95, p. 98.

54. Edvard Munch, postcard to Emanuel Goldstein, dated Nice, 22 January 1891. Munch Museum Archives.

55. Edvard Munch, letters to Karen Bjølstad, dated 25 April 1891 and 6 May 1891, *Brev*, 113–14, p. 113. The 1891 Salon des Indépendants is discussed by Rewald, *Post-Impressionism, op. cit.*, p. 391.

56. It has been argued that Munch's work at this time was directly dependent on Caillebotte's example; see J. Kirk Varnedoe and Thomas P. Lee, *Gustave Caillebotte: A Retrospective Exhibition* (Museum of Fine Arts, Houston, and Brooklyn Museum 1976–7), pp. 149–50. Not only are the two painters' works thematically and compositionally similar, but Munch also appears to have been painting from Caillebotte's balcony at 29/31 Boulevard Hausmann. This evidence for Munch's personal knowledge of Caillebotte and his paintings (those that could have influenced Munch remained in Caillebotte's own collection) is not conclusive, however. Nowhere in Munch's writings is Caillebotte mentioned, and in Paris Munch spent most of his time in the company of other Scandinavian artists. Moreover, in 1891 Caillebotte was no longer living at the Boulevard Hausmann address, nor is it currently known who was, although this would be the person with whom Munch might have been acquainted – could it have been a Scandinavian artist, who in turn may have known Caillebotte and thus acted as intermediary? Prior to Munch, other Norwegian artists created compositions of streets, most notably Christian Krohg, Hans Heyerdahl and Eilif Peterssen – all artists close to Munch – and it is more likely that one of them would have known Caillebotte, since their relationships to the French artists' community were far more developed. These possibilities, which would clarify much about Norwegian painting during the 1880s and early 1890s, have not been explored.

57. Application for Renewal of the State Fellowship, dated 24 March 1891. Statsarkivet, Oslo. The letter is discussed by Nergaard, 'Despair', *op. cit.*, p. 120.

58. Edvard Munch, letter to Emanuel Goldstein, undated (*c*. summer 1891). Munch Museum Archives.

59. Manuscript T 2760 (Violet Book, typescript, p. 35b). Munch Museum Archives. Entry dated Tuesday 29 [September (?)] 1891. The nine quotations come from the same manuscript, as follows: (p. 41) Nice, 14 January 1892; (pp. 20–6) Friday 28 [August (?)] and Thursday 27 August; (pp. 31–2) Sunday, 6 September; (p. 31); (p. 29) Sunday 30 August; (p. 42) Nice, 14 January 1892; (p. 42) Nice 14 January 1892; (p. 41) undated entry; (p. 44) Nice, 22 January 1892.

60. The association with Milly Thaulow was made by Trygve Nergaard, 'Refleksjon', *op. cit.*, pp. 22–3, the dating of the drawing is problematic. Munch himself wrote that his original sketch for *Kiss* dated from 1886, but his memory seems to have been incorrect, distracted by the time when his relationship with Milly Thaulow was at its most intense (letter to Jens Thiis, *c*. 1932). More recently Arne Eggum has sought to date this drawing, as well as several notebooks, to 1889, but has provided no justification for the dating (Arne Eggum, 'Der Kuss', in *Edvard Munch: Liebe, Angst, Tod* (Exh. Cat. Bielefeld 1980), pp. 19–21. More frequently, 1890–1 has been suggested, as by Nergaard, 'Refleksjon', *op. cit.*, ill. 142; Heller, 'Life Frieze', *op. cit.*, fig. V: 14; Pål Hougen, *Edvard Munch: Handzeichnungen* (New York 1976), no. 58, p. 14. Johan Langaard and Reidar Revold, *Edvard Munch som Tegner* (Oslo 1958), p. 33, date the drawing 1892 in conjunction with a painting of that date; on stylistic grounds, this is certainly too late, while 1889 is too early unless it can be demonstrated that numerous other drawings generally dated to 1890–1 were also created earlier.

61. Text as cited in *Munch: Tegninger, op. cit.*, p. 8.

62. Thiis, *Munch* (1933), pp. 238–9, following Munch's instructions, wrote: 'An exemplary instance of how a moment experienced once, a situation or a motif lives and continues to work in Munch's fantasy is the motif *Kiss*. In its origins, the motif goes back to '86. In its first painted version the motif was created in Kristian IV's street where several artists including Munch shared studios during the winter of '90 to '91. In the room's blue shadows, near a window lit up by lights from the street, a loving couple stands in passionate embrace. Through the process of the embrace, their shadows glide together into a single dark mass.'

63. If in 1891 there was a new and direct confrontation between Munch and Gauguin's Synthetism, it most likely excluded the example of Gauguin himself, who did not exhibit at the Salon des Indépendants, although artists directly influenced by him or associated with him – Anquetin, Bernard, Bonnard, Denis, Séguin, Vallotton and Willumsen – did send their works. In addition, there is the probability of Gauguin's ideas indirectly affecting Munch while he was still in Nice, primarily

through Albert Aurier's article in the *Mercure de France, op. cit.*, and the publicity concerning Gauguin's departure for Tahiti. Munch's development, in *Evening*, of a personal variation of Symbolist Synthetism may also have been reinforced by the experience of other Symbolist-orientated or associated artists exhibiting at the Salon of the Société Nationale des Beaux-Arts, including Ferdinand Hodler, Max Klinger, Puvis de Chavannes and Whistler.

64. Emanuel Goldstein, letter to Edvard Munch, dated 15 July 1892. Munch Museum Archives. The specific reference to Synthetism is unusual. It may be a result of contacts between Munch and Willumsen earlier in 1892 when the Dane exhibited in Kristiania, suggesting that neither Munch nor Goldstein were familiar with the term or habitually used it earlier. Munch's reaction to Willumsen was reserved, finding him 'a bit too contrived in his pictures, but he certainly has a lot of talent and should be able to stir things up in Denmark'. (Undated letter to Emanuel Goldstein, *c.* July 1891.)

65. Manuscript N30c, *c.* 1894–5.

66. Listed among paintings in the 1891 Autumn Exhibition catalogue were: (118) *Night in Nice*, the National Gallery's first Munch acquisition; (119) *Sunshiny Day in Nice*; (120) *Study: A Young Girl*; and among drawings, watercolours and pastels: *Boys' Bathing Place*, *Study* and *Evening*. For detailed consideration of which painting corresponds to *Evening*, see Nergaard, 'Despair', *op. cit.*, pp. 124–31.

67. When the title *Melancholy*, which is now the one most frequently applied to the motif, was first used by Munch is not clear. Munch seems not to have applied it to the image during the 1890s, most frequently continuing to entitle it simply *Evening* or, apparently in association with a slightly altered image, *Jealousy*, but at the 1902 Berlin Secession exhibition the title *Melancholy* was used.

68. Théo van Gogh died on 25 January 1891, and his successor at Goupil's did not continue the policy of supporting Gauguin and other avant-garde painters, so that what work if any by such painters Munch might have seen there in 1891 remains problematic. See Rewald, *Post-Impressionism, op. cit.*, p. 427.

69. On the tradition of the *figura sedens*, see André Chastel, 'Melancholia in the Sonnets of Lorenzo de' Medici', *Journal of the Warburg and Courtauld Institutes*, 8 (1945), pp. 61–7; also Heller, 'Night', *op. cit.*, pp. 99–100. Nergaard, 'Refleksjon', *op. cit.*, p.29, has pointed to Sven Jørgensen's *Askeladen* (1891) and Christian Krohg's portrait of Skredsvig (1891) as prototypes for Munch.

70. Erik Werenskiold, letter to Andreas Aubert, dated December 1891. Oslo University Library, Letter Collection 32, as cited by Ingrid Langaard, p. 138. Also see Nergaard, 'Despair', *op. cit.*, p.32.

71. Christian Krohg, 'Munch', *Verdens Gang* and *Dagbladet*, 27 November 1891, as reproduced in *Kampen for tilværelsen*, pp. 174–5.

72. Christian Skredsvig, *Dager og nætter blandt kunstnere*, 3rd edn (Oslo 1943), p. 152.

73. Munch varied the title of the painting, as he did of many others; it was exhibited as *Mood at Sunset, Deranged Mood at Sunset* and *Despair*. For further discussion of the painting, see Nergaard, 'Despair', *op. cit.*, pp. 122–3, and Heller, *The Scream, op. cit.*, pp. 69–75.

74. Letter to Emanuel Goldstein, dated Nice, 8 February 1892. Munch Museum Archives. The correspondence between Munch and Goldstein concerning the title vignette has been most systematically analysed by Nergaard in 'Goldstein og Munch', in *Louisiana revy*, October 1975, and 'Despair', *op. cit.*

75. The practice of projecting thoughts or visions behind the thinker or dreamer is one common to Symbolist-orientated art, as well as being a traditional device found in paintings dating back to the Middle Ages. See Reinhold Heller, 'The Iconography of Edvard Munch's Sphinx', *Artforum*, IX: 2 (October 1970), pp. 73–4.

76. Emanuel Goldstein, letter to Edvard Munch, dated Copenhagen, 30 December 1891. Munch Museum Archives.

77. Letter to Emanuel Goldstein, dated Nice, 20 February 1892. Munch Museum Archives.

78. In addition to the pastel-oil now in the Munch Museum, there are three other paintings of the *Evening-Melancholy* composition. One of these, in the Rasmus Meyer Collection, Bergen, is dated 1894–5. The dates of the other two are debated. Arne Eggum, 'Melancholie', in Bielefeld Catalogue (1980), p. 31, argues that the painting in a private Norwegian collection is the original *Evening* of the 1891 Autumn Exhibition, but this ignores Werenskiold's and Thaulow's comments about the painting's mixed technique and large areas of bare canvas. It seems possible that prior to leaving for Nice, Munch painted this version, which shows none of the alterations of the vignette drawings, and that the version now in the National Gallery is therefore the third variation on the motif, created early in 1892. This chronology agrees essentially with that suggested by Nergaard, 'Despair', pp. 127 ff.

79. Thiis, *Munch* (1933), pp. 182–3.

80. Manuscript T 2782. He wrote two versions of the text. They are written on different kinds of paper, among them an unsent letter datable to 1892. Although this need not be the date of all the texts, it suggests they were at least worked on then, and probably completed during the next year with some editing as late as the 1920s. The papers were clipped by Munch into a ledger, probably about 1915, in an attempt to organize them. The first text (T 2782 bw) has a heading written during the 1920s: 'At the Seashore – Melancholy'. The second text (T 2782 r), the one cited here, is in more careful handwriting, possibly because Munch considered using it in a recital of his writings or to be read by others. Both texts are published in *Munch: Tegninger* (1973), p. 9.

81. Manuscript T 2782 j. Munch Museum Archives.

82. Manuscript OKK T 2760 (Violet Book, typescript pp. 5–6), cited in *Munch: Tegninger* (1973), p. 4. The entry is dated 8 February 1892.

83. Letter to Emanuel Goldstein, dated 20 February 1892. Munch Museum Archives.

84. Obstfelder wrote to Eugenia Paulsen: 'Just imagine, the painter Edv. Munch heard some of my poems . . . and is reading them. He wants to draw one or perhaps several vignettes for the collection of poems Krag is urging me to compile for Christmas.' Sigbjørn Obstfelder, *Brev*, ed. Arne Hannevik (Oslo 1966), p. 144.

85. Manuscript, cited in *Munch: Tegninger* (1973), p. 5.

86. Emanuel Goldstein, letter to Edvard Munch, dated 15 July 1892. Munch Museum Archives.

87. Manuscript T 2782 l, Munch Museum Archives. The date of the text is difficult to determine, although it seems likely it was written between 1892 and 1894. Gerd Woll, 'The Tree of Knowledge of Good and Evil', in *Munch: Symbols and Images* (1978), p. 242, associates the text with works of 1896. The imagery evoked, however, would seem to correspond more closely with Munch's thought process of the 1892–4 period when he sought verbal poetic similes for his painted images.

88. Schopenhauer's concepts of Will and aesthetic salvation are proposed in his major work, *Die Welt als Wille und Vorstellung*, 'The World as Will and Idea', Books II and III, first published in 1819.

89. See Schopenhauer, *op. cit.*, Vol. IV, *Sämmtliche Werke*, ed. J. Frauenstädt, 2nd edn (Leipzig 1891), p. 463.

90. The painting, purchased by Olaf Schou, was destroyed in 1901, while en route to an exhibition. The date of the painting has been debated; Jens Thiis, *Munch* (1933), pp. 198–9, suggests a date of 1891, probably on the basis of Munch's own dating, which in turn must have been based on the date of the drawings of the motif. More recently, Gøsta Svenaeus, *Edvard Munch: Das Universum der Melancholie*, p. 157, proposed 1892–5, without justifying this bizarre suggestion. Arne Eggum, 'Die Einsamen', in exh. cat. Bielefeld (1980), p. 139, agrees with Thiis' dating. Trygve Nergaard, 'Refleksjon', p. 20, believes the painting to be from the summer of 1892.

91. The comparison of Munch's *The Lonely Ones* to Friedrich's paintings has been repeatedly made. To my knowledge, the first to do this was the German art historian Herman Beenken in a letter to Munch (dated Leipzig, 12 June 1938, Munch Museum Archives) pointing to the similarity of composition and inquiring if Munch knew Friedrich's work during the 1890s. What response, if any, Munch made is not known. For more recent comparisons, see Heller, *The Scream*, pp. 26–7; Rosenblum, *Modern Painting*, pp. 107–8; and William Vaughan, *German Romantic Painting* (New Haven 1980), pp. 239–41.

92. Munch may have been aware of Friedrich's concepts of empathy through Aubert. See above, Ch. 3, note 14.

93. Carl Gustav Carus, *Neun Briefe uber Landschaftsmalerei, geschrieben in den Jahren 1815 bis 1824* (Leipzig 1831), p. 20, as cited in Friedrich, *Briefe*, p. 214.

94. Manuscript N59–3. Munch Museum Archives.

95. Manuscript T 2782 j. Munch Museum Archives.

96. Manuscript T 2782 af. Munch Museum Archives. As cited by Reinhold Heller, 'Edvard Munch's "Vision" and the Symbolist Swan', *Art Quarterly*, 36:3 (Autumn 1973), p. 234.

97. For full discussions of these images, see Trygve Nergaard, 'Edvard Munch's Visjon', *Kunst og Kultur*, 50:2 (1967), pp. 69–92; and Heller, 'Munch's "Vision"', *op. cit.*, pp. 209–49.

98. Manuscript T 2782 at, as cited by Heller, *idem.*, p. 235.

Chapter 5

'*I am working on studies concerning love and death*': Letter to Johan Rohde, undated (*c.* February–March 1893). Rohde Archives, Royal Library, Copenhagen.

1. Bjørnstjerne Bjørnson, 'Kunstnerstipendierne paa Afveje', *Dagbladet*, 427, 16 December 1891.

2. Edvard Munch, 'Til Bjørnstjerne Bjørnson', *Dagbladet*, 4 January 1892.

3. Frits Thaulow, 'Vore Kunstnerstipendier paa Afveje: Svar til B.B.',

Dagbladet, 429, 17 December 1891. Rep. in Frits Thaulow, *I Kamp og i Fest* (Kristiania 1908), pp. 116–19. The exchange between Bjørnson, Munch and Thaulow is discussed with insight by Nergaard, 'Despair', pp. 113–15.

4. Max Nordau, *Degeneration*, 5th edn (New York 1895), pp. 558–60. The original German publication of Nordau's book was in 1892.

5. 'Prosit', 'Edvard Munchs Udstilling', *Morgenposten*, 289, 15 September 1892.

6. In the literature on Munch, there has been some confusion concerning this. Thiis, *Munch* (1933), confessed that he had not seen the show and that the catalogue titles were not revealing, but believed works such as *The Sick Child, Spring,* and an 1886–7 version of *The Day After* were included. None of these was actually in the exhibition (the version of *The Day After*, judging from a photograph of Munch's Berlin exhibition, must have dated *c.* 1891–2). Following Thiis' example, other authors have similarly concluded that the 1892 Kristiania exhibition was a reprise of the earlier 1889 exhibition, but with new pieces added.

7. Manuscript T 2760 (Violet Book, typescript, pp. 14–15).

8. Two catalogue listings, slightly varying the titles, exist for the exhibition; in the first, the paintings are nos. 4–9, in the second, nos. 3–8. None of the critics says that these paintings were displayed cohesively as a group, but their arrangement in the catalogue suggests such a possibility. Groupings of paintings from the Riviera, of the Monte Carlo casino, and of 'sunlight effects' also suggest that Munch is exploring the effects of serial imagery.

9. Hermann Bahr, 'Die Décadence', *Studien zur Kritik der Moderne* (Frankfurt am Main 1894), pp. 20–1.

10. Munch's exhibition in Berlin is discussed at length by Reinhold Heller, 'Affæren Munch, Berlin, 1892–1893', *Kunst og Kultur*, 52 (1969), pp. 175–91, and Peter Paret, *The Berlin Secession: Modernism and its Enemies in Imperial Germany* (Cambridge, Mass., and London 1981), pp. 49–54.

11. Momme Nissen, 'Vom Münchener Glaspalast', *Freie Bühne für modernes Leben*, I (1890), p. 774.

12. Bernhard Kahle, *Henrik Ibsen, Björnstjerne Björnson, und ihre Zeitgenossen* (Leipzig und Berlin 1907), p. 3.

13. See Paret, *op. cit.*, pp. 9–28, for a concise consideration of the state of art in Berlin during the early 1890s.

14. Thiis, *Norske malere*, I, p. 265.

15. See Anonymous, 'Ein Epilog zur Berliner Kunstausstellung', *Freie Bühne für modernes Leben*, I (1890), p. 965.

16. Heller, 'Night', p. 95 and note 130, p. 105.

17. Munch, *Brev*, 128, p. 122, dated 12 November 1892.

18. Letter of Protesting Artists, dated 18 November 1892, as cited in 'Kunstchronik', *Münchener Neueste Nachrichten*, 534, 22 November 1892. Among the signatories were Max Liebermann, Walter Leistikow and Ludwig von Hofmann.

19. See Heller, 'Affæren Munch', p. 188; Paret, *op. cit.*, pp. 51–2.

20. Lovis Corinth, *Das Leben Walter Leistikows* (Berlin 1910), p. 48.

21. 'L. Sch.', Kleines Feuilleton: Der Impressionismus in Berlin', *Frankfurter Zeitung*, 37:315 (10 November 1892), p. 1.

22. Theodor Wolff, 'Bitte Ums Wort', *Berliner Tageblatt*, 576 (12 November 1892).

23. 'Walter Selber' [i.e., Walter Leistikow], 'Die Affaire Munch', *Freie Bühne für modernes Leben*, III (December 1892), p. 1298.

24. Stefan George, 'Einleitungen und Merksprüche', *Blätter für die Kunst, eine Auslese aus den Jahren 1892–98* (Berlin 1899), pp. 13–14.

25. Max Dauthendey and C.G. Uddgren, *Verdensaltet: Det nye sublime i Kunsten* (Copenhagen 1893), pp. 27–37.

26. Robert Musil, *Der Mann ohne Eigenschaften* (Munich 1952), p. 40.

27. As reported in *Kunstchronik*, NS IV (1892–3), p. 363.

28. Edvard Munch, draft of a letter to Jens Thiis (?), *c.* 1932. Munch Museum Archives. As cited by Heller, 'Life Frieze', *op. cit.*, p. 36.

29. Edvard Munch, letter to Johan Rohde, undated (February or March 1893). Rohde Archives, Royal Library, Copenhagen. Reproduced in Ingrid Langaard, pp. 192–3.

30. Cited in *Munch: Tegninger* (1973), p. 5.

31. As cited by Göran Söderström, *Strindberg och bildkonsten* (Stockholm 1972), p. 21.

32. Stanislaw Przybyszewski, *Overboard*, in *Homo Sapiens: A Novel in Three Parts*, tr. T. Seltzer (New York 1915), p. 21. Also compare the description in *Vigilien* (Berlin 1895), pp. 15–17, cited by Heller, *The Scream*, p. 75:

 And a mood arises within me and then reflects my own deepest, innermost feelings onto the outside world in a rainbow of powerful light . . . And I see the sky dissolving into every color, into glowing fires, into clouds constantly shifting in great haste. Yellow-green at the edges, ash-grey above the violet-purple shore of the horizon,

and from the west a jagged wound in the giant brow of the sky.

33. Stanislaw Przybyszewski, 'Psychischer Naturalismus', *Die freie Bühne*, 5:1/2 (January 1894), pp. 150–6, reprinted in Przybyszewski, ed., *Das Werk des Edvard Munch: Vier Beiträge* (Berlin 1894), pp. 11–31.

34. As cited by Heller, *The Scream*, pp. 104 and 107. The text appears in the border of a charcoal drawing of the *Despair* motif (OKK T 2367), which has been variously dated between 1891 and 1893. For arguments supporting the date of 1892–3, see Heller, *ibid.* pp. 76–7.

35. Przybyszewski, *Overboard*, *op. cit.*, pp. 31–3.

36. Przybyszewski, 'Psychischer Naturalismus', in *Vier Beiträge*, pp. 16–17.

37. Przybyszewski, *Totenmesse* (Berlin 1893), p. 7.

38. *Ibid.*, p. 5.

39. Manuscript N30, Munch Museum Archives. The note probably was written about 1895. See Heller, 'Love', in *Munch: Symbols and Images*, note 60, p. 110.

40. Adolf Paul, *Strindbergsminnen och brev* (Stockholm 1915), pp. 98–9.

41. Edvard Munch, 'Dagny Przybyszewska', *Kristiania Dagsavis*, 25 June 1901. The article was written as a memorial at the request of Dagny's family after her death.

42. Franz Servaes, in *Das Werk des Edvard Munch*, p. 56.

43. Paul, *Strindbergsminnen*, p. 100.

44. Letter to Karen Bjølstad, *Brev*, 137, pp. 127–8.

45. Notation in Sketchbook No. 31 (T 2938), *c.* 1891. Munch Museum Archives.

46. Edvard Munch, letter to Johan Rohde, *c.* March 1893, see Note 29 above.

47. Dauthendey, *Ein Herz*, p. 127.

48. Arne Eggum, 'Munch's Self-Portraits', p. 19, argues that the entire painting was created before Munch's arrival in Germany. He ignores the diversity of styles between the face and the surrounding areas, however, and does not note that the background area was definitely painted after and over the portrait image.

49. For a fuller consideration of these associations, see Heller, 'Vision', *passim*.

50. Johan Rohde, letter to Edvard Munch, *c.* June 1893. Munch Museum Archives. Also see Nergaard, 'Vision', p. 80, and Heller, 'Life Frieze', for further discussion of the letter.

51. No catalogue or listing of the exhibition seems to exist. Among other artists exhibiting with the 'Free Artists' were Normann, Strindberg and Käthe Kollwitz.

52. Franz Servaes, 'Von der "freien Kunstaustellung"', *Die Gegenwart*, XLIII:25 (1893), pp. 397–8.

53. Draft of a letter to Jens Thiis, *c.* 1932. Oslo, Munch Museum Archives.

54. Edvard Munch, letter to Karen Bjølstad, dated 3 December 1893. *Brev*, 141, pp. 129–30.

55. Two variants of the 'woman's corpse' motif exist: OKK M756, now entitled *The Dead Mother and the Angel of Death*, in which the corpse shares the interior space with a statue of an angel; and OKK M516, now entitled *The Dead Mother with Spring Landscape*, here discussed in the text. Both paintings were included in the 1893 exhibition, under the respective titles of *A Corpse* and *Death*, suggesting that the first forms a specific representation dependent on a particular setting and model while the second is a universal statement on the nature of death itself. This distinction also explains why the images differ stylistically, with *A Corpse* rendered in a quasi-impressionist facture Munch also used in portraits in 1893, while *Death* is rendered more flatly, decoratively or synthetically. The styles used by Munch were thus adapted according to their suitability to the nature of the subject matter. Also see Eggum, 'Death', Washington Catalogue 1978, pp. 168–9.

56. Hermann Beenken, *Das neunzehnte Jahrhundert in der deutschen Kunst: Aufgaben und Gehalte* (Munich 1944), pp. 244–5. The 'precedents' for Munch's composition should also include Japanese woodcuts and the drawings of Aubrey Beardsley being published in *The Studio* in 1893.

57. The chronology here suggested need not be absolute. The casein painting in Oslo's National Gallery shows several areas where Munch painted over or corrected aspects of the composition – a cat seems to have disturbed the middle of the large floor area on the right – and the charcoal drawing remains very much visible. This suggests that Munch may have worked out his composition directly on the canvas, rather than imitating a composition that was already refined in numerous sketches. If this is so, the sketches may all derive from the painting itself, rather than vice versa.

Arne Eggum, 'Das Todesthema', *Munch: Liebe, Angst, Tod,* p. 375, suggests a date of 1894/5 for the casein painting and argues

that an oil in the Munch Museum was the one exhibited in 1893. The visible changes in the casein painting would seem to argue against this, however.

58. Willy Pastor, 'Edvard Munch', *Frankfurter Zeitung*, 24 January 1894, reprinted in *Das Werk*, p. 74.
59. Jens Thiis, 'Minneord om Helge Rode', in *Festskrift til Francis Bull på 50 årsdagen* (Oslo 1937), p. 307.
60. Pastor, *op. cit.*, p. 72.
61. Przybyszewski, letter to Edvard Munch, dated 16 April 1894. *Brev.*, 156, pp. 139–40.
62. Przybyszewski, *Das Werk*, pp. 17–24.
63. Careful reading of the critics suggests that the work exhibited in 1893 was a pastel, as I suggest here and in 'Love', p. 97. My prior dating of *c.* 1893/4 for the National Gallery painting in 'Life Frieze', p. 237, and *Munch: The Scream*, p. 51, should be corrected to 1894. Since this painting shows numerous traces of *pentimenti*, I believe it to ante-date the four other paintings of the *Madonna* motif. Servaes, in Przybyszewski, *Werk*, pp. 38–9.
64. Manuscript T 2547, '*Kunskapens træ på godt og ondt*', p. 24. Concerning the history of this portfolio of texts, prints and drawings, see Gerd Woll, 'The Tree of Knowledge of Good and Evil', *Munch: Symbols and Images*, p. 229 ff.
65. The similarity of the facial features to those of Ragnhild Bäckström aroused the ire of Dr Juell in Kristiania in 1895, cf *Brev*, 177, p. 154.
66. Thiis, *Munch* (1933), p. 217. Thiis himself considered the frame 'tasteless' and may well have contributed to Munch's decision to remove it.
67. Manuscript OKK T 2771. Munch Museum Archives.
68. Edvard Munch, Draft of a Letter to Jens Thiis, *c.* 1932. Munch Museum Archives.
69. Manuscript OKK T 2761 (EM I., typescript, p. 24). The text probably dates from 1891–2.
70. Arne Eggum, 'Vampir', in *Munch: Liebe, Angst, Tod*, p. 69, emphasizes this aspect of Munch's attitudes. The alternating sense of attraction and revulsion represented by *The Vampire* was first discussed by Trygve Nergaard, 'Refleksjon', p. 66 ff.
71. Anonymous, 'Fra Munchs Atelier', *Morgenbladet*, 76:229 (1 May 1894), evening edn, p. 1. The column is dated Berlin, 28 April 1894.
72. Servaes, in Przybyszewski, *Werk*, pp. 37–8.
73. Anonymous, 'Fra Munchs Atelier', loc. cit.
74. H.P. Blavatsky, *The Secret Doctrine*, I (London and Benares 1893), p. 381.
75. Servaes, in Przybyszewski, *Werk*, pp. 40–1.
76. Przybyszewski, letter to Baron Eberhard von Bodenhausen, undated (between 27 June and 13 July 1894). Schiller National Archiv, Marbach.
77. The exhibition and events surrounding it is discussed by Arne Eggum, 'Edvard Munchs första utställning i Sverige – Edvard Munch's First Exhibition in Sweden', in *Edvard Munch* (Malmö Konsthall, 22 March–25 May 1975), pp. 19–30.
78. Manuscript N30, Munch Museum Archives. The date of the text most likely is 1895. See Heller, 'Love', in *Munch: Symbols and Images*, p. 103, and note 60, p. 110.
79. The title in the Stockholm catalogue is *Summer Night's Mystique*, which can readily refer to Munch's painting of that title from 1892. In Berlin, in 1895, the title *Mystique*, similarly might refer to the earlier painting, but critics' descriptions more aptly apply to the *Starry Night* painting. It is not improbable that in Stockholm and Berlin two different paintings were involved.
80. Manuscript T 2782 ah. Munch Museum Archives.
81. For a full consideration of the painting's evolution and iconography, see Reinhold Heller, 'The Iconography of Edvard Munch's Sphinx', *Artforum*, IX:2 (October 1970), pp. 72–80.
82. See note 78 above.
83. See Klaus Lankheit, *Das Triptychon als Pathosformel* (Abhandlungen der Heidelberger Akademie der Wissenschaften. Phil.-hist. Klasse, 1959, 4) Heidelberg 1959, who discusses the triptych as 'pathos formulation' in its uses during the nineteenth century.
84. Manuscript OKK T 2781 ah. Munch Museum Archives.
85. Edvard Munch, *Livsfrisen* (Kristiania, *c.* 1918), p. 2. Most frequently the painting is dated 1898, although no justification for this date has ever been presented. Trygve Nergaard, 'Refleksjon', suggests 1895 as a date. A date of *c.* 1894/95 was first suggested by me in 'Love', *Munch: Symbols and Images*, p. 101. Stylistically there is no reason this date could not be justified, and the painting also fits Munch's iconographic concerns of the time.
86. Manuscript OKK T 2601.
87. Letter to Karen Bjølstad, dated 24 October 1894. *Brev*, 166, p. 146.
88. Gustav Schiefler, *Verzeichnis des graphischen Werk Edvard Munch bis 1906* (Berlin 1907), the standard catalogue of Munch's graphics,

lists the *Portrait of a Young Woman* as No. 2, but Schiefler apparently did not know the proofs now in the Munch Museum. Sigurd Willoch, *Edvard Munchs radinger* (Oslo 1950) follows Schiefler's ordering. Jens Thiis, *Munch* (1933), p. 237, identifies *American Woman* as Munch's first print, but misdates it to 1893.
89. Edvard Munch, letter to Karen Bjølstad, dated Berlin, 14 November 1894. *Brev*, 167, p. 147.
90. For a perceptive analysis of this print, see Trygve Nergaard, 'Kunsten som det evige kvinneligeen vampyrgate' in *Hyllest og triumf fra antikken til var tid*, 'Kunst og Kulturs serie' (Oslo 1979), pp. 119–29.
91. Thiis, *Munch* (1933), p. 237.
92. Sår Josephin Péladan, *L'Art idéaliste et mystique, doctrine de l'Ordre et du Salon Annuel de la Rose Croix* (Paris 1894), p. 1. The essay was cited by Richard Muther, *Geschichte der Malerei in XIX. Jahrhundert* (Munich 1894), p. 444, a book much admired by members of Munch's circle in Berlin. Przybyszewski, among others, was also familiar with Péladan's writings.
93. The full content of the portfolio was, using the titles there applied, *Morning Mood* (Sch. 15), *Portrait* (Sch. 27), *The Lonely Ones* (Sch. 20), *Tête-à-tête* (Sch. 12), *Moonlit Dusk* (Sch. 13), *Bohemian Scene* (Sch. 10), *Girl at the Window* (Sch. 5), *The Sick Girl* (Sch. 7).
94. Julius Meier-Graefe, *Edvard Munch: Acht Radierungen* (Berlin 1895), p. 22.
95. In his portfolio, Meier-Graefe announced the cycle as consisting of both engravings and lithographs, p. 19.
96. Sigbjørn Obstfelder, 'Edvard Munch, et forsøg', *Samtiden*, 7 (1896), pp. 17–21.
97. Anonymous, 'Nye Arbeider', *Aftenposten*, 4 October 1895.
98. Camille Mauclair, 'Chronique de l'art', *Mercure de France*, 19, July 1896.
99. Yvanhoe Rambosson, 'Le Salon des Indépendants', *La Plume*, 194, 15 May 1897.
100. August Strindberg, 'L'exposition d'Edvard Munch', *La Revue Blanche*, 72, 1 June 1896.
101. As cited by Söderström, *op. cit.*, p. 309.
102. Concerning the Molard Circle see Söderström, *op. cit.*, pp. 273 ff, and Bente Torjusen, 'The Mirror', in *Munch: Symbols and Images*, pp. 197 ff. Ms Torjusen's essay provides the most extensive consideration of Munch's stay in Paris and the developments of his graphics there.
103. Several drawings for Baudelaire's poems remain extant. See Johan Langaard, 'Munch og Baudelaire', *Oslo Kommunes Kunstsamlinger Årbok 1952–1953* (Oslo 1960), pp. 13–17, and Torjusen, *op. cit.*, pp. 201 ff.
104. See Torjusen, 'The Mirror', for a detailed discussion of the print series. Also Heller, 'Clarification of Life'.
105. As cited by Pål Hougen, 'Kunstneren som stedfortreder', *Nationalmusei årsbok*, 1968, p. 127.
106. This aspect of Munch's thought has been explored sensitively by Hougen, *op. cit.*, pp. 123–40. The association with Strindberg was first made by Trygve Nergaard.
107. August Strindberg, *Inferno, Alone, and other Writings*, tr. Evert Sprinchorn (Garden City, N.J. 1968), pp. 180–1.
108. Draft of a letter to Tulla Larsen, *c.* 1900. Munch Museum Archives.
109. Munch's relationship to Tulla Larsen remains shrouded in secretiveness and myth in large part due to the attempts by Munch, his friends and relatives to hide the true nature of it. Many of the letters and other documents relating to the relationship have been destroyed or not yet made available, so that a full consideration of this most significant aspect of Munch's life still cannot be written. The most extensive discussion heretofore is by Arne Eggum, 'Det gröna rummet: The Green Room', in *Edvard Munch, 1863–1944* (Stockholm 25 March–15 May 1977), pp. 62–100.
110. Draft of a letter to Tulla Larsen, *c.* 1900. Munch Museum Archives. As cited by Eggum, 'Gröna rummet', p. 64.
111. Edvard Munch, 'Den gule huset'. Manuscript in Munch Museum Archives.
112. Notes dated Florence, 22 April 1899. Munch Museum Archives.
113. Edvard Munch, draft of a letter to Tulla Larsen, *c.* November 1899. Several drafts of this letter exist in the Munch Museum Archives; the version cited here was among documents displayed at the exhibition *The Prints of Edvard Munch* (New York, Museum of Modern Art, 13 February–29 April 1973), checklist item No. 82.
114. Manuscript T 2759 (EM III, typescript, pp. 1–2). Munch Museum Archives. The precise date of these notations is difficult to determine. In content and style they are similar to others dated 1905, notably Manuscript T 2776.
115. Manuscript cited in *Munch: Tegninger* (1973), p. 3.

Notes

Chapter 6

'I have been faithful to the Goddess of Art': Tilbakeblikk 1902-3-4-5-8-7, typescript p. 10. Munch Museum Archives.

1. Manuscript T 2759 (EM III, typescript, pp. 12–14).
2. Manuscript T 2787, entry dated 15 February 1929.
3. Manuscript T 2776 (typescript, pp. 1–5).
4. All the literature on Munch has followed the example of Langaard and Revold, *Fra år til år*, p. 30, in listing two exhibitions for 1900, one at Kristiania's Dioramalokalet, the other in Dresden at Arno Wolf-ramm's. Documentation for these exhibitions consisted of two un-dated catalogues in the Munch Museum Archives. The Diorama exhibition listing to which they attributed the 1900 date is actually the exhibition of September and October 1897. The undated Wolframm catalogue contains a reprint of a review of an 1899 Munch exhibition at the same gallery by Ernst Hardt in the *Dresdner Zeitung*, providing a date *post quem*. However, a search of Dresden newspapers of 1900 fails to find any review or notice of another Munch exhibition, so that the catalogue must be from an exhibition after 1900 or else a revision and expansion of the 1899 show (which the listing itself suggests).
5. Letter dated 28 November 1901, *Brev*, 200, p. 169.
6. Glaser, *Munch*, pp. 131–3.
7. Thiis, *Munch* (1933), p. 287.
8. Glaser, *Munch*, p. 129.
9. Edvard Munch, letter to Andreas Aubert, dated 18 March 1902. Oslo, University Library, Letter Collection No. 32.
10. The catalogue listings, with identifications according to titles currently commonly in use, are as follows:
 Left wall: 'The Seeds of Love'
 187. *Abendstern* (*Evening Star*, i.e. *The Voice*) 1894 and *c.* 1902, OKK M 44.
 188. *Rot und Weiss* (*Red and White*), *c.* 1894. OKK M 460.
 189. *Aug in Aug* (*Eye in Eye*), 1894. OKK M 502.
 190. *Tanz* (*Dance*), *c.* 1899–1900. Prague, Narodni Gallery.
 191. *Kuss* (*Kiss*), *c.* 1893–5. OKK M 59.
 192. *Liebe* (*Love*, i.e. *Madonna*), 1894. Oslo, National Gallery.
 Wall facing entrance: 'Blossoming and Fading of Love'
 193. *Nach dem Sündenfall* (*After the Fall into Sin*, i.e. *Ashes*), 1894. Oslo, National Gallery.
 194. *Vampyr* (*Vampire*), 1893. Gothenburg, Art Museum.
 195. *Johannisnacht* (*St Hans' Night*, i.e. *Dance of Life*), 1899–1900. Oslo, National Gallery.
 196. *Eifersucht* (*Jealousy*), 1895. Bergen, Rasmus Meyer's Collection.
 197. *Sphinx* (*Sphinx*, i.e. *Three Stages of Woman*), 1893–5. Bergen, Rasmus Meyer's Collection.
 198. *Melancholie* (*Melancholy*), 1894–5. Bergen, Rasmus Meyer's Collection.
 Right wall: 'The Anxiety of Life'
 199. *Rote Wolken* (*Red Clouds*, i.e. *Anxiety*), 1894. OKK M 515.
 200. *Strasse* (*Street*, i.e. *Evening on Karl Johan's Street*), 1893–4. Bergen, Rasmus Meyer's Collection.
 201. *Herbst* (*Fall*, i.e. *The Red Vine*), 1898. OKK M 503.
 202. *Letzte Stunde* (*The Final Hour*, i.e. *Golgotha*), 1899–1900. OKK M 36.
 203. *Angstgeschrei* (*Scream of Anxiety*, i.e. *The Scream*), 1893. Oslo, National Gallery.
 Rear wall: 'Death'
 204. *Todeskampf* (*Death Struggle*, i.e. *Fever*), *c.* 1894. Bergen, Rasmus Meyer's Collection.
 205. *Sterbezimmer* (*Room of Death*, i.e. *Death in the Sickroom*) *c.* 1893–4. Oslo, National Gallery.
 206. *Tod* (*Death*, i.e. *The Smell of the Corpse*), *c.* 1894. OKK M 34.
 207. *Leben und Tod* (*Life and Death*, i.e. *Metabolism*), *c.* 1894 and later. OKK M 419.
 208. *Der Tod und das Kind* (*Death and the Child*), *c.* 1893–4. OKK M 420.
 Munch must have changed the total content of his Frieze between the time of his letter to Aubert and the time of the exhibition, adding three paintings to those that comprised the cycles of 'Love' and 'Death', which consisted of nineteen paintings during 1895–6. The paintings *Dance, Dance of Life, The Red Vine* and *Golgotha*, all painted during 1898–1900, could be identified with these three, with only *Dance of Life* clearly contributing to the Frieze content and using its established iconographic vocabulary. During later exhibitions of the Frieze in Leipzig and Kristiania, Munch returned to the total of nineteen paintings, while in Prague he limited the Frieze to fifteen items because of a lack of space.
11. Julius Meier-Graefe, 'Beitrag zu einer modernen Aesthetik', *Die Insel*, I:3 (1900), pp. 215–16.
12. J. Norden, 'Die grosse Berliner Sommerausstellung', *Die Gegenwart*, no. 24 (1902), p. 381.
13. Karl Scheffler, 'Berliner Sezession', *Die Zukunft*, 39 (14 June 1902), pp. 423–5.
14. Hans Rosenhagen, 'Die fünfte Ausstellung der Berliner Sezession', *Die Kunst für Alle*, 18 (1902), p. 438.
15. Manuscript T 2759 (EM III, typescript pp. 1–2).
16. *Ibid.*, p. 3.
17. As cited by Eggum, 'Gröna rummet', pp. 67–8.
18. Concerning Munch's relationship to the Linde Family, see particularly Gustav Lindtke, ed., *Edvard Munch-Dr. Max Linde Briefwechsel 1902–1928*, Veröffentlichungen VII, Senat der Hansestadt Lübeck, Amt für Kultur (Luebeck 1978).
19. Gustav Schiefler, *Verzeichnis des graphischen Werks Edvard Munchs*, 2 vols (Berlin 1906 and 1927). Concerning Schiefler see Hans Platte, *Gustav Schiefler aus den Erinnerungen von Luise Schiefler* (Hamburg 1965).
20. Eva Mudocci was born Evangeline Muddock in London. See Waldemar Stabell, 'Edvard Munch og Eva Mudocci', *Kunst og Kultur*, 56:4 (1973), pp. 209 ff.
21. According to Stabell, the Salome lithograph resulted in a serious argument between Munch and Eva Mudocci, who must have misread his meaning, as have most art historians and critics since then, identifying her as a *femme fatale* depriving Munch of his strength in the print; see e.g. Torjusen, 'Mirror', pp. 204–5.
22. Manuscript T 2739, as cited in *Edvard Munch: Alpha & Omega* (Oslo, Munch Museum, 25 March–31 August 1981), p. 42.
23. Letter dated 5 April 1903, Edvard Munch – Dr Max Linde Briefwechsel 1902–8, No. 15, p. 25.
24. Glaser, *Munch*, p. 134. The portrait is discussed in detail by Carl Georg Heise, *Die vier Söhne des Dr. Max Linde von Edvard Munch*, Reclams Werkmonographien (Stuttgart 1956).
25. Letter dated 3 July 1903, Briefwechsel, No. 20, p. 29.
26. Manuscript 'Tilbakeblikk' 1902-3-4-5-8-7 (typescript, p. 1).
27. Letter to Jappe Nilssen, dated Berlin, 13 January 1904. In Erna Holmboe Bang, *Edvard Munchs kriseår* (Oslo 1963), p. 19.
28. The exhibition and its contents are documented in *Edvard Munch og den Tsjekkiske kunst* (Oslo: Munch Museum, 27 February–30 April 1971).
29. Arthur Moeller van den Bruck, 'Munch', *Die Zeitgenossen* (Munich 1906), p. 217. Van den Bruck initially met Munch during the Schwarze Ferkel era; for their association, and on Van den Bruck's ideology of culture, see Fritz Stern, *The Politics of Cultural Despair* (Berkeley and Los Angeles 1963), pp. 183 ff.
30. Van den Bruch, *ibid.*, pp. 217–18.
31. Van den Bruck, *Die moderne Literatur in Gruppen- und Einzeldarstellungen* (Berlin and Leipzig 1902), p. 608.
32. *Ibid.*, pp. 222–3.
33. Julius Langbehn, *Rembrandt als Erzieher* (Leipzig 1890), pp. 200–2.
34. Concerning Munch and the Brücke artists, see Marit Werenskiold, 'Die Brücke und Edvard Munch', *Zeitschrift des deutschen Vereins für Kunstwissenschaft*, XXVII (1974), pp. 140–152, and *Die Brücke-Edvard Munch* (Oslo, Munch Museum, 16 October–26 November 1978).
35. The Linde Friese paintings were identified in the Munch Museum collections by Arne Eggum, *Der Lindefries* (Senat der Hansestadt Lübeck, Amt für Kultur, Veröffentlichung XX, 1982).
36. Letter dated 12 June 1905, Linde-Munch Briefwechsel, 24, p. 32.
37. Manuscript 'Tilbakeblikk 1902-3-4-5-8-7' (typescript, p. 1). Munch Museum Archives. The precise date of this manuscript is difficult to determine; 1909 is the most likely time of writing, but definitive evidence to this effect is lacking.
38. As cited by Heller, 'Strømpefabrikkanten', *op. cit.*, n. 40, p. 93.
39. The evolution of the Nietzsche portrait has been traced repeatedly by Gösta Svenaeus, most extensively in 'Trädet på berget: En studie i forhållandet Munch–Nietzsche'. *Edvard Munch 100 år, Oslo Kommunes Kunstsamlinger Årbok 1963*, pp. 26 ff.
40. Letter to Ernest Thiel, dated 29 December 1905. Thiel's Gallery, Stockholm.
41. Glaser, *Munch*, pp. 129–30.
42. 'Tilbakeblikk', p. 3.
43. *Ibid.*, p. 3.
44. Letter to Karen Bjølstad, dated Warnemünde, 26 December 1907. *Brev*, 264, p. 213.
45. For extensive discussion of the Reinhardt Frieze, most of which is now housed in West Berlin's National Gallery, see Peter Krüger, *Edvard Munch, der Lebensfries für Max Reinhardts Kammerspielhaus* (Berlin 1978).
46. Arne Eggum, 'Gröna rummet', p. 72, suggests the influence of Henri Matisse on Munch's art at this time. More likely is a combination of influences from late Impressionism, Van Gogh, Neo-Impressionism, and perhaps the early Matisse-related paintings of the Brücke painters.

47. Letter to Christian Gierløff, *c.* 1908. In Gierløff, *Munch selv*, p. 158.
48. Letter to Ernest Thiel, dated Berlin, 10 March 1908. Thiel's Gallery, Stockholm.
49. Letter to Ernest Thiel, dated Warnemünde, 21 September 1907. Thiel's Gallery, Stockholm.
50. Letter to Ernest Thiel, undated (*c.* October 1908). Thiel's Gallery, Stockholm.
51. Draft of a letter to Harald Nørregaard, undated (*c.* May 1908). *Brev*, 269, p. 216.
52. 'Tilbakeblikk', p. 5.
53. The most accurate accounting of the events in Copenhagen appears in Arne Eggum, 'Alpha and Omega: Edvard Munch's Satirical Love Poem', *Alpha & Omega*, pp. 39 ff, and his 'Edvard Munch i Danmark' in *Louisiana Revy*, 26:1 (October 1975), p. 24.
54. *Ibid.*, p. 8.
55. Letter to Jappe Nilssen, dated 27 October 1908, in *Kriseår*, p. 54.
56. See note 50, above.
57. 'Tilbakeblikk', p. 10.
58. Extensive discussions of the *Alpha and Omega* lithographs is provided by Lesley Morrisey, 'Edvard Munch's Alpha & Omega', *Arts Magazine*, 54:5 (January 1980), pp. 124–9, and the Munch Museum catalogue *Alpha & Omega* (1981).
59. Letter to Jappe Nilssen, dated 1 March 1909. *Kriseår*, p. 56.
60. One painting – *Dance on the Shore* – was sold in Prague in 1904, but it was a late addition to the series and essentially not related to the remaining canvases. In Prague, moreover, it was not displayed as a part of the 'Frieze of Life'. Also see note 10, above.
61. Letter to Sigurd Høst, dated 4 April 1909. In *Vennene forteller*, p. 146.
62. Letter to Jappe Nilssen, dated 3 February 1909. *Kriseår*, p. 57.
63. Letter to Jappe Nilssen, dated 8 April 1909. *Kriseår*, p. 74.
64. Letter to Jappe Nilssen, dated 20 April 1909. *Kriseår*, p. 77.
65. The widespread phenomenon of sun-worship and its accompanying cult of nudism in pre-World War I Europe remains largely unevaluated in its cultural and ideological significance. One of the artists loosely associated with the Schwarze Ferkel group – Fidus – was one of its leading propagandists. See Janos Frecot, J.H. Geist and D. Kerbs, *Fidus 1868–1948, zur aesthetischen Praxis bürgerlicher Fluchtbewegungen* (Munich 1972).
66. As cited in *Farge på trykk*, pp. 26–7.
67. *Munchs Konkurranceutkast til Universitets Festsal* (Kristiania 1911), pp. 5–6.
68. *Ibid.*, pp. 12–13.
69. *Ibid.*, p. 14.
70. Thiis, *Munch* (1933), p. 309.
71. Richard Reiche, 'Vorwort', *Internationale Kunst-Ausstellung des Sonderbundes westdeutscher Kunstfreunde und Künstler zu Cöln* (Cologne 1912), p. 3.
72. August Macke, letter to Edvard Munch, dated Bonn, 29 March 1913. Munch Museum Archives. Macke's opinion was by no means shared universally among the avant-garde in Germany. Kandinsky, for example, thought far less highly of Munch, see Wolfgang Maske, ed. *August Macke-Franz Marc Briefwechsel* (Cologne 1964), p. 158.
73. Gustav Schiefler, Diary entry, *c.* early May 1907. As cited by Eggum, 'Brücke og Edvard Munch', in *Brücke-Munch*, p. 19.
74. Letter to Jappe Nilssen, undated (*c.* 23 May 1912). *Kriseår*, pp. 87–8.
75. Glaser, *Munch*, pp. 25–6.
76. Letter to Sigurd Høst, as cited by Pola Gauguin, 'Munch Utstilling', p. 151.

Chapter 7

'*We do not die, the world dies from us*': 'The Tree of the Knowledge of Good and Evil', T 2547–A 17. Munch Museum Archives.

The 'late Munch' period of 1916 to his death remains the least known and studied part of the artist's career. Among the reasons for this is the relative dearth of documentation in comparison to the earlier phases of his life, the lack of firm guidelines for dating much of the work, and – until recently – the perception that his late work is significantly weaker in quality. The efforts of the Munch Museum to disseminate the totality of his production has helped to counteract the critical rejection of Munch's last thirty years, note in particular Ragna Stang's 'The Aging Munch: New Creative Power', *Edvard Munch: Symbols and Images*, pp. 77–85, an essay she sadly could only sketch out before her tragic death, and the exhibition, *Edvard Munch: Expressionist Paintings 1900–1940*, Elvehjem Museum of Art, Madison, organized by the Munch Museum. If nothing else, they testify that in our era of post-Modernism and neo-Expressionism our own perceptions in painting are finding in 'the aging Munch' a prediction of what our own artists continue to seek today. In this context of changing critical evaluations and incomplete historical research, this chapter necessarily presents an incomplete picture of Munch's work from the beginning of World War I to the middle of World War II. I hope, however, that it can be viewed as a sketch suggesting a means of evaluating and comprehending the productive – as well as unproductive – years of Munch's old age.

1. Karen Bjølstad, letter to Edvard Munch, dated 18 October 1915. *Brev*, 312, p. 238–9.
2. Munch rented Skrubben in 1909 and Grimsrød in 1913; he bought Ramme in 1910, and Ekely in 1916. The cabin in Aasgaardstrand was purchased in 1897.
3. Schiefler, Vol. II, 459, *Picking Apples (Neutralia)*, p. 120, observes: 'The title "Neutralia" refers to the profits made by the neutral countries during the storms of the World War.'
4. Munch's attitude to the First World War is summarized by Ragna Stang, *Edvard Munch* (London 1979), p. 209.
5. Edvard Munch, letter to Dr Max Linde, undated (*c.* September 1914). *Munch–Linde Briefwechsel*, 44, p. 47. The correspondence between Munch and Linde did not resume until 1920.
6. OKK N 67, *c.* 1916–17? The text, as well as Munch's other wartime lithographs, is discussed by Woll, 'Tree of Knowledge', pp. 245–7, and 'Angst findet man bei ihm überall', in *Edvard Munch: Liebe, Angst, Tod* (Bielefeld 1980), pp. 328–34.
7. See Karen Bjølstad's letter to Munch, dated 7 September 1917, *Brev*, 318, p. 242.
8. OKK T 2782. See Woll, 'Tree of Knowledge', for discussion of Munch's various ledgers and their dates.
9. In his pamphlet *Livs-frisen*, p. 3, Munch identifies as 'later reproductions' the paintings *Ashes, Dance of Life, Scream, The Sickroom* and *Madonna*; the pamphlet also includes an illustration of a new version of *Woman in Three Stages*.
10. *Livs-frisen*, pp. 1–2. The essential formulation of the *Livs-frisen* text, with its disassociation from Germany and emphasis on the Norwegian origin of Munch's art, also appears in a letter to Jappe Nilssen:
 'I see you intend to write soon about my Aasgaardstrand Period and the Frieze of Life. Since there is so much misunderstanding concerning it, like you I have wanted to write a bit in the catalogue. People want to pretend that it is from my first stay in Berlin, and under the influence of Strindberg and the Germans. In Paris in 1889, as I have already told you, I wrote something concerning a planned series of paintings.
 I say: no longer should only knitting and reading and eating people be painted. There should be people who live, love, and suffer. All in all, living life. *La vie vivante*, as the French now call it. It would be good if you quoted these words from my diary.
 With the Evening House – the two standing outside the house in 1889, the beginning was basically made. That is to say, the Sick Child and the White Woman on Stones was really the beginning of the linear cult or the Frieze of Life. Now Vigeland through Barbara Ring says the same thing. He intends to paint life, he says. I'm sure he heard about it.'
 The letter is dated Spring 1910 by Erna Holmboe Bang, *Edvard Munchs Kriseår*, pp. 86–7, however it seems probable that this date is incorrect; the references to Vigeland, to numerous exhibitions, and to a catalogue text all suggest a date around 1923–4.
11. *Ibid.*, pp. 3–4.
12. 'I anlednigg kritikken', *Livs-frisen*, p. 5 (i.e. p. 9).
13. Unnumbered manuscript. Munch Museum Archives.
14. Schiefler, Vol. II, pp. 395–404; *Jealousy, The Bite, The Cat, Two People, Lovers, Ashes, Lovers, Burlesque Dance Scene, Secret* and *The Tempter*. Whether or not Munch considered these prints to be an actual unified series remains unknown at present, but their concentration on motifs of sexuality and consistent use of the etching technique suggests this. Sch. 396–400, 403, and 421 are classified by Arne Eggum under the title 'Erotica', in *Munch: Liebe, Angst, Tod*, pp. 269–72, and he proposes that Munch printed the motifs in Paris in 1914 in reaction to Albert Besnard's *Petites Voluptés*; there is no particular evidence to support his conjecture, however.
15. Edvard Munch, Draft of a letter to Dr Daniel Jacobsen, undated. Munch Museum Archives, Oslo.
16. Edvard Munch, letter to Jappe Nilssen, dated 12 December 1908, in Bang, *Kriseår*, p. 33.
17. Birgitte Prestøe, 'Modellen', *Norsk dameblad*, 1:3 (March 1954), p. 6.
18. K.E. Schreiner, 'Minner fra Ekely', *Edvard Munch som vi kjennte ham: Vennene forteller*, Oslo 1946, p. 25.
19. Manuscript OKK N 79, *c.* 1929, cited in *Farge på trykk*, p. 26.
20. The most extensive discussions of Munch's worker imagery is by Gerd Woll, *Edvard Munchs Arbeiderfrise*, unpubl. paper, The University of Oslo, 1972; 'Arbetarsskildringar: Pictures of Workers', in *Edvard Munch 1863–1944* (Stockholm 1977), pp. 135 ff.
21. Draft of a letter to Curt Glaser, dated 9 December 1918, as cited by Gerd Woll, 'Angst', p. 333.
22. Felix Hatz, 'Minnen av möten med Edvard Munch', *Edvard Munch* (Malmö, 22 March–25 May 1975), p. 35.
23. OKK T 2547–A 3.
24. OKK T 2547–A 13.

SELECT BIBLIOGRAPHY

Askeland, Jan, 'Angstmotivet i Edvard Munchs kunst: The Fear Motif in Edvard Munch's Art', *Kunsten idag* 20:4 (1966), 4–57.

Bang, Erna Holmboe, comp. and ed., *Edvard Munch og Jappe Nilssen: Efterlatte brev og kritikker*. Oslo 1946. Rev. edn: *Edvard Munchs krisear belyst i brever*. Oslo: 1963.

Benesch, Otto, *Edvard Munch*. Cologne and London 1960.

Benesch, Otto, 'Hodler, Klimt und Munch als Monumentalmaler', *Wallraf-Richartz-Jahrbuch* 24 (1962), 333–58.

Boe, Roy A., 'Edvard Munch's Murals for the University of Oslo', *Art Quarterly* 23:3 (1960), 231–64.

Boe, Roy A., 'Edvard Munch, his Life and Work from 1880 to 1920', Unpubl. diss., New York University, 1970.

Bock, Henning, and Günter Busch, eds., *Edvard Munch. Probleme-Forschungen-Thesen*. (Studien zur Kunst des 19. Jahrhunderts, 13). Munich: Prestel, 1973. Contributions by G. Busch, H. Bock, J. Dobai, G. Gerkens, C.G. Heise, W. Jaworska, W. Masch, J.A. Schmoll gen. Eisenwerth, J. Schultze, W. Stubbe, and G. Svenæus.

Burckhardt, Hans, 'Angst und Eros bei Edvard Munch', *Deutsches Artzteblatt – Artztliche Mitteilungen* 62:39 (25 Sept. 1965), 2098–101.

Dedekam, Hans, *Edvard Munch*. Kristiania 1909.

Deknatel, Frederick, *Edvard Munch*. New York: Museum of Modern Art, 1950.

Eggum, Arne, 'The Linde Frieze', unpubl. ms., Oslo 1972.

Esswein, Hermann, *Edvard Munch* (Moderne Illustratoren, 7). Munich and Leipzig 1905.

Gauguin, Pola, *Edvard Munch*. Oslo 1933; rev. edn 1946.

Gauguin, Pola, *Grafikeren Edvard Munch*. Trondheim 1946.

Gerlach, Hans Egon, *Edvard Munch, sein Leben und sein Werk*. Hamburg 1955.

Gierløff, Christian, *Edvard Munch selv*. Oslo 1953.

Glaser, Curt, *Edvard Munch*. Berlin 1917: 2d edn 1920.

Gløersen, Inger Alver, *Den Munch jeg møtte*. Oslo 1956; repr. 1964.

Gløersen, Inger Alver, *Lykkehuset: Edvard Munch og Aasgaardstrand*. Oslo 1970.

Goepel, Erhard, *Edvard Munch: Selbstbildnisse und Dokumente*. Munich 1955.

Greve, Eli, *Edvard Munch: Liv og verk i lys av tresnittene*. Oslo 1963.

Hals, Harald II, *Edvard Munch og byen: Oslo i bilder fra kunstnerens ungdom*. Oslo 1955.

Heise, Carl Georg, *Edvard Munch: Die vier Söhne des Dr. Max Linde* (Reklams Universal-Bibliothek: Werkmonographien zur bildenden Kunst, 7). Stuttgart 1956.

Heller, Reinhold, 'Strømpefabrikanten, Van de Velde, og Munch', *Kunst og Kultur* 51 (1968), 89–104.

Heller, Reinhold, 'Affæren Munch, Berlin 1892–1893', *Kunst og Kultur* 52 (1969), 175–91.

Heller, Reinhold, 'Edvard Munch's "Frieze of Life": Its Beginnings and Origins', Unpubl. diss., Indiana University, 1968.

Heller, Reinhold, 'The Iconography of Edvard Munch's *Sphinx*', *Artforum* 9:2 (Oct. 1970), 72–80.

Heller, Reinhold, 'Edvard Munch and the Clarification of Life', *Allen Memorial Art Museum Bulletin* 29 (1972), 121–9.

Heller, Reinhold, 'Edvard Munch's *Vision* and the Symbolist Swan', *Art Quarterly* 36:3 (Autumn 1973), 209–49.

Heller, Reinhold, 'Edvard Munch's "Night", the Aesthetics of Decadence and the Content of Biography', *Arts Magazine* 53:2 (Oct. 1978), 80–105.

Heller, Reinhold, *Munch: The Scream* (Art in Context), London 1973.

Hodin, Josef Paul, *Edvard Munch, der Genius des Nordens*. Stockholm 1948; 2d edn Berlin and Mainz 1963.

Hodin, Josef Paul, 'A Madonna Motif in the Work of Munch and Dali', *Art Quarterly* 16 (1953), 106–13.

Hodin, Josef Paul, 'Edvard Munch and Depth Psychology', *The Norseman* 14 (1956), 27–37.

Hodin, Josef Paul, *Edvard Munch*. London, Washington and New York 1972.

Hofmann, Werner, 'Zu einem Bildmittel Edvard Munchs', *Alte und neue Kunst: Wiener kunstwissenschaftliche Blätter* 3:1 (1954), 20–40; repr. in *Bruchlinien: Aufsätze zur Kunst des 19. Jahrhunderts*. Munich 1979.

Hoffmann, Edith, 'Some Sources for Munch's Symbolism', *Apollo* 81 (1965), 87–93.

Hoppe, Ragnar, 'Hos Edvard Munch pa Ekely', *Nutida Konst* 1 (1939), 8–19.

Hougen, Pal, 'Kunstneren som stedfortreder', *Nationalmusei arsbok* 1968, 123–40.

Hougen, Pal, *Edvard Munch, Handzeichnungen*. Hamburg and New York 1976.

Kokoschka, Oskar, 'Edvard Munch's Expressionism', *College Art Journal* 12:4 (Summer 1953), 312–20, and 13:7 (Autumn 1953), 15–18.

Langaard, Ingrid, *Edvard Munch: Modningsar*. Oslo 1960.

Langaard, Johan, and Reidar Revold, *Munch som tegner*. Oslo 1958.

Langaard, Johan, and Reidar Revold, *Edvard Munch: Masterpieces from the Artist's Collection in the Munch Museum in Oslo*. New York 1964.

Langaard, Johan, and Reidar Revold, *Edvard Munch*

fra ar til ar: A Year by Year Record of the Artist's Life. Oslo 1961.

Langaard, Johan, and Ragnvald Væring, *Edvard Munchs selvportretter.* Oslo 1947.

Linde, Max, *Edvard Munch und die Zukunft.* Berlin 1902; 2d edn 1905.

Linde, Max, *Edvard Munchs brev fra Dr. med. Max Linde* (Munchmuseets skrifter, 3). Oslo 1954.

Messer, Thomas, *Edvard Munch* (Library of Great Painters). New York 1973.

Moen, Arve, *Edvard Munch; Age and Milieu, Woman and Eros, Animals and Nature.* 3 vols. Oslo 1956–8.

Munch, Edvard, *Alfa og Omega.* Copenhagen 1908.

Munch, Edvard, *Konkurrenceutkast til Universitets festsal utstillet i Dioramalokalet.* Kristiania 1911.

Munch, Edvard, *Livsfrisen.* Kristiania c. 1918.

Munch, Edvard, *Livsfrisen tilblivelse.* Oslo c. 1929.

Edvard Munch: Mennesket og kunstneren (Kunst og Kulturs serie). Oslo: Gyldendal Norsk, 1946. Contributions by C. Dahl, P. Gauguin, C. Gierløff, J. Langaard, E. Pedersen, D. Prestøe, A. Romdahl, and N. Stenerund.

Edvard Munch som vi kiinte han: Vennene forteller. Oslo: Dreyer, 1946. Contributions by D. Bergendahf, P. Gauguin, C. Gierløff, I.M. Løchen, T.V. Müller, L.O. Ravensberg, J. Roede, and K.E. Schreiner.

Munch, Inger, ed., *Edvard Munchs brev: Familien* (Munch-museets skrifter, 1). Oslo 1949.

Nergaard, Trygve, 'Edvard Munchs Visjon: Et bidrag til Livsfrisens historie', *Kunst og Kultur* 50 (1967), 69–92.

Nergaard, Trygve, 'Refleksjon og visjon: Naturalismens dilemma i Edvard Munchs kunst', unpubl. thesis, University of Oslo, 1968.

Næss, Trine, 'Munch og den "Fri Kjærlihets By"', *Kunst og Kultur* 56 (1973), 145–60.

Obstfelder, Sigbjørn, 'Edvard Munch; Et forsøg', *Samtiden* 7:1–2 (1896), 17–22.

Oslo Kommunes Kunstsamlinger Arbok, 1952–1959. Oslo: Oslo Kommunes Kunstsamlinger, 1960. Contributions by R. Boe, P. Hougen, O. Johannesen, J.H. Langaard and Reidar Revold.

Oslo Kommunes Kunstsamlinger Arbok: Edvard Munch, 100 ar. Oslo 1963. Contributions by O. Benesch, H. Bisanz, J. Cassou, I. Hauptmann, H. Mead and G. Svenæus.

Østby, Leif Jørgen, 'Fra Naturalisme til Nyromantikk: En studie i norsk malrkunst i tiden c. 1888–95'. (*Kunst og Kulturs* serie). Oslo 1934.

Plather, Leif Einar, 'Det Syke Barn og Var: En røntgenundersøkelse av to Munch-billeder', *Kunst og Kultur* 57 (1974) 103–15.

Przybyszewski, Stanislaw, 'Psychischer Naturalismus', *Freie Bühne* 5 (1894), 150–6.

Przybyszewski, Stanislaw, and Julius Meier-Graefe, Willy Pastor and Franz Servaes, *Das Werk von Edvard Munch: Vier Beiträge.* Berlin 1894.

Röthel, Hans Konrad, *Welt und Werk Edvard Munchs.* Vienna 1954.

Sarvig, Ole, *Edvard Munchs Grafik.* Copenhagen 1948; 2d edn 1964.

Schiefler, Gustav, *Edvard Munchs graphische Kunst.* Dresden 1923.

Schiefler, Gustav, *Verzeichnis des graphischen Werks Edvard Munchs bis 1906.* Berlin 1907; repr. Oslo 1974.

Schiefler, Gustav, *Edvard Munch, das graphische Werk, 1906–1926.* Berlin 1928; repr. Oslo 1974.

Smith, John Boulton, *Edvard Munch 1863–1944.* Berlin 1962.

Smith, John Boulton, 'Portrait of Friendship: Edvard Munch and Frederick Delius', *Apollo* 83:47 n.s. (Jan. 1966), 38–47.

Stabel, Waldemar, 'Edvard Munch og Eva Mudocci', *Kunst og Kultur* 56 (1973), 209–56.

Stang, Nic, *Edvard Munch.* Oslo 1971–2.

Stang, Ragna Thiis, *Edvard Munch: Mennesket og kunstneren.* Oslo 1977. Eng. tr. New York 1979.

Steinberg, Stanley, and Joseph Weiss, 'The Art of Edvard Munch and its Function in his Mental Life', *Psychoanalytic Quarterly* 23 (1954), 409–23.

Stenersen, Rolf E., *Edvard Munch: Nærbilde av et geni.* Oslo 1946; 1964. Eng. tr. *Edvard Munch: Close-Up of a Genius.* Oslo 1969.

Strindberg, August, 'L'exposition d'Edvard Munch', *La Revue Blanche* 10 (1 June 1896), 72.

Svenæus, Gösta, *Edvard Munch – Das Universum der Melancholie.* Lund 1967.

Svenæus, Gösta, ' "Aimer et mourir", en associationskedja hos Edvard Munch', *Paletten* 28:4 (1967), 12–18.

Svenæus, Gösta, *Edvard Munch. Im männlichen Gehirn.* 2 vols. Lund 1973.

Thiis, Jens, 'Edvard Munch', *Samtiden* 12 (1901), 24–30.

Thiis, Jens, *Edvard Munch og hans samtid: Slekten, livet og kunsten.* Oslo: Gyldendal Norsk, 1933. German condensation: *Edvard Munch.* Berlin 1934.

Thue, Oscar, 'Edvard Munch og Kristian Krohg', *Kunst og Kultur* 57 (1974), 237–56.

Timm, Werner, *Edvard Munch. Graphik.* Stuttgart, Berlin, Cologne: Kohlhammer, 1969. Eng. tr. *The Graphic Art of Edvard Munch.* Greenwich, Conn. 1969.

Varnedoe, J. Kirk, 'Christian Krohg and Edvard Munch', *Arts Magazine* 53:8 (April 1979), 88–95.

Werenskiold, Marit, 'Die Brücke und Edvard Munch', *Zeitschrift des deutschen Vereins fur Kunstwissenschaft* 28 (1974), 140–52.

Willoch, Sigurd, *Edvard Munchs raderinger* (Munch museets skrifter, 2). Oslo 1950.

Woll, Gerd, 'Edvard Munchs Arbeiderfrise', Unpubl. thesis, University of Oslo 1972.

INDEX